A–Z
OF
DERBY
Places - People - History

Maxwell Craven

AMBERLEY

First published 2018

Amberley Publishing
The Hill, Stroud, Gloucestershire, GL5 4EP
www.amberley-books.com

Copyright © Maxwell Craven, 2018

The right of Maxwell Craven to be identified as the Author of this work has been asserted in accordance with the Copyrights, Designs and Patents Act 1988.

ISBN 978 1 4456 8173 3 (print)
ISBN 978 1 4456 8174 0 (ebook)

All rights reserved. No part of this book may be reprinted or reproduced or utilised in any form or by any electronic, mechanical or other means, now known or hereafter invented, including photocopying and recording, or in any information storage or retrieval system, without the permission in writing from the Publishers.

British Library Cataloguing in Publication Data.
A catalogue record for this book is available from the British Library.

Origination by Amberley Publishing.
Printed in Great Britain.

Contents

Introduction	4
Assembly Rooms	5
Arboretum	7
Babington Hall	10
Bassanos	12
Blue Plaques	13
Civic Society	15
Cars	16
China	17
Danes	19
Darley Abbey	20
Darwin	21
Emes	23
Emblems	24
Flamsteed	26
Fresh Water	27
Friary	29
George Yard	31
Guildhall	32
Gynaecology	34
Handyside	36
Headless Cross	37
Improvement Acts	39
Ironwork	41
Jacobean House	43
Joseph Wright	45
Judges' Lodgings	46
Keene	49
King Street	50
Little Chester	52
Lowell	54

Midland Railway	56
Museum	58
Name	60
Nightingale	61
Old Mayor's Parlour	63
Old Spa	64
Orrery	66
Pickford	67
Prince Charles Edward Stuart	68
Queen Aethelflaeda	70
Queen Street	71
Railway School of Transport	74
Royce's	75
St Helen's House	77
Silk Mill	78
Slavery	80
Townsend	81
The Turf	82
University	84
Victoria Crosses	86
Wardwick	88
Whitehurst	90
X-engine	92
Yates	93
Zoning, Planning	94
Acknowledgements	96
About the Author	96

Introduction

Derby has a history stretching back over 1,100 years, prefaced by a 400-year-long Roman settlement, *Derventio*, which, after a brief revival during the Danish conquest, dwindled into a small village and now lies within Derby's boundary. Much of interest has transpired over that period and, by employing a restrictive alphabetical formula, it is to be hoped that a nicely varied flavour of those elements that make Derby (since 1977 a city) a place of importance and distinction can be set out almost as a literary and historical potpourri to inform and entertain.

There can be no doubt that despite the fame of the Midland Railway, Rolls-Royce and modern developments – like the birth here of the virtual Lara Croft – Derby's finest hour was the age of the Enlightenment, when groups of highly talented men came together informally in Birmingham, Derby and also in Edinburgh to drive forward the development of modern political, philosophical and scientific endeavour. Derby contributed John Whitehurst FRS; harboured in his final two decades Erasmus Darwin FRS (allowing him to invent the artesian well in Full Street) and for a while was home to Peter Burdett PRSA, not to mention those closely associated with them: Joseph Wright, William Duesbury and many others – some still well known, others undeservedly forgotten.

Not only that, but a substantial portion of the town, rebuilt during those prosperous years, remains in desperate peril, despite the best efforts of the council – although through sheer municipal vandalism we have lost the homes of Darwin, Joseph Wright, and both houses associated with Herbert Spencer, and the house Pickford rebuilt for John Whitehurst (earlier owned by John Flamsteed and later where Joseph Wright died). The house of William Strutt and anti-slavery campaigner Thomas Gisborne was almost lost too, all going to show that however glorious the past, and whatever benefits exploiting it could bring, lack of interest in such a heritage, heedlessly giving in to developers, still takes precedence among those elected to run the city.

Nevertheless, using a book like this to help local people and visitors alike to reconnect with what is a pretty impressive heritage is an opportunity not to be missed, and if anyone, having read it, feels inclined to take up cudgels on behalf of Derby, do not hesitate for a second. And if an ally you require, feel free to contact our excellent Civic Society.

Assembly Rooms

From at least 1714, and probably earlier, there had evolved two separate assemblies in Derby, one for the gentry and another for the burghers of the town and their ladies. The former was housed in a pleasant double-fronted and twin-gabled three-storey building of 1714, which survived as a china showroom on the corner of Full Street where that street once turned north to the Market Place. It was swept away unrecognised in 1971 to make room for the multistorey car park, which today serves the present Assembly Rooms.

The lesser assembly was held in the old Moot Hall of 1610, on the east of Iron Gate. The rules of the former survive in Derby Museum and seem to date from the 1730s. These include such strictures as, 'No attorney's clerk shall be admitted' and 'No shopkeeper or any of his or her family shall be admitted except Mr Franceys.' The latter exception was not, certainly, because he was mayor, but as the borough's leading apothecary he was privy to too many of the medical secrets of the county gentry.

This assembly was presided over by Mrs Barnes, called 'Blowzabella'. She was a lady of pretension but of no great family, whose husband was a 'Derbyshire Gentleman of small fortune'. She held sway from 1741 to 1752, when she handed over to Countess Ferrers, writing smugly on the back page of the assembly account book: 'I told her that Trade never mix'd with Us Ladies.' Nevertheless, the two assemblies plainly needed amalgamation. One lady wrote, 'Tis hard out of two Assemblies you have at Derby people can't agree to make one good one.' Apparently county ladies had become reduced to dancing with each other.

Eventually a committee was set up under the patronage of the Duke of Devonshire to raise subscriptions to build a new joint Assembly Room. The architect was one of their number, retired admiral Washington Shirley, 5th Earl Ferrers. The resulting building was as stylish as any of its period in England, of brick with an elegant Palladian revival stone façade.

A further subscription was raised in 1770, eight years after building was started, to fund the finishing of the interior, a scheme for which was drawn up by Robert Adam. The assemblies themselves, held fortnightly with additional occasions for race weeks and fairs, were 'A stated and general meeting of the polite persons of both

Assembly Rooms' façade, photographed in 1931 by C. B. Sherwin.

sexes, for the sake of conversation, gallantry, news and play'. Normally they took place after dinner, a meal which was then taken in the late afternoon. Supper was served towards the end of the function. Occasionally the evening was declared a 'Derby rout' – a particularly informal type of ball.

One of the great advantages, therefore, of this new assembly was that the men who formed the kernel of the burgeoning intellectual circle, and also to some extent the better sort of tradesmen-craftsmen, had access through them to their patrons. The assembly was an element in the rising prosperity of the town and it was the assemblies that enabled client and professional man or tradesman to meet, with benefit to both.

Present Assembly Rooms, as closed, March 2016.

In 1963 a minor fire broke out in the building, which did superficial damage, but it was enough for the council to take the opportunity to pull the afflicted building down except the stone façade, and start again. They got Sir Hugh Casson to design a vast, brutalist 'Civic Halls' complex, far too big for a Georgian marketplace and entirely without grace. Sir Hugh was sufficiently egotistic to refuse to incorporate the old façade, which now graces Crich Tramway Museum. The new 'facility' opened in 1977.

Ironically, another serious fire in the adjoining multistorey car park in March 2014 seriously compromised the heating and air conditioning ducting of the building. The impecunious council closed it, took the insurance money, airily promised a new, much-improved, venue and then did nothing. Brutalist it may be, but any replacement is likely to be far, far worse.

Arboretum

The Arboretum was given to the town in 1840 by Joseph Strutt, one of the sons of cotton-spinning pioneer Jedediah. It is arguably the earliest public park in England.

Sometime before 1811, Strutt had bought some land on or near the site in Litchurch to make a 'summer rural retreat'. The Arboretum was originally 11 acres in extent, and was landscaped by the distinguished Regency architect and landscape gardener John Claudius Loudon. It was created with gently undulating hillocks, artfully contrived to between 6 and 10 feet and among which meandered 6,070 feet of gravel walks,

Above: Arboretum Square and entrance lodge, June 2015.

Below: Arboretum fountain with a throng of Sunday visitors, *c.* 1900.

the major arteries 15 feet wide, the lesser ones but 8 feet. All this was set off with more than 1,000 trees, which were the true glory of the area and from which Strutt rightly christened it the Arboretum. Not only were the trees and shrubs grouped according to type and variety, but Loudon also had managed to achieve a pleasing effect despite this, a consequence of Strutt's insatiable desire to educate.

The main entrance, not completed until 1853, was from a short avenue and square, known locally as 'Little Moscow', leading to a classical frontispiece by Henry Duesbury, a grandson of the younger William Duesbury of the china factory family. Two lodges elsewhere in the Arboretum, completed by the opening, were by E. B. Lamb. Various vases and statues from the garden of Strutt's nearby villa and his house in Derby were introduced, a mixture of terracotta sculpture by W. J. Coffee and cast-iron ornaments from a local foundry. Centrepiece of the whole ensemble was the full-scale copy by Coffee of the Florentine Boar on a gritstone plinth, much loved by the public. Unfortunately, this was destroyed by flying wreckage when the later Victorian bandstand was hit by a bomb in 1941. Nevertheless, the popularity of the place during its first century was enormous.

The Arboretum opened on 16 September 1840 with a great procession, 6,000 people in the park itself dancing to a band in an adjacent field. A ball at the Mechanics' Institute and a children's day on the 17th took place. The park was 'open to all classes of the public without payment ... on every Sunday, and also on the Wednesday in every week, from sunrise to sunset ... and that it shall be closed between ten and one o'clock on Sundays'.

At other times a small charge for admittance was made, which was abolished in 1881. It was physically extended south and west to Rose Hill Street in 1892. An impressive iron and glass conservatory was also built, known universally as the Crystal Palace, clearly inspired by Paxton's original but much smaller, designed by his Derby-born engineer Sir Douglas Fox. It was cleared away due to maintenance difficulties over a century ago. The Arboretum, now statutorily listed, was very well restored with a Heritage Lottery Fund grant in 2006. Even the boar was replaced.

B

Babington Hall

Derbyshire makes much of its connections with Mary, Queen of Scots, mainly because George Talbot, Earl of Shrewsbury, was, for much of the time she was in England, her 'minder' and he was then the greatest landowner in the county with a house in Derby Market Place. Yet, on the one occasion Mary came to Derby it was in the charge of Sir Ralph Sadler, who lodged her in Babington Hall, Derby. The whole episode is all the more enigmatic because the house itself vanished in 1811 and no image of it exists.

The Babington family, originally from the North East, came to Dethick in Derbyshire in the Middle Ages, and by 1466 were lords of the manor of Litchurch, a settlement on the immediate south side of Derby. The family had a town residence north and west of The Spot by 1534, which positions it about right. It had a gatehouse to St Peter's Street, with the rebus of the Babington family carved upon it: a baboon standing on a barrel (tun). This theme reappeared on the Tudor panelling inside and the house set in a small park stretching to the point where Green Lane meets Burton Road.

At some stage, Anthony Babington of Dethick, later executed for backing a plot to put Mary on the English throne, sold the house to Sir George Beaumont of Gracedieu, Leicestershire.

Two medieval carved panels saved (and since lost again) from Babington Hall.

B

Lithographic Victorian portrait of Mary, Queen of Scots.

On 13–14 January 1585, Sir Ralph Sadler, thwarted by the weather in an effort to lodge the Queen at Tutbury, was forced instead to stop with her at Babington Hall. He wrote,

> I, going next before her [to the house] her entertaynment was this. In the little hall was the goodwife, being an ancient widow, named Mrs. Beaumont [mother to Sir Francis], with iiii other women her neighbors. So sone as she knew who was her hostesse, after she had made a beck to the rest of the wemen standing next to the doore, then went to her and kissed her, and none other, sayeing that she was comme thither to trouble her, and that she was also a widow, and therefore trusted that they shulde agree well inough together, having no husbands to trouble them. And so went into the parler upon the same low floure, and no stranger with her but the goodwyfe and her sister.

That is about all we hear of the house until sometime after 1682 it passed to Derby Recorder Sir Simon Degge. His grandson built a new house in the park, and it is thought Babington Hall was sold off. In 1789 a new road, Babington Lane, was pitched beside it by the Improvement Commissioners so that in 1791 William Hutton could say of it that 'It was once the most eminent [house] in Derby but now ruined by time ... though this venerable antique has perhaps, experienced as many mutations as years and is multiplied into half-a-dozen tenements. Yet the original taste and grandeur of the matter are easily traced.' It was later unceremoniously removed by Joseph Gascoyne, who replaced it with a plain Georgian House, itself replaced by a shopping development in 1870.

A fine stone house of 1626 built by Derby's first mayor, Henry Mellor, was built immediately south of the old hall, and in the nineteenth century was renamed Babington House. It too fell victim to redevelopment in 1897. The Babington rebus in terracotta still graces the side of the replacement building, now Waterstones.

A–Z of Derby

Bassanos

Derby has long been happy to host modest quantities of migrants (*see also* 'D for Danes'). Two particularly talented families of Italians came to Derby and stayed, both making their mark: the Bassanos in the seventeenth century and the Bregazzis from Stazzona, in the far north of the Duchy of Lombardy. The latter were eminent gilders and barometer makers whose products are much valued by collectors, and other members of the family spread out over the British Isles in the same way of work too.

The Bassanos, however, came to England in the reign of Henry VIII as members of the king's band of musicians, Jeronimo di Bassano being a virtuoso sackbut player. They came from Bassano del Grappa in the Serene Republic of Venice, and are thought to have been of Jewish extraction. The family supplied many musicians for the Royal band for over a century until the Civil War, when it was dispersed.

Two members went to Lichfield, where they became vicars choral at the cathedral. Two sons of the younger came to Derby: Christopher (1679–1745) and Francis. Christopher was at first a music teacher and composer of anthems in Lichfield, but married the daughter and heiress of a Derby attorney and moved to the city, continuing with his music. Their son Richard inherited the legal practice and his wife,

Above left: Maria Bassano as *Maria*, from Sterne, by Joseph Wright. (Derby Museums Trust)

Above right: A 1908 Bassanophone.

Maria (1750–1815), was the model for Joseph Wright's celebrated painting of *Maria and her Dog Silvio*, an illustration from Laurence Sterne's *Sentimental Journey*.

Christopher Bassano's brother Francis (1675–1746) was a painter of some distinction, almost all of whose creative work is unfortunately lost, not least the frescoed ceiling of Franceys's House, Market Place, hacked down in 1936. He painted the heraldic roundel on Bakewell's mayor's pew in the cathedral, and numerous funeral hatchments, which appear to have been his bread and butter. Thanks to a surviving account book we can actually tell which.

There seems to have been no diminution of the talent in this family, for a contemporary of Dickens was Louisa Bassano, who became an international diva, and George Henry (1840–1913), both descendants of Christopher. G. H. Bassano was a humble mechanic in a mill, but discovered a streak of genius. He later became an early manufacturing electrician who designed and perfected the Bassanophone, the Rolls-Royce of early gramophones, in 1905–06. Today, collectors will pay a high price for rare examples of these.

Blue Plaques

For two decades Derby Civic Society has argued that London-style blue plaques should be mounted on appropriate buildings to commemorate eminent people of the town. This was always rejected by the council. Then in 2007 English Heritage declared that the London scheme would be extended to the provinces, and we all took heart. Yet within nine months it was announced that there was, after all, no money (thanks, Gordon Brown!) but towns could put them up in approved style if they wanted to.

Derby blue plaque to Charles Rolls and Henry Royce, Nightingale Road, 2016.

The Civic Society, undaunted, went back to the city council and offered to go half-and-half with them in raising plaques and, much to everyone's surprise, in 2012, with local elections looming, it was agreed. A white-on-blue plaque with both parties' names around the edge was agreed on. Local people were invited to suggest suitable names (the society already had a list to hand) and the scheme went ahead.

Over the years since, it has slowed down, largely through local authority parsimoniousness, but at the time of writing some eighteen have gone up, commemorating no less than twenty-five people, and the project proceeds. The list to date is as follows:

Bakewell, Robert (1682–1752), Yorkshire Bank, St Peter's Street
Bloomer, Steve (1874–1938), his former school, Peartree Road
Duesbury, William (1725–86), Landau Forte College, Fox Street
Evans, Thomas (1723–1814), former Long Mill, Darley Abbey
Flamsteed, Revd John, FRS (1646–1719)*, No. 27 Queen Street
Gisborne, Revd Thomas (1758–1846)*, St Helen's House, King Street
Lombe, John (1693–1722)*, Silk Mill, Silk Mill Lane, Full Street
Lombe, Sir Thomas (d. 1739)*, Silk Mill, Silk Mill Lane, Full Street
Mundy, Emily Georgiana Maria (1845–1929)*, The Orangery, Markeaton Park
Mundy, Francis Clarke Noel JP DL (1739–1815)*, The Orangery, Markeaton Park
Pickford, Joseph (1734–82), Pickford's House Museum, No. 41 Friar Gate
Rivers, Pte. Jacob, VC (1881–1915), south-east corner of Queen Street and Bridge Gate
Rolls, Capt. the Hon. Charles Stuart (1877–1910)*, Rolls-Royce works, Nightingale Road
Royce, Sir Henry, Bt., OBE (1863–1933)*, former Rolls-Royce works, Nightingale Road
Simpson, Sir George Clarke, KCB, CBE, DSc, FRS (1878–1965), Halifax Bank, East Street
Sorocold, George (1668–1738)*, Silk Mill, Silk Mill Lane, Full Street
Spencer, Herbert (1820–1903), Exeter Arms, Exeter Place
Strutt, Jedediah (1726–97), No. 67 Friar Gate
Strutt, William, FRS (1756–1830)*, St Helen's House, King Street
Towle, Sir William (1849–1929), former Midland Hotel, Railway Terrace
Wast, Joan (1532–55), south end wall of Lime Avenue
Wheeldon, Alice (1866–1919), No. 29 Pear Tree Road
Whitehurst, John, FRS (1713–88), No. 24 Iron Gate
Willoughby, Percival, MD (1596–1685), Registry Office, Tenant Street
Wright, Joseph, ARA (1735–97)*, No. 27 Queen Street

* Indicates one of more than one name on a particular plaque.

C

Civic Society

Derby Civic Society was founded in 1963 as an organisation dedicated to the well-being of the city, the preservation of its built and natural environment and to campaign for beneficent changes and to oppose destructive ones. The first patron was Very Revd Ronald Beddoes, the Provost of Derby Cathedral and the committee included councillors, architects and business people. A newsletter was sent out to the burgeoning membership twice in every year.

Over the years, the society has researched and made submissions for new conservation areas (Friar Gate, 1969; Strutt's Park, 1987) and persuaded the council to begin a campaign of pedestrianisation, starting with Sadler Gate in 1965 and ending in 1991 with the Derby Promenade. Campaigns were launched to save important buildings from demolition, not always successfully. A major *cause celèbre* was the destruction in 1984 of Derby's 1839 Trijunct Station, which had become so neglected by British Railways that its chairman, appalled, demanded its immediate replacement.

Leeds Place from Railway Terrace: the restored railway cottages, June 2014.

A–Z of Derby

Nor did the Secretary of State agree to its listing. Yet with the Derbyshire Historic Buildings Trust, three streets of adjoining housing, a travellers' pub and the Midland Hotel – all by the same architect, Francis Thompson – were saved and restored and the whole declared a conservation area.

The society has managed to get numerous buildings onto the statutory list and is represented on the Derby Conservation Area Advisory Committee and the Historic Buildings Trust.

A campaign to save St Helen's House from local authority neglect was successful in 2008 after two decades of strife, as was one to save most of the Shire Hall legal complex in St Mary's Gate in 1998; numerous other campaigns, mainly against unsightly or oversized developments, continue too. There are monthly meetings, including social events, outings and lectures.

The society gives out annual awards called ABCD – A Better City of Derby – for excellence in two categories – new build and restoration – and a six-year-long campaign to put up blue plaques to commemorate local people, eminent locally or internationally, continues in partnership with the city council.

Cars

Rolls-Royce started as electrical engineers under Henry Royce in Manchester and had been making motor cars only for three years when it was decided to move to Derby in order to mount production of the new 40/50hp car, later known as the *Silver Ghost*. Royce was an engineering perfectionist, working to much finer tolerances than his contemporaries.

Despite the lower local wages, once established Rolls-Royce (known universally in Derby as 'Royce's') paid Manchester rates in order to attract labour from elsewhere. They were, in 1907, looking to make a modest 200 cars a year in the works, opened on 9 July 1908. The end of the *Silver Ghost* series in 1925 was to be followed by three successive developments of its successor, the *Phantom*, the last of these rejoicing in a superb 12-cylinder power plant, along with the smaller 20/25 and 25/30hp models. Even before the First World War, the Rolls (*never* the Arthur Daley-ism 'Roller') was being acknowledged as one of

A Silver Ghost chassis with Ambrose (Tubby) Ward up, No. 1 Yard, 1911. (Late Mrs O. Fraser)

Toyota works site: aerodrome with the house beyond, 1939, from a Frank Scarratt photograph.

the best cars in the world. Post-war, with fewer rivals, the accolade was rarely disputed. Furthermore, in 1931 the company took over their old aero-engine and automotive rivals, the Bentley Company ('M. Bentley produces the fastest lorries in Europe' Ettore Bugatti had earlier remarked of W. O. Bentley's sturdy but incomparable products) and added the Rolls-Bentley $3^1/_2$ and $4^1/_4$ litre 'silent sports cars' to their range.

Unfortunately, all production stopped in 1939 when war broke out in favour of aero engines, and after the war car production was moved to Crewe and is now also based at Goodwood in Sussex.

Then in 1988, moves were put in train to attract Japanese motor car manufacturer Toyota to Derby, or at least to the site of the former Municipal Airport at Burnaston, 4 miles from the city boundary. The county and city councils (of opposing political kidney, it might be added) collaborated to bring it about and in 1989 work began, unfortunately at the cost of the listed local country house, Burnaston House, just undergoing restoration as a care home after years of neglect – the Japanese were not much interested in heritage conservation apparently. A local developer bought the house and dismantled it for re-erection, but all his efforts since have been thwarted by local authority pusillanimity. That aside, the first Carina E car came off the production line in 1992, and production since has continued apace. The downside is that yet another attractive part of the Trent Valley has been sacrificed to all the ugliness of industry.

China

The Derby china factory was founded in around 1750. Huguenot exile André Planché (1728–1805) had settled in Derby making small porcelain figurines in an old clay pipe kiln on Lodge Lane, but this enterprise in the hands of Cannock-born William Duesbury (1725–86) soon blossomed into a full-scale china manufactory on Nottingham Road, founded with money leant by banker John Heath, in the process of which poor Planché was rapidly elbowed aside, although as Andrew Floor he moved to Bath and continued to flourish, becoming an actor-manager; a cousin, J. R. Planché FSA, became a herald and antiquary.

A factory at Cockpit Hill was founded at the same period to make superior-quality earthenware but which did produce some china too. Also supported financially by Heath, it failed to survive his bank's failure in 1779, unlike the Nottingham Road concern.

The Derby china factory made high-quality porcelain figurines and objects, and took over the Chelsea factory, establishing an international reputation. The Duesbury family relinquished control in 1812 to the Bloors (a period less esteemed by the purists) but closed in 1848. A group of workers, however, set up a new, more modest factory beside the marble works in King Street, and this enterprise, although never financially very stable, flourished until the Great Depression killed it off in 1935.

Meanwhile, in 1875, William Litherland (1803–83) and Edward Phillips (1817–81) co-founded another china factory, reviving the name 'Crown Derby', in a redundant workhouse in Osmaston Road beside the Arboretum (qv), with financial support from Derby printing magnate and connoisseur Alderman William Bemrose (1831–1908). This quickly obtained a royal warrant, becoming the Royal Crown Derby Porcelain Company. Quality was again paramount, and many notable artists were employed as decorators, as had been the case with the original company. In 1935 they took over the King Street China Works, re-employing the decorators but closing the premises. Nevertheless, the acquisition endowed the new company with a continuous tradition of porcelain manufacture going right back to the beginning of the industry in Britain.

More recently Stefan Nowacki, a particularly talented decorator at RCD, set up on his own as Lynton Fine Bone China, making modest quantities of sumptuously decorated porcelain, although the company has had a chequered history to date.

Above: Derby porcelain tureen made for Viscount Tamworth, *c.* 1779. (Bamfords Ltd)

Left: King Street (Sampson Hancock) china plate with a view of Derby's Bridge Chapel. (Bamfords Ltd)

D

Danes

In 874, the Danish Great Army defeated Mercian king Burgred, drove him into exile and dismembered his kingdom, leaving Ceolwulf II with a western rump. The Derby area – although the town was not founded until 921 – fell under Danish/Viking rule for some forty-three years. The Roman fort of *Derventio* (later Little Chester) was refortified and renamed with the Celtic prefix *Deru-* (= white) added to the Danish suffix *-by* (= place) and was the local Viking strongpoint, later characterised by the Saxons as one of the Five Boroughs.

Aethelflaeda (qv) ended the Danish occupation at *Derventio* in 917, but the Danish legacy was considerable. They must have had a settlement just south of Derby, hence the suburb of Normanton ('the place of the Northmen') and once Derby had been

Iron Gate, looking south: a Danish street on a prehistoric alignment, April 2011.

founded by King Edward the Elder, it acquired a mint, which issued silver pennies until 1154. Something like half the moneyers (whose names appear on their coins) bore Danish names. Several places in Derby bore Danish names, like The Holmes (*holmr* = island) and some streets have the suffix '-gate' (from Norse *geata* = street): Bridge Gate, Iron Gate, Sadler Gate and Friar Gate, of which the first and last were named as late as the thirteenth century, showing that Danish linguistic traditions must have survived in the town for some centuries.

Once we have documentary evidence for Derby, we find that a significant proportion of the population bore Danish names in the early twelfth century: Coln, Eric, Swein, Tovi, Waltheof, and so on. The most powerful family in the town from the late eleventh century until they were decimated by the Black Death in 1349 was the family of Hugh de Derby, a founder of the Abbey of Darley in 1135 (qv) whose brother bore the Danish name of Anghemund, founder of the Touchet family lords of Markeaton and Mackworth until 1516.

As today, Derby a thousand years ago was successfully multicultural.

Darley Abbey

Today the historic core of Darley Abbey is one of the very best late eighteenth/early nineteenth-century mill villages in England; it exceeds Cromford in the completeness of its mills complex and it is also older than New Lanark.

The suburb of Darley Abbey owes its origin to a burgess of Danish ancestry, Tovi, who owned his proprietorial parish church of St Helen, which he donated as the core of an oratory around 1137. Around nine years later Hugh de Derby, Dean of the College of St Alkmund and All Saints, gave land a mile up the Derwent at Little Darley to expand the foundation as a monastery dedicated to St Mary. The abbey became the largest monastic house in Derbyshire until its dissolution in 1538, when Robert Sacheverell acquired the site from the Crown, and appears to have removed all the buildings except what was possibly the infirmary and the Abbott's lodging, which he converted into a house.

Darley Abbey: the mills and weir from the west, 2015.

Darley Abbey: school by Moses Wood, 1824, in August 2014.

The house, later the hall, survived until demolished by the council in 1962; latterly it was set in a superb park by William Emes (qv). From 1782 it coexisted with the cotton-spinning mills complex, founded by banker Thomas Evans (1723–1814), whose family were allied by marriage to the Strutts and by association with the Arkwrights. This relied on the power of the Derwent, and was situated on the east side of the river above a large weir. Evans and his family immediately set about providing decent housing for their burgeoning workforce on the opposite side of the river and up the hill behind. The housing is well designed and handsome.

The family later took over the hall, rebuilt by Moses Wood of Nottingham, who also designed a fine new Gothic church (1819) and an exceedingly handsome classical school (1821). The effect of Derby absorbing the settlement in 1968 (at around the time the mills finally closed) was unfortunate, for instead of preserving the settlement and expanding it tactfully, developers were allowed to run riot across the surrounding land.

The mills complex happily survived, was redesignated mainly Grade I in 2000, and the historic village, now a very sought-after place to live, became an integral part of the Derwent Valley Mills World Heritage Site. The industrial complex is currently being tactfully restored and brought back into use.

Darwin

Erasmus Darwin was the scion of an old Nottinghamshire family of minor gentry who, as a younger son, trained as a doctor, settling at first at Lichfield, where his elegant house is now a delightful museum. Here he met Matthew Boulton, who introduced him

Above: Iron plaque Darwin attached to his house by his pioneering artesian well.

Left: Erasmus Darwin, MD, FRS: the museum's plaster bust by William John Coffee.

to Benjamin Franklin, James Ferguson the Scots mathematician, and Derby's John Whitehurst (qv). With Franklin as a sort of absentee patron, they began meeting on the first Sunday evening of the full moon once a month to discuss the latest innovations in science (natural philosophy), politics, and their own particular ideas. They were joined by Josiah Wedgwood, James Kier, Richard Lovell Edgeworth, Thomas Day and James Watt and were later known as the Lunar Society. Theirs was probably the most fertile intellectual coterie of the eighteenth century and their influence underpinned the Industrial Revolution and lives on today.

Darwin was probably the most notable and visionary polymath of his age, his commonplace book bursting with ideas, inventions and advanced thoughts, many of which were absurdly ahead of their time. When his first wife died in 1780, he married the widow of one of his patients (the tabloids would never have let him get away with it today!) She was Elizabeth Pole of Radburne Hall, where they moved, but rural life bored Darwin, and by 1783 they had set up home, along with an expanding second family in Full Street, where Darwin lived until a month before his death in 1802. Here he put down the world's first artesian well and contrived a hand-operated ferry across the Derwent so his family could reach their pleasure grounds opposite.

Darwin spread his scientific and botanical ideas by putting them into long poems written in a very polished style in heroic couplets backed up by copious footnotes. The ideas included among these poems, which were enormously popular, were the survival of the fittest and the idea of evolution, both taken up and expanded by his grandson, Charles. Like all of his fellow Lunar Society friends he was elected a Fellow of the Royal Society. He was a close friend of John Whitehurst (qv) and William Strutt (qv) became his most important protégé.

E

Emes

William Emes lived on the western edge of Derby from 1760 to 1790 and was a landscape gardener working in the same pastoral style as Lancelot ('Capability') Brown. His origins have so far defied research, but he came to Derbyshire to work as gardener to Lord Scarsdale at Kedleston in 1756. When Robert Adam took the project over, Emes resigned and went freelance, enabling him to help realise Adam's landscape but also work on projects of his own, the first being Foremark Hall and Markeaton Hall. Wrightson Mundy of the latter, rented him 51 acres at Mackworth, where Mundy's architect James Denstone built him a house 1760–63.

His parkland at Markeaton in Derby is well thought out, although dimidated through loss of the house in 1964, but it was not the only park in Derby he landscaped: St Helen's followed in 1767 and the adjoining Darley Park (qv) in 1778, the remaining portions of the former now being subsumed by the latter. He worked extensively

Part of William Emes's 1763 landscape at Markeaton Park, May 2015.

Silver brandy pan made by John Emes, 1808. (Bamfords Ltd)

with Joseph Pickford, notably at Etruria Hall for Josiah Wedgwood, Longford and Knowle Hill. He worked with the Wyatts at Egginton and for Lunar Society patron Lord Shelburne at Bowood, Wilts, and extensively on the Welsh borders, including Chirk Castle.

He married local girl Mary Innocent (cousin to a London silversmith) and had a large family, one of his sons, John also becoming an eminent London silversmith and another son, Philip, of Ashby, later becoming brother-in-law of the third John Whitehurst. The Hollywood actresses Joan and Constance Bennett were among his posterity. William himself moved to Elvetham Park, Hants, in 1790 and died in London in 1802, an undeservedly neglected character, three of whose works have endowed Derby with much beauty.

Emblems

Derby has its emblems, not all of which are as obvious as one might think. Ask most people, local or otherwise, and they will plump for the Derby ram. He originates in a traditional folk song that tells the story of a ram of epic proportions and the difficulties involved in butchering, tanning, and otherwise processing its carcase. Llewellyn Jewitt wrote about the song in his *The Ballads and Songs of Derbyshire* of 1867, asserting that the song had been current at least a century before, rather borne out by its inclusion as a three-part glee in a collection adapted by composer John Callcott (1766–1821). It was known in America before the end of the eighteenth century, too. The Derby Regiment (now part of the 2nd Battalion The Mercians) adopted it as their regimental song and have had thirty-two rams as their mascot, and Derby County FC employ it as a badge and indeed are known universally as The Rams. There are a number of references to a ram throughout the architecture of Derby – perhaps the most notable is a large street sculpture on the junction of East Street (qv) and Albion Street by Michael Pegler. Jewitt's first verse and refrain:

E

Above left: City arms granted in 1939 with buck-in-park and ram crest. (Derby City Council)

Above right: The statue of the Derby ram, East Street, March 2018.

> As I was going to Darby, Sir,
> All on a market day,
> I met the finest Ram, Sir,
> That ever was fed on hay.

Yet the fifteenth-century seal of Derby bears 'a buck sejant within park pales proper', a much earlier emblem, usually thought to have inspired the interpretation of the etymology of the name (qv) of Derby. The buck in the park has actually been the prime emblem of the city since (allegedly) 1378, and is found all over the town, including some quite early manifestations. In 1939 the Borough of Derby obtained a formal grant from the College of Arms with the buck in the park on the shield and a Derby ram as crest, supported by two deer (derived from the shield) and all differenced with spring of broom, the canting badge of the house of Plantagenet.

Why the horseshoes and *vairé* (a red-and-gold fur) emblems of the de Ferrers family, Earls of Derby (entitled to a third of the borough's revenues in 1066–1268), were not included is hard to discern. Yet they certainly constitute yet another Derby emblem.

F

Flamsteed

Flamsteed, Britain's first Astronomer Royal, is usually claimed by the former mining village of Denby for it was there that he was born on 19 August 1646, at the height of the Civil War. His father was Stephen Flamsteed, a Derby merchant who later built a fine house in Queen Street, which still survives, albeit rebuilt beyond recognition and heavily truncated. Flamsteed was educated at Derby School but caught what is thought to have been rheumatic fever, which led to him being kept at home, where he began to read avidly. Two Derby men and the Duke of Norfolk's agent at South Wingfield, Immanuel Halton – the latter England's pioneer of algebra – encouraged him to research astronomy, to which he took like a duck to water.

By 1669 he had drawn up a set of Equation of Time tables (published 1673), constructed a 3-foot quadrant, made important tidal calculations and successfully modified Halton's 'improved sundial' and in 1670 he was able to proceed to Jesus College, Cambridge, and also to obtain an introduction to the secretary of the newly constituted Royal Society,

Revd John Flamsteed FRS, 1st Astronomer Royal, engraved by Glover after Thomas Gibson, 1712.

Greenwich Royal Observatory, as built by Wren for Flamsteed. (National Maritime Museum)

to which he was elected in 1677. In 1675 he was appointed 'Astronomical Observer' by the king at an annual salary of £100. Charles II was keen to improve navigation and maritime safety by discovering a method of determining longitude.

Sir Christopher Wren designed an observatory in Greenwich Park, with equipment by Thomas Tompion and Flamsteed, all set in a park landscaped by the celebrated André le Notre. In 1691 William Mountford could write:

> At Greenwich lies the scene, where many a Lass
> Has bin Green-Gown'd upon the tender Grass.
> If Flamstead's Stars would make a true Report,
> Our City Breed's much mended by the Court.

He proceeded, despite earning the jealous enmity of Sir Isaac Newton and his successor, Halley, to map the heavens as a guide to astronomy, although it was not until sixteen years after his death in 1719, that his finished and fully authorised *Atlas Coelestis* was published by his widow.

Fresh Water

By the seventeenth century, with Derby's population expanding, fresh drinking water was becoming something of a problem. The Derwent was then still unpolluted, but only the rich had wells and there was a general shortage of water for washing, cooking, cleaning and horses. The problem was timely resolved by a man from Lancashire, George Sorocold. He was born at Eyebridge, Ashton-in-Makerfield (Lancs) but moved to Derby in 1684 to marry the elder sister of Alderman Henry Franceys, the town's most notable apothecary. His career developed as a millwright and hydraulic engineer, yet he first comes to notice in 1687 when he rehung the ten bells of All Saints' Church, one of which still bears his name. He later also installed a carillon to play seven tunes on them, the instrument being later modified by John

Whitehurst (qv). Also in 1687 he designed and built a water supply for the Cheshire town of Macclesfield and developed a much more sophisticated device for raising and distributing water, which he installed as part of a similar scheme at Derby in 1691. This brought water from the River Derwent to a storage tank behind St Michael's Church – virtually opposite Flamsteed's house – which flowed from thence through elm pipes to a number of public outlets, called conduits, which he also designed. In its flow, the water turned a machine which could be adapted either to bore out more elm pipes or to grind flints, thus virtually financing itself. Water could be collected at public outflows like The Conduit in the Market Place and Becket Well.

This system, with variations, Sorocold later established at seventeen other towns and cities, and he developed hydraulic works of a similar nature at three gentlemen's parks: at Melbourne, Calke and at Sprotborough (Yorks). He was a friend and collaborator of Robert Bakewell, John Flamsteed and atmospheric engine pioneer Thomas Savery. Sorocold went on to build docks, canals, drain fens, lead and coal mines and devise dams and hydraulic schemes in Scotland and on the Continent. His two final achievements were the co-design and engineering of the Derby Silk Mill (qv) in 1717–21 for the Lombes and the linked creation of the Derwent Navigation also in 1721, which improved Derby's transport infrastructure enormously and only became redundant when the Derby Canal opened in 1796. Sorocold's death has not been positively dated, and it may have occurred on the Continent, but his Derby waterworks were re-franchised in 1738, which is the most likely date.

Sorocold's system began to fail when the Derwent became polluted from the later eighteenth century, and was replaced by a modern filtrated system based on a plant at Little Eaton in 1846.

Sorocold's water lifting engine as installed at London.

Melbourne Hall gardens, looking across the lake to Bakewell's arbour, June 2018.

Friary

The Friary stands on the south side of the road to Ashbourne. The original religious foundation dates to 1224/1238 having been made by Sir William de Verdun of Foremarke. The 16-acre site was given to the Dominican Friars Preachers, otherwise known as the Black Friars. It certainly incorporated a church after its foundation and associated buildings, which themselves seem to have been grouped between where the Heritage Gate office development stands today and Friary Street. The friars also dammed the Bramble Brook, a tributary of the Markeaton Brook flowing from Mickleover, on the south-west to make fishponds. It was dissolved in 1539 and acquired by the Bainbrigge family, who pulled it down and built a large jettied timber-framed town house on the site, still called The Friary.

It eventually came into the possession of Samuel Crompton, a banker, who built a new four-square brick house to the designs of Richard Jackson, who was also building the Guildhall (qv), somewhat nearer the street. Being canny, rather than demolish the Bainbrigges' old house, he split it as tenements and rented them out until 1760 when the leases fell in and he removed it, extending his new house at the same time. Meanwhile, 10 acres had been sold somewhat before to a charity to build almshouses nearby. In the 1870s it was owned by lace manufacturer Henry Boden, who added the *porte cochère* in 1875. His widow, a keen temperance enthusiast, sold it in 1921 only to find, to her chagrin, it turned into a licensed hotel. Despite many vagaries of fortune, unsympathetic extensions and having its garden built upon by an overlarge and unprepossessing office block in 1972, this Grade II* listed building remains as one of Derby's historic gems.

Left: The first house at the Friary, detail of 1712 map, from Keys' *Sketches*.

Below: The Friary with 1870s porte cochère, from Friar Gate, May 2015.

G

George Yard

Of all the nooks and crannies of Derby, George Yard is at once one of the least prepossessing and the most interesting. Running as a cobbled lane from an opening sat at the north-east end of Sadler Gate, it runs south-west to an apex and then south to another opening right at the bottom of Sadler Gate.

George Yard from the lower entrance looking towards the cathedral tower, May 2017.

It is said to take its name from the ancient George Inn, Iron Gate, which is mentioned in various local deeds from 1648. Yet it was much earlier on called George Lane. The inn was named after the jewel of the Order of the Garter (the Great George) itself dedicated to England's patron saint. Long prior to the existence of the inn, however, it was in 1343 called *Juddekynlone* (Judkin Lane) from an obsolete personal name, but significantly, *Jud* was anciently a North West counties' dialect diminutive for George, Judkin being thus a double diminutive. As nobody bearing the surname Judkin occurs in any early charter, we may be looking at vestigial evidence of a lost parish church, for the six mentioned in the Domesday Book are clearly not all. It was presumably dedicated to St George and vanished before the Reformation. Parish boundaries here rather reinforce this theory. The pub closed in 1819 (although a smaller one grew up on the site) and in 1878 there were twenty-one houses, but now it is entirely denuded of buildings, although the side of a new building on Sadler Gate Bridge (qv) now lines the lower west side. From the part parallel to Sadler Gate there is a fine view of G. H. Widdows's 1932 former County Offices, in Whitehurst's Yard.

Guildhall

The medieval Guildhall was a freestanding structure in the Market Place just clear of the houses on the south side, the intervening space being known as Breadleaps. There was a meeting room set above a lower floor containing a lock-up, so it probably resembled the surviving one at Aldeburgh, Suffolk. It became largely redundant in 1616 when a new Moot Hall was built in Iron Gate, vestiges of which still remain in a desolate space behind the Assembly Rooms.

A new Guildhall by Francis Smith of Warwick was planned for 1713, but the owners of the houses on the south side of the Market Place pitched their price for the site too high and the council instead replaced it in 1730–31 on the old site, effectively blocking the greedy south side owners' light. The building was a fine baroque affair by Richard Jackson of Armitage (qv Friary), looking for all the world like a country mansion, with a John Whitehurst clock and ironwork by Robert Bakewell. Its fate was sealed,

George Pickering's 1828 drawing of the Market Place. The 1731 Guildhall is to the left. (Derby Museums Trust)

Above: Steel engraving of the 1828 Guildhall; the Piazzas are on the extreme right behind the lamp.

Right: Present Guildhall photographed on 20 May 2015.

however, when the south side houses finally became available at an affordable price, and in 1828 it came down to be replaced by a fine Greek revival affair by Matthew Habershon. Unfortunately, however, it burned down on Trafalgar night 1841 and was replaced by the present structure by Henry Duesbury (great-grandson of the founder of the china factory), completed in 1843 and incorporating much of its predecessor, but with a tower instead of a pediment. It has a fine council chamber inside with an elaborately coffered ceiling, now a theatrical space. It became redundant as a council chamber with the completion of the present Council House in 1947.

Gynaecology

Derby was home to one of the most important pioneers of the science of gynaecology: Percival Willoughby, author of *Observations in Midwifery* and contributor of much of the basis of modern practice in childbirth. He was born a younger son of the Willoughbys of Wollaton Hall in 1596, educated at Eton and Trinity, Oxford, before spending 1619–26 in practice with an eminent physician, taking his MD thereafter. In 1631 he married Elizabeth, daughter of Sir Francis Coke of Trusley.

> There came into my house, at Darby, my honoured good friend Dr Harvey 1642.
> wee were talking of severall infirmities, incident to ye wombe.
> After that I had related ye aforegoing story de caudâ mulieris, & how shee flouded, & was cured, hee added to my knowledge an infirmity, which hee had seen in women, & hee gave it the name of a honey-comb, which also, hee said, would cause floud-

A page from one of the two original MS copies of Willoughby's *Observations*. (Dominic Winter Ltd)

He set up in practice in Derby, living in the eastern half of the large fifteenth-century timber-framed town house in Tenant Street called the Old Mayor's Parlour (qv), criminally demolished by the council in 1947. Willoughby was admitted LRCP in 1641. He was a Royalist, so exiled himself to Stafford and London under the Commonwealth, but returned in 1660, writing nine years later: 'Nigh 45 years have I practised in the midwife's bed and in it, I humbly thank God for his assistance and help, I ever delivered to all women to whom I was called.'

Even in old age, Willoughby did not hesitate to travel remarkable distances in all kinds of weather, his elder daughter, Helen, acting as his nurse/midwife and later by his younger son as assistant.

He pioneered techniques now taken for granted, banished traditional midwives (as doing more harm than good) and replaced them with people trained to his own precepts. He appears to have consistently saved life where others would have been prepared to leave for dead, and had been a lovable character. The torch of his teachings was kept burning by Derbyshire-born Dr Thomas Denman (father of Judge Lord Denman), who had acquired Willoughby's casebook/journal and who passed it on to another aristocratic gynaecologist, Sir Richard Croft of Croft, Bt. who had it published.

He died in Derby on 5 October 1685 and lies beneath a slab in St Peter's Church. When the Derby Royal Hospital (as it became) was seeking a name for its new gynaecological unit in the 1990s, Willoughby's name was most emphatically put forward, but it was inexplicably rejected. There are only two MS copies of his original *Observations*, one being sold for over £30,000 in 2012.

St Peter's Church, where Willoughby is buried, 11 May 2015.

H

Handyside

Andrew Handyside, and the iron-founding firm he took over in Derby, forms a major element in Derby's links with Russia. He is remembered locally for two memorable bridges: the astonishingly ornate cast-iron four-track Great Northern Railway bridge over Friar Gate of 1876 (designed by Henry Stevens, Derby's best Victorian architect) and the iron bowstring bridge for the same company across the Derwent between Strutt's Park and Little Chester.

Handyside himself was born in Edinburgh in 1805, but his maternal uncle Charles Baird was an engineer in St Petersburg where Andrew and his brothers all joined him on leaving school. The eldest brother William became a major designer and builder of bridges and ships in Russia, to whom Andrew later supplied components from Derby. The family remained in Russia until the revolution in 1917, but Andrew returned to Derby with his Russian bride in 1848, acquiring the Britannia Foundry, Duke Street (set up in 1818), from Samuel Job Wright, another Derby man who traded silk at St Petersburg. They lived at The Cedars, Ashbourne Road, a Georgian house leased from the Kedleston Estate.

Handyside's iron bridge across Friar Gate from the east, November 2013.

Victorian Handyside pillar box, Isle of Wight. (M. Allseybrook)

Handyside dramatically increased the scope of the foundry, making ambitious installations for railways, buildings and ports, sometimes in collaboration with architects/engineers like Sir Gilbert Scot and Sir Charles and Sir Francis Fox (both locally born). Their iconic red pillar boxes can be seen all over the British Isles and our former empire. Handyside himself died in 1887, but the firm continued under his son-in-law Alexander Buchanan (1829–1912), and built the Rolls-Royce factory in Nightingale Road in 1907. The foundry finally succumbed to the Great Depression in 1931.

Headless Cross

The west end of Friar Gate is home to an odd-looking loaf-shaped stone mounted on three grieces or steps among the trees on the north side. This is the so-called headless cross, so named on John Speed's map of Derby of 1610. It is all that remains of a tall preaching cross of presumed medieval date – the name has been current since at least 1483, so the loss of the cross shaft must have been down to misfortune rather than any act by radical protestants in the 1540s. Speed, usually very reliable, shows it intact.

The cross base is, unlike the grieces, original, and contains a hollow made by the removal of the iron fixing of the shaft into which, it was said that, at the time of the plagues (1631 was worst in Derby), a vessel was placed, filled with vinegar. People who came here to buy goods (for this wide part of Friar Gate was the beast market area until 1861) placed their money in the vinegar – a crude method of disinfectant. In the 1840s this venerable relic was moved to the Arboretum, but in 1979 the cross base was moved back to approximately its old site. It is thought originally to have been the cross from which nearby Whitecross Fields, part of the Corporation's common lands, took their name, so its original position may have been in the immediate vicinity, or possibly nearer the Kedleston Road.

A–Z of Derby

Left: The cross inexplicably complete, from John Speed's map of 1610. The Friary is on the lower left.

Below: The Headless Cross, Friar Gate, 25 March 2018.

Inset: The recessed top.

I

Improvement Acts

By the mid-eighteenth century improvements to infrastructure were needed, but the Corporation, constrained by its ancient charter only to finance itself from market rents, tolls and income from its common land, had insufficient finance to begin any projects. The rebuilding of the town church (now the cathedral) had been done in the teeth of their opposition by public subscription, as had the provision of the new Assembly Rooms in 1763.

In 1768, therefore, the Borough, wishing to clear Nuns' Green (qv) of courting couples, rubbish and malefactors and sell some of the land to improve the street on

First Improvement Act: Georgian Houses of 1768–70 on Nuns' Green, photographed 15 June 2017.

its south side (now part of Friar Gate), obtained an Act of Parliament which set up a group of trustees for the purpose. Once the row of fine Georgian houses between Ford Street and Bridge Street had been built and the area improved, a second Act was obtained in 1788 to replace St Mary's Bridge, this time with the right to levy a rate to pay for it. The chairman was the relentlessly energetic young William Strutt, eldest son of cotton pioneer Jedidiah. By 1794, the town had a spanking new bridge designed by Thomas Harrison of Chester, and a run of smaller new ones over the Markeaton Brook, designed by Strutt himself.

A third such Act was sought in 1792 in order to further exploit the resources of Nuns' Green, with Strutt the instigator and eventual chairman. This was despite vehement opposition from the owners of the houses built under the 1768 commission, who suspected that the brook, as it passed through the green, would see the arrival of a rash of factories and low-grade housing. They were of course right, for whilst radical idealists like Strutt thought that workers' housing would be of a good standard like that built by his family in Belper, reality was quite different, and the Act led to the creation of Derby's notoriously poor West End.

The streets were also numbered and resurfaced, a process started by the Second Commission in 1789 with the pitching of Babington Lane, although how this related to building a new bridge is quite unclear. Between 1824 and 1827 all the streets were numbered, street lighting extended and they also controlled the watch and the constables appointed by the justices, thus achieving some overall control within the town's boundaries. In 1825 a further Act allowed Strutt to borrow £20,000 at 4 per

Second Improvement Act: Thomas Harrison's St Mary's Bridge, 1794, seen in August 2017.

Third Improvement Act: No. 20 Bridge Street of 1794 by Charles Finney, March 2018.

cent to extend the experimental gas lighting, which had been inaugurated with a single lamp outside the old Guildhall on 19 February 1821 and further to improve, extend, name and pitch new streets.

Essentially between 1788 and his death in 1831, Strutt was in full charge of the town. The last commission was abolished by the Municipal Corporations Act of 1835 and wound up in 1848.

Ironwork

Derby is famous for the quality of its wrought iron, a tradition firmly rooted in the career of Robert Bakewell. A member of an old Derby family, Bakewell was born at Uttoxeter in 1682, but his mother was the daughter of a Derby smith and when his father died she remarried another, which rather determined young Robert's career. He worked in London from the age of fourteen with Jean Tijou and Jean Montigny at Hampton Court, Canons, and Chatsworth.

He started working independently at Melbourne Hall, where he made the incomparably delicate arbour for the gardens, where he met Sorocold (qv Fresh Water), working on the hydraulics for the lake. In 1711 he moved to Derby and his career really took off. In Derby his wrought-iron screen at the Cathedral, the mayor's pew, the Chambers tomb and the west gates are a wonderful testimony to his skill. He also made the clock for St Peter's Church, iron for the Guildhall and gates for several houses, not to mention for country houses all over England and the grilles for Gibbs's Radcliffe Camera at Oxford. He died in 1752, and was succeeded by Benjamin Yates (qv).

Yet Derby's excellence in ironwork did not die, for the art was revived by William Haslam in the mid-nineteenth century and continued in the good Arts and Crafts tradition by his son Edwin (1843–1913), working from a surviving (just) workshop in St Helen's Street. His work was continued into the interwar years by Taylor, Whiting & Taylor.

Left: Bakewell's iron screen, Derby Cathedral, September 2015.

Below: 1908 wrought-iron railings, former County Offices, St Mary's Gate, by Edwin Haslam.

J

Jacobean House

The Jacobean House is one of Derby's oldest houses, although it has not been a domestic residence for well over a century. It is also only two-fifths of its original size, which is a tragedy, but it is, nevertheless, listed Grade II*, which emphasises its importance.

It was built in 1611 (dated on the tympanum over the entrance) and originally sported five gables (three with balconied canted bays below) stretching to meet the east gable of the house on the other side of Becket Street. It was built as the town residence of the Gisborne family, which then had an estate at Hartington, but later had one in Staffordshire. Of brick and stone and standing three stories high with attic gables, it was architecturally adventurous, having two almost continuous runs of mullioned windows, closely comparable to John Smythson's Caverswall Castle 30 miles away down the road to Stoke-on-Trent.

In 1852 the council decided to create Becket Street to run through the 2-acre park to meet The Wardwick (qv) just where the house stood. Enlightened owner Alderman

Jacobean House: original façade drawn by John Price, 1852. (Derby Museums Trust)

Above: Jacobean House as rebuilt, corner of Wardwick and Becket streets, May 2015.

Left: A surviving interior: platinotype photograph by Keene, 1870s. (George Cash)

Francis Jessopp employed artist Octavius Oakley to record the interiors and John Price to record the original house in plans and elevations and to take down the three gables in the way of the road and tactfully rebuild as much of the façade as possible to face the new street. Some original interiors, nevertheless, survived. This must have been one of the earliest pieces of building conservation recorded in the Midlands. Unfortunately, the twentieth century was less kind, for the Regency Gothic stable block was lost in the 1960s to a huge office block, which was built on most of the surviving grounds and the ground-floor windows were dropped to street level when it became the Jacobean Café in the 1920s.

Joseph Wright

Along with John Whitehurst (qv), Joseph Wright must be the most internationally renowned person to have come from Derby. His stature as an artist has grown enormously since the 1990 Tate, Louvre and Metropolitan (New York) exhibitions of his work, itself driven by Benedict Nicolson's two-volume monograph of 1968. Whilst he made his bread and butter painting superior portraits of not particularly superior people, he was pre-eminently the artist of the Midlands Enlightenment. He painted most of the Lunar Society (qv Darwin) and astounding set pieces illustrating aspects of the science and industry that they espoused: *A Philosopher Lecturing upon an Orrery, An Experiment with a Bird in an Air Pump, An Iron Forge, The Alchymist Discovering Phosphorous,* and so on. Many of his superb landscapes are expressions of the contemporary concept of the Sublime, including *Arkwright's Mill by Night, Willersley Castle* and his several versions of *Mount Vesuvius in Eruption*

Contemporary pastel after the 1780 Yale 'green coat' portrait. (Abbott & Holder Ltd)

Wright's last landscape: Willersley Castle, 1796. (Derby Museums Trust)

and many others. He painted Darwin, Whitehurst, Thomas Day of the Lunar Society, and his double portraits are particularly stunning, notably *Mr. & Mrs. Peter Burdett*, *Mr. & Mrs. Thomas Gisborne* and *The Arkwright Children*. His paintings are also notable for his use of light, moonlight, hidden sources and light effects.

Wright was born the son of a Derby attorney of an old Staffordshire family living in Iron Gate in 1734, educated at Derby School and trained in London under Thomas Hudson and Alan Ramsay, commencing his career in the Midlands in 1759. In 1773 Wright married Anne Swift (d. 1790), the sister of the manager of the Silk Mill (later its proprietor); the wife of another of her brothers was the mother of Erasmus Darwin's natural daughter, Lucy Hardcastle. Shortly afterwards the couple embarked on a tour of Italy, which greatly influenced Wright's style and technique. He was made ARA but later fell out with Reynolds and the Academy. He also had short spells in Bath and Liverpool.

Wright lived and worked from 1772 to 1793 in Old St Helen's House, King Street, but for the few years prior to his death in 1797 he lived in John Whitehurst's old house at No. 27 Queen Street, where he died after a long illness on 29 August. Needless to say his father's house has been demolished, but its successor bears a neat plaque and there is an ugly granite pillar outside to mark his life, erected in 1991.

Judges' Lodgings

The Grade II-listed Judges' Lodgings make up a third of the superb classical legal complex occupying a notable position on the lower part of St Mary's Gate. The 1659–60 stone-fronted Grade I-listed Shire Hall forms the centrepiece with the 1796

Judges' Lodgings: west front from St Mary's Gate, July 2016.

former inn to the left and the Lodgings opposite forming a fine *cour d'honneur*, separated from the street by a massive screen.

The building of 1809–11 was designed by Derby architect John Welch (1759–1823) and was designed to hold two assize judges with families and entourage. It originally presented three bays to the street (end-on) and is seven bays wide to the courtyard, the central five breaking forward. It is two and a half storeys high with a hipped roof behind a stone parapet. It has a central Doric portico and a street door too.

The interior was plainly but well fitted out with, most importantly, an Ashford black marble chimneypiece in one of the bedrooms by Richard Brown & Co. with a central tablet engraved after the method of their carver Henry Moore (1776–1848). There were two sets of everything including twelve-piece dining sets of chairs and tables along with marked silverware and Derby porcelain table settings, all heedlessly sold off by the county council in the late 1990s. The eastern bay of the building was removed in 1910 to build an office (now the Cathedral Quarter Hotel) leading to a tactful reordering of the interior by George Henry Widdows (1871–1946), his first job as County Architect.

Ashford marble chimneypiece by Richard Brown and Henry Moore, photographed 1996.

The building was unused from the 1970s to 1999, when it was an element of the complex's conversion to magistrates' courts, done with scant regard to the historic fabric of any of its components. The Henry Moore chimneypiece, for instance, ended up in a ladies' loo and one cannot photograph or visit the place because of the restrictions attached to its PFI and the draconian security of the courts.

K

Keene

Richard Keene was Derby's pioneer Victorian photographer whose earliest surviving image dates from 1853 and who started taking photographs commercially in 1862. His specialty was topography, and his best pictures have a limpid clarity which would be very difficult to achieve today; they compare very favourably with the

Below left: Richard Keene, photographed by J. A. Warwick, sitting on the Saxon cross at Eyam, 1858.

Below right: Keene's studio on top of No. 24 Iron Gate, photographed 2012.

sort of work Fenton was producing after the Crimean War. The fact that he learnt his trade from the Revd Edward Abney, an amateur who was a personal friend of W. H. Fox-Talbot, Britain's ultimate photographic pioneer, says everything about his quality and competence. Early on he worked with his close friend John Alfred Warwick, later signal and telegraph superintendent of the Midland Railway. In 1858 they made an epic tour of the Peak District, which led to the taking of some celebrated images – as Warwick seems to have taken most of the pictures, Keene appears in quite a few!

Keene also had a shop in Iron Gate (formerly John Whitehurst's house), which was part picture gallery, part photographic studio, part picture restorer and framers and part photographic retail emporium. The building still exists, now an estate agent, with Keene's 1864 glass studio still perched on the roof. In 2010 Derby Civic Society managed to get it listed by English Heritage. Keene was born in 1825 and came to Derby as a child. He married and had a number of talented sons. He was a founding member of the Derby Photographic Society and the UK Photographic Convention. A Tory councillor, he died at home – No. 100 Radbourne Street – in 1894. The firm was carried on by sons Richard and Charles until the latter's death in 1936.

King Street

King Street is an element of the prehistoric spinal road that runs right through Derby and which long predates it. As early as around 1250 it is named *regiam viam* – 'the King's Street' – although in the late seventeenth century it was also known as The High Street. It then still included the more modern Queen Street (qv), which was separately named only in the eighteenth century. There were tram tracks from 1905 to 1933, but much destruction was wrought in 1967–68 to put St Alkmund's Way underneath and an important part of Richard Brown's 1802 marble works was lost in 2007 to an extension to that scheme, which effectively dualled the road.

The noblest building on the street by a considerable distance and probably the finest Palladian town house outside London is St Helen's House (qv) diagonally opposite, which is a vernacular brick house of 1680 that since the 1770s has housed the Seven Stars inn, beside which, from 1849 to 1935, was the King Street Derby China Factory, all demolished in the 1970s although a surviving part, and terrace No. 85, the showroom and proprietor's house still (just) survives.

Opposite St Helen's was the marble works of Richard Brown & Co. founded in 1802 on the site of Old St Helen's House (where Joseph Wright had lived) and largely demolished in 2006 to accommodate road widening, although the works closed in 1931 after two changes in proprietorship. It was, though, largely intact and the last surviving purpose-built marble works north of the Alps. The Blue John ornaments made by Browns today sell for five-figure sums, and are of consummate quality.

Above: King Street: Seven Stars inn, photographed on September 2015.

Right: King Street: former marble works prior to truncation, 1996.

Little Chester

Little Chester is a settlement that grew up and acquired its (English) name between the defeat of the Danes in 917 and the compilation of the Domesday Book in 1086. The site was founded by the Romans as *Derventio*, as the successor of an early fort on Belper Road and within a few decades had become a Roman small town, with pottery making and lead processing its staple industries. Probably in the late third century it acquired a circuit of 20-foot-high walls, strengthened by the Danes after 874. Some life within the walls seems to have survived continuously between the end of Roman rule and the founding of the village, for at least two later buildings were discovered to have been built straight onto Roman foundations.

The township was part of the College of St Alkmund, founded after around 650, and a number of farmhouses were built, the produce of each to supply a canon of the college. Two of these, one seventeenth century and earlier, and another seventeenth century survive. Queen Mary gave these farms to the Borough in 1555. The walls were

Little Chester, Roman well and column bases, March 2018.

A former prebendal farm: early seventeenth-century Derwent House, February 2016.

removed in 1721, but the basic road pattern survives as Old Chester Road and City Road along with two excavated Roman wells.

The coming of a number of foundries from 1792 expanded the settlement, although Alderman Sir Alfred Haslam MP (1844–1927), proprietor of the biggest of these, caused a large common space (Chester Green) to be preserved and the suburb is today part of the World Heritage Site, despite being partly ravaged by a wholly unnecessary flood-prevention scheme.

Lowell

Kirk Boott (1790–1837) was from a Derby family; his homonymous father, a close friend of Joseph Wright's brother John, had emigrated to Boston before his birth. Kirk had married a member of the Derby elite whom he had met when living in the borough as a young man. He was educated in England and later served in the British Army. In 1821 Boott was co-founder, with Francis Cabot Lowell, Nathan Appleton and Patrick T. Jackson, of a new settlement at East Chelmsford, off the confluence of the Merrimack and Pawtucket rivers in Massachusetts. This was to be a cotton-spinning city, and Boott's role was to set it up and run it. He had hoped to call it Derby, but the sudden death of Lowell led to its being given his name instead. The idea was to found a model textile industry in New England to rival Belper-born Samuel Slater's Pawtucket Mills, set up a little before using ideas pirated from the Strutts. Boott, on the other hand, had the support of the Strutts in his enterprise, which was an important difference.

Like Strutt, Boott was a competent architect, designing not only the church (loosely modelled on St Michael's, Derby) but workers' housing, mills and municipal buildings, some of which survive. His biggest mill has a tower with an octagonal bell turret, a rather ornate version of that on Derby's Silk Mill, itself part designed by Joseph Strutt after a serious fire in the 1820s. In the end, the city of Lowell was a great success.

Portrait of Kirk Boott, c. 1834. (Lowell Historical Society)

Lowell, Boott Mills, photographed by the late John Kavanagh, 2004.

One of the entrepreneurs attracted to the new city by Boott was George Washington Whistler, who set up business constructing railway locomotives there in 1832. His son was the eminent London-based impressionist painter James Abbott McNeil Whistler. Boott himself was killed in 1837, but his legacy continued.

One of the earliest residents of Lowell was the underestimated William Duesbury III, in reality a formidably talented chemist, but ahead of his time by around 150 years. He worked on dyes for the fabrics being manufactured there. He was a convinced Universalist and also a competent architect, designing a fine chapel in Shattuck Street, Lowell. Tragically he committed suicide, for reasons that remain obscure, on 12 December 1845. Lowell's textile mills were then still attracting a significant proportion of their workforce from Derby and its region before being supplanted by Irish migrants fleeing the potato famine in the later 1840s. Why Lowell has never been seriously thought of as a formal twin town of Derby one cannot imagine. It was canvassed in 1990, but was met with a tide of indifference.

M

Midland Railway

In 1839–40 the Midland Counties, Birmingham & Derby Junction and North Midland Railways all converged in Derby and shared a single station called the Trijunct Station. It was designed by Francis Thompson, who also designed the North Midland Company's housing over three streets, the Institute, the Midland Hotel and the Brunswick inn, not to mention the locomotive roundhouse, all now listed and part of a conservation area – only the station has gone (qv Civic Society). Thompson's locomotive roundhouse is the earliest example surviving anywhere. The three amalgamated in 1844 at the instigation of Railway King George Hudson, and went from strength to strength for the following seventy-nine years.

Interior of the Trijunct Station, *c.* 1901, from a postcard.

Exterior of Thompson's first locomotive roundhouse, March 2018.

In 1868 a direct line to London opened, the south end being marked by Sir Gilbert Scott's magnificent St Pancras Station with iron roof by Derby engineer W. H. Barlow. In 1871 access to Manchester via Buxton was achieved and a route to Scotland via the Settle and Carlisle line was opened in 1876. Later a link from Manchester to Sheffield was added, making the Midland a national company.

Then company dominated the Litchurch part of the borough, and the station expanded several times. Locomotives (including the famous 4-2-2 'Spinners' and 4-4-0 compounds) were built from the 1850s in-house, as were carriages and even Pullman cars. Sir William Towle (1849–1929), ex-manager of the Midland Hotel, pioneered on-train catering and quality railway hotels. The company ceased to exist in 1923 when the railways were grouped into four companies becoming part of the London, Midland and Scottish, of which the last locomotive superintendent of the Midland, Sir Henry Fowler (1870–1938), became from, 1925 to 1930, the second Chief Mechanical Engineer.

W. H. Barlow's spectacular roof of St Pancras station, October 2011.

A–Z of Derby

The spirit of the line lives on at the Midland Railway Museum, Butterley, set up jointly by Derby Museums and Derbyshire Council in 1969 and continued independently from 1975.

Museum

A museum at Derby began with a phenomenally successful exhibition in the Mechanics' Institute in The Wardwick in 1839. This led to the foundation of the Town and County Museum housed in a former Georgian town house a few yards away. In 1879, however, Derby MP Michael Thomas Bass gave the money for the Corporation to put up a new building on the site to house a free library and museum. R. K. Freeman of Bolton won the competition to design it, and produced a masterpiece in Gothic Arts and Crafts style with fine frescoes and ironwork (qv) by Edwin Haslam. An art gallery by J. S. Story was added on the north side in 1882.

In 1972 the famous Derby Silk Mill was leased from the CEGB and in 1974 opened as Derby's Industrial Museum with a ground-floor loaned display of Rolls-Royce aero engines. The freehold was acquired in 1999. In 1984 No. 41 Friar Gate, the house designed by architect Joseph Pickford for himself, was acquired and opened as a social history museum with period interiors in 1988.

The museums (as they now were) were consistently neglected by the council from the 1980s, with revenue and capital cuts curtailing improvements and impeding purchases, especially of potential additions to the impressive collection of Joseph Wright paintings and drawings. Yet, thanks to a dynamic Friends' organisation, money was raised, but when one of the parties contesting in the 2009 local elections proposed pulling them into an independent trust, a demographic twist of fortune allowed this to be planned and the Derby Museums Trust was inaugurated in 2012. Since then, despite the removal of most of the council's promised annual subvention, the museums at Derby have gone on from strength to strength.

Mechanics' Institute 1839 exhibition by Samuel Rayner. (Derby Museums Trust)

Right: Wardwick, Derby Museum and Library of 1879 with 1915 extension to left, October 2011.

Below: Pickford's House Museum, the saloon, June 2017.

N

Name

The name Derby – in its earliest form *Deoraby* – appears to be a Danish name, as the '-by' (= place) suffix suggests. But nothing is as simple as it seems. The name may have evolved under the Danish occupation of the Northworthy area (the land north of the Trent, east of the Dove and west of the Erewash) to describe not the as-yet-unbuilt town, but the refortified Roman settlement of *Derventio*, as the *Anglo-Saxon Chronicle* entry implies merely by using it. The 'Der-' element in Derby in this case is actually a contraction to a single syllable of the (Celtic) river name or (Roman) place-name *deru-* (= oaken) to which the Danes, out of habit, contracted to a handy syllable and added '-by'.

This carries much more conviction in the light of modern advances in place name studies than the traditional explanation that the first element was a mutation of the Danish word *djur* (= deer) plus '-by', making 'place of the deer'. Apparently, the extension by Danish usage into two syllables of *deor-* does not necessarily imply

Copy of the city's fifteenth-century common seal.

derivation from *djur* at all. Most likely Victorian etymologists found inspiration of the mid-fifteenth century town badge of a buck lodged within park pales.

Thus, our Derby is more like a contraction of *Der[ventio]-by*, giving the name a very sound 2,000-year evolutionary pedigree.

Nightingale

Florence Nightingale's story is well known, but her connection with Derby itself less so. The family made a vast fortune in the eighteenth-century lead trade, partly in alliance with Sir Richard Arkwright, and they were strengthened by their heiress marrying Sheffield banker William Edward Shore, who assumed the Nightingale name and built the fine house at Lee Hurst and acquired another at Embley Park, Hants. Florence was born near Florence in 1820 and made her reputation giving nursing care (unheard of then in the field) during the Crimean War, an experience which informed numerous tracts and books written subsequently by her and which were instrumental in turning nursing from an amateur affair into a well-ordered profession. She was made a DStJ (Order of St John) in 1894 and in 1907 was the first woman to be awarded the Order of Merit.

Derbyshire Royal Infirmary, north pavilion just prior to demolition, February 2015.

A–Z of Derby

Despite radical attempts to downgrade her achievements in the Crimea on grounds of colour and class, her subsequent pre-eminence and capabilities speak for themselves. Her advice was sought by Dr William Ogle (1824–1905), from 1860 chief physician of the Derbyshire General Infirmary, London Road (built to the designs of William Strutt in 1806–10), seeking a way to alleviate cross-infections within the building. Her stream of epistolatory advice is a masterclass in analytical thought and up-to-date reasoning on her part and through her advice, freely given, the hospital was rebuilt and expanded to designs by H. I. Stevens. The new portion was called the Nightingale Wing and was completed in 1869.

When the hospital was replaced in 1891–97 by the Derbyshire Royal Infirmary, again with advice from Miss Nightingale, her statue in Portland stone, with lamp raised high, by Countess v. Gleichen ARA (HSH Princess Feodora v. Hohenlohe-Langenburg, 1861–1922) was raised in London Road, ensigned with the words *Fiat Lux* (Latin: 'let there be light'). Later some Edwin Haslam ironwork was added to prevent unruly youths from stealing her lamp. It stands in a semicircular recess with seats outside the Nurses' Home (now, reprehensibly, demolished), where it has happily outlived the hospital. A second life-sized, rather mournful-looking statue in bronze was placed in an aedicule above the entrance to the Nightingale Institute in Trinity Street, opposite, a few years later. This is still in situ, although the future of the building is highly uncertain. Its sculptor is not known for sure.

Countess v. Gleichen's statue of Nightingale, London Road, May 2017.

O

Old Mayor's Parlour

The accounts of the life of Dr Percival Willoughby, Derby's pioneer gynaecologist (qv) make it clear that he lived in half of the house later known as the Old Mayor's Parlour. The architecture is generally accepted as typical of the late fifteenth century, an assumption reinforced by a dated overmantel said to read 1483, which, along with panelling, part of the main staircase and other fragments, was removed by the Gadsby family, the last owners prior to the house's unforgiveable demolition in 1948, just as the statutory list was being drawn up.

From its size and magnificence it is likely to have been the town residence of one of the grandest county families. By the time of the 1670 Hearth Tax return for Derby, it had been divided into two, with the east end much modernised and clearly visible on the East Prospect views of the town. This was down to Dr Percival Willoughby (qv).

Old Mayor's Parlour looking east, painted by Ernest Townsend, *c.* 1920. (Derby Museums Trust)

Old Mayor's Parlour, measured north elevation, drawn by T. H. Thorpe, October 1896. (Bamfords Ltd)

The gardens stretched down to the river where there was once was a fishing pavilion. The river here was once spanned by a 'bridge of crazy timbers'. Around 1740 the street front was rebuilt in Georgian style with a fine interior including a pretty mahogany staircase, which was when the western part of the old house was adapted as a service wing and the eastern part divided up to make three houses – hence the multiplicity of doors seen in paintings.

By 1750 it belonged to the Heath brothers, bankers, and from them it came to Thomas Evans (qv Darley Abbey), who let it to another banker, Henry Richardson (1736–1815). John Gadsby (1818–83) bought it from Alderman Sir Thomas William Evans Bt., who was mayor in 1858, which is perhaps how it got its name. His family let it to the Corporation, which bought it in 1931 to make way for the Central Improvement Plan. The mayor at the time, W. H. Hoare, assured the Archaeological Society that they would have first refusal of it, and he also had an approach from the city of Boston, Massachusetts, imploring him to ensure its survival. But in the harsh post-war world, such assurances counted for nothing and demolition began on 9 January 1948. Numerous chunks were saved or carved into trinkets, but today it would merit Grade I listing.

Old Spa

The bulk of the surviving building in Abbey Street – for a long time a much-valued and agreeable pub – would seem to date from 1733 when Dr William Chauncey erected the gabled part (then more extensive) as the accommodation portion of his newly founded spa. Contemporary accounts say that he decided to exploit a mineral spring and 'put down a basin into the spring of it, to come out fresh; he built a cover over the spring which discharges itself by a grate and keeps the place always dry. About twenty yards

below the spa he made a handsome cold bath and some rooms to it ... two dressing rooms and with a large room over the whole and pleasure walks.'

Chauncey died in 1736, but it continued as a spa until at least 1766. By 1784 it appears to have become the house of ironfounder Thomas Wheeldon. In 1800 the daughter of Archer Ward of Green Hill House married Wheeldon's partner William Boothby, who rebuilt it. By 1819 there seems to have been an ornamental canal or lake with rounded ends immediately west of Spa Lane and embowered with trees at its south end.

In 1832 it was sold as a pub with 3 acres to one Bentley, who built terraced cottages in front and behind (mercifully cleared in 1977) – so the 3 acres did not last very long undeveloped! The pub was refurbished in 1947 by Allsopp's Brewery (to which it was by then tied) and again in 1983 and 2001. What must have once been a prettily set semi-rural residence, with its canal to the south and garden stretching down to the Littleover Brook on the west, is now hemmed in by housing from almost every era over the past 175 years. Nevertheless, it remains a building of some importance and with a particularly interesting history.

The Old Spa Inn from Abbey Street, March 2018.

Orrery

Wright's most famous painting, *A Philosopher giving a Lecture on the Orrery in which a lamp is put in place of the Sun*, shows a lecturer, quite probably John Whitehurst (qv), giving a demonstration of an orrery, a form of miniaturised clockwork planetarium, to a select group. An anonymous review from the time called Wright 'a very great and uncommon genius in a peculiar way'. The *Orrery* was commissioned by Washington Shirley, 5th Earl Ferrers, an amateur astronomer who had an orrery of his own, and with whom Wright's friend Peter Perez Burdett stayed in 1760–64. Ferrers purchased the painting for £210 to hang at Staunton Harold, his Leicestershire house. Both the present author and Wright's biographer Benedict Nicolson have argued that John Whitehurst FRS (qv) was the model for the lecturer.

Strangely, Wright only received half his fee, mainly as the payment by Lord Ferrers was channelled through Peter Burdett to pay for the house in Derby that the architect Joseph Pickford rebuilt for him in Gothic style, Ferrers being keen to have Burdett move out. The idea was that Ferrers would pay Burdett, who would settle with his architect/builder and recompense his friend Wright. Unfortunately Burdett was somewhat feckless, and it took a decade before Wright got the balance of his fee.

A recent attempt to exactly date the painting using the alignments visible in the work carried some conviction, although it is never too safe to read too much into a work of art; an attempt to identify the lecturer with the largely unsung mendicant mathematician John Arden suffers from the lack of any mention of him in the correspondence/papers of either Wright, Erasmus Darwin or John Whitehurst, all close friends of the artist.

The painting, an icon of the Enlightenment, was acquired by Derby Museum in 1884.

A Philosopher Lecturing upon an Orrery (1765) by Joseph Wright. (Derby Museums Trust)

P

Pickford

Joseph Pickford was a London-trained architect working in the Palladian and neoclassical tradition who settled in Derby in 1760. His superior talent raised local standards of building immeasurably and he remained there until his premature death in 1782. The elegant house he built for himself around 1765 on Nuns' Green (qv, now Friar Gate) is a *tour de force* of the effects he could deploy for his customers and is now a Grade I-listed part of Derby Museums Trust.

A son of a mason from Warwickshire, Joseph was baptized at Ashow on 6 October 1734. Orphaned at seven, he went to London to serve as apprentice and assistant to his uncle, Joseph Pickford of Hyde Park Corner, one of the leading builders of his day.

Above: Pickford's own house, Friar Gate, now a fine museum, November 2013.

Right: Joseph Pickford's armorial bookplate with his signature below.

He came to Derby as Clerk of Works at Foremarke Hall (1759–61), during which period he encountered Matthew Boulton, the first of many strong links with members of the Lunar Society. In 1761 he rebuilt Longford Hall and a large, very fine hunting stables, currently in severe decay. In 1763–64 he built the Derby Assembly Rooms (qv) before setting up independently in Derby. Pickford was a friend of Joseph Wright, Peter Perez Burdett and John Whitehurst, FRS (qqv), building houses for both the latter and being painted by the former. He was, like most of his friends, a London Freemason and in 1781 was made a member of the Corporation of Derby.

In his short life Pickford achieved great things, including the epoch-making industrial buildings in the Etruria Works, Burslem, for Josiah Wedgwood (1767–70), and almost certainly the Soho Works at Birmingham for Boulton and St Helen's, Derby (qv). His country houses included unrealised designs for a new house at Keele Hall (1763), Calke Abbey (1764) and for rebuilding the east front of Sherborne Castle for Earl Digby. Those completed included Hams Hall, Warwickshire (1768), Sandon Hall, Staffordshire (1769–71), and in Derbyshire Swanwick Hall (c. 1771), Darley Hall (1778), and Ashford Hall (c. 1776) in Derbyshire. He designed the extension to the Derby Shire Hall including a new grand jury room in 1771–72 (rebuilt again in 1828 and demolished in 1999). He also designed St Mary's Church, Birmingham (1782), an octagonal composition, and acted as clerk of works at Kedleston (1775–82), almost certainly as a result of an acquaintanceship with Robert Adam going back to the 1760s.

Prince Charles Edward Stuart

Derby is proud to be home to a bronze equestrian statue of Bonnie Prince Charlie by Anthony Stones, which has stood opposite the east end of Derby Cathedral on Cathedral Green since it was unveiled on the 250th anniversary of the prince's visit to Derby on 4–6 December 1745.

In his bid to regain the throne of his ancestors, the prince landed in Scotland in 1745, proclaimed his father as James VIII and III, secured all of Scotland (bar Edinburgh Castle) and, acting as Prince Regent, collected an enthusiastic army (mainly of highlanders) and marched south, meeting little opposition.

He reached Derby on the 4th and lodged at Exeter House, Derby's largest mansion – the panelling from the council chamber there eventually made its way to Derby Museum where, since 1997, it has formed an integral part of the Bonnie Prince Charlie Room display.

An unfortunate concatenation of factors caused him to stop his march south and he decided to turn back to Scotland and consolidate. Nevertheless, a contingent of his entourage managed to reach Loughborough (where they were well received). The Jacobite army withdrew before dawn on 6 December and met their fate at Culloden four months later.

The prince's manifesto was a great deal more enlightened and liberal than any other European government at the time, proposing freedom of religion and fixed-term

parliaments, among other things – although such refinements had been long forgotten in 1995 when some radical councillors ludicrously sought to label him a 'fascist'. Yet his decision to turn around at Derby put the city briefly at the fulcrum of European events.

Above: Derby Museum's Bonnie Prince Charlie room: the prince considering his options.

Right: Statue of Bonnie Prince Charlie, Full Street, October 2017.

Queen Aethelflaeda

Between 873 and 917 the area where Derby is now was subject to the violent occupation of the Norse Great Army, which chopped the Kingdom of Mercia in half and ushered in a decades-long existential conflict between the Anglians of Mercia, the Saxons of Wessex and the invading Norse.

Place names suggest, however, that Danish settlement was fairly intense, as does evidence culled from study of the Domesday Book as it relates to the administrative structure of the later shire of Derby. Further, one or two local gentry families, emergent after the Norman conquest, stem from recorded men with Danish names. Quite a few of the moneyers of the mint in the town also have Danish names, and, of course, there was a linguistic Norse legacy in Derby: several streets bear names ending in '-gate' (*geata* = street).

Danish power in the area was broken by a warrior queen, Aethelflaeda, widow of the Wessex-appointed Mercian ealdorman Aethelred, effectively King of Mercia

Aethelflaeda leading her levies against Derby's Danes, from a Victorian lantern slide.

from 884. He died around 910 and his campaigning against the Vikings – a veritable Mercian *reconquista* – was brought to a triumphant conclusion by his queen, Aethelflaeda, a daughter of his ally Alfred of Wessex.

The crucial event, as far as Derby was concerned, occurred in 917, under which date the *Anglo-Saxon Chronicle* states that the Mercian queen, 'With the help of God, before Lammas, [she] obtained the borough which is called Derby with all that belongs to it, and there also four of her thegns who were dear to her were killed within the gates.'

'Before Lammas', a forgotten Christian festival ('loaf mass'), which marks the wheat harvest, clearly suggests this happened in late July.

Use of the name Derby implies that it had come into existence by 917/20, despite no town on the site of the present city being in existence. 'Killed within the gates' suggests a fortified place. Today we understand this battle to have happened at Little Chester, Roman *Derventio*, then still strongly walled, and proven by archaeology to have been refortified at just this period.

The local Danish legacy, despite the Mercian victory of late July 917, was thus a solid one. Somewhere in the bloodline of probably quite a few Derby families traces of this Norse heritage must still lurk.

Queen Street

The Queen Street name is relatively modern, first appearing on a map of 1767. Prior to some date during the previous forty-five years, Queen Street, which had previously formed part of King Street (qv), was detached from it and renamed. It was named after Queen Charlotte (v. Mecklenburg-Strelitz), who married George III as sovereign on 8 September 1761. From July 1905 an electrified tram route ran down it and in 1926 the west side was widened and the tramlines doubled in 1927, causing the attractive Palladian refronted house that Pickford had rebuilt for John Whitehurst in 1764 to be severely truncated.

The street is of considerable importance architecturally, too. It is dominated by James Gibbs's great Doric preaching box of 1723–25, since 1927 Derby Cathedral, with its late Perpendicular tower completed in 1531 and containing a sixteenth-century ring of ten bells, a carillon and clock, the two latter both Smith of Derby replacements of early originals by Sorocold (qv Fresh Water) and John Whitehurst (qv). The interior is a masterpiece of light and has recently been redecorated with more than a nod toward the original colours. The giant order, inside and out, is Doric, chosen by Gibbs to complement rather than compete with the Gothic of the tower, which at 172 feet was the tallest of any UK parish church excepting Boston Stump. Entered via a fine pair of Robert Bakewell gates (1730s, from demolished St Mary's Gate House), the lightness of the interior is aided by the refusal of Gibbs to countenance galleries (as at his St Martin-in-the-Fields, London, upon which this church is to some extent based),

although Thomas Trimmer, a gifted Derby joiner, added a modest one at the west end in 1731. Furthermore, the filigree iron screen by Bakewell (tactfully extended by Edwin Haslam 120 years ago and supplemented with reused side gates in 1967) greatly enhances this impression. The monuments range from a colossal one to Bess of Hardwick (1608) by Robert Smythson, through others by sculptors of the eminence of Ruysbrack, Nollekens, Westmacott and Chantrey to talented local men like George Moneypenny, Richard Brown, James Sherwood and Joseph Hall. There is also a good set of seven funeral hatchments to local families. The building was extended with the addition of a chancel, retro-choir song school and other offices designed by Sebastian Comper in sympathetic but by no means imitative style.

Next to the church is The College, a large Georgian house reconstructed from the fabric of the residence of the pre-Reformation canons of All Saints' by the Coke family of Trusley, and nearby is the Dolphin, an inn of alleged pre-Reformation foundation in a good early seventeenth-century timber fabric, still retaining three distinct bars and run with discretion and aplomb.

Whitehurst's house started off as that of the father of John Flamsteed FRS (qv) and following Whitehurst was the residence from 1793 until his death in 1797, of Joseph Wright (qv). The rear panelled dining room where Whitehurst entertained Benjamin Franklin and other friends is particularly impressive. The somewhat reduced building in peril has been three times refused listing and has been derelict for twenty years, a fact of which both local authority and the nation should feel thoroughly ashamed.

Opposite is the small secularised church of St Michael, by H. I. Stevens, 1857 replacing a medieval one which collapsed after morning service in May 1856. It has a squat tower and distinctive horizontal tooling to the grey ashlar of which it was constructed. It was declared redundant in the 1970s and was later imaginatively converted into studios (initially for himself) by Derek Latham FRIBA. The brick house beside it is of seventeenth-century origin, five bays wide and of two storeys rising to three behind.

Queen Street: St Michael's, May 2015, tactfully converted as offices by Derek Latham.

Queen Street: cathedral tower from St Michael's, May 2015.

R

Railway School of Transport

Wilmorton is a Derby suburb created in the later nineteenth century by the Midland Railway out of the parkland of the Wilmot-Hortons' Osmaston Hall (demolished 1938). At its south end, beside the Derby Canal, was built the fine Arts and Crafts church, almshouses and vicarage of St Osmund by Percy H. Currey (1902). A large area next to it was fixed upon by Sir Ernest Lemon and Lord Stamp of the London Midland and Scottish Railway for the building of a railway School of Transport, an institution in which trainee railwaymen could be taught.

The brick and stone building, by the firm's architect, W. H. Hamlyn, was a masterpiece of Scandinavian *moderne*, with a stunning interior. There were stone bas-reliefs on the exterior by Denis Dunlop, and the hallway, with a fine curving staircase, greets the

Railway School of Transport's (RST) main east façade, March 2013.

Norman Wilkinson's two frescoes in the RST entrance hall, 2009.

visitor with a pair of frescoes by Norman Wilkinson CBE (1878–1971), more famous for decorating the interior of RMS *Queen Mary*. This leads through to the centrepiece of the building, a 117-foot-long sunken-floored top-lit room in which was placed a 1-inch-gauge electric model railway, upon which trainee signalmen could train in best practice without their errors proving fatal.

There was also an impressive lecture hall and at the other end a vast dining room, its walls decorated with a large and impressive 28-foot fresco by Hamlyn of a pageant of transport 1838–1938, the year the building was opened.

The redundant building, shorn of its model railway in the 1960s, was sold in 1998 to Arab Investments Ltd, which in 2005 applied to demolish it for a vast housing estate. The Civic Society and the Derby Railway Engineering Society managed to have it spot-listed, and the application was refused. It is now a conference centre and agreeable hotel.

Royce's

Sir Henry Royce and Hon. Charles Rolls moved their enterprise to Derby from Manchester in 1907, and the saga of car production can be found above (qv Cars). Yet Rolls, killed in 1910, was an aviation enthusiast, and had urged his partner to build the best aero engine to capitalise on their motors' perfection. This idea stalled until the exigencies of the First World War rather brought the matter back into focus,

A–Z of Derby

and Sir Henry designed the successful Eagle engine – the first of several. From there the firm never looked back and, led by the very able Lord Hives, from their research appeared the Schneider Trophy R engine (developed into the Second World War Merlin and later the Griffon), the first post-Whittle jet; the Derwent, the first turboprop engine; the Trent; and the fanjet RB 211, which bankrupted the company in 1971, leading to a fifteen-year nationalisation.

From their headquarters in Nightingale Road, from 2007 redundant and now all cleared bar the recently listed HQ building (qv Handyside), the firm expanded into Sinfin, where it still continues to expand. Until the 1960s 'Royce's', as Derby people call it, was the city's second largest employer after British Railways; now it has top spot, and is still expanding.

Old Rolls-Royce offices, Nightingale Road, from the Marble Hall, July 2016.

Part of the present Rolls-Royce complex, Wilmore Road, April 2017.

S

St Helen's House

Derby's grandest domestic residence is St Helen's House, designed by Joseph Pickford (qv) for local grandee John Gisborne MP, father of Thomas (qv Slavery). It is generally reckoned to be the finest purpose-built town house outside London in the Palladian style; it is also Pickford's *chef d'oeuvre*. It was built in 1766–67 and is loosely based on Robert Adam's Lansdowne House, built in Berkeley Square, London, for Prime Minister Shelburne from 1762. The Ionic façade exactly matches it in measurements, although with a Whig client, Pickford had to adapt Adam's neoclassical façade to his more conservative tastes.

Below left: St Helen's House: entrance front after restoration, 2014. (Richard Blunt)

Below right: St Helen's House: Rococo ceiling in the saloon, April 2014.

A–Z of Derby

The Gisbornes also had a house and estate at Yoxall, and the Derby house was purely to accommodate the family on race days, when assemblies were on and when attending the bench or business, and was specifically planned for entertaining. It sat in a 16-acre park landscaped by William Emes.

Eventually it was acquired in 1807 by William Strutt (qv Improvement Acts), who extended it, installing all the latest household refinements, mostly pioneered by John Whitehurst and improved by himself. He entertained lavishly here, but his son, 1st Lord Belper, moved to the Strutt country seat, Kingston Hall, Nottinghamshire, and let it, eventually selling it to the governors of Derby School, and developing the parkland, hence the suburb to its north, Strutt's Park.

The school sold Strutt's extension to the Corporation put in Arthur Street, and using money from the Great Northern Railway extension in 1876 built a huge extension in a grim pastiche of the original. When the local authority comprehensivised the school in the 1960s, it moved out the house which went into decline as a teachers' centre, taken over by the county council and neglected completely, so that when the city recovered it in 1997, it was closed.

A change of municipal control in 2006 allowed a 250-year lease to be sold to an improving developer, Richard Blunt, and the house was completely restored, reopening as a corporate headquarters in 2013.

Silk Mill

Thomas Cotchett, an enterprising Mickleover attorney, first attempted to throw usable silk thread from imported raw silk in a mill built on an island in the Derwent called the Byflatt in 1704, but the attempt failed. John Lombe, a Norwich-born assistant, undeterred and determined to perfect the method, went to Italy to learn the secrets, covertly sending technical drawings back to his half-brother Thomas, who, with George Sorocold (qv Fresh Water), constructed them in the Moot Hall, ignorant of the fact that a full set of early seventeenth-century drawings by Vittorio Zonca were available in the Bodleian Library!

A new silk mill was completed in 1721, engineered by Sorocold, and Thomas Lombe, later knighted, obtained a patent from Parliament protecting his process until 1732, when more mills opened in Macclesfield and Congleton. In the mid-eighteenth century Wright's brother-in-law, Lamech Swift, leased the mill and later bought it. It was damaged by fire in 1826, rebuilt a decade later and continued until the 1890s, when a chemical company took it over. The adjoining doubling shop collapsed in 1893, and the main mill burnt down again in 1910 – more thoroughly this time – but was rebuilt to only three instead of five storeys.

The Derby Municipal Power Station was built next door in 1893, and once nationalised, took the mill over in 1948, but the first two floors and the later wing (Sowter's Mill) were let to the council and opened as the Industrial Museum in 1974,

S

becoming council property again in 1999. In 2017 a £13 million project began to turn the entire building into a much-anticipated Museum of Making for the Museums Trust to celebrate Derby's long history of innovation and manufacture.

Above: Silk Mill: coloured engraving by Moses Webster, 1774.

Right: Silk Mill today from Cathedral Green, August 2017.

A–Z of Derby

Slavery

Apart from the select coterie of the Lunar Society (qv Darwin), two Derby men played pivotal roles in the abolition and suppression of the slave trade. The first was Revd Thomas Gisborne (1758–1846), who lived at St Helen's House until 1797 but also owned Yoxall Lodge in Needwood Forest, Staffordshire, a place he loved dearly. At St John's, Cambridge, he had met and befriended William Wilberforce and together they embarked upon the uphill struggle to bring about the abolition of the slave trade, Wilberforce through agitation and debate in Parliament and elsewhere, and Gisborne by rationalising the underlying moral philosophy and writing tracts like *Remarks Respecting the Abolition of the Slave Trade*, 1792, in support of his friend, a frequent visitor to both houses. He and his wife Mary (née Babington) were painted by his close friend Joseph Wright, who visited him often to make music (Wright being a flautist) and to paint together in Darley Grove or Needwood Forest.

Having seen the passing of the Slave Trade Act in 1807, there followed the problem of policing it. The British element of the Atlantic trade ceased quickly, especially with a war raging, but elsewhere things were different, for the Act only applied in British jurisdiction. The worst surviving trade was between central and east Africa to the Ottoman Empire and Arabia generally, something not finally eradicated until the 1970s.

Fairfax Moresby, a member of a leading Derby family, again with connections to Joseph Wright, came to Derby to succeed to Alderman Henry Franceys's apothecary's practice in 1742. Fairfax, the third of this name, was born in 1787 and entered the Royal Navy, becoming dashing commander of HMS *Wizard*, who from 1811 helped clear the Mediterranean of French privateers and North African pirates. After the Napoleonic Wars he was promoted to command HMS *Menai*, where he did some astonishingly effective work suppressing the East African slave trade operated mainly by Arabs from what is now Yemen. So effective was his squadron that at the insistence of Wilberforce his command was extended until 1823, by which time the trade barely existed.

Moresby went on to have a distinguished career, dying at Exmouth in 1877 as an Admiral of the Fleet and Knight Grand Cross of the Order of the Bath.

Thomas Gisborne and Admiral Moresby with Wedgwood's anti-slavery plaque. (Moresby: courtesy of the National Maritime Museum, Greenwich)

Townsend

Ernest Townsend was probably the second finest artist to have come out of Derby after Joseph Wright. Although he relied on portraiture to make a living, he was also a very fine topographical artist with a natural flair that went well beyond the ordinary. His portraits are of rare quality. He was born in Derby in 1880, articled to architect James Wright (whose practice majored on pubs) and later attended the new Derby Art School, then Heatherley's in Chelsea, gaining a place in the Royal Academy Schools in 1902, studying under Sargent Clausen and Alma-Tadema and making friends with Munnings, Augustus John and Laura Knight, also from Derbyshire.

He left London just as the UK's avant-garde was burgeoning to travel in the Netherlands and France before returning to Derby and marrying in 1912. The fact that he preferred life in Derby restricted his opportunities to become a national figure, leading *The Guardian's* art critic at the museum's 1989 Townsend retrospective to remark, patronisingly, that had Townsend stayed in London as a young man 'he would have been as famous as Opie and Sargent instead of wasting his talent on Mayors and Freemasons'!

Ernest Townsend's 1942 portrait of Alfred Goodey. (Mellors & Kirk)

Nevertheless, he painted memorable portraits of Churchill and George VI as well as practically every local grandee from his old tutor at the art school, T. C. Simmons, through philanthropist A. E. Goodey to entrepreneurs like Sir Francis Ley Bt. and plenty of simpler folk. He painted a lively frieze for the Whitehall cinema, St Peter's Street (lost on its demolition in the 1960s), and did much camouflage work in the Second World War, especially at the Rolls-Royce works. He died in 1944, leaving two sons.

The Turf

Derby had a notable racecourse and an even more notable dynasty of the turf. From before 1733, races had been held on Sinfin Moor, aided by the erection of a large flat-pack timber grandstand, which could be disassembled after use and stored. In 1803 the racecourse moved to The Sidalls, water meadows beside the Derwent, where a permanent grandstand was put up. Racing continued here until the coming of the railway adjacent began to cause waterlogging on the course and racing ceased in 1845. It was only by the races' patron, the Duke of Devonshire, bringing pressure to bear that a new course was made on Cowsley Fields, between the Derby Canal's Little Eaton arm and the scarp to the east. A new grandstand by Henry Duesbury was opened in 1852 (replaced in 1911) and racing continued until the outbreak of the Second World War, the last race of the last meeting, on 9 August 1939, being won by a young Sir Gordon Richards. When war ended and the army moved out, the Corporation was approached about a resumption of racing, but the newly elected council sniffily

A Regency sketch of racing on The Siddalls, Derby. (Derby Museums Trust)

decided that a resumption of racing would 'bring all the wrong sort of people into the town' irrespective of the much-needed money it would bring!

The sorry tale of the decline of racing in Derby was long preceded by the rise of the Loates family. Archibald Loates was the landlord of the Oddfellows' Arms, King Street, and had an extensive family. Three of his sons, however, became jockeys, although one, Charles, did not become particularly well known but his brothers, Sam (1865–1932), and Tom (1867–1909), became celebrities. Sam won seven classics between 1884 and 1900 and was champion jockey with 160 winners in 1899, including the 1884 and 1885 Derbys, the former a dramatic dead heat on Harvester and the latter on Sir Visto. Tom rode for most of his career in the colours of the Duke of Portland. In 1889 he won the Derby on Donovan, in 1893 repeating the achievement on Isinglass – he also won the St Leger that year on this horse. Indeed 1893 was his *annus mirabilis*, for he won the Thousand Guineas on Siffleuse and back on Isinglass took the Two Thousand Guineas too, a classic he won again three years later on St Frusquin. He was champion jockey with 167 winners in 1889 and a year later with 147 and in 1893 repeated the accolade with 222 victories. Neither married, but Sam left a colossal £74,000 when he died in 1909. Even their nephew, Sam Heapy, son of a Midland Railway clerk at Derby, followed in their hoof-prints, going on to become premier jockey and later trained in Belgium.

Above: Isinglass with Tom Loates winning the 1893 Derby, by G. D. Giles. (Sotheby)

Right: Sam Loates, as sketched by 'Spy' (Leslie Ward) for *Vanity Fair*, 5 November 1896.

U

University

The University of Derby traces its origins back to 1851 when a School for the Training Schoolmistresses was set up in Uttoxeter New Road, in a handsome building by Henry Isaac Stevens. Two years later came the establishment of the Derby School of Art, which later acquired an even more distinguished building on Green Lane by F. W. Waller of Cheltenham. By 1892 the Derby Technical College had emerged from this matrix too, eventually moving to a campus in Normanton Road by C. H. Aslin,

The University of Derby, Kedleston Road, February 2016.

which the Second World War prevented from being completed and the institution eventually settled in a veritable hurst of modernist glass towers on a hill on the former golf course on Kedleston Road. Meanwhile the training college had expanded to Mickleover as the Bishop Lonsdale College of Education. In 1973 the two merged, taking the Technical (by then Higher Education) College out of local authority control, called Derby Lonsdale College, which scooped into its maw a couple of other county higher education establishments.

In 1992, however, the government created a whole raft of new universities mainly by promoting polytechnics, but Derby was the only one to have side-stepped the polytechnic stage. It continued to expand in Derby and in 1998 absorbed the Buxton Higher Education College centered on R. R. Duke's spectacular domed adaptation of Carr of York's round stable block there. Under Vice Chancellor John Coyne, it made great strides, in 2012 adding Leek (Staffordshire) College and the former St Helena's Grammar School, Chesterfield, two years later as a centre for nursing and midwifery. It now boasts three faculties controlling eleven schools. It has yet to produce any alumni of earth-shattering consequence, but no doubt it will. The present Vice Chancellor (appointed 2015) is Kathryn Mitchell, but the Chancellor from 2008, the Duke of Devonshire, was succeeded by his son, Lord Burlington, in 2018.

V

Victoria Crosses

Derby has produced a handful of winners of the VC. In order of having been awarded, they are: Robert Humpstone, Sir Henry Wilmot Bt., Edward W. Unwin, Jacob Rivers and Charles Edward Hudson.

Robert Humpstone was a tobacconist's son born in Derby in 1832 who won his VC on 22 April 1855 as a rifleman in the 2nd Battalion The Rifle Brigade when he and two others beat back a number of Russian snipers who had captured the unit's water supply. The award was gazetted on 24 February 1857 and he attended the first ever VC investiture in Hyde Park that year. He also received the Legion d'Honneur. He later served in India, and died in 1884.

Derby's five VC winners: top – Humpstone and Wilmot; centre – Rivers; lower – Unwin and Hudson.

V

Sir Henry Wilmot was born at Chaddesden Hall a year before Humpstone's birth, and in 1849 was commissioned into the 43rd Light Infantry, later transferring into Humpstone's regiment, 2nd Rifle Brigade, also serving in the Crimea. He won his VC whilst Deputy Judge Advocate in India during the Mutiny, in heavy fighting around Lucknow on 11 March 1858, saving the lives of four men, one badly wounded, under constant fire. The award was gazetted on 24 December that year. Wilmot later served in China, retiring in 1862 as a major. He was elected Conservative MP for South Derbyshire in 1868 and served until 1884. In 1872 he succeeded his brother as 5th Bt. and in 1897 he was made KCB. He died at his house in Bournemouth in 1901, but his successors sold the estate after the First World War.

Jacob Rivers was the son of poor parents living in a court off Bridge Gate, but joined the army in 1898 at eighteen, serving in India until 1907 when he was put on the reserve. He re-enlisted in the 1st Battalion Sherwood Foresters in 1914, but was killed in action at Neuve Chappelle on 12 March the following year, in the act of single-handedly staving off a German outflanking move with grenades. He was gazetted VC on 28 April, but his body was never recovered. On 23 March 1923, his mother was made an honorary Freeman of the Borough.

Revd Edward Unwin was vicar of St Werburgh's Church in Derby in 1809–47 and commissioned the delightful stone villa Highfields House, Derby, from amateur architect Richard Leaper in 1824. His grandson, Capt. Edward W. Unwin RN, was born in 1864 and entered the navy in 1880. He had already been mentioned in despatches, when he won the VC in an action off the Dardanelles on 25 April 1915, repeatedly trying to reposition some broken-away landing barges at V Beach under murderous fire. He was later made CMG in 1916 and CB in 1919, retiring from the navy in 1920. He died in 1950.

Charles Edward Hudson was born at Fern Bank, Trowells Lane, in Derby in 1892, son of a serving officer in the Sherwood Foresters. After Sandhurst he was commissioned into the Sherwood Foresters and displayed exceptional dash and courage in the First World War, winning an MC, DSO & bar, an Italian *Valore Militare*, a French *Croix-de-Guerre* and was mentioned in despatches four times before, as acting Lieutenant 11th Sherwood Foresters, he was awarded a VC on 15 June 1918. He led a desperate counter-attack with a motley crew of B-echelon personnel after the enemy unexpectedly penetrated the front line, killing all the other officers. Despite being wounded in the foot, he took on 200 Germans, capturing 100, plus six machine guns. He served as Brigade Major in a force despatched to Russia to oppose the Red Army in 1919 being twice more mentioned in despatches. He was at Dunkirk as commander 2nd Infantry Brigade and was made CB, retiring in 1946 after two years as ADC to the king. He died in 1959.

Wardwick

The Wardwick, one of Derby's finest streets, is the earliest Derby street name recorded – in 1085 as Walwik Street in a Burton Abbey charter. Later it is rendered Waldewico (c. 1200), although the modern spelling does not appear before 1767. Wardwick was originally the name of the small settlement centred on the church dedicated to St Werburgh (a Mercian Saxon princess who died in 699). This is now mainly an 1894 replacement of a baroque church by Sir Arthur Blomfield; here Dr Johnson married Tetty Porter in 1735. The chancel sports a superb iron font cover by Bakewell and a fine monument by Sir Francis Chantrey.

As Wardwick became absorbed within Derby, so the name dwindled into a street name. The term *wic* can be interpreted as meaning both a market and as a dairy farm, whereas *Walda* is a Saxon personal name, perhaps of the founder of the church. Recent research has tended towards the 'market' interpretation, and a possible early Saxon market site has been postulated behind Sadler Gate Bridge. The place gave rise to a surname – one Ingram de Waldewick flourished at Derby in 1202.

Aside from the dominating presence of the museum (qv) nearby is the ashlar façade of the Mechanics' Institute, added to an 1836 building when the street was widened and the lecture hall reduced in length in 1882, by Arthur Coke-Hill. Diagonally opposite is a real gem, the Wardwick Tavern, the former Alsop's House – of 1708, brick, very metropolitan, of seven bays, three storeys and parapet cleverly recessed over the windows. Fragments of an earlier building remain inside with enfiladed and panelled reception rooms on the first floor. There is a cast-iron plate marking the height of the flood of 1 April 1841 beside the stone-hooded entrance.

Further along is the former Mundy House – five bays and three storeys under a hipped and sprocketed roof – built by Adrian Mundy of Quarndon in 1696, but was rebuilt for entertaining by Edward Mundy MP with the help of his architect at Shipley Hall, William Lindley, 1799. Next to it is Jacobean House (qv) and across Becket Street is another later seventeenth-century house, rebuilt in the eighteenth, and beside Nos

Wardwick: St Werburgh's Church: 1610 tower and 1896 nave, May 2016.

51–55, a seven-bay two-and-a-half-storey house built for the Mundys of Markeaton (kin to those of Shipley) in 1768–71 by James Denstone. On the corner, the ornate Lord Nelson pub (established before Trafalgar and probably after The Battle of the Nile) replaced Pountains by James Wright 1894.

Wardwick looking from Friar Gate after a summer storm, May, 2014.

Whitehurst

Derby became one of the two major foci of the Midlands Enlightenment from the 1750s. Credit for this must go to John Whitehurst FRS (1713–88), who settled in the borough as a clock, watch and instrument maker in 1736. He was a divergent-thinking mechanical genius, and such was the success he made of his clocks – providing precision, quality and yet cheapness – that he was able to leave the business largely in the hands of his brother and spread his wings. Some of his later clocks were of immense sophistication. His mechanical instruments included barometers (with a new type of scale of his own devising), pyrometers, compasses, a device to measure 100ths of a second and various industrial timers, all ahead of their time. His invention of the hydraulic ram has transformed farming in the country and subsequently in the Third World.

By 1758 he had become a close friend of Matthew Boulton, the Birmingham entrepreneur, and with Dr Erasmus Darwin, then a Lichfield general practitioner. Over the following six years they recruited a number of other figures, forming the celebrated Lunar Society. Overseen by Benjamin Franklin they were, like him, all Freemasons and all became Fellows of the Royal Society.

The reach and breadth of their individual genius, collectively driven forward, had a profound effect on Industrial Revolution, and their links to like-minded people on

the Continent drove the Enlightenment as they enthusiastically espoused such causes as the abolition of the slave trade, the grievances of the American colonies and the precepts (but not the execution) of the French Revolution. Indeed, this last led to the development of the metric system and its adoption, through conquest, throughout much of Europe. Whitehurst, who had died in 1788 (the year before this cataclysm engulfed the French), had already written a treatise on the advisability of the adoption of a universal system of measurement, the use of decimals and had developed a device from which he was able to arrive at a viable universal unit of measurement of 39.2 inches, only 0.15 short of the length eventually arrived at for the metre.

Whitehurst published *An Inquiry into the Original State and Formation of the Earth* in 1776 (revised 1782), which is the foundation for modern geological science, influencing a number of eminent men like James Hutton (who went to see Whitehurst in the 1760s) who have subsequently been given credit for it themselves. His numerous other, largely unacknowledged, achievements include flushing lavatories, the hydraulic ram, the back boiler, an improved cooking range, and many others. He helped Derby architect Joseph Pickford and Josiah Wedgwood evolve and build the Etruria Works at Stoke, the prototype of the modern ceramic factory. He was eventually appointed to a sinecure at the Royal Mint and left for London in 1780, dying in 1788. His firm continued in his family at Derby until 1855 and under Roskell of Liverpool until 1862.

Above left: John Whitehurst FRS: Detail of Wright's 1785 portrait. (Smith of Derby Ltd)

Above right: Large dial compass made by Whitehurst for Peter Burdett, *c.* 1765, in Derby Museum.

X

X-engine

Rolls-Royce, ever keen to develop their best products, spent the years leading up to the Second World War at Derby seeking to improve the power output of their engines. One of their early engines was developed as the Peregrine, a V-12 machine of 750 horsepower (hp). This was then developed with two horizontally opposed V-12 units driving a common crankshaft thus forming, in section, an approximate 'X'. The result was the 1750-hp Vulture, 650hp more than a standard V-12 Merlin. The Vulture was not reliable enough to go into proper production, leaving some aircraft designed to take it like the Avro Manchester and Hawker Tornado virtually stillborn. However, a more reliable smaller version for Fleet Air Arm use called the Exe was developed but halted when work stopped on the Vulture, so that the firm could continue to develop the highly successful Merlin and continue developing its successor, the Griffon.

Rolls-Royce Exe – a later X-engine. (Rolls-Royce Heritage Trust)

Y

Yates

The Yates family first achieved prominence (or rather notoriety) in 1639 when the Town Annal records that in that year 'William Yates farted as he passed by Mr. Mayor and was imprisoned for it.' It is not clear what the profession was of William Yates (1600–72) but he might well have been a blacksmith, for certainly his grandson was, for in 1757 he appears as a beneficiary in the will of the great French wrought iron gate-smith Jean Montigny whose foreman he was. He made the stair balustrade at Woburn Abbey in 1795, the year he died. His sons John and Benjamin (1709–78) were also gate-smiths, the former also working for Montigny, and the latter working, from 1730, as foreman to Robert Bakewell (qv), whose business he took over in 1752. He produced the ironwork for Staunton Harold and St Helen's House (qv) and the Corporation screen which now connects St Werburgh's with the Bold Lane car park. He was assisted by his sons, William (1731–1803) and John (1746–78), who made the magnificent screen and gates for Kedleston Hall, stair balustrade at Kenwood, and gates at Emmanuel College, Cambridge.

William's son John (1751–1821) was a gilder/painter at the Crown Derby china factory (qv) where his brother William also worked, alongside the famous china painter George Robertson (1777–1833), who married John's daughter Anne. Her sister Sarah married a nephew of Joseph Wright in the shape of John Wallis, a nationwide stagecoach and inn proprietor. Finally, Minshall Birchall (1761–1811), a barometer maker and ex-apprentice of John Whitehurst (qv), married their aunt Elizabeth, becoming the grandparent of W. Minshall Birchall, the US-born British marine painter.

Benjamin Yates: stair balustrade made for St Helen's House, 1767. (Richard Blunt)

Z

Zoning, Planning

Although the 1947 Town and Country Panning Act allowed local authorities to make their own planning decisions free from any strict guidelines, post-war planners were, mainly through their training, strongly influenced by such precepts, especially

St Mary's Gate looking east: quality housing zoned as offices post-war, March 2018.

Z

Euclidean Zoning, wherein various uses – industry, retail, residential, etc. – should be strictly segregated, an idea given legal force by a much earlier US court decision concerning the town of Euclid, Ohio. This certainly had its effect in Derby, most disastrously in St Mary's Gate, Vernon Street and Friar Gate in which after the war office use of the fine Georgian houses was encouraged (with disastrous effect on the interiors) by the council and its officers at the expense of the residential use for which both areas were built. This is why only now, some sixty or seventy years later, houses in both areas are beginning to return to single residential use, like the recently and splendidly refurbished No. 40 St Mary's Gate, previously a solicitor's office, and two or three fine Regency houses in Vernon Street. We can only hope this unfortunate piece of baleful statist planning can continue to be reversed and life is breathed back into some of the most splendid parts of our historic city.

Acknowledgements

My thanks are due to a good number of individuals to whom I am as so often extremely grateful for help, information, illustrations and guidance. Of these I must single out for special mention the excellent Derby Museums Trust, the indefatigable staff of the Derby Local Studies Library and particularly my wife, Carole, for driving me to a number of (to her) unexpected locations while the sun shone, in order to get some decent photographs.

About the Author

Maxwell Craven was born in London, son of a shipbroker, and was educated in the West Country, but lost his parents in his teens. He obtained a University of Nottingham B.Ed (Hons.) degree and worked for a while in business in London before obtaining a post at Derby Museum, where he remained for twenty-five years, for eighteen of them as Keeper of Antiquities. In 1980 he began to write books, mainly about architecture and local history, including *The Derbyshire Country House* (3rd rev. edn 2001) and culminating in his 2015 life of John Whitehurst FRS.

Since 1998, he has combined journalism, researching and producing architectural statements of significance with continuing work for various local and national amenity societies. He is also a consultant for Bamfords Auctioneers and has concentrated on campaigning to preserve historic buildings, urban environments and country houses. He has edited Derby Civic Society's *Newsletter* for over twenty-five years and that of Derby Museum Friends for seven. He is a long-serving member of the Derby Conservation Area Advisory Committee (Chairman 2006–09 and again currently) and Derby Cathedral Fabric Committee. He is a member of the Board of Derby Museums Trust, of the Derbyshire Historic Buildings Trust and a trustee of Derby Bridge Chapel.

In 1996 the University of Derby awarded him an honorary degree and appointed him to the University Court; he was further awarded an honorary D.Litt. by the university in 2013.

He was elected a Fellow of the Society of Antiquaries of London (FSA), made MBE in 1999 and elected FRSA in 2016. He lives in Derby with his wife and daughter.

Monkee Magic

a Book about a TV Show about a Band

Melanie Mitchell

Monkee Magic
a book about a TV Show about a Band

Copyright © 2013 Melanie Mitchell. All rights reserved. No part of the contents of this book may be reproduced or transmitted in any form or by any means, including recording or by any information storage and retrieval system, without the written permission from the author.

Cover illustration by Jaime Hitchcock
Cover design by Auger Artwork Studios, Arty4ever.com

ISBN: 1493544314
ISBN-13: 9781493544318

THE MONKEES® is the federally registered trademark of Rhino Entertainment Company. There is no affiliation, endorsement or connection between Rhino Entertainment Company and this book or its author.

For Andrew, who told me it could happen,

and Janet, who held my hand.

Table of Contents

Preface ...ix

Introduction ..xi

Alias Micky Dolenz ... 1

Art, for Monkees' Sake ... 5

The Audition (Find the Monkees) .. 9

Captain Crocodile ... 13

What is "Monkee Magic"? ... 18

Card Carrying Red Shoes .. 22

The Case of the Missing Monkee 27

The Chaperone .. 31

The Christmas Show ... 35

A Coffin Too Frequent .. 39

Dance, Monkee, Dance ... 44

The Devil and Peter Tork .. 48

Don't Look a Gift Horse in the Mouth ... *54*

Everywhere a Sheikh, Sheikh ... *58*

Fairy Tale ... *62*

A Visit from Princess Gwen .. *64*

Here Come the Monkees (The Pilot) ... *72*

Here Come the Monkees, Extra Credit ... *78*

Hillbilly Honeymoon (Double-Barrel Shotgun Wedding) *80*

Hitting the High Seas ... *85*

I've Got a Little Song Here ... *89*

I've Got a Few Dozen Songs Here ... *95*

I Was a 99 Lb. Weakling ... *108*

I Was a Teenage Monster ... *112*

Mijacogeo (The Frodis Caper) .. *117*

Monkee Mayor .. *122*

Monkee Mother .. *127*

Monkee See, Monkee Die ... *132*

Monkee Chow Mein ... *137*

Monkee vs. Machine ... *141*

Monkees a la Carte ... *145*

Monkees a la Mode .. *149*

Monkees at the Circus .. *153*

The Monkees at the Movies .. *158*

The Monkees Blow Their Minds ... *163*

Don't Trust Anyone Over Thirty .. *168*

The Monkees Get Out More Dirt .. *173*

Monkees in a Ghost Town ...177

Monkees in Manhattan .. 182

The Monkees in Paris... 187

Monkees in Texas..191

Monkees in the Ring ... 196

Monkees Marooned.. 201

The Monkees Mind Their Manor...206

The Monkees on the Line ...211

Monkees on the Wheel... 215

The Monkees on Tour...220

The Monkee's Paw ..224

Monkees Race Again..229

Mary, Mary, Valleri and the Girl I Knew Somewhere 233

Monkees Watch Their Feet ..246

Monstrous Monkee Mash .. 251

It's a Nice Place to Visit .. 257

One Man Shy (Peter and the Debutante)263

The Picture Frame ..268

The Prince and the Paupers .. 273

Royal Flush .. 278

Some Like it Lukewarm ... 283

Son of a Gypsy...288

The Spy Who Came in From the Cool.......................................292

Success Story...297

Too Many Girls (Fern and Davy) ...302

The Wild Monkees ..*307*

Your Friendly Neighborhood Kidnappers .. *312*

The Beginning of the End (or the End of the Beginning) 318

Head ...*320*

33 and 1/3 Revolutions per Monkee ... *325*

A Lizard Sunning Itself on a Rock (Hey, Hey, It's the Monkees) *331*

Postscript ..338

For Further Reading and Viewing ... 339

Appendices

 I: Episodes in Filming Order and Broadcast Order342

 II: Actors in Multiple Roles ...344

 III: Index of Songs ...348

Acknowledgements .. 351

Preface

Before the first gold record, before the first concert tour, before the Monkees racked up four number-one albums in a single year and outsold the Beatles and the Rolling Stones, THE MONKEES was a half-hour TV show, airing Monday nights on NBC. Given its outsize weight in my cultural consciousness, I was surprised to learn that the show's original run on the network lasted only two years: September 12, 1966 to September 9, 1968.

I was only six years old when THE MONKEES was cancelled. I have no clear memory of watching the show as a child; I know I must have seen it, probably on Saturday mornings in 1970 or so, as there are moments in a handful of episodes that elicit a visceral sense of fear or sadness that is far out of step with my mature understanding of the show's humor and emotional center. My first clear memories of the show are from the late 70's, when THE MONKEES was an occasional after-school diversion at a friend's house, viewed on her bedroom TV set.

As a young adult I managed to miss the 80's revival altogether, as I did not have cable TV at the time MTV was bringing the band and the TV show to the attention of a new generation of fervent fans. Too young for the initial run, too old for the revival—the Monkees never quite cemented a place in my thoughts.

Until February 29, 2012: the day that Davy Jones died. That was the day that the Monkees burst into my attention, in a whirlwind of secondhand grief and disquieting curiosity. The *Monkees*? Were they still around? Nudged by the intense media coverage, I decided to check it out for myself.

Over the course of a month I fell deep, deep, deep into the Monkee Hole, a vast internet wonderland of news, concerts, interviews, gossip, teen magazines, photos, love, laughter and tears. And music! Of course I was familiar with the band's major hits, staples on the oldies radio stations that I love, but there were so many more songs that I never knew existed.

Before long I had purchased a complete set of Monkees DVDs. I plowed through the discs greedily, watching the episodes through an odd, triple lens: fleeting impressions of childhood wonder and fear, hazy memories of adolescent fantasy, newly awakened admiration, nostalgia, joy and *regret*. I had missed so much! I grew up, became mature and responsible, and never knew what goofy, liberating fun had been available to me all along, if only I had reached out for it.

I started to write. The television show is where I was grounded, so the television show is where I focused my energies. It started hesitantly, with a Tumblr blog, and blossomed and grew to the book you are reading now.

It has not ended yet.

Introduction

If you're looking for a history of the band, or even a history of the TV show, a book that will confirm whether Charles Manson auditioned for THE MONKEES (he didn't) or a book that relates the awesome moment when Mike Nesmith put his fist through a wall (he did)—this is not that book. Those stories have already been told, by the people who were there; I'll provide some suggestions for additional reading and viewing at the end of the book.

Monkee Magic is an episode-by-episode analysis of the TV show itself. There's a review for each episode, plus one each for the feature film *Head* and the two Monkees TV specials. The reviews include examples of quality dialogue, comedy highlights, nitpicks, clunkers, cultural clarifications and other observations and oddities.

What little behind-the-scenes information I have to share will be found under the heading, "Production Notes." These nuggets come from various public sources, primarily the definitive Monkees reference book, Andrew Sandoval's *The Monkees: The Day-by-Day Story of the 60s TV Pop Sensation.* I am also indebted to Aaron Handy's thorough and well-organized website, *The Monkees Film & TV Vault,* for easy access to details such as character names, filming dates, airdates and credits.

Each episode review concludes with a set of letter grades, like a miniature report card. These grades are purely arbitrary and do not reflect any attempt at consistency or fairness. The show isn't trying to get into grad school, for heaven's sake! Please enjoy reading the grading categories and don't give overmuch thought to whether your favorite romp deserves a better grade than the B+ I assigned.

The episodes are arranged in alphabetical order, by the episode titles as they appear on the Eagle Rock Entertainment DVDs. This reflects the approach I originally took with my blog; the alphabetical order provides an element of randomness-by-design to the project.

The mood jumps back and forth between the sweet innocence of 1966 and the heady excesses of 1968; fashion bounces between matching eight-button shirts and psychedelic paisley; music veers between crowd-pleasing bubblegum and the sophisticated artistry of the *Pisces, Aquarius, Capricorn and Jones* era. It should be a continuous series of surprises. Only the post-cancellation productions—the feature film and the two TV specials—are placed in chronological order at the end of the book.

I have taken care to differentiate between the four actors and the fictional characters they portrayed on TV. The characters are always referred to by their first names; the real-life actors are identified by their last names only. In a similar manner, "the Monkees" refers to the four characters, or occasionally the band as a recording/performing unit, while "THE MONKEES" refers specifically to the TV series.

One feature of each episode review is the Question, titled "What I want to know…" The Question can be anything from the trivial to the whimsical to the profound; in every case, however, it is something I do not know and would truly love to learn. Some of my blog readers have encouraged me to reach out to the surviving Monkees, or to other actors, writers, producers or directors who might be able to answer my questions. I gave it careful consideration, but ultimately decided to maintain an outsider's perspective. I have no information other than that which is available to anyone with a complete set of MONKEES DVDs, a modest collection of books on the subject and a good internet connection.

That said, my discovery of THE MONKEES is a work in progress. I started this project simply as a way to connect with other fans and start a conversation. If you have information to share, or if you just want to debate the merits or explore the possibilities or shoot the breeze, I invite you to send me an email or visit my blog.

<div style="text-align: right;">
Melanie Mitchell

bluemoonalto@yahoo.com (email)

bluemoonalto.tumblr.com (blog)
</div>

Babyface! Aren't you gonna give your Ruby a great big review of *Alias Micky Dolenz*?

The In-Which
The police recruit Micky to go undercover, impersonating a gangster.

This is a difficult episode for me to start with—it's a pity that I decided to do these reviews in alphabetical order, but there it is: *Alias Micky Dolenz* comes first. It's such an atypical episode, focusing almost entirely on one Monkee, and half the time he's out of character. It's also a very dark story, with very little levity and almost no fun. Nothing demonstrates this better than the episode's lone musical romp, in which Micky sits dazed on the floor while a crowd of extras—hoods, drunks and floozies—beat each other senseless.

The best aspect of this episode is, without question, Dolenz's masterful portrayal of three characters: Micky, Babyface, and Micky pretending to be Babyface. That last character is the most impressive of all, as the actor slips nimbly back and forth between the two personas whenever the character is under stress. The illusion is strengthened by the scene in the prison cell, which is blocked and edited extremely well, much better than the similar doppelganger scenes in *The Prince and the Paupers*.

A tip of the fedora goes to Maureen Arthur as Babyface's baby doll of a girlfriend, Ruby. Her sweet, breathy voice and vacuous expressions provide a glimmer of humor in the melodramatic scenes in the saloon.

While Dolenz shines, Nesmith's involvement is peripheral, Tork is barely present and Jones is missing altogether. Micky is very much alone in his dangerous mission, in stark

contrast to the usual "we're all in this together" attitude of the four friends. There's just that one flash of camaraderie when Mike spontaneously volunteers himself and Peter as Babyface's two specialists.

Strangely, Davy's absence is never explained or even acknowledged in the context of the story—his friends don't even seem to notice that he's not there. (Compare this to *I Was a 99 Lb. Weakling*, in which both Davy and Peter comment that they wish Mike were there to help deal with Micky's crisis.) I'm glad they at least brought it up in the context of the post-episode interview.

Production Note
Principal filming for this episode ended on Thursday, December 22; the following Monday the band would begin an eight-city concert tour. Production of the series would resume in early January.

Zingers
Tony: It's no good, Babyface. You're a has-been.
Micky: Nah, Tony. I was a has-been. Now I'm an am-is.

Micky: Busted out yesterday. Clean break.
Tony: Didn't they spot you with their searchlights?
Micky: Fixed it so the searchlights was useless.
Mugsy: How'd you do that?
Micky: Busted out in the daytime.

Runner-Up Physical Comedy Highlight
Micky's rambunctious panic attack in the police station.

Physical Comedy Highlight
Mike folding himself gracefully—twice!—to duck under the mantelpiece while at the same time climbing over the fireplace screen. Totally unnecessary, but fun to watch.

Sight Gag Highlight
Micky's endearingly clumsy attempt to look cool and threatening with a handgun.

Absolutely Not a Sight Gag Highlight
As Micky exits the police station for the first time, we catch a glimpse of a handcuffed peace protester, an unusual sign of the times from a series that tried so hard to steer clear of any commentary about the escalating war in Vietnam.

Third Runner-Up Nitpick
The hood in the teaser scene apologizes again and again while swatting Micky with a rolled up newspaper. Given the level of violence in the rest of the episode, this scene makes no sense at all.

Second Runner-Up Nitpick
During the fight scene at the bar, Ruby is shown unconscious beside Micky on the floor even before her look-alike rival breaks a bottle over her head.

Runner-Up Nitpick
In the police station, the detective tells Micky and Mike who Babyface Morales is. Micky responds, "Where do I come in?" as though he has already been asked to help the police—but no such request has yet been made.

Nitpick
Overlooking for a moment the complete insanity of a police detective dishing out handfuls of stolen jewels as an impromptu reward, the detective doesn't even take the time to figure out whether he is rewarding Micky or Babyface.

We're the young generation, and we have something to recycle.
- Recurring sight gag: blowing up the wrong thing. (See also *Monkees a la Carte* and *Son of a Gypsy*.)

What I want to know…
According to Andrew Sandoval's definitive reference work *The Monkees: The Day-by-Day Story of the 60s TV Pop Sensation*, the scenes shot on the last day of filming were the ones in which only Dolenz (of the four Monkees) appeared. Was this episode such a "solo" outing for California-native Dolenz specifically so that Jones, Nesmith and Tork could visit far-flung families for Christmas?

Beverage to enjoy while watching *Alias Micky Dolenz*:
A shot of bourbon, straight up *(cough, cough)*.

Music
- *The Kind of Girl I Could Love:* vaguely narrative romp.
- *Mary, Mary:* isolated performance.

Episode 1-25
Written by: Gerald Gardner, Dee Caruso and Dave Evans
Directed by: Bruce Kessler

Principal Filming Ended: 12/22/1966
First Airdate: 3/6/1967

Grading
- Hoods, floozies and drunks, oh my! **C+**
- Micky **A-**
- Babyface **A**
- Micky pretending to be Babyface **A+**
- Hey, hey, where are the Monkees? **C-**

And the cookie goes to...
Dolenz, for carrying this episode nearly single-handedly.

A robbery? Ridiculous! There are too many safeguards. During the day, two guards protect the painting, and at night I personally review *Art, for Monkees' Sake.*

The In-Which
Peter is tricked into forging a valuable oil painting.

Because I'm writing these reviews in alphabetical order, *Art, for Monkees' Sake* comes right after *Alias Micky Dolenz*, and everything that I didn't like about that earlier episode is made right. All four Monkees are present and heavily involved throughout the plot. The bad guys' criminal scheme is high-concept and low-violence, and the band's solution manages to be clever and wacky at the same time. The episode sparkles with snappy dialogue, delightful hijinks and sly social commentary aimed at the oblivious curator and the eccentric artists and highbrow patrons who populate the museum.

 Peter's earnest enthusiasm for his new hobby is sweetly in-character; the pleasant surprise is his actual competence as a painter. I was a bit put off by the snarky comments about his limited intelligence, a motif that crops up quite a few times during the second season, but at least his artistic gift was given proper respect. And speaking of respect, I have to give credit to Coslough Johnson for a tight story that actually makes sense from start to finish, not relying on the rapid fire, nonsensical editing of a romp to tie up unresolvable plot lines.

 The two villains are not particularly well drawn; there is little sense of who they are, why they do what they do, and whether they were already planning to steal that particular painting before Peter wandered into the gallery with his odd talent for painting portraits of doors.

Less focus on the villains means more time spent with the Monkees, and with writing of this quality, that's a very good thing.

I treasure the many delightful details that sparkle throughout the story. Peter crosses his eyes, transfixed by his own paintbrush. Mr. Schneider sits at the breakfast table, dressed in Peter's pajamas. Mike sinks to the floor in silent laughter at Liberace's dignified performance art. Micky makes random cat noises in his role as the Los Angeles Leopard. All four Monkees engage in a rapid-fire game of Telephone in the middle of their late-night caper. Davy poses with a stunning "sour lemon" face during the romp. Back at the pad, Micky frames and displays the *avant-garde* work of art that used to be his shirt, while Mike belts out a silly rendition of *Papa Gene's Blues*.

Zingers

Duce: What's with the hat? The hat's not needed.
Peter: It's Mike's hat. It's knitted.
Duce: I know it's knitted, but it's not needed.
Peter: How did you know it was knitted?
Duce: I can tell it's knitted. But it's not needed.
Peter: Oh! For a moment I thought you knew Mike.

Mike: Gua— guard! Guard?
Peter: Hey, Mike! Mike!
Mike: Uh, pardon me, you don't know me, but I'm... oh well, look... the paintings that you have here have been switched. You know, somebody stolen them.
Peter: Mike?
Mike: I mean, stealed them.
Peter: Mike, that's one of the thieves.
Mike: Oh....
Peter: I mean, thieven....

Production Note

The legendary flamboyant pianist/showman Liberace makes a cameo appearance, destroying a grand piano with a gold sledgehammer.

Cultural Clarification

The episode title refers to the expression "Art, for art's sake." The Latin translation of the phrase, "Ars gratia artis," was the motto of movie studio Metro-Goldwyn-Mayer.

Peter forges a copy of *Laughing Cavalier,* painted by Frans Hals in 1624.

We Do Our Own Stunts

Four Monkees and one rope ladder. Watch it in slow motion, if you can, and be amazed.

Runner-Up Physical Comedy Highlight
The guard inspecting (and brushing some dust from) the new "installation" of four black-clad statues, followed by Mike toppling over on his side.

Physical Comedy Highlight
Three Monkees doing the "stuck in a door" shtick in the middle of an open hallway. Nice variation on an oft recycled gag.

Sight Gag Highlight
Mr. Schneider wearing Peter's orange bunny jammies.

Breaking the Fourth Wall
Mike's delightful voice-over narration, describing the members of the assembled team as they climb up to the roof.

Second Runner-Up Nitpick
Just after the opening credits, a stray microphone is visible in the lower-left corner of the frame.

Runner-Up Nitpick
The bearded artist is finger-painting in Studio 3, Liberace is destroying a piano in Studio 1—but we never do see what Davy finds in Studio 2.

Nitpick
Judging from the curator's demonstration, five seconds is plenty of time for a thief to grab the painting and duck out of the way of the descending cage.

We're the young generation, and we have something to recycle.
- Returning actor: Monte Landis as Duce. (See also *Everywhere a Sheikh, Sheikh*; *I Was a 99 Lb. Weakling*; *Monkees Marooned*; *Monkee Mayor*; *The Devil & Peter Tork* and *The Monkees Blow Their Minds*.)
- Returning actor: Victor Tayback as Chuche. (He also played George in *Your Friendly Neighborhood Kidnappers* and Rocco in *Son of a Gypsy*.)
- Recurring shtick: hand-over-hand competition for a prop. (See also a rifle in *Monkees in Texas*, a telephone in *Too Many Girls*, a spear in *Monkees Marooned* and a shotgun in *Hillbilly Honeymoon*.)
- Recurring physical comedy: Mike toppling over while frozen. (See also *Monkees on the Wheel* and *Monkees a la Mode*.)
- Recurring set: the rooftop with the view of a large suspension bridge in the distance. (See also *The Picture Frame*.)

Monkee Magic
Peter and Mike fluttering in midair near the museum roof.

What I want to know...
Did the show have a stunt coordinator to oversee moments like the rope ladder tangle? Did they plan that stunt ahead of time and practice it with harnesses or mats or any safety measures at all?

Snack to enjoy while watching *Art, for Monkees' Sake*:
Cheese sandwiches on rye, with hot mustard. "Ha, ha!"

Music
- *Randy Scouse Git*: vaguely narrative romp.
- *Papa Gene's Blues*: Mike sings a few lines of the song at home.
- *Daydream Believer*: Isolated performance.

Episode 2-5
 Written by: Coslough Johnson
 Directed by: Alex Singer
 Principal Filming Ended: 4/14/1967
 First Airdate: 10/9/1967

Grading
- Fine art, skewered finely. **A**
- Mission: Ridiculous. **A+**
- Monkees shouldn't be allowed to have hobbies. **A**

And the cookie goes to...
Liberace, for being such a good sport.

That's the story, boys! The mystery group and the half-million dollar review of *The Audition*.

The In-Which
A pompous TV producer is auditioning local rock bands for a new show.

Theoretically, this entire series is about a young rock band struggling to succeed. In practice, this entire series is about a young rock band having wacky adventures involving crooks, swindlers, spies and various fantasy bad guys. *The Audition* is a rare episode that actually hearkens back to the show's root premise. The only "bad guy" is a well-meaning TV executive with a short attention span and a long-suffering assistant. Conflict is supplied by a series of weak coincidences, a friendly crowd of rival bands, and a stubborn bout of hiccups. It's a sweet story, but a bit thin—with plot holes big enough to drive a motorized massage table through.

The primary problem is that the lightweight plot lacks any sense of urgency. The only possible bad outcome is that the Monkees will continue to be just as obscure as they already are. There's no threat of death, injury, prison, financial loss or moral compromise. Because we are never told the nature of the job they're trying to land, we cannot feel the value of their loss. In fact, a good case could be made that they are better off *not* getting this job, since getting the job would mean having the insufferable Hubbell Benson as a boss.

The episode provides several sweet glimpses into the Monkees' everyday lives: they are friendly with other bands, they had to rent a tape recorder to listen to themselves play, they read the newspaper together and play cards on lazy mornings, and Davy is learning to play the euphonium.

There is a missed opportunity for a clever plot twist; the Monkees could have performed *Mary, Mary* in the telephone booth, which would have made it so much more painfully ironic when Benson puts the phone down and ignores the call. (*Mary, Mary* is the song on the mystery tape.)

The after-show interview is unusually serious and topical. Each Monkee has something profound to add to the conversation about the teenagers protesting in Los Angeles.

Zingers
Mike: Well, what are we going to do?
Peter: Well, we can't take this lying down.
Davy & Micky: Oh, Peter.
Peter: Boy, I hope we starve.
Mike: We are starving!
Peter: They'll be sorry when they find us, dead on the floor.
Mike: Peter....
Peter: I can see the headlines now: Skinny Group Found in California.

Benson: Say you're the Monkees!
Davy: What?
Benson: I said, say you're the Monkees!
Davy: Oh, we're the Monkees!
Miss Chomsky: Eureka!
Peter: No, we're Americans.

Production Note
Principal filming took place in late September 1966, but the tag interview was filmed in early December, on the set of the episode *Monkees in the Ring*. The Sunset Strip Riot (or Demonstration, as Micky would prefer it be known) took place in November.

Cultural Clarification
During the attempt to scare the hiccups out of Peter we get a glimpse of a long-necked, smoke-breathing monster. That's a clip from *Reptilicus*, a 1961 Danish horror film; we will see the same monster pop up from time to time in other episodes.

Physical Comedy Highlight
Superman stuck in a phone booth.

Sight Gag Highlight
Davy holding a phone receiver in his mouth for Mike to sing into—while Clark Kent fidgets anxiously in the line of people waiting to use the phone booth.

Fourth Runner-Up Nitpick
The Four Martians and the Jolly Green Giants make social calls during the day while wearing their bizarre stage costumes and makeup? (Disclaimer: yes, I realize that the Monkees wander around during the day in their matching eight-button shirts. But *still*.)

Third Runner-Up Nitpick
After Benson decides to use Miss Chomsky in his show instead of the Monkees, Davy gives Peter a shove for no apparent reason. In the very next scene, Peter apologizes—but losing the TV job wasn't *his* fault.

Second Runner-Up Nitpick
Mike grouses that they can't pretend to be Benson's mystery band without knowing what kind of group it is. They then romp around the offices at NBC posing as a Salvation Army band, a jug band, a marching band and a gypsy string quartet. But they *know* that Benson had sent audition invitations to the Four Martians, the Foreign Agents and the Jolly Green Giants. Wouldn't it be reasonable to assume that he is looking for a *rock* band?

Runner-Up Nitpick
Benson doesn't think to tell the reporters the lyrics of the song the mystery group is performing on the tape.

Nitpick
I usually give lots of leeway when it comes to instrumentation when the band performs on the show—Peter can't play the bass and the keyboards at the same time, after all—but it's hard to swallow three performances of *Sweet Young Thing* with nobody even pretending to play the fiddle.

We're the young generation, and we have something to recycle.
- Recurring plot device: nobody can use a tape recorder properly. (See also *Royal Flush* and *Monkees a la Carte*.)
- Recurring catch phrase: "He's gone!" (See also *Monkee See, Monkee Die; Monkees Marooned; Monstrous Monkee Mash* and *Monkees Race Again*.)
- Recurring stock footage: *Reptilicus*. (See also *I Was a Teenage Monster, Monkee Chow Mein, Monkees Marooned* and *The Monkees Mind Their Manor*.)
- Recurring costume: the Four Martians wear the same costumes as the Mozzarella Brothers (from *Monkees at the Circus*).

Runner-Up Monkee Magic
Mr. Schneider intently watches a card game.

Monkee Magic
During the romp, the Monkees appear out of thin air, one at a time, to form a jug band.

What I want to know...
What was Dolenz's experience at the Sunset Strip riot? (Bear in mind that the show had already been on the air for two months by that time, and *Last Train to Clarksville* was sitting proudly at #1.)

Snack to enjoy while watching *The Audition*:
Why do I have this urge to heat up some frozen vegetables? Yo-ho-ho!

Music
- *Mary, Mary*: short excerpt on a rented tape recorder.
- *Sweet Young Thing*: three abbreviated plot-related performances.
- *Papa Gene's Blues*: narrative romp intercut with clips from an isolated performance.

Episode 1-19
 Alternate Title: *Find the Monkees*
 Written by: Dave Evans
 Directed by: Richard Nunis
 Principal Filming Ended: 9/27/1966
 First Airdate: 1/23/1967

Grading
- We're trying to get in to see him. **B**
- At the same time, *he's* trying to find *us*. **B-**
- Martians and Agents and Giants, oh my! **C**

And the cookie goes to...
Bob Rafelson, for asking the guys about serious matters and putting their serious answers on the air.

I guarantee there will be no more pies in the face. And you will write a review of *Captain Crocodile.*

The In-Which
The Monkees get a big break—appearing on a children's TV show.

What are the odds that the two "we're going to get a TV show" episodes would be back-to-back in the alphabetical listing? In contrast with *The Audition*, this episode has more plot, better characters, and funnier dialogue. More importantly, it has depth.

Beneath the superficial conflict between the Monkees and Captain Crocodile burbles another conflict, one with far more relevance and satirical bite. It's the battle between the tired old establishment and the creativity of youth. Captain Crocodile hates the children in his audience, expects them to cheer on cue and do his bidding, but gives them nothing in return. Behind the scenes, ten-year-old *wunderkind* TV executive Junior Pinter is eager to give the kids what they want, and he knows what they want because he's a kid himself.

I can't help but think that making Junior the child (literally!) of a network president must have been a wink at 33-year-old Bert Schneider, co-producer of THE MONKEES and son of Columbia Pictures president Abe Schneider. (The poor guy already had a wooden dummy named after him.) As producers, both Schneider and his partner Bob Rafelson (also 33 when this episode aired) were "kids" by Hollywood standards.

A highlight of the episode is the rapid-fire parody of popular TV shows of the era. I show my age, because I remember all of them: the *Huntley-Brinkley Report, What's My Line? To Tell the Truth* and *Batman*. I do wonder whether the dry humor of the first few scenes might be lost on subsequent generations of viewers. They're all dead-on accurate

spoofs of the source material, but with the exception of Mike's weather report they are merely amusing rather than outright funny. The *Frogman* sequence, on the other hand, with the unexpectedly rebellious Reuben the Tadpole, is a parody worthy of *Laugh-In* or *Saturday Night Live*.

The show builds to two sequences of child-pleasing fun. First, there's the romp set to *Your Auntie Grizelda*, a song that fits this episode's theme perfectly. For a nice change of pace, the chase is all good-natured fun rather than menacing action, play instead of pursuit. In the end, the supposedly vicious kids manage to chase the four musicians right back where they want to be—in the television studio, where they proceed to win the day by improvising a sweetly silly fairy tale that actually entertains the children.

Production Notes
Captain Crocodile was the next episode filmed after *Dance, Monkee, Dance*—which may explain why the *Your Auntie Grizelda* romp cheerfully spoofs many of the dances showcased in the earlier episode.

Zingers
Micky: This guy must be important. We're on the road to success!
Mike: Yeah, we're almost at the heights!
Davy: We're nearly at the top of the heap!
Peter: It's all downhill from here!

Davy: Holy frogs' legs, that really makes me mad!

Peter: Thus shall it ever be, when men of evil oppose the forces of goodness and sweetness and niceness. Crime does not—
Davy: —not pay!
Peter: That's my line.
Davy: No, that's my line.
Peter: Crime does not pay!
Davy: Crime does not pay!
Peter: No, that's my line.
Davy: In the script it said it's my line.
Peter: It's my line, man. Crime does not—
Davy: Do that once more and—
Peter: Crime does not—
 [poke, poke, shove, shove, shove, shove, punch!]
Davy: That's what I said, folks. Crime doesn't pay.

Runner-up Physical Comedy Highlight
Maybe it's Frogman and Reuben the Tadpole flailing away at the two henchmen, while obviously never landing a blow. Or maybe it's the two henchmen enthusiastically over-reacting to the phantom blows.

Physical Comedy Highlight
No, it's Frogman and Reuben the Tadpole getting into a shoving match. Whose line is it, anyway?

Runner-Up Sight Gag Highlight
Mike shaking a cramp out of his left hand after playing *Valleri*.

Sight Gag Highlight
Davy's "Happy Fingers" hat with the hand sticking out the top. I just want to give that hat a high-five.

(Appearing to) Break the Fourth Wall
The episode seems to include two references to the real-world tensions between the band and music supervisor Don Kirshner. In one scene, Mike threatens, "Either you let us play, or we quit!" Later in the episode, Micky starts off their improvised fairy tale with, "Once upon a time, in the Land of Kirshner...."

That said, if there is any relevance to those lines, it's purely foreshadowing. The episode was filmed in October 1966; the conflict with Kirshner would not come to a head until January 1967—when Nesmith would indeed threaten to quit unless they were allowed to play the instrumental tracks on their own records.

Second Runner-Up Nitpick
After the Monkees' first meeting with Junior Pinter, Captain Crocodile and Howard have a frantic discussion about a memo from Pinter. They devise a plan, which involves sabotaging the Monkees' upcoming first appearance on the show. But the Monkees have *already* made their first appearance on *Captain Crocodile*.

Runner-Up Nitpick
If the show has been off the air for five minutes, why is that guy in the chipmunk costume jumping around in front of the camera just seconds before the band starts playing *Valleri*?

Nitpick
During the romp, some children clamber out of an old wooden trough in a Western movie set. As they run away, a bra can be seen clearly, hanging over the side of the trough. *What the...?*

Absolutely Not a Nitpick
Howard says, "One minute to air!" eight times over the span of 30 seconds. I can't resist a challenge like that, so I put a stopwatch on it. One minute 25 seconds after the first "One minute to air" (and only 55 seconds after the last one) *Captain Crocodile* is on the air. Not bad!

My eyes! What are you doing to my eyes?
Shiny plaid double-breasted suits. Times four. With eight shiny brass buttons each. Plus more shiny brass buttons on the pockets. And even more shiny brass buttons on the epaulets and cuffs. (Incidentally, this is the same JC Penney jacket Dolenz wears on the album cover *More of the Monkees*.)

We're the young generation, and we have something to recycle.
- Recurring location: TV station KXIU. (See also *Too Many Girls* and *Monkee Mayor*.)
- Recurring punch line: "I *am* standing up." (Listen also to *Royal Flush* and *I Was a 99 Lb. Weakling*.)
- Recurring superhero speech: "Thus shall it ever be...." (See also *The Case of the Missing Monkee*.)
- Recycled costumes: just about every costume from the *I'll Be Back Up on My Feet* romp in *Dance, Monkee, Dance*.

Runner-Up Monkee Magic
Micky conjures up a dictionary.

Monkee Magic
Shared Imagination: *The Hinkley-Bruntley-Chinkley-Hankley-Barkley-Weekly-Wallheight-Chuckly-Smith Report, What's My Scene?, To Tell A Fib,* and *The Adventures of Frogman and Reuben the Tadpole*.

What I want to know...
Did the actors improvise the fairy tale they read out of the dictionary?

Beverage to enjoy while watching *Captain Crocodile*:
Milk. What, no cookies?

Music
- *Valleri*: plot-related performance.
- *Your Auntie Grizelda*: playful, yet ultimately narrative romp.

Episode 1-23
Written by: Gerald Gardner, Dee Caruso, Peter Meyerson and Robert Schlitt
Directed by: James Frawley
Principal Filming Ended: 10/21/1966
First Airdate: 2/20/1967

Grading
- On second thought, it *is* a vast wasteland. **B**
- We're the young generation, and we know what the kids want. **B+**
- During the romp, the kids don't just yell "fun!" They actually have fun. **A**

And the (milk and) cookie goes to…
Bert Schneider, the real-life Junior Pinter.

What is "Monkee Magic"?

My earliest memories of THE MONKEES are not about the music, or social satire, or cutting-edge film techniques, or even good-looking young men. I was far too young for that. Strangely enough, what I remember most clearly is the Monkee Magic. Mind you, I grew up in a world where magical television characters were commonplace—not only were there suburban witches and genies running rampant in primetime, but there were other, lesser-known magical beings on the airwaves as well. Remember *Nanny and the Professor*? *The Ghost and Mrs. Muir*?

What was so amazing about Monkee Magic, what so intrigued and delighted me, was that these four young musicians wielded their magical abilities with utter nonchalance. *Bewitched* and *I Dream of Jeannie* were always about the rules: who has magical powers, who doesn't, when magic should be used, what can go wrong, why magic must be kept secret, and so on, week after week. In contrast, the four carefree Monkees never gave such rules a moment's thought. Their magic was as natural as breathing and as fun as singing. Nobody ever talked about it, it just was.

But what was it?

Conjuring

This is the most common form of Monkee Magic. Props appear as needed, usually produced silently and without fanfare, but without any rational explanation either. For example, Micky whips out a pillow in *The Devil and Peter Tork*, and Davy produces a huge block of ice in *Monkees in a Ghost Town*.

The most visually impressive example of this type of Monkee Magic occurs in *I Was a 99 Lb. Weakling*, when Peter declares his intention to make a phone call, then holds out his

hand and conjures up a telephone. Occasionally, this form of magic is practiced by other characters on the show; for example, Natasha Pavlova is able to conjure up a gun in *Card Carrying Red Shoes*.

A variation on conjuring is the Monkees' ability to create disguises out of thin air. In many cases this can be chalked up to Shared Imagination (for example, the four card-playing gunslingers in the pilot) but in other cases the magical disguises can clearly be seen by other characters—and therefore, must be real. Examples include the Purple Flower Gang disguises in *Monkees a la Carte*, and the leather biker outfits in *The Wild Monkees*.

Teleporting

Most of the time, the Monkees' teleporting ability is manifested with subtlety; for example, in *A Coffin Too Frequent*, Micky manages to jump from his place in the séance into Elmer's coffin. (Where Elmer went does not bear thinking about.) In *Monkee See, Monkee Die*, Davy pops into a suit of armor that is standing in the middle of a group of bad guys, without being noticed by any of them. He pops back out again, too.

There are some more obvious instances of teleporting, most notably the exquisite "getting dressed" sequence in *Your Friendly Neighborhood Kidnappers*. Peter also does quite a bit of flitting about while adoring Valerie's portrait in *One Man Shy*.

Shared Imagination

Of all the forms of Monkee Magic, "Shared Imagination" is the most un-magical and yet, in a way, the most impressive. The first occurrence comes in the pilot, when Mike calls a board meeting and the four are immediately seated in a paneled board room, dressed in business suits.

It's not that the guys have healthy imaginations that makes this Monkee Magic, it's that they each seem to be able to instantly immerse the others—and the viewers—in a vivid fantasy world. In *Royal Flush*, for example, Micky doesn't just imagine himself as a drill sergeant and conjure up a floor plan of the Ritz Swank Hotel. He draws Peter, Mike and Davy into the same fantasy, dresses them all in military fatigues, and they all adapt effortlessly to the altered reality.

Shared Imagination can even be extended to other characters' clothing. In *Royal Flush*, both Davy and Archduke Otto are outfitted for their swordfight with appropriate swashbuckling clothes; in *A Coffin Too Frequent*, Davy dresses himself and Boris in natty striped jackets for a soft-shoe routine.

The television parodies of *Captain Crocodile*, the courtroom dramas of *Dance, Monkee, Dance* and *A Coffin Too Frequent*, and the bike club sequence in *The Wild Monkees* are all excellent examples of this type of Monkee Magic.

Breaking the Fourth Wall

A vivid game of Shared Imagination may provide the four Monkees with a brief escape from their impoverished existence, but they have yet another layer of reality available to them. In

nearly every episode there comes a moment when one or more of the guys glances outwards into the real world—*our* world—where their antics are being recorded by television cameras and broadcast to millions.

At some level they are fully aware that they are merely characters in a fictional story; it's no big deal to speak directly to the audience, provide a quick episode recap to *TV Guide*, mention an upcoming commercial break or ask the writers to come up with a really brilliant idea. And the television meta-reality returns the favor by decorating their world with title cards, thought balloons and the occasional cartoon light bulb.

Mr. Schneider

I'll be darned if I know what Mr. Schneider is. On first blush, it's just an oversize wooden ventriloquist's dummy, taking the place of that responsible adult whose absence Tork is so fond of pointing out in interviews. And yet, Mr. Schneider's ongoing role in the series is so animate, it's sometimes hard to decide which pronouns to use for it.

When a bill collector threatens, Mr. Schneider ignores the abuse. When Micky goes werewolf and starts tearing the dummy's head off, no harm is done. But when Mr. Schneider applauds, or winks, or gives advice, or shows intense interest in a card game, is it a *he*? Or is this just another manifestation of Shared Imagination?

Monkeemen

If the Monkeemen had only appeared in *I've Got a Little Song Here*, I would have simply categorized them as a particularly groovy instance of Shared Imagination. However, there's no denying that the guys use their Monkeeman powers again in *Monkee Chow Mein, I Was a 99 Lb. Weakling* and (by implication) *Mijacogeo*. In the first Monkeemen appearance, Micky, Davy and Peter share a clever "see no evil, hear no evil, speak no evil" transformation sequence; in later episodes there seems to be a need for a phone booth.

Other than flight, it's not entirely clear what superpowers the Monkeemen are supposed to have; in *Monkee Chow Mein* Davy and Mike try to exercise some kind of temporary mind control over their opponents, but nothing much comes of it.

A Magical World

Looking back at the show with adult eyes, the biggest problem I see with Monkee Magic is that they don't seem to use it often enough. Having all these magical powers at their disposal, why do they spend so much time in so much danger? Nearly every week they're at the mercy of some kind of criminal, swindler, spy or monster. From observation, I infer the following limitations:

- They can't use magic to become professionally successful.
- They can't conjure money, or food, or anything they actually need.
- They can't magic themselves out of danger.

Perhaps the rules are hard-wired into the magic itself, or perhaps they are self-imposed guidelines observed by the Monkees because of bad karma that would result if their magic were misused. Magic mostly seems to be used for amusement or minor convenience.

The Monkees live in a world that is teeming with magic. The devil walks among the living, vampires are planning a comeback, aliens are preparing for an invasion and if you don't believe me, I've got a monkey's paw I'd like to sell you. And yet, most of the people of their world don't seem to have magical abilities. So how did these four musicians get so lucky? It would seem that the first rule of Monkee Magic is that you don't talk about Monkee Magic. What makes it so inspiring, so entertaining, so doggone whimsical is that it is never analyzed.

So, from my seat here in the real world, all I can do is speculate weakly. It could be that one of them has the gift and somehow shares it with the others through the music they make together. It could be that each one of them has a low-level gift that is somehow boosted by working together in a group. Or perhaps it is the music itself that makes the magic—an echo, in a way of Mike's "he loves music, and that's where the power is" speech from *The Devil and Peter Tork*.

My favorite theory is that the magic is invested in that weird beach house in Malibu. Perhaps it sits on some kind of mystical nexus, or maybe one of the strange artifacts in the pad is a magical talisman. (Perhaps Mr. Schneider?) One reason I'm fond of that last theory—that the magic is invested in the pad—is because Monkee Magic appears several times in the Nesmith-penned MONKEES TV special in 1997. In that special, the four guys are still living together in the pad, and are still able to imagine themselves out of a jam, or conjure up a piano on the beach.

You know, guns never really solved anything. They're not the solution to the problem, they're only a coward's way out. Wouldn't you rather write a review of Card Carrying Red Shoes?

The In-Which
A prima ballerina from Druvania defects, taking refuge with the Monkees.

When I started typing out Zingers for this episode, I suddenly noticed that there are entire scenes worthy of the honor. The dialogue is rip-roaringly funny, lightning fast and wickedly clever. Micky's turn-on-a-dime mood swings are hilarious, and Peter's pleased, puzzled and panicked chemistry with the passionate Natasha is sweet and sexy at the same time. I was a bit surprised by this realization—this particular episode had never stood out very much for me. And then Act II begins and it all falls flat, like an open can of soda that's been left on the kitchen counter overnight. The dialogue loses all its fire, resorting to trite punch lines like "You can say that again," and "I saw it in a movie once."

Act I is all about setting up the improbable scenario, and giving us good cause to sympathize with Natasha. There is a remarkable amount of character development packed into just a few scenes, much more than was provided for other sympathetic female characters such as Leslie (*The Chaperone*) or Valerie (*One Man Shy*). Those characters started out as little more than pretty targets for the guys to admire and pursue. Natasha's connection to the spy subplot is that of an unwitting mule, as she doesn't know the microfilm is in her shoe and is never in any particular danger. Her personal motivations, on the other hand, are noble and compelling and have nothing to do with the bad guys' schemes: though she wants to stay in America and be free, she'll risk both her life and her freedom to rescue Peter.

Act II, on the other hand, does nothing to build character. It's a series of flat, plodding scenes leading up to the romp—such as it is—which suffers both from being set to the music of Tchaikovsky instead of a finger-snapping pop tune, and also from having the three Monkees effectively separated from each other and operating independently.

Three Monkees. Mike's absence is so complete, so thorough, that it almost seems that the group is a trio by design. At least in *Alias Micky Dolenz*, *I Was a 99 Lb. Weakling* and *Hitting the High Seas* there was no attempt to depict the Monkees as a performing trio. The fact that they do so in this episode is jarring and discomfiting. Unfortunately, the intricate and high-stakes plot makes this an episode in which Mike's steadying presence is sorely needed.

One last comment. In the second act there is a scene in which a dancer opens a door to find an execution by firing squad in progress. He asks the condemned man whether his name is Peter Tork; when the man says he is not, the dancer closes the door and a gunshot is heard. I am absolutely flabbergasted that this scene was ever thought to be appropriate, much less funny.

Zingers

Natasha: Now, let whatever happens, happen.
Ivan: Let me in, Monkee, I've come to kill you!
Peter: Oh, thank goodness.
Natasha: Quickly, quickly! Come hide in the trunk with me.
Peter: Oh— uh, you hide in the trunk. I'll go take my chances with Ivan.
Natasha: No, my Petrov! He is dangerous!
Peter: A man's got to do what a man's got to do.
Natasha: What are you going to do?
Peter: I think I'll pretend to be sick.

Ambassador: Are you from the MKVD?
Davy: No, we're from the BVD.
Ambassador: I've never heard of the BVD.
Davy: Well, we investigate the MKBVD, because we're an undercover organization, that uncovers the... uh....
Micky: We cover the unders! And when we're under the covers, the BVD is known as the under-where.

Clunkers

Nyetovich: How are your lovely red shoes?
Natasha: They're fine.
Nyetovich: You mean, they're really fine?
Ivan: They're really fine.
Nyetovich: You're sure they're really, really, really fine?

Ivan: I mean that they are really, really, really, really, really fine.
Nyetovich: Really, really, really fine?
Ivan: Really, really, really fine.
Nyetovich: Really fine?
Ivan: Really fine!
Nyetovich: You mean, really fine.
Ivan: Real fine!
Nyetovich: Really fine?
Ivan: Magnificently fine!

I may have lost a small piece of my soul while transcribing that. Really.

Cultural Clarification
The title is a double reference. The phrase "card-carrying Communist" was used during the Red Scare of the 1950's. *The Red Shoes* is both the title of a Hans Christian Andersen fairy tale about a cursed pair of dancing shoes, and a 1948 film tragedy about a ballerina.

Runner-Up Sight Gag Highlight
Peter and Natasha's all-too-brief lion-taming act.

Sight Gag Highlight
Davy carefully removing a wrong note from the rehearsal score.

Second Runner-Up Breaking the Fourth Wall
Micky: Ward, I don't wanna be a chicken.

Micky is apparently addressing his complaint to production supervisor Ward Sylvester.

Runner-Up Breaking the Fourth Wall
Davy: Now let's understand this. You mean you're going to shoot us, and keep him because of his face? Well, what do you think this is—chopped liver?
Peter: Well, it can't be you every week, Davy.

Breaking the Fourth Wall
Micky: Not bad for a long-haired weirdo, huh, America?

Fourth Runner-Up Nitpick
Natasha's yellow leotard is decorated with fluttery feathers. Why? The whole leotard would be covered with the huge chicken costume.

Third Runner-Up Nitpick
Micky is a *lot* taller than Natasha. Even if the chicken costume covers up a host of other differences, there's no way her dance partner wouldn't notice the change in height. (Natasha and *Davy*, however, are just about the same height.)

Second Runner-Up Nitpick
Natasha sprains her ankle so badly that she needs Davy's help to hobble into a closet—but a few minutes later she is dashing around backstage.

Runner-Up Nitpick
There's no way that trunk could hold even one guitar, much less all the Monkees' instruments plus one ballerina. But that's okay, because apparently they leave their instruments behind at the theater. The trunk is empty when Natasha hides inside it!

Nitpick
If the Monkees are harboring a political refugee who is trying to defect, why in the world would they go anywhere near the Druvanian Ambassador? This is why they need Mike in the story—and why they don't usually let Peter make the plans.

We're the young generation, and we have something to recycle.
- Returning guest actor: Vincent Beck as Ivan. (He was also Sigmund in *Royal Flush*, and Marco in *Son of a Gypsy*.)
- Recycled music: brief rinky-dink piano theme inserted into Symphony No. 4 at the moment Peter breaks free and starts running away from Nicolai (borrowed from the romp in *Here Come the Monkees*.)
- Recycled stock footage: a rocket launch. (See also *Your Friendly Neighborhood Kidnappers* and *The Case of the Missing Monkee*.)

Runner-Up Monkee Magic
Peter conjures up a bottle of detergent, and Davy conjures up a drinking glass.

Guest-Star Ballerina Magic
Never mind Peter's detergent and Davy's drinking glass—Natasha conjures up a *gun!*

Monkee Magic
Never mind Natasha's gun. *Micky lays an egg!*

What I want to know…
Why did Treva Silverman, a prolific member of the show's writing staff, pen this episode under a pseudonym?

Snack to enjoy while watching *Card Carrying Red Shoes*:
Roasted chicken, and one jumbo-sized egg.

Music
- *Tchaikovsky's Symphony No. 4 in F Minor:* narrative romp.
- *She Hangs Out:* isolated performance.

Episode 2-9
Written by: Lee Sanford
Directed by: James Frawley
Principal Filming Ended: 9/29/1967
First Airdate: 11/6/1967

Grading
- Act I: Hilarious dialogue **A+**
- Act II: Disjointed plot **C+**
- We're the young generation, and we've got Tchaikovsky to play? **B-**

And the cookie goes to...
Natasha Pavlova, for helping to defeat the bad guys and winning her own freedom. Welcome to America, Natasha.

I need love and understanding! My mother rejected me, my sister resented me, I've lost all my confidence, and now... this review of *The Case of the Missing Monkee.*

The In-Which
Peter gets kidnapped, along with a prominent scientist.

I vaguely remember watching this episode as a child; it may have been one of my first encounters with the show. It made quite an impression on me, and even today as a middle-aged woman, my visceral reaction to the episode is not delight, but low-level horror. MONKEES episodes are often full of cartoonish violence, but the violence in this episode is wholly medical, and medical violence is not part of the cartoon violence canon. The Remington Clinic is a creepy fantasy version of a hospital: strangely empty of staff and patients, with no sign of health care going on. As the episode reaches its climax, Dr. Marcovitch is only just prevented from doing violence-by-surgery to a very conscious Micky.

And yet, in the course of writing my review—transcribing quotes, picking magic moments, highlights and so forth—I am suddenly struck by how downright *funny* this episode is. The dialogue zings. The scenes are packed with silly gags, absurd twists and delightful reaction shots. The lone musical romp is woefully cheesy as an action sequence, but as an *homage* to silent movie slapstick humor, it's adorable.

We never do figure out who Professor Schnitzler is, who Marcovitch is working for, why he wants to sneak Schnitzler out of the country, or whether the Remington Clinic is an actual hospital or just a front operation for a medical House of Horrors. But that's a minor matter; the plot is well structured and makes a fair amount of sense. I can easily imagine the same

story being developed for an hour-long television spy drama, along the lines of *Mission: Impossible* or *The Man from UNCLE*.

I was prepared to be offended by the heavily stereotyped Chinese man in the faux Chinese restaurant. But now that I think about it, it's a nice twist that the offensive stereotyping was done by the episode's villain, who was not Chinese at all. Pity I can't say the same about for the characters in *Monkee Chow Mein*.

THE MONKEES as a series is usually dated only by its hip slang and groovy fashion sense. But one scene in this episode has two topical and timely references that seem quite strange today. The nurse at the Remington Clinic seems concerned that Davy might not know his "zip code number," and then muses that he probably isn't old enough to qualify under Medicare. Zip codes were introduced in 1963 but were not made mandatory until 1967; Medicare was created in 1965.

Zingers
Davy: You know, it's not like Peter to take off in the middle of a gig.
Micky: Man, he sure takes a lot of looking after.
Mike: Oh I don't know. Not any more than the average aircraft carrier.

Bruno: Shut up!
Peter: You can't do that to me! I need love and understanding! My mother rejected me, my sister resented me, I've lost all my confidence, and now... this operation....
Marcovitch: What is that?
Peter: *Ben Casey*, Act I.

Davy: You look very nervous, Doctor.
Peter: Nervous? Don't be silly! Look at how slowly I'm twitching.

Cultural Clarifications
Ben Casey was a medical drama set in a hospital, which aired on ABC from 1961 – 1966. Coincidentally, Jones had a guest-starring role in an episode of *Ben Casey* in 1965.

"Shazam!" is the magic transformation word of comic book superhero Captain Marvel.

Let's See if We Can Slip This Past the Censors
The nurse is pushing cough drops. (Not one of your standard brands.)

Second Runner-Up Sight Gag Highlight
Davy getting rid of his spare tire.

Runner-Up Sight Gag Highlight
Three Monkees shuffling along under a moving gurney.

Sight Gag Highlight
The empty gurney making a run for the exit.

Runner-Up Physical Comedy Highlight
Micky playing jockey, whipping his stationary bike to make it go faster.

Physical Comedy Highlight
Davy, Mike and two pairs of rubber gloves.

Breaking the Fourth Wall
Mike: Hello? Yeah! Bruno just gave us physical therapy. Yeah, Peter's somewhere in the hospital. And Dr. Schnitzler's still missing. Okay, goodbye!
Micky: Who was that—the police?
Mike: No, TV Guide.

Second Runner-Up Nitpick
The nurse seems dubious that Davy would remember his zip code—but Davy doesn't even get his address right.

Runner-Up Nitpick
How does Professor Schnitzler know—*before* he is kidnapped—that he will be taken to the Remington Clinic?

Nitpick
When Peter reads Schnitzler's note, it says, "They are taking me to the Remington Clinic." When Mike reads the same note a few minutes later, it says, "I am being taken to the Remington Clinic."

We're the young generation, and we have something to recycle.
- Recurring gag: Monkees stuck in a door. (See also *The Picture Frame*; *The Christmas Show*; *Everywhere a Sheikh, Sheikh*; *Monkees in Texas*; *The Monkees Watch their Feet* and *Monstrous Monkee Mash*.)
- Recurring gag: Peter sticks around to ask the defeated bad guy for some advice. (See also *Dance, Monkee, Dance*.)
- Recycled stock footage: traffic far below. (See also *Monkees Marooned* and *The Picture Frame*.)
- Recurring gag: getting yanked into the wall by weight-lifting pulleys. (See also *Monkees in the Ring* and *I Was a 99 Lb. Weakling*.)
- Recurring superhero speech: "Thus will it always end…." (See also *Captain Crocodile*.)

Third Runner-Up Monkee Magic
Mike conjures up a pretty girl to row his rowing machine (and a banjo to serenade her with).

Second Runner-Up Monkee Magic
Davy finds Micky inside a steam cabinet; in the very next shot, Micky finds Davy inside another steam cabinet.

Runner-Up Monkee Magic
In the operating room, Peter conjures up a cleaver and a deck of cards, Davy conjures up a jar of peanut butter, and Mike conjures up a menu from the Vincent Van Gogh Gogh.

Monkee Magic
Peter: Shazam!

Okay, so it doesn't work the way Peter *intended* it to work—but it shouldn't work at all.

What I want to know…
Did Peter really quote dialogue from *Ben Casey*?

Snack to enjoy while watching *The Case of the Missing Monkee:*
"We don't have Schnitzler here. But I can bring you fried rice, chicken chow mein, wonton soup…."

Music
- *The Old Folks at Home:* a little soft-shoe by Davy.
- *(I'm not Your) Steppin' Stone*: vaguely narrative romp.

Episode 1-17
 Written by: Gerald Gardner and Dee Caruso
 Directed by: Robert Rafelson
 Principal Filming Ended: 11/11/1966
 First Airdate: 1/9/1967

Grading
- Peter and Professor Schnitzler: hapless hostages. **B-**
- Marcovitch, Bruno and the creepy nurse: malevolent medicine. **B+**
- Micky, Davy and Mike to the rescue! **A-**

And the cookie goes to…
Writers Gerald Gardner and Dee Caruso, for a delightful combination of creepy plot and hilarious dialogue.

Mr. Babbit, we're having a party tonight. And what we need is a review of *The Chaperone.*

The In-Which
The Monkees throw a party to impress Davy's latest girl—and her overprotective father.

Overall, this episode is a simplistic plot tied to an overextended drag joke, saved from utter insignificance by two of the best romps in the series. My biggest beef with the episode is not the weakness of the plot, but the way it contradicts Davy's well established character: mooning over Leslie from across the lawn, urged on by the advice and encouragement of his bandmates, he comes across more like the tongue-tied Peter of *One Man Shy* than the suave, confident Davy of so many other episodes.

The entire situation serves to make the characters seem more like teenagers than young adults. I'm not sure whether Leslie is meant to be perceived as an underage schoolgirl, but that's how she comes across—meekly accepting her father's authoritarian ways, then pleading with him rather than defying him. In return, Davy's character reads like a cheeky schoolboy, trying to sneak a moment alone with the girl behind her daddy's back. There's even something about the way Davy delivers the line about Mrs. Arcadian being "my roommate, Micky" that sounds very juvenile. I don't recall any other instance of the Monkees referring to one another as roommates.

Tork is fond of telling interviewers that their TV show was revolutionary, in that it depicted a functional group of young adults with no older adult in charge. In that vein, *The Chaperone* is especially disappointing, focusing on the band's resigned cooperation with Vandenberg's requirement that they find a "real" grownup to oversee their party. And when

all their best-laid plans and back-up plans and emergency fallback plans fail, they simply stand there and allow the uninvited authority figure to break up the party *in their own home*.

Except for the lecherous behavior of some of the older grownups in the room, the party looks like a lot of innocent fun. Not as much fun as the earlier *preparations* for the party, but then, *This Just Doesn't Seem to be My Day* is my favorite romp of the entire series. There's a lively crowd of guests, Mr. Schneider's sage advice, Mr. Clean's cheerful boogie, the magic telescope out on the deck, and best of all, the moving performance (literally—the band can't seem to stay in one place) of *Take a Giant Step*. On the other hand, the general's "Hup two three four" cadence to end the party goes on far, far too long.

I must say, Mrs. Arcadian is a lovely woman. The ridiculously oversized wig does a nice job balancing out Micky's large jaw, framing his face very well. Princess Gwen (*Fairy Tale*) may be funnier, but Mrs. Arcadian is by far the most convincing Monkee in drag.

I cannot fathom (no pun intended) why somebody thought that a few shots of the Monkees in SCUBA gear, splashing around in the shallow end of a swimming pool, would be a useful or amusing prologue to the performance video of *You Just May Be the One*. That whole musical sequence seemed tacked on, and probably was.

Zingers

Davy: I tell you, Peter— Give me six months, and I could pass her off as a duchess at an embassy ball.
Peter: How about at the party, tonight?
Davy: Wewl, 'at would be a li'le 'arder.

Micky: I've had it, I'm through!
Mike: Oh man, keep your dress on. What's the matter?
Micky: He's getting fresh!
Mike: Okay, so he's getting fresh. It's for a pal, anyway. Davy's in love with his daughter.
Micky: Yeah, and I'm going to be his mother-in-law.
Mike: If you play your cards right.

Cultural Clarification

The Monkees' efforts to prepare Mrs. Weefers for her role as chaperone are inspired by the George Bernard Shaw play *Pygmalion*, and its musical offspring, Lerner & Lowe's *My Fair Lady*.

Runner-Up Physical Comedy Highlight

Peter and a mouthful of marbles.

Physical Comedy Highlight

Micky sliding down the banister of the spiral staircase, landing face-first in the cake.

Runner-Up We Do Our Own Stunts
Dolenz sliding down the narrow banister of the spiral staircase, all the way from the top to the bottom. In a *spiral*. That can't be easy.

We Do Our Own Stunts
Dolenz climbing up onto the outside of the balcony railing. Falling off. *Climbing back up again*.

Runner-Up Sight Gag Highlight
Mrs. Arcadian splashing herself with imaginary Venetian canal water.

Sight Gag Highlight
Mrs. Arcadian blowing the hair out of her eyes.

Breaking the Fourth Wall
Peter: C'mon, Davy, quit fooling around. What TV show was she watching?
Micky: Ours, I hope.

Third Runner-Up Nitpick
Only two songs are listed in the credits. *You Just May Be the One* may have been tacked on to fill time at the end of the episode, but it should be listed in the credits.

Second Runner-Up Nitpick
Four perpetually broke, out-of-work musicians can afford a cleaning lady?

Runner-Up Nitpick
Davy simply does not waste time mooning over a girl from afar.

Nitpick
It is not socially acceptable, anywhere, at any time, for a man (much less two) to enter a bathroom that is occupied by a woman. Even if she is their roommate in drag.

We're the young generation, and we have something to recycle.
- Recurring prop gag: a hidden spigot for a sot's personal supply of alcohol. (See also *The Monkees Mind Their Manor*.)
- Recurring costume: the animal-print caveman look. (See also *Dance, Monkee, Dance*; *One Man Shy* and *Monkees Marooned*.)

Runner-Up Monkee Magic
After the end of *This Just Doesn't Seem to be My Day*, the four Monkees combine their efforts to levitate a cluster of balloons and streamers into the air above the middle of the pad.

Monkee Magic
Micky plays the drums and sings *Take a Giant Step* with the band while simultaneously attending the party as Mrs. Arcadian. This leads to the delightful shot of Mrs. Arcadian singing wistfully as she sits alone on the love seat.

I Can't Tell Whether It's Really Monkee Magic
While Micky talks on the phone with General Vandenberg, we see the general dressed in fatigues and jungle camouflage, playing with toy soldiers. Or... do we? That might just be Micky's imagination at work.

What I want to know...
How many times did Dolenz practice that slide down the railing in order to match it to Nesmith's arrival with the cake? (And did they get the face-plant in the cake on the first take?)

Snack to enjoy while watching *The Chaperone*:
A pretzel, if you can get the bag open. Here's an axe.

Music
- *This Just Doesn't Seem to be My Day*: delightfully playful, yet narrative romp.
- *Take a Giant Step*: performance with plot-related dance.
- *You Just May Be the One*: isolated performance (borrowed from *One Man Shy*).

Episode 1-9
 Written by: Gerald Gardner and Dee Caruso
 Directed by: Bruce Kessler
 Principal Filming Ended: 7/22/1966
 First Airdate: 11/7/1966

Grading
- Davy wants to date Leslie. **C**
- General Vandenberg wants to marry Mrs. Arcadian. **B-**
- Huntington Hartford hates *My Fair Lady*. **C+**
- I love these romps! **A+**

And the cookie goes to...
Costumer Gene Ashman, for Micky's stunning purple dress and blonde wig.

I've always felt that if you stripped all the tinsel off of Christmas, underneath you'd find nothing but a review of *The Christmas Show*.

The In-Which
The Monkees are hired to babysit a boy who doesn't believe in Christmas.

On a grading scale of one to a hundred, a dedicated Christmas episode deserves a head-start of ten points or so, just for being saddled with the thankless duty of being a frikkin' Christmas episode. Every TV show of my youth that made it to a second season had to have one, and typically it would be an *homage* either to It's a Wonderful Life or A Christmas Carol. And typically, it would be awful.

Par for the course! This one follows the Dickens plot, with a painful lack of subtlety. They didn't even try to come up with a title for this pale excuse of a script. (How hard could it be? *A Christmas Pop Tune. A Very Merry Monkee. Bah, Hum-Along.*)

At its core, the story is sound and has strong potential. A lonely child is far too sophisticated to enjoy Christmas; the young-at-heart Monkees try to cheer him up and, in the process, realize that what he really needs is love. Melvin is a well-defined character, and the viewer can easily sympathize with him and cheer for the band's efforts to teach him the spirit of the season. And yet, the execution fizzles. If only the script had a little more depth and a little less razzle-dazzle; fewer plot points and more character development. If only the director had taken the time to draw a calmer, less antic performance out of the Monkees, to get them to interact meaningfully with Butch Patrick's thousand-yard stare rather than bouncing giddily off the walls.

There's a tantalizing potential for a second theme along the lines of *Gift of the Magi*, as the band helplessly fritters away a $400 windfall in their efforts to awaken the true meaning of Christmas—which, as anyone who has ever seen *How the Grinch Stole Christmas* knows, doesn't require any money at all. Sadly, all this potential is wasted on a handful of "oh, cruel world" moments with no underlying message.

Just when the story should be reaching its emotional climax, we are subjected to an interminable medley of insipid holiday music. (Actually, it's about three and a quarter minutes; by way of contrast, the sublime *Riu Chiu* only runs for a minute and a half.) The more the romp tries to convince me that Melvin is discovering Christmas joy, the less I believe it. I can almost hear the director's voice: "Come on, everybody, smile! Laugh! Look like you're having fun! I know you're tired, but jump around and dance, okay?" By the time Melvin is being lifted into the air for the third, fourth and fifth time, I'm starting to notice that the young actor is older and bigger than he looks, and I wonder whether it's such a good idea to have Davy try to carry him.

Finally, the introduction of the crew during the closing credits was delightful in concept but too chaotic in execution. The first few people on the set were introduced with care, but by the end Jones was just waving people across with a resigned, "I don't know who he is." Sigh.

Zingers

Butler: There must be some mistake. We were expecting four gentlemen.
Mike: Would you accept four ladies who shave?
Butler: I can accept anything. Wait in here, ladies.

Micky: How come I'm all clean and you're all dirty?
Davy: Don't you mean how come you're all dirty and I'm all clean?
Micky: Yeah!
Davy: Well, you see, you're always on about me being little, teeny, tiny, weenie little David, you see, so I figured I'd come down the middle of the chimney and avoid the sides. You see?
Micky: Oh, right! *Pppppbbbbttth!*
Davy: That's charming.

Cultural Clarification

The Monkees sing a line from "Deck us all with Boston Charlie." This parody originally appeared in the Walt Kelly comic strip *Pogo*.

Let's See if We Can Slip This Past the Censors

Micky and Davy's limp-wristed pose on the word "gay" in *Deck the Halls*. Mildly offensive today, it would have been downright risqué in 1967.

We Do Our Own Stunts
Jones took a very scary dive off a tall ladder. Hopefully there was more than just a Christmas tree to break his fall.

Second Runner-Up Sight Gag Highlight
Micky the werewolf, tearing Mr. Schneider's head off.

Runner-Up Sight Gag Highlight
A Melvin-shaped computer.

Sight Gag Highlight
Davy the Christmas Elf, wearing Mike's wool hat.

Breaking the Fourth Wall
Clerk: Where'd he come from?
Davy: Left on Gower, through the studio gates, and right on the set here.

Third Runner-Up Nitpick
Poison ivy doesn't grow in California. It might have been poison oak, though.

Second taken in by the swindle is no surprise Runner-Up Nitpick
Melvin demands one fact about Christmas; Peter replies that it's December 25th. That's exactly one fact. Shut up, Melvin.

Runner-Up Nitpick
As he prepares to leave the Monkees' pad and go home, Melvin says that he won't be alone—he has a maid and a housekeeper. I wonder which job title is held by the old guy in the butler's outfit?

Nitpick
After the disaster at the toy store, the band has $60 left from the $400 they were paid for babysitting Melvin. $19.95 of that goes to the doctor for treating Peter, so when they arrive at the Christmas tree lot they should have $40.05 left. But Mike says they only have $30.

We're the young generation, and we have something to recycle.
- Recurring gag: Monkees stuck in a doorway. (See also *The Case of the Missing Monkee*; *The Picture Frame*; *Everywhere a Sheikh, Sheikh*; *Monkees in Texas*; *Monkees Watch Their Feet* and *Monstrous Monkee Mash*.)
- Recurring actor: Rege Cordic as the doctor. (He also plays the town crier in *Fairy Tale*.)
- Recurring actor: Burt Mustin as the butler. (He also played Kimba in *Monkees Marooned*. Wow.)

Monkee Magic
The Monkees somehow manage to retrieve Melvin's aunt from a holiday cruise.

What I want to know...
After Melvin poses his arithmetic problem during the Simon Says game, we see Micky attempt to solve the problem on a blackboard and Davy try to solve the problem with an abacus. In the next shot, Peter tugs eagerly on Mike's sleeve and whispers, "I know, I—" But he never gets a chance to give his answer, because Mike simply says that nobody could solve that problem in his head.

 I must have watched that scene a dozen or more times before I noticed Peter's behavior in that shot. Am I reading his body language correctly? Are we supposed to believe that he actually solved Melvin's equation?

Snack to enjoy while watching *The Christmas Show:*
Have a lollipop. "Merry Christmas to you, little man."

Music
- Insipid seasonal medley: fantasy sequence romp.
- *Deck the Halls*: plot-related *a capella* performance, live to camera.
- *Riu Chiu*: sublime isolated performance.

Episode 2-15
 Written by: Dave Evans and Neil Burstyn
 Directed by: Jon Anderson
 Principal Filming Ended: 11/22/1967
 First Airdate: 12/25/1967

Grading
- The premise has a proud pedigree. **B+**
- The execution is excessively energetic. **C**
- The musical montage is monotonous. **D**
- Ten free points just because it's Christmas. **A**

And the cookie goes to...
Whoever it was who suggested *Riu Chiu*. Seriously. It could have been *Silver Bells* or *Jingle Bell Rock* or the rest of *Deck the Halls*. Who would expect the TV pop group to sing an antique song *a capella*, with a religious text in a foreign language?

At dawn, Elmer's spirit will arrive, blow the trumpet, and write a review of *A Coffin Too Frequent.*

The In-Which
A charlatan spiritualist shows up at the Monkees' pad with a sweet little old lady and a very large coffin.

I'm not going to speculate on the pharmaceutical status of the writer, the director, or the editor of this episode, but *A Coffin Too Frequent* is one goofy trip. There's a plot here, I think, but not much of one—and what little plot there is doesn't make a whole lot of sense. Why any self-respecting swindler, mentalist, mystic or mad scientist would need to do his semi-scientific flim-flammery at 1334 North Beachwood in Malibu is never asked, nor explained.

The biggest problem is inconsistency; the Monkees can't seem to settle on a motivation for their interactions with Henry, Boris or Mrs. Weatherspoon. The pattern is set from the very opening scenes. Get out of our house! Okay, we'll leave! Okay, we'll stay! That's it, we're out of here! No, we'll stay and help! No, we'll stay and interfere! By the time the romp gets started, what little plot there is has already been resolved and there's nothing left to do but run around and goof off.

The central plot of the episode is remarkably unfunny, and the dialogue is rather flat. Most of the humor comes from a series of whimsical skits: the fantasy courtroom sequence, the tea incident, Davy's attempt to engage Boris in some song-and-dance, and the "we're no angels" mini-romp.

The courtroom fantasy is one of the most sparkling scenes of the series, although it doesn't seem to have anything to do with the episode in which it is dropped. (The connection *via* the word "witnesses" is extremely weak, as only one Monkee is a witness in the fantasy.) I can't decide which part of the scene I love more: the camera swinging wildly from side to side as the Monkees break character to give directions, or Peter's aged, cantankerous judge.

Zingers
Peter: Sixty years of service... ruin't. But I won't take the blame alone! The real brains behind the crime was the witness! Dashing, debonair Mike Nesmith.
Mike: I never should have opened my mouth.

Henry: I told you, I am a scientist.
Mike: I know, you told us.
Micky: A mad scientist?
Henry: No, but I will be if he keeps making those remarks.

Peter: I know why everybody joins hands at a séance.
Davy: To make sure they have contact?
Peter: No, because they're scared silly.

Production Note
Comic actress Ruth Buzzi was just 31 years old when she appeared in this episode as the elderly Mrs. Weatherspoon. At approximately the same time, she was developing the elderly character Gladys Ormphby for *Rowan & Martin's Laugh-In*.

Coincidence? *Laugh-In's* pilot was aired as a TV special on NBC just ten days before filming began on *A Coffin Too Frequent*. And Buzzi's elderly Gladys was paired with a lecherous old man played by Arte Johnson, who is the brother of writer Coslough Johnson, who wrote episodes for both series (though he did not write this one).

Let's See if We Can Slip This Past the Censors
Micky: Aspirin in disguise? I don't believe it.
Mike: Well, I do. I also get it. You see, he gives *us* the pill, and we believe that Elmer came back from the dead. We also see pretty colors—
Micky: Right.
Mike: —things climbing up the walls... oh, I bet it does a lot of things.

Runner-Up Sight Gag Highlight
Micky and Mike as lifeguards, firemen and policemen, coming to Peter's rescue.

Sight Gag Highlight
Mike holding the cup of coffee upside down.

Second Runner-Up Physical Comedy Highlight
Davy and Boris recreating Davy's "Hi, 'Lo" act.

Runner-Up Physical Comedy Highlight
Micky getting his head stuck on Boris, and Mike struggling to get him unstuck.

Physical Comedy Highlight
Boris and Mrs. Weatherspoon dancing together during the romp.

Runner-Up Breaking the Fourth Wall
After the angels sequence: "Now *that's* a trip."

Breaking the Fourth Wall
All four Monkees giving directions to a confused cameraman.

Micky: Ah, over here.
Mike: Barrister Dolenz.
Peter: No, take it to Micky!
Micky: Right here! Right here!

Third Runner-Up Nitpick
During the latter part of the séance, while Micky is hiding in the coffin, Mike is holding Mr. Schneider's hand in the group shots but not in the close-ups.

Second Runner-Up Nitpick
At one point, Henry asks Boris if everything is ready in the basement, and Boris indicates with a grunt that everything is ready. First of all—what basement? I don't recall the pad having a basement in any episode before or after. But more to the point—what preparations? Nothing came of it.

Runner-Up Nitpick
After determining that they have lain down in the wrong beds, the four Monkees dash around the room and then get right back into the same beds they were in to start with.

Nitpick
When Micky hides in the coffin, what happens to Elmer's remains?

We're the young generation, and we have something to recycle.
- Recurring gag: breaking off the end of a prop. (See also pointers in *Royal Flush* and *Monkees Watch Their Feet*; a walking stick in *The Prince and the Paupers*.)
- Recurring catch phrase: "Isn't that dumb?" (See also *Hillbilly Honeymoon*, *Monkees in Texas*, *The Wild Monkees* and *Monkees on the Wheel*.)
- Recurring furniture: Throne Model 309, The Usurper. (See also *Royal Flush*, *The Prince and the Paupers*, *The Devil and Peter Tork*, and *Head*.)
- Recurring guest actor: George Furth as Henry. (He was also Ronnie Farnsworth in *One Man Shy*.)

Runner-Up Guest Star Widow Magic
Mrs. Weatherspoon conjures a sandwich, a steaming hot cup of coffee and a ringing telephone from her bag. (Presumably she subsequently conjures 14 cups of tea from the same bag, unless the Monkees keep a hotplate and tea supplies upstairs.)

Guest Star Widow Magic
Mrs. Weatherspoon teleports from the Monkees' upstairs bedroom down to the living room, just in time to whack Micky over the head because he was poking around Elmer's coffin.

Third Runner-Up Monkee Magic
Peter temporarily levitates a trunk.

Second Runner-Up Monkee Magic
Micky and Mike conjure up lifeguard, fireman and police uniforms in their efforts to rescue Peter from Mrs. Weatherspoon's ministrations.

Runner-Up Monkee Magic
Davy conjures up song-and-dance outfits (and piano accompaniment) for himself and Boris for their "Hi, 'Lo" routine.

Monkee Magic
Micky teleports himself into the coffin during the séance—and gets Mr. Schneider to take his place holding Mike's hand—without anybody noticing.

What I want to know...
Was that delightful courtroom fantasy scene written by Stella Linden as part of the episode? Or was it added to fill time, or was it borrowed from another script?

Snack to enjoy while watching *A Coffin Too Frequent*:
A sandwich, a cup of coffee, and lots of tea. Lots and lots of tea. *Way* too much tea.

Music
- *Goin' Down:* semi-narrative romp.
- *Daydream Believer:* isolated performance.

Episode 2-11
Written by: Stella Linden
Directed by: David Winters
Principal Filming Ended: 9/22/1967
First Airdate: 11/20/1967

Grading
- The Monkees cooperate with Henry and Boris. **B-**
- The Monkees try to get away from Henry and Boris. **C-**
- The Monkees try to help Mrs Weatherspoon. **B**
- The Monkees take matters to court. **A**

And the cookie goes to...
Guest star Ruth Buzzi, for stealing the romp.

Do you mean that if I take this contract and sign it here... and there... I will be forced to write a review of *Dance, Monkee, Dance*?

The In-Which
Peter is swindled into signing a lifetime contract for dance lessons.

The opening scene, in which the chirpy Miss Buntwell enthusiastically prompts Peter through the trivia question, sparkles with wit and establishes the episode's premise with remarkable efficiency. Almost immediately I find myself *liking* Miss Buntwell, even though it's abundantly clear that she is up to no good. Throughout the episode, both she and Reynaldo are unexpectedly charming and fun to watch, making them wholly believable as con artists.

That Peter gets taken in by the swindle is no surprise. That Micky and Mike manage to get swindled as well is a delightful change of pace. That Davy turns out to be the problem-solver (and is *never* the problem) is ground-breaking. This switch-up in their roles, with three of the four Monkees absently practicing their dance steps around the pad while Davy puts his thinking cap on, makes the episode fresh.

Ultimately, Davy's elaborate plan to interfere with Reynaldo's swindle is not all that successful. Fortunately, the aimless and chaotic romp achieves their purpose: the guys simply annoy Reynaldo into submission.

It astonishes me that the Monkees never talk about the cost of the lessons. They all seem to be dismayed to be tied to a lifetime contract, but there's no information about how much was paid up-front or how much they will have to pay going forward. They seem to be focused entirely on cancelling the commitment for lessons, not in getting their money back.

There are certain moments of comedy throughout the series that may have been rip-roaring funny back in the sixties, but today have a hint of ugliness to them. In this episode, it's the sight of Mike lustily chasing a terrified Miss Buntwell around the office. Watching it in 2013, I'm cringing at the scene even while I'm laughing at the dialogue.

Zingers
Mike: Not only did I sign the lifetime contract, man, I enrolled in graduate work.
Peter: Mike, don't be depressed.
Mike: Yeah, I guess you're right. My three's getting better.

Mike: I can't fight it! I can't fight it! It's like chemistry.
Miss Buntwell: I failed chemistry.
Mike: I can't fight it! I can't fight it! It's like… biology?
Miss Buntwell: I *passed* biology.

Production Notes
According to Director James Frawley's commentary track, Davy's dance-teacher audition was filmed without any music. Jones improvised dance moves at random and changed styles on a verbal cue; the music was added in later to match his moves.

The elegant lady in the dark blue dress who dances with Nesmith during the romp is his mother, Bette Nesmith Graham.

Captain Crocodile was the next episode filmed—and its *Auntie Grizelda* romp echoes many of the dances, sets and costumes seen in *I'll Be Back Up on my Feet*.

Runner-Up Breaking the Fourth Wall
Peter: Are we going to do that for every lesson?
Davy: You must be joking! You know how much it cost for those sets and costumes?

Breaking the Fourth Wall
Micky: Hi, fellas. Listen—we need an idea for the show, you know. Gotta be something fast and groovy and hip, and everything. You know. Can you do it?

Second Runner-Up Nitpick
Davy tells his friends that he's about to teach them "one of the newer dances." As clearly shown by the stock footage during the romp, what he's teaching them is the Charleston—the hottest dance craze of 1926.

Runner-Up Nitpick
Where does Peter get the copy of his contract for Mike to examine? He didn't have a copy when he left the school.

Nitpick
All four Dancing Smoothies are roughly the same height. Where does Davy's Dancing Smoothie costume come from?

We're the young generation, and we have something to recycle.
- Recurring costume: the animal-print caveman look. (See also *The Chaperone*, *One Man Shy* and *Monkees Marooned*.)
- Reused footage: Mike as bullfighter, in the pen with a milk cow. (See *Don't Look a Gift Horse in the Mouth*.)
- Recurring take-charge behavior: Mike snatches a contract in order to check the terms. (See also *The Devil and Peter Tork* and *The Monkees Mind Their Manor*.)
- Recurring shtick: choosing fingers. In the chaos of the romp, it's hard to tell who won (or lost). Too many other references to count!
- Recycled gag: the Monkees hold a mumbled "rhubarb, rhubarb" conference. (Listen also to *Your Friendly Neighborhood Kidnappers*, *Hillbilly Honeymoon* and *Monkees on the Wheel*.)
- Recurring gag: Peter sticks around to ask the defeated bad guy for some advice. (See also *The Case of the Missing Monkee*.)

Second Runner-Up Monkee Magic
Peter conjures up an all-day sucker.

Runner-Up Monkee Magic
Shared Imagination, *Rumpole of the Bailey* edition. All objections are, apparently, overruled.

Monkee Magic
The boys conjure up four handguns in order to hijack the Dancing Smoothies' costumes.

What I want to know…
How did the decision to have look-alike romps in this episode and in *Captain Crocodile* come about? Did production assume that the episodes would air back-to-back? They didn't. Two more months would pass before *Captain Crocodile's* first appearance on the network.

Snack to enjoy while watching *Dance, Monkee, Dance:*
The place is gonna be loaded with suckers. All day.

Music
- *I'll Be Back Up on My Feet*: playful romp.
- *I'm a Believer*: vaguely narrative romp.

Episode 1-14

Written by: Bernie Orenstein
Directed by: James Frawley
Principal Filming Ended: 10/14/1966
First Airdate: 12/12/1966

Grading

- Nice to see that Peter's not the only screw-up in the band. **B+**
- Nice to see Davy can run a rescue mission all on his own. **B+**
- Nice to see such a charming, funny pair of swindlers. **A-**

And the cookie goes to...

A room full of overworked Chinese scriptwriters. And to real-life scriptwriter Bernie Orenstein, for breaking the fourth wall as it had never been broken before.

You know what's even more scary? You can't say "*cuckoo*" in a review of *The Devil and Peter Tork*.

The In-Which
The Devil tricks Peter into signing a contract exchanging his soul for a beautiful harp.

When I sat down to write my first MONKEES episode review, I tried to summarize the reasons for my general disappointment in the episode *Alias Micky Dolenz*. I wrote, "It's such an atypical episode... a very dark story, with very little levity and almost no fun." I went on to praise Dolenz's superb acting in the episode, and gave it an overall grade of B minus. Not bad, I suppose, but certainly not great.

As I worked on the easy part of the review for *The Devil and Peter Tork*, picking out Zingers and Nitpicks and Monkee Magic and so forth, I noticed that the episode had few exchanges of dialogue funny enough to quote. It was difficult to come up with Physical Comedy Highlights or Sight Gag Highlights. I heard my own words coming back to haunt me: "It's such an atypical episode... very dark... little levity and almost no fun." Why, I asked myself, did *Alias Micky Dolenz* get downgraded for being dark and serious, while *The Devil and Peter Tork* stands unchallenged as my favorite episode of the whole series?

One of the strikes against *Alias Micky Dolenz* was that it was very nearly a solo performance for Dolenz. He deserves highest praise for his acting, but the episode sadly lacked the Monkees' usual one-for-all, all-for-one camaraderie. *The Devil and Peter Tork*, on the other hand, keeps all four Monkees close together throughout the episode (with the sole exception of the opening scene in Mr. Zero's store). The story itself is a tight three-character drama,

surprisingly well anchored by the two "non-actor" actors in the cast and a guest star who was on other occasions so unmemorable that the producers saw nothing wrong with casting him in seven different roles in seven different episodes.

I tend to associate Tork's work as an actor with his silly facial expressions, endearing reactions and pitch-perfect delivery of funny lines, but I tend not to focus on him when he's not speaking. (In a couple of instances I have caught him mouthing another actor's lines.) But in this episode, I am astonished not so much by the delivery of his dialogue, but by the depth, range and raw honesty expressed in long silences, reacting to the things that are being said around him and about him. His wordless performance during the climactic harp solo is heartbreaking.

Nesmith's major contribution is the pivotal courtroom speech, echoing the legendary eloquence of Daniel Webster in the short story that gave this episode its title. Ironically, his brilliance in this episode is not in the delivery of a persuasive argument—just the opposite, in fact. True to his character, Mike fumbles his folksy way throughout the speech and, just as he reaches the crux of the matter, gets painfully tangled up in his own words. "People say, 'Well, I can't carry a note. I can't, I can't say— I can't sing— I'm, I'm tone deaf.' But nobody's tone deaf!" It's Nesmith's flawed delivery that keeps his oration in character.

Jones and Dolenz don't have much to do, but they are present throughout and are clearly involved in the fight, and they add a great deal to the drama simply in the way they listen and react. As they step away from the foreground, Monte Landis steps up. In several other episodes he annoys me in with his scenery-chewing comic accents and antics. Here, he calmly stays in harmony with the dramatic performances being delivered by Nesmith and Tork. He can belt out an evil cackle with gusto, when it's called for, but he's at his best when he's glibly passing himself off as Peter's most munificent benefactor.

Zingers

Devil: You know how musicians are: here today... gone tomorrow.
Peter: That's very true. I'm a musician, and I'm here today myself.

Mike: Now, look. There's no reason to get uptight, no reason to lose our senses. We just gotta remember that we're dealing with a cool, diabolical mind.
Peter: Thank you!
Mike: I'm talking about the devil.

Micky: You have the odd finger, Mike.
Mike: Well, I don't see what's so odd about my finger. It's about as normal as anyone else's.
Micky: You have the odd finger, Mike.
Mike: I've seen odd fingers around a lot.
Micky: You have the odd finger, Mike.
Mike: I've got the odd finger.

Clunkers
Davy: Don't get too upset, Peter. It might not be all that bad.
Micky: Naw, of course not. And all those things you read about, it couldn't be true.

There's nothing particularly wrong with those lines of dialogue, except that they contradict the emotional tone of the scene, which should be flowing swiftly and forcefully towards, "There's no way we're going to let this happen!"

Davy: Um, wait a minute, Mr. Zero—I'd like to make a deal with you. It doesn't really matter who you take. Why don't you leave Peter and take me, instead?

Taken in isolation, this is a noble and self-sacrificial deed. But because none of the other Monkees react to Davy's horrific suggestion—Mr. Zero simply dismisses it out of hand—the line falls flat.

Beautiful Moments
Many of the most impactful moments had no dialogue at all. I could not bear to pass them by without a salute.

- The beatific smile on Peter's face—with just a little of his tongue peeking out—as he plays the harp for the first time.
- "Micky's semi-cross-eyed rage look" at Mr. Zero. (That's how Tork describes it on the commentary track. He goes on to say, "I always thought that was one of the great takes of anybody I've ever seen.")
- Peter's wise, knowing nod after Mike says, "If you love music, man, you can play music."
- Micky's rapt expression, and subsequent beaming smile as he listens to Mike's courtroom speech.
- Peter flexing his fingers as the courtroom waits in silence. Making sure he's warmed up? Or stalling for time? Either way, it's marvelous how much time passes in silence before he starts playing.
- Mike's gentle finger-touch on Davy's arm, and his fleeting "okay" gesture as the three friends exchange a hopeful glance.
- The moment, halfway through the song, when Peter glances upwards, squeezes his eyes shut for just a second, then suppresses a sob. To my eyes, that's exactly when he stopped being afraid.

Production Notes
That's Producer Bob Rafelson's voice commenting on the nature of a man's soul at the end of the teaser sequence.

Nine whole months passed between the principal filming of this episode and its first airing on NBC. There are two different (and not altogether contradictory) reasons given for this unusual delay. Either the network was concerned about implied drug content in the song *Salesman*, or the network was irritated at the way the episode pokes fun at company Standards and Practices regarding the use of the word... er, "cuckoo."

Cultural Clarification

The episode title refers to the 1937 short story *The Devil and Daniel Webster*, in which the silver-tongued statesman takes the devil to court to break a contract for a poor farmer's soul.

Runner-Up Breaking the Fourth Wall

Micky: I insist that the prosecution call another witness.
Judge Bean: On what grounds?
Micky: On the uh, on the grounds that...the television show's not over, and we have to have a little more.

Breaking the Fourth Wall

Mike: So that's— that's what *"cuckoo"* is all about.
Davy: Yeah. *"Cuckoo"* is pretty scary.
Micky: You know what's even more scary?
Peter: What?
Micky: You can't say *"cuckoo"* on television.

Third Runner-Up Nitpick

Blackbeard was not particularly known for Englishman-blood-smelling. That phrase pairs up with "Fee Fi Fo Fum," and was spoken by the Giant in *Jack and the Beanstalk*.

Second Runner-Up Nitpick

Billy the Kid testifies twice (responding to leading questions from both Mr. Zero and Mike) that he entered into a contract with Mr. Zero in the year 1882. It would have been so easy for the writers to fact-check this! For the record: Billy the Kid was killed in July, *1881*.

Runner-Up Nitpick

Neither *Pleasant Valley Sunday* nor *I Wanna Be Free* were listed in the credits.

Nitpick

Considering that Mr. Zero is dragged back to *"cuckoo"* at the end of Peter's trial, how in the *"cuckoo"* are the Monkees going to get home?

Absolutely Not a Nitpick
The devil was sloppy with the terms of his contract. "In exchange for fame, fortune, and the ability to play the harp, I purchased Peter Tork's soul," he says. Well, guess what? *The only thing Peter wanted was the harp itself*—and apparently, the terms of the contract did not include ownership of the harp in the price for Peter's soul. The harp itself was free.

We're the young generation, and we have something to recycle.
- Recurring shtick: choosing fingers. (See also *Monkee See, Monkee Die*; *The Monkees Get Out More Dirt*; *The Monkees on the Line* and *Dance, Monkee, Dance*.)
- Recurring furniture: Throne Model 309, the Usurper. (See also *Royal Flush*, *The Prince and the Paupers*, *A Coffin Too Frequent* and *Head*.) The other throne from *Royal Flush* also makes an appearance, in the *Salesman* video.
- Recurring take-charge behavior: Mike snatches a contract in order to check the terms. (See also *Dance, Monkee, Dance* and *The Monkees Mind Their Manor*.)
- Recurring actor: Monte Landis as Mr. Zero. (See also *Everywhere a Sheikh, Sheikh*; *I Was a 99 Lb. Weakling*; *Monkees Marooned*; *Monkee Mayor*; *Art, For Monkees' Sake* and *The Monkees Blow Their Minds*.)
- Recycled footage: from the Phoenix concert in *The Monkees on Tour*.

Runner-Up Monkee Magic
Micky conjures up a pillow, and Davy conjures up a bible.

Monkee Magic
Micky conjures up a stack of newspapers with front-page stories about a rock and roll group with a harp.

What I want to know...
How did Nesmith's brilliantly flawed delivery of a crucial line of his courtroom speech come to be? Was it written that way? Did he choose to deliver it that way on purpose? Or did he flub the line for real, and director James Frawley simply chose to leave it that way?

Beverage to enjoy while watching *The Devil and Peter Tork:*
A bottle of rum. Preferably while smelling an Englishman.

Music
- *Pleasant Valley Sunday*: plot-related instrumental montage.
- *Salesman*: vaguely narrative romp.
- *I Wanna Be Free*: plot-related instrumental performance.
- *No Time*: isolated performance.

Episode 2-20
Written by: Robert Kaufman, Gerald Gardner and Dee Caruso
Directed by: James Frawley
Principal Filming Ended: 5/4/1967
First Airdate: 2/5/1968

Grading
- Tork and Nesmith: for your Emmy consideration. **A+**
- Robert Kaufman: best adaptation. **A+**
- Seven times at bat, and Monte Landis finally hits a home run. **A**
- I cry during that harp solo, and I don't even like *I Wanna be Free*. **A-**

And the cookie goes to...
Stephen Vincent Benet, author of the short story *The Devil and Daniel Webster*. It's in the public domain, so you can find it on-line. Go. Read it.

I don't know where you fellows are keeping that dog, but you won't get away with it. And don't think for one moment that you got me fooled, because I'll be writing a review of *Don't Look a Gift Horse in the Mouth!*

The In-Which
A beachfront bungalow is no place to keep a horse.

This episode is essentially two separate one-act plays, completely different in style, with only the barest common plot thread to tie them together. Act I is an old-fashioned living-room sitcom, with a script that might have been at home on *The Honeymooners* or *I Love Lucy*; it's a fast-paced series of heavily contrived misunderstandings, crammed full of jokes, puns, sight gags and pratfalls. It takes place almost entirely indoors—mostly on a single set—and the entire sequence, from Davy's first encounter with Jonathan on the beach through Mr. Babbit's faint, transpires in just an hour or so.

Act II takes us to the great outdoors, for a leisurely fish-out-of-water story. The pace slows down as the space opens up; the expanded geography lends itself to scenes with sparse dialogue and lots of physical movement. (Compare Davy's long drive across the farm with Mike's instantaneous appearance in the veterinarian's office.) The action spans at least a couple of days in a series of disconnected vignettes. My favorite moment of the episode is the impromptu game of catch with the empty milk bucket, which has absolutely zero bearing on the plot, but it's a gallon and a half of sorely needed character development.

Trying hard to tie everything together is the sketchy plot about little Jonathan and his horse. And the general thrust of that story is that the Monkees are just nice guys, trying to help people. No teenage girls staying out after midnight on a school night, no sir! After the initial problems with the show's pilot episode—the first test audience thought the characters

were unlikeable—I can understand why Raybert would want to start off with an episode that makes the four Monkees seem as friendly and harmless as possible. And in case we missed the point, the farmer sums it up after the race: "I think I had you boys pegged wrong."

This was the first regular episode filmed, despite its delayed position in the broadcast order. The characters of Mike, Micky and Davy seem quite familiar, but Peter's character hasn't quite settled in yet. He doesn't have much to do in the episode, but there are a couple of flashes of sour sarcasm that just don't fit his usual easygoing personality. When Micky begins his manic werewolf act, triggered by a mere taste of cream of root beer soup, Peter says bitterly, "Here we go again." Later at the farm, when Micky's "Sooey!" hog call brings in a flock of chickens, Peter smirks and teases, "Now why don't you try the chicken call?"

There's one other thing that seems out of character, but delightfully so. In most episodes, Mike's body language during musical performances tends to be rather stiff and dignified. He usually stands in stark contrast with Peter, who can't seem to stop bouncing around while he plays. But in this episode, at the very end of the reprise of *Papa Gene's Blues*, Mike grins like he's having the time of his life, lip-synching and finger-synching his own song. After winking at the camera, he finishes off the performance with an almost giddy flourish.

Zingers

Mike: Man, we'll get in trouble. The landlord was just over here, asking a lot of questions....
Davy: He doesn't think we stole him, does he?
Mike: Oh no, no, he thinks we're keeping a dog in here.
Davy: A dog? This is a *horse*.
Mike: I know! No, no, he thought he heard a dog in here.
Davy: A dog. Now, how can a dog sound like a horse?

Mike: Hi, I'm the fellow that called before.
Dr. Mann: Where's the monkey?
Mike: Oh, *I'm* the Monkee.
Dr. Mann: *You're* the monkey? You don't need a vet, young man, you need a psychiatrist.
Mike: No, wait a minute! You don't—you don't understand. I'm not a real monkey, I'm the kind of Monkee that sings.
Dr. Mann: Well, no wonder you're hoarse! Probably your throat muscles are tired.
Mike: No, I'm not—I'm not hoarse at all. I *have* a horse.
Dr. Mann: Oh. Does he sing, too?

Runner-Up Physical Comedy Highlight

Micky coaching Davy on how to ride a racehorse. And Davy, the former apprentice jockey, earnestly pretending to take instruction from Micky.

Physical Comedy Highlight
Micky's exuberant werewolf adventure.

Runner-Up Sight Gag Highlight
Micky's spectacular hog call echoing across Los Angeles, bringing Mr. Babbit back to the Monkees' door.

Sight Gag Highlight
Micky's spectacular hog call ending with the arrival of a flock of chickens.

We Do Our Own Stunts
Davy launching Peter into an airborne forward flip.

Third Runner-Up Nitpick
I get that Davy might have his own racing silks, helmet, boots, etc. But where did the racing saddle and other specialty tack come from?

Second Runner-Up Nitpick
In the first two scenes on the beach (at the beginning of the episode and just after the commercial break) the horse is left loose while Davy and Jonathan talk. In fact, just after Davy dismounts in the later scene, he gives Jeremy a friendly slap on the hindquarters. Shouldn't they be concerned about him wandering away?

Runner-Up Nitpick
If the farm is close enough to the Monkees' pad for little Jonathan to make the trip on his own, why do the Monkees have to spend the night in the barn?

Nitpick
All four Monkees arrive at the farm on Monday. They ride together in a jeep, with Davy at the wheel. They then spend the night in the barn so they can do chores at the break of dawn on Tuesday. So... where did they leave the horse?

We're the young generation, and we have something to recycle.
- Recycled plot development: a Monkee pawns, sells or otherwise puts an instrument at risk. (See also Peter's guitar in *Monkees Marooned*, Mike's guitar in *I've Got a Little Song Here*, and Micky's drums in *I Was a 99 Lb. Weakling*.)
- Recycled gag: Micky acts out a werewolf fantasy. (See also *The Christmas Show* and *Monstrous Monkee Mash*.)

Monkee Magic
Shared Imagination: Four well-dressed matadors and one very confused cow.

What I want to know…
How many well-trained horses were needed for the role of Jeremy?

Runner-Up snack to enjoy while watching *Don't Look a Gift Horse in the Mouth:*

Mrs. Purdy's homemade cake. Quick, before the horse gets to it!

Snack to enjoy while watching *Don't Look a Gift Horse in the Mouth:*
Salami, with a bowl of cream of root beer soup. *Thud!*

Music
- *Papa Gene's Blues*: playful romp, interrupted by a bullfighting sequence.
- *All the King's Horses*: narrative romp.
- *Papa Gene's Blues (reprise)*: playful romp intercut with isolated performance.

Episode 1-8
Written by: Dave Evans
Directed by: Robert Rafelson
Principal Filming Ended: 6/3/1966
First Airdate: 10/31/1966

Grading
- Act I: I Love Loosely. **B-**
- Act II: *Green Acres* is the place to be. **A-**
- A horse is a horse, of course, of course. **B+**

And the cookie goes to…
Jeremy the horse, who survived Peter's cooking and won the race.

Do not question the strange ways of our people. Marry the princess, and write a review of *Everywhere a Sheikh, Sheikh.*

The In-Which
A visiting princess must choose a husband immediately—and chooses Davy.

I can just imagine the meeting: somebody must have said, "Arabs! We haven't done Arabs yet. Scowling bad guys in flowing robes, exotic girls in skimpy outfits...it'll be a riot." Unfortunately, it's an idea half a mile wide and only half an inch deep. The cultural references for Arabs in the 1960's were *Lawrence of Arabia* and *I Dream of Jeannie,* so we get a mishmash of cutthroat brutality and candy-colored romantic twaddle.

Not that THE MONKEES displayed much sensitivity in any episode depicting a foreign culture; at least the exotic and anachronistic characters in this episode hail from a fully fictional place. Nonetheless, this episode leads off my list of "stereotype episodes," outings that depict exotic cultures dressed up in the crudest and least accurate of wild Hollywood notions.

The story comes across as a parody of a "real" MONKEES episode. Under a thick padding of cross-cultural nonsense, the plot is a mere sketch; there's no *there* there. The premise is bizarre, the dialogue is insipid and the characters are two-dimensional. There are only a handful of scenes where the Monkees can utilize their remarkable comic chemistry. Davy is saddled with nothing more than cringeworthy dialogue and moon-calf gazing. I mean, really:

Davy: I love your hair.
Colette: I love your hair.

Davy: I love your eyes.
Colette: I love your eyes.
Davy: I love your nose.
Colette: I love your nose.
Davy: I love your mouth.
Colette: I love your mouth.
Davy: I love your neck.
Colette: I love your neck.
Davy: I love you.
Colette: My handsome prince!

The nameless girls of the harem—I might as well call it what it was meant to be—are meaningless as individuals; the king summons them as *de facto* bribes to keep his prospective son-in-law's friends in line, and the guys happily treat them as such. During the romp we actually see the Monkees take turns making out with the same girl in a secluded corner of the ballroom.

At one point, the four Monkees meet in Davy's room and agree that the situation is dire and they need a *plan*. They huddle together as the scene comes to a close. And yet, the next time we see them they are happily digesting a meal, choosing music for the wedding and raising their goblets to toast the happy couple. The blatant absence of any semblance of a plan draws attention to the weak script. Having the bad guy turn out to be an oilman from Oklahoma is an excellent plot twist, adding a badly needed layer of complexity and flavor to the floundering plot, but sadly it comes far too late to save the story.

The episode ends with a gratuitous extra music segment—coming only seconds after the episode-ending romp—and a fairly long, scattershot interview segment. In a surprising moment of self-referential irony, the interview ends with Dolenz's exhausted plea: "I really hate these interviews."

I sigh back, "I really hate these stereotype episodes."

Zingers
Davy: What's that? What's that?
King: This is where you will live.
Mike: It's a little small, isn't it?
King: The palace has 700 bedrooms, 22 swimming pools and an indoor polo field.
Micky: 700 bedrooms....
Peter: Yes, but what kind of neighborhood is it in?

Davy: Micky, I think I'm going to make you Secretary of Defense. (Peter, don't worry.)
Micky: Oh, I'll certainly keep it mended.

Davy: What?
Micky: Da fence.

Mike: Which sounds better in a peace treaty: 'We humbly request,' or 'Pretty please'?

Physical Comedy Highlight
Three Monkees pratfalling their way down a hallway outside Davy's room.

Runner-Up Sight Gag Highlight
Micky and Mike in mismatched military uniforms, with Micky knocking off Mike's silly hat with every salute.

Sight Gag Highlight
Mike keeps up a droll running commentary while preparing a peace treaty between Nahoodi and the Ice Capades, adding an olive branch and a fake dove to the envelope, and casually knocking some papers on the floor to set up the paperweight joke.

Runner-Up Nitpick
In the scene where Peter reads the wedding invitation, Micky is wearing dark glasses in the group shots but not in the close-up.

Nitpick
Why does Davy climb into the sack? There hasn't been such a cooperative kidnap victim since... well, since *Your Friendly Neighborhood Kidnappers*.

Absolutely Not a Nitpick
In the teaser, Colette points to a picture of Davy in a magazine. At first, I was going to nitpick this on the grounds that the TV-show Monkees have never become famous. But then I took a closer look. Although the magazine is never clearly identified, in one of the photos Peter is wearing the same loud, blue shirt he wore briefly during the photo shoot in *Monkees a la Mode*. So this could conceivably be the issue of *Chic* from that episode—the only canonical appearance of the band in a magazine.

We're the young generation, and we have something to recycle.
- Recurring plot device: a young royal person comes to Los Angeles for a crucial coming-of-age moment. (See also *Royal Flush* and *The Prince and the Paupers*.)
- Recurring gag: Monkees stuck in a door. (See also *The Case of the Missing Monkee*; *The Picture Frame*; *The Christmas Show*; *Monkees in Texas*; *The Monkees Watch their Feet* and *Monstrous Monkee Mash*.)

- Recurring actor: Monte Landis as the king. (See also *Art, for Monkees' Sake, I Was a 99 Lb. Weakling, Monkees Marooned, Monkee Mayor, The Devil and Peter Tork* and *The Monkees Blow Their Minds*.)
- Recurring shtick: Monkees strike a "hello" chord. (See also *Monkees a la Mode, Some Like it Lukewarm* and *The Monkee's Paw*.)

Monkee Magic
Vidaru gathers his henchmen into a huddle, at which point the henchmen are magically replaced with Monkees.

What I want to know…
Was there a plan that got edited out of the final episode?

Snack to enjoy while watching *Everywhere a Sheikh, Sheikh*:
Pelican livers and yak tail. (I've had better.)

Music
- *Love is Only Sleeping*: vaguely narrative romp intercut with isolated performance.
- *Cuddly Toy*: isolated performance.

Episode 2-3
Written by: Jack Winter
Directed by: Alex Singer
Principal Filming Ended: 4/27/1967
First Airdate: 9/25/1967

Grading:
- Scowling bad guys in flowing robes. **C+**
- Mindless pretty girls in skimpy outfits. **C-**
- Half-wit royalty… *again?* **C**
- The Monkees have no plan, but they *are* trying to be funny. **B**

And the cookie goes to…
The 1955 film *The Court Jester*, which likely provided the inspiration for the "Golden Grecian Goblets" joke.

Abandon the format, and don't give me grief,
This book's overdue for some comic relief.
Four friends in the village of Avon-on-Calling,
A visiting princess with manners appalling;
The sets are all cardboard, the princess is male —
A rhyming review, just this once. *Fairy Tale!*

As cast and crew labored through late Season Two,
They struggled to keep the old show looking new.
The series weighed down in its fixed incarnation,
They opened their minds to experimentation.
A weird episode, just to show they could do it?
Perhaps NBC would decide to renew it!

"So what if it's not about kids of today?
And what if we toss the whole premise away?
And use our four actors in eight or nine roles?
And fashion a script that is full of plot holes?
And shoot on a set that's essentially bare?
And spring this surprise on the fans unaware?"

It wouldn't have made an impression so lasting
To use the same script with conventional casting.
So Nez volunteered to appear in it twice
To give the odd story some gender-bent spice.
The standards all broken, the rule book ignored,
And Tork thinks that Nez earned an Emmy Award.

The stats: Peter Meyerson wrote this confection.
James Frawley provided the expert direction.

The filming wrapped up on the tenth of November;
It languished unseen throughout all of December,
Then aired in the New Year—the eighth, so I'm told—
To start '68 with some comedy gold.
And as for the grade, there's no need to discuss:
By every conceivable measure: **A+**.

Quotations can summarize plot points concisely,
But dialogue won't work in rhyme—not precisely.
I'll paraphrase here; do forgive me for straying
Too far from the words that the actors were saying.

'Twas the Night Before Fairy Tale
or A Visit from Princess Gwen

The Teaser

Exterior, Avon-on-Calling

Town Crier:	A trumpet, a fanfare, and then introductions:
	Those four groovy actors from Raybert Productions.
	A shoemaker, innkeeper, tailor and Peter,
	Who worships the princess and longs just to meet her.
	He can't get the fantasy out of his mind.
	(Have *you* seen the princess? I guess love is blind.)
All:	Oh, hark! Are those horses we happen to hear?
Town Crier:	I think Davy just stabbed himself in the ear.
	The princess's carriage is stuck in the mud;
	The horses can't shift it, and *she's* out for blood.

Act I

Mike:	Oh wow! I must say, what a great looking chick!
	That body! Those sideburns! Just look at her, Mick!
Peter:	My princess, the jewel of my long-held desire,
	Allow me to carry you out of the mire.

Gwen:	You peasant? You *serf*? You're the humblest of men. Of the low, you're the lowest.
Peter:	You've heard of me, Gwen!
Gwen:	If you want to serve me, you penniless swine, Get down in the mud, and I'll honor your spine!
Peter:	I'd charge you a toll after you get across— But for traffic official, I'll just take the loss.
Sir Harold:	'Twill take us some time to get moving, my dear.
Gwen:	Oh, 'twill it? That's not what I'm longing to hear. Get me out of here, now! Or we won't tie the knot!
Peter:	(Those two star-crossed lovers from Shakespeare, they're not.)

Interior, Micky's Inn

Sir Harold:	Where is the innkeeper? Don't you ignore me! A peasant like you ought to grovel before me.
Micky:	No, that is not grovel, it's tile of concrete.
Sir Harold:	Fetch wine, a dessert, and some spinach and meat!
Micky:	This inn is too poor to supply all that stuff.
Sir Harold:	Then send out for sandwiches, 'twill be enough.
Town Crier:	Observe how the knights are both stuffing their faces; I'm not seeing much that I'd call "courtly graces."

Exterior, Avon-on-Calling

Sir Harold:	Take Gwen to the tower, then torture and kill her!
Town Crier:	See, Peter is listening—there—by that pillar.
Peter:	My princess! My princess!
Gwen:	My bridge!
Peter:	I have news— Oh well, here I am again, down in the ooze.
Sir Harold:	Here's food for the princess. Nice seeing your back!
Peter:	I wish I could say that it's nice to be back.

Gwen:	Now wait just a minute! Let no man e'er say That a favor so small I would fail to repay. Here, take this—it's junk.
Peter:	I am not worth the price.
Gwen:	I'm hip! Wear it anyway. Makes you look nice.

Interior, Micky's Inn

Peter:	It's treachery! Harold is faking his ardor! He'll get an impervious dragon to guard her.
Davy:	Then what will you do, now that she has gone missing?
Peter:	I'll just have to settle for fond reminiscing.
Micky:	What's that 'round your neck?
Peter:	Oh, it's just made of tin. (Well, whaddaya know? There's a fairy within!)
Fairy:	Please call me back later—I'm doing my hair.
Davy:	But if we don't save her, Gwen won't have a prayer!
Fairy:	This Gwen—she's the one who is always complaining? Conceited and proud, with a sneer that's disdaining? Whose selfish assertiveness rudely rejects us? Long hair, raspy voice—and the accent from Texas? Her life's on the ball, this is what you should do: First, Michael, you cobble a wall-climbing shoe; And Davy, chain mail that will take some abuse, And Micky: a sword sure would be of some use.
Peter:	Then what should I do?
Town Crier:	Asks young Peter, annoyed.
Fairy:	While they are all working, you'll be unemployed. But when they are finished, you'll go to the tower, And rescue the princess in your finest hour. Remember! Be careful, don't damage the locket; That trinket's my home, and I might kick the bucket.
Town Crier:	So Davy sends Peter a suit through the mail, (Or something like that). And then Mike taps a nail In the heel of a shoe that can scale any height,

> And Mick makes a blade that is fit for a knight.
> He then tries it on, and if I may be crass,
> That magical sword goes and cuts Micky's... *hip*.
> And thus, our brave Peter is dressed to amuse:
> Chain mail, magic sword, and those brown-and-white shoes.

Interior, Sir Harold's Castle

Gwen: Don't think that you've won, Harold, don't laugh so freely;
A prince will arrive soon, and then he will free me.

Sir Harold: Oh? Who will be coming? I hate to surprise you:
The nobles, the clergy and people despise you.

Exterior, Avon-on-Calling

Peter: Why *me*? She is no longer one of my faves.
The army should save her.

Micky: Hey, Pete—don't make waves.

Exterior, Somewhere in the Forest

Little Red: Tra-la and tra-lee, to my grandma's I'm going!

Peter: I can't let you walk into danger, unknowing.
The wolf ate your grandma—he'll eat you too, soon.

Little Red: Yeah, sure. And the cow will jump over the moon.

Interior, Micky's Inn

Micky: Sir Peter of Tork might not live to tomorrow.

Davy: Let's all seek some comfort, this hour of sorrow.

Exterior, Another Part of the Forest

Gretel: No, Hansel, let's not eat that house-shaped confection;
The sweets are no good for my milky complexion.

Interior, Sir Harold's Castle

Sir Richard: The princess's shouts are too loud to ignore.
Let's torture her soon; I can't take any more!

Exterior, Yet Another Part of the Forest

Goldilocks: Steal porridge from bears? Yeah, I'll give it a whirl.
Don't worry 'bout me—I'm a **mean** little girl.

Exterior, Sir Harold's Castle

Dragon: I'm roaring to show I'm a moat-guarding dragon!

Peter: My sword's made with magic, and that's not just braggin'.

Dragon: Oh, put that away! I won't kill you, don't fear.

Peter: I really must say, that's refreshing to hear.

Dragon: What manner of creature would have, so I'm told,
Two eyes and two ears and won't live to grow old?
Now answer my riddle! Be clear, and don't bluff!

Peter: I really don't know!

Dragon: Very well, close enough.
Now, lower the drawbridge! Sir Richard, attack!

Town Crier: It's time for commercials, so let's fade to black.

Act II

Town Crier: Sir Richard tries every weapon in town,
But Peter just smiles—visor up, visor down.

Interior, Sir Harold's Castle

Gwen: Languishing, languishing, dimly lit cell.
Get me out of here, now!

Town Crier: (Man, that princess can yell.)

Peter: Please don't give up hope, Gwen, I'm coming to save you!

Gwen: Well, use the back entrance, you servant-class knave, you!

Peter:	Just climb through the window, and you will be free.
Gwen:	Oh, not a chance, buster! I'm phobic, you see. A fall from this height—the results would be tragic.
Peter:	You've nothing to fear, for this locket is magic!
Gwen:	I wouldn't have given you that. 'Twas a loaner! So hand it back now, because *I* am its owner.
Sir Harold:	Now grab them, Sir Richard, let evil prevail!
Sir Richard:	There's no need to fight, they're already in jail.
Peter:	My sword's stuck! Oh, give me the locket back, please! I need it to give me combat expertise.
Gwen:	You'll fight with a *locket*? You might as well dance To the season of spring. No sirree, not a chance.
Sir Harold:	Your death by slow torture is long overdue.
Gwen:	You realize, Harold, that we are tha-rough.

Interior, Micky's Inn

Town Crier:	Hear ye, oh hear ye! I bring you sad news, That Peter of Tork has the Death Sentence Blues.

Exterior, Somewhere in the Forest

Micky:	I've a plan to find Peter: Let's split up in thirds, Leave a trail made of breadcrumbs, then follow the birds.

Exterior, Yet Another Part of the Forest

Micky:	Hey! Little Red Riding Hood! Where are you going?
Little Red:	To Grandma's.
Micky:	Oh dear! Then perhaps you weren't knowing: The wolf—the big, bad one—has killed grandma, dead.
Little Red:	That's true. I'll be visiting *Dad's* Mom, instead.
Goldilocks:	Two bears in pursuit! Oh, my prospects are grim. But Papa Bear hoped I would stay there with him.

Exterior, Sir Harold's Castle

Dragon: What manner of creature would have, so I'm told,
Six eyes and six ears and won't live to grow old?
Now answer my riddle—no time to discuss!

Micky: That's three stupid peasants. (I guess that'd be *us*.)

Exterior, the Battlements of Sir Harold's Castle

Sir Harold: Throw Gwen off the parapet, into the ditch!

Gwen: You dingbat! Now who's gonna care for my fish?

Town Crier: Right now's a good time for the friends to arrive
With weapons—I think Pete and Gwen might survive.

Peter: Hey, Micky! And Davy, and Pete—um, no—Mike!

Sir Harold: 'Tis no place for women—so Gwen, take a hike.

Town Crier: Without the tin locket, Pete's magic has fled!
He can't draw his sword, so it's daggers instead.

Davy: So why aren't all of you fighting? Don't shirk!
I'm sick of contributing all of the work.

Micky: Hey, Peter! The locket should stop this attack!

Peter: You'd think, but Her Highness made me give it back.

Gwen: You're darned right, I took it. It's true, yes indeedy,
That magical locket is *mine*, and I'm greedy.

Town Crier: It turns out that Harold and Pete aren't fans
Of violence, so they'll just fight with their hands.

Gwen: Oh, isn't that groovy? Defending my honor!
But that hairy weirdo now looks like a goner.
All right, if you're going to lose, here's the locket.

Town Crier: Hooray for our side! In the Win column, chalk it.

Gwen: My goodness! A bitter defeat nearly tasted—
I'm sure glad we won, 'cause I could have been wasted.
Now Peter—I'll grant you one wish!

Mike: Go ahead!
Pop the question!

Peter:	I can't! I'm too young to be wed!
Audience:	(I wonder why that sentence prompted such laughter?)
Peter:	Then marry me, Gwen, we'll have joy ever after!
Town Crier:	They break the fourth wall beyond hope of repair The minute the princess removes her blonde hair. The hand of the princess can never be won; He already has both a wife and a son.
Mike:	And so ends the story of Gwen and the Fairy. Save Chickens from Texas who Live on the Prairie!
Monkees:	We'll all say goodbye, but we'll get our names wrong, and then do a spoof of our famous theme song.

The Tag

Interior, the Pad

Producer:	So Michael, did we see your feminine side?
Mike:	I'm twenty-four now, and I still have my pride. I refuse to acknowledge that's something I'd do.
Producer:	Would Christian enjoy it?
Davy:	The same as a Jew. I'm really quite proud of my cross-dressing mettle. How would you describe it?
Peter:	The word would be *Gretel*.

Interior, the Pad, Night

Narrator:	See Micky freak out with his new synthesizer, While Michael sits motionless, there on the riser, And Davy plays drums while he's looking quite fetching, And Pete's doing yoga, or maybe just stretching. The lyrics remember the Sunset Strip riot; With questions—no answers—and then, all is quiet. Till Micky looks up with expression angelic: What more can he say? Only this:
Micky:	Psychedelic.

When Patrick Henry was in Virginia,
He made a speech we all recall;
He said to the people of Charlotte-Town,
"*Here Come the Monkees.*"

The In-Which
The Monkees get a gig playing for a Sweet Sixteen party, and Davy falls in love with the birthday girl.

Before I could write this review, I had to decide whether to examine the episode as a pilot, or as the tenth episode of the series. Is the audience made up of people who know nothing about the show? Or is it made up of people who have already been watching the show for several weeks? As a pilot, it had a responsibility to sell the series. As episode 10, it had to fit in the context and continuity of the series already in progress. For the time being, I will focus on *Here Come the Monkees* as a series pilot.

A pilot episode has three tasks.

1. Introduce the premise.
2. Introduce the characters.
3. Tell a compelling story about the premise and the characters.

How does *Here Come the Monkees* do on these three tasks? By the first measure, the pilot does very well indeed. The viewer learns that the Monkees are a down-on-their-luck rock band. They play small gigs, live together at the beach, and share a lively sense of humor and a vivid imagination. There are a couple of loose ends that will be clipped off before the

series goes into production, primarily the record store hangout and the manager, Rudy, but the basic bones are all there.

On the second task, the pilot falls far short of the mark. Just from watching the pilot itself, one would think that the show's main characters are Davy and Vanessa. Throughout the episode, those two names are repeated and reinforced again and again.

Mike: I've been thinking. Davy's right—we should help Vanessa.

Vanessa: Davy, it's cold!
Davy: Hey, Vanessa? Hey, Vanessa, look at this.

Russell: Oh, there you are, Vanessa!
Davy: Remember, Vanessa! December the 16th, 1773 was the date of the—
Vanessa: —Boston Tea Party.
Teacher: Perfect, just perfect, Vanessa.

Here's some food for thought. How many of the Monkees are actually named in the pilot? The answer is *three*—but that's only if you include the black-and-white screen tests that were added after the pilot's first, disastrous screening. Mike's name is revealed only in the screen test; Peter's name is mentioned once in passing. ("Sure you want to help. I want to help Peter, but I can't. He's a bird-brain.") As for Micky? For all the audience knows, his name might be Alexander Hamilton. And for what it's worth, the characters' names are not shown in the opening credits of the original pilot (as seen on disc 6 of the Season One DVD set).

Of course, there's more to establishing a character than just a name. We do learn that the wool-hat guy is the leader, we can see that the curly-haired drummer is a bit of a clown, and we are told that the other guy is not very bright. And that's pretty much it.

That brings us to task number three: tell a compelling story about the premise and the characters. And this is where *Here Come the Monkees*—as a pilot episode—goes completely off the rails. At its heart, this story is not about the band at all; it's a story about Vanessa and her father. The Monkees are just outside irritants. She wants them to play at her party; he's reluctant. She decides to date one of them; he disapproves. She flunks her test; he is angry. She slips out of the house; he goes looking for her. She cries at her party; he tries to make her happy. In the end, it's *Mr. Russell* who has all the personal growth, forgiving his daughter's youthful indiscretions and "selling out" his country-club standards.

You Never Get a Second Chance to Make a First Impression
The pilot's most jarring flaw is the scene that writers Paul Mazursky and Larry Tucker put at the very beginning of the story. You remember it, don't you? It's a dark, self-contained "man-on-the-street" sketch about hypocrisy, starring… Paul Mazursky and Larry Tucker. As

an intense dose of cynical satire it would have worked perfectly on *Laugh-In* or *The Smothers Brothers* or even *Saturday Night Live*. Where it doesn't work well is as the opening scene of a lighthearted television series about a happy-go-lucky band of young musicians.

What were they thinking? Why did Rafelson and Schneider let them get away with it? This is the very first chance for THE MONKEES to make a good impression on an audience, and the two writers stick in a "look at us, aren't we clever?" vanity scene for themselves. It wastes a full minute of a story that runs (once you subtract commercials, credits and screen tests) only 18 minutes.

Worst of all, the scene introduces Mike, Micky and Peter to the viewers as hooligans, fighting three-against-one against a guy much smaller than any one of them.

Zingers

Mike: Hey Davy? Where you goin' babe?
Davy: I've got a date.
Peter: Got your handkerchief?
Micky: Carfare?
Mike: Might rain. Better take your galoshes.
Davy: Hey—come on, you guys.
Micky: Your mother and I have been worried about you for some time now, Davy.
Peter: You've been setting a poor example for your baby brother.
Micky: Gootchi-gootchie-goo, baby.
Mike: Please, son. Don't talk to no strangers after midnight!

Micky: How're we gonna get Sven and the Rhythm Kings off the bandstand?
Mike: Ladies and gentlemen, your attention, please. I regret to inform you that Norway has just declared war on Sweden, and all Swedish nationals are to report to their embassy.

Clunkers

Davy: I never want to see you again!

This line—apparently an extension of Davy's fantasy—contradicts the plot. Davy immediately starts dating Vanessa.

Unidentified Woman: You play beautifully.
Unidentified Monkee: I know it.

I have no idea what this exchange was supposed to be about, but it sticks out like a sore thumb in the context of the romp. The unidentified squeaky voice, and the woman's subsequent vacant smile, have always left me confused and distracted.

Production Note
The pilot scored very poorly at its first test screening; audience members commented that they didn't find the characters very likable. The producers re-edited the episode before a second screening, making room for Nesmith's and Jones's audition screen tests.

Cultural Clarifications
Vice President Aaron Burr challenged former Secretary of the Treasury (and current face on the US $10 bill) Alexander Hamilton to a duel in 1804. Hamilton died; Burr was charged with murder, but was acquitted.

Runner-Up Sight Gag Highlight
Peter and Micky, playing with props during the "Where you goin', babe?" scene. Peter is putting nail polish on a statue, for goodness sake!

Sight Gag Highlight
Three Monkees' heads under buckets.

Breaking the Fourth Wall
Title cards: A typical teenager?
 No, a friend of the producer.

Third Runner-Up Nitpick
When the guys run away from the bandstand after Davy's second attack of starry eyes, Mike, Peter and Davy are all carrying their instruments. In the next shot, as they run to the door, the instruments have vanished.

Second Runner-Up Nitpick
Micky doesn't do Vanessa any favors by pronouncing "Aaron Burr" as "Dan Barr."

Runner-Up Nitpick
They leave that donated cabinet sitting on the Russells' front lawn.

Nitpick
Vanessa is dressed to the nines, with her hair up in an extremely elaborate 'do, for the audition scene, then wears a much plainer dress for the party itself, with her hair down.

We're the young generation, and we have something to recycle.
- Recycled plot point: Davy gets stars in his eyes. (See also *Monkee See, Monkee Die* and *Some Like it Lukewarm*.)

Third Runner-Up Monkee Magic
Unless Davy distracted Vanessa while somebody else buried Micky, Mike and Peter up to their necks in sand, there has to have been some magic going on.

Second Runner-Up Monkee Magic
Davy conjures up a spare G string for Mike. (Not that Mike needs one.)

Runner-Up Monkee Magic
The first documented instance of Shared Imagination: the board meeting of the firm Vanessa, Russell and Vanessa.

Monkee Magic
An even better instance of Shared Imagination: the four gun-slinging card sharps.

Apparently not Monkee Magic
The duel between Alexander Hamilton and Aaron Burr is apparently real—or at least, the guns are. The bullet fired from Mike's gun breaks a man's coffee cup at a nearby picnic table.

What I want to know...
What was removed from the pilot to make room for the screen tests?

What I want to know, Screen Test edition...
What is the Colonel Mallard story?

Snack to enjoy while watching *Here Come the Monkees:*
A full picnic lunch, with a historical drama floor show. And random gunfire.

Music
- *When You Were Sweet Sixteen*: *a capella* fragment
- *I Wanna Be Free*: playful romp combined with plot-related performance.
- *I Wanna Be Free (reprise)*: pensive walk on the beach.
- *Let's Dance On*: plot-related dance performance.

Episode 1-10
 Written by: Paul Mazursky and Larry Tucker
 Directed by: Mike Elliot
 Principal Filming Ended: 11/23/1965
 First Airdate: 11/14/1966

Grading
- Vanessa and Davy. **B+**
- Vanessa and Daddy. **B-**
- Vanessa and her history final. **F**
- Vanessa and her make-up history final. **A+**
- Who are those other three guys? **Incomplete**

And the cookie goes to...
Bob Rafelson and Burt Schneider, for salvaging a saleable product out of an abysmally low-testing pilot.

I flunked my history final. But don't get excited—I can write an extra-credit review of *Here Come the Monkees (episode 10)*.

In the fall of 1966, the pilot episode was held back for a couple of months, until the series had managed to establish itself and develop a devoted following. Good thing, too, because the series that premiered in September bore little resemblance to the pilot shot the previous November. Attentive viewers would surely notice that the run-down, eccentric pad had become sun-drenched and cozy, and that the Monkeemobile had been replaced with a broken-down station wagon.

More significantly, *Here Comes the Monkees* stands out because of its excessive ordinariness. We've come to expect a certain level of fantasy and suspense from the show; after a steady diet of royalty and spies, ghosts and gangsters, the low-stakes drama of Vanessa's history final just doesn't quite make the grade. Compared to the puffed up pomposity of General Vandenberg, the sarcastic narrow-mindedness of toy company executive Daggart, or the red-faced rantings of the Monkees' landlord, an anxious daddy with a country-club membership to defend just doesn't quite reach the standard of a true MONKEES villain.

Perhaps the producers had learned some valuable lessons from the poor scores given by the pilot's first test audience. Perhaps the series' tone evolved after the extensive improvisation exercises run by James Frawley in the spring of 1966. I can't help but notice that Paul Mazursky and Larry Tucker did not write for the series again after the pilot. Nor did Mike Elliot direct any other episodes of the show.

There's little point in nitpicking the episode for details that were deliberately changed between the pilot and the series. Rudy, the band's manager, was dropped. Davy stopped playing guitar. The band's logo changed, as did the pad and the car. These were all noticeable changes, but they certainly weren't goofs.

I will, however, ding them for the lack of continuity in the show's two performance scenes. These sequences had to be re-shot before the episode could be aired, because the music in the pilot had been sung by songwriters Tommy Boyce and Bobby Hart. When the pilot's songs were recorded again in 1966, the tempos changed. (*I Wanna Be Free* was slower, and *Lets Dance On* was faster.) The new film was shot with the band standing in front of a gold-colored curtain that vaguely resembled the backdrop of the country club's bandstand. However, they didn't bother to match other details from 1965: balloons draped in front of the curtain, the guys' position on the stage, Micky's silver-colored drums and, most noticeably, Mike's dark brown guitar.

Perhaps the greatest improvement to the episode was the brief introduction for the screen tests, featuring a hyperactively talkative Micky and a silently expressive Peter. Judging by Peter's costume, the introduction must have been shot in late October, during filming for *Son of a Gypsy*. (When the screen tests were originally added to the pilot in 1965, they came at the beginning and had no introduction at all.) Not only does the introduction give the extra material some context that was missing from the pilot, but it also showcases the two Monkees whose screen tests were not shown—and who barely had anything to do in the pilot itself.

The fower qualities that a lady respects most in a gennleman: Kindness, cornsideration, affection, and this review of *Hillbilly Honeymoon*.

The In-Which
Ella Mae Chubber has to get married, fast—any Monkee will do.

Perhaps *Hillbilly Honeymoon* deserves a place on the list of stereotype episodes, but I have to admit that it is, at its heart, a parody of another TV series rather than an attempt to depict any actual residents of any actual hills. And if there were any doubt, the four principal guest characters have a one-to-one correspondence with the four principal characters of *The Beverly Hillbillies*. Of course, the Clampetts are all members of a single family rather than a pair of feuding clans, but otherwise the parody is obvious.

It was a pleasure to watch *Hillbilly Honeymoon* over and over again while working on the review. It has one of the most intricate plots of any Monkees episode, with the action switching back and forth between the two warring camps, and shifting combinations of characters interacting in both antagonistic and collaborative modes. The story fills up every moment of allotted time without needing an extra music segment or interview for padding. There's conflict and danger, emotional growth, and a happy ending for all. Not to mention... pages and pages of hilarious dialogue. If it weren't for copyright laws, I would be hard-pressed to resist transcribing the entire episode.

Most Monkees episodes made use of songs that were currently hot on the charts or at least prominent on the latest album. This episode, aired in late 1967, is a remarkable exception; they reached all the way back to the first album for *Papa Gene's Blues*. Excellent choice: the song is a perfect fit for the episode's setting and theme.

The well-developed guest characters are played with great comic skill by Dub Taylor (Paw), Billie Hayes (Maw), Melody Patterson (Ella Mae) and especially Lou Antonio (Jud). Peter Meyerson is the same writer who gave us *Fairy Tale*—what more needs to be said? Oh—only that show's improvisation instructor James Frawley was in the director's chair, as he is in so many of THE MONKEES' better outings. In other words, *Hillbilly Honeymoon* is a little All-Star Game.

Zingers

Micky: Oh, cease and desist, friends and neighbors, do not fight at each other in anger, lay down your arms! ... Pick up your arms, and fight for what's yours!

Jud: Who's you?
Mike: You remember your cousins, Claude and Leroy?
Jud: No, I don't.
Mike: You remember your cousins Luke and Ezra?
Jud: No, I don't.
Mike: You remember your cousins Roland and Clem?
Jud: Yes, I do!
Mike: Yep! That's who we are—Roland and Clem.
Jud: Whatever happened to cousins Luke, Ezra, Claude and Leroy?
Mike: Well, they said to say hello.

Paw: Repeat after me. Ella Mae, honey—
Davy: Ella Mae, honey—
Paw: I wanna—
Davy: I wanna—
Paw: Go ahead! Go ahead!
Davy: I wanna— I wanna be free, free, free... like the blue, bluebird—
Paw: Anybody who sings like that, deserves to die.

Clunkers

Davy: Why's he always doing this all the time, spittin' all over the floor and everything? That's disgusting.

With all the stereotypical "hillbilly" behaviors being exhibited in this episode, it makes no sense for Davy to make an issue of Paw's spitting. It makes even less sense for him to ask Ella Mae about it while Paw is standing right there with a shotgun in his hands.

Second Runner-Up Sight Gag Highlight

Mike losing sight of Micky (who's standing right beside him) as they approach the Weskitts' cabin.

Runner-Up Sight Gag Highlight
Micky losing his right arm while chopping wood during the romp.

Sight Gag Highlight
Mike and Micky going hand-over-hand for the shotgun, leaving the shotgun in Jud's hands.

Second Runner-Up Physical Comedy Highlight
Micky vaulting over the porch railing, then proudly taking a bow.

Runner-Up Physical Comedy Highlight
Micky playing the pig while Mike tries to get a tune out of his cheap, borrowed nose.

Physical Comedy Highlight
Jud's hilarious overreaction to having his foot stomped on.

Runner-Up Breaking the Fourth Wall
Raybert presents, comin' straight from the mountains, Uncle Raccoon!

Breaking the Fourth Wall
Micky: What do we do now?
Mike: Huh? Oh, I got a script. Just a second, I'll see. Uh, it says Jud and Maw rush out—
Micky: We did that.
Mike: Mike and Micky free Davy.
Davy: Right.
Micky: We've got to get Peter at Ella Mae's!
Davy: I'm not going in there again! Was that good, dramatic? Was it good?

Fifth Runner-Up Nitpick
The War of 1812 ended in 1814—which is the last time the US and Great Britain were at war with each other. (Maw probably remembers that well, too.)

Fourth Runner-Up Nitpick
I know Davy is short, but that sack full of oats that Micky and Mike "rescue" is only about 2 feet high.

Third Runner-Up Nitpick
In Act I, Jud thinks knowing that $1 + 1 = 2$ is proof that a person is a fast-talkin' sharpie. In Act II, he knows the exchange rate for US dollars and British pounds. Mind you, his calculation is a bit off: at the time the episode was filmed and aired, the exchange rate was

fixed at £1 = $2.80, which makes $2 equivalent to 14 shillings 4 pence. But then, I figured it out with a calculator, and Jud did it in his head.

Fast-talkin' sharpie.

Second Runner-Up Nitpick
Surely Davy should be used to thinking in American currency by now.

Runner-Up Nitpick
The black soot marks on Davy's face appear and disappear in various shots.

Nitpick
Davy makes such a fuss over Paw's spitting, then does a very Paw-like spit himself when he gets a bit of soot in his mouth.

We're the young generation, and we have something to recycle.
- Recurring plotline: Davy dragged to the altar. (See also *Everywhere a Sheikh, Sheikh* and *The Prince and the Paupers*.)
- Recurring line: "Don't do that." (Too many examples to list.)
- Recycled footage: Clips from the farm chores sequences in *Don't Look a Gift Horse in the Mouth*.
- Recurring gag: mumbling "rhubarb, rhubarb" in place of actual discussion. (Listen also to *Your Friendly Neighborhood Kidnappers*; *Dance, Monkee, Dance* and *Monkees on the Wheel*.)
- Recurring gag: hand-over-hand competition for a prop. (See also a paintbrush in *Art, For Monkees' Sake*; a rifle in *Monkees in Texas*; a spear in *Monkees Marooned*; and a telephone in *Too Many Girls*.)
- Returning actor: Jim Boles as the preacher. (He was the farmer in *Don't Look a Gift Horse in the Mouth*.)

Runner-Up Monkee Magic
Micky, Mike and Peter conjure up hillbilly disguises for their visits to the Weskitts' cabin. And Peter conjures up photographs of his current wife and girlfriend. Er... how lonely is he?

Monkee Magic
Just after the opening credits, Davy yells, "Helllllp!" While he is yelling, you can see Micky in the distance, standing directly in front of the Monkeemobile. Before Davy can even finish the word, Micky teleports and appears immediately behind Davy.

What I want to know...
Where is this mythical town? Are we supposed to assume that there's a community of Hillbillies in California, or did the Monkees drive all the way to the Ozarks?

Beverage to enjoy while watching *Hillbilly Honeymoon*:
A very nice English gin. A little dry....

Music
- *Papa Gene's Blues*: playful romp.
- *I Wanna Be Free*: plot-related... I'm not exactly sure what to call it.

Episode 2-7
Alternate Title: *Double-Barrel Shotgun Wedding*
Written by: Peter Meyerson
Directed by: James Frawley
Principal Filming Ended: 9/15/1967
First Airdate: 10/23/1967

Grading
- Dem wacky Weskitts. **B**
- Dem charmin' Chubbers. **A**
- Dem meddlin' Monkees. **A**
- Dat Delightful Dialogue. **A+**

And the cookie goes to...
Peter Meyerson, for giving us an intricate plot, fascinating characters and rip-roaring dialogue.

Men, you've been found guilty of insubordination to a commanding officer, inspiring to mutiny, and what is even worse, impersonating a review of *Hitting the High Seas*.

The In-Which
The Monkees are recruited as crew for a pirate ship.

This episode gets by on three strengths: an absurd but comfortably familiar premise, plenty of delightfully silly dialogue, and sterling comedic performances by three of the four Monkees. Nesmith fell ill during location filming on the ship, and had to be edited out of most of the episode. Given the show's tight filming schedule, that didn't leave much time for the writers to revise the script. I do wonder how the episode would have been different if Nesmith hadn't been sick; might the plot have had more meat on the bones?. As it is, the story is rather sketchy, and is filled out with some non-plot sequences, such as Davy's encounters with various fantasy captains and Peter and Micky's lovely duet in their cabin.

Chips Rafferty (what a name!) gets extra credit for his role as the captain. He carries this improbable plot nearly single-handedly, with a only handful of extras and stock ruffians as a crew. Somehow he manages to make his silly, delusional character believable and even sympathetic, a comic sendup of pathos. It's a pity we never see any kind of resolution of his story; he just disappears during the romp and is never seen again.

One of my frequent complaints is that romps often serve to "resolve" irresolvable plots simply by throwing a lot of nonsense action at the viewer. This episode provides a sterling example; there is no reason why three unarmed Monkees should be able to defeat an armed pirate crew, and yet (with a lot of running around, jumping and swinging) they somehow

manage to win the battle. At the same time, *Daydream Believer* is a horribly unsuitable song for a violent action sequence.

Zingers

Harry: They gotta have knowledge of the seven seas.
Peter: Uh... Atlantic, Pacific, uh, Arctic, Antarctic, Baltic, Northern, Mediterranean, Indian, uh, Lake Havasu and the Mississippi.
Micky: Boy, Pete, you sure know how to use your mouth.

Captain: Here's your swords and your pistols. Oh—and the lyrics of some of the better-known pirate songs.

Captain: This man's leading a mutiny aboard my boat, and I want to know who's helping him!
Davy: Uh, will it be easier on him if you find the others?
Captain: No, he'll die just the same.
Davy: We told you not to try it!
Peter: We said single-handed mutinies never work, stranger!
Captain: Stranger? I thought you came aboard with him!
Davy: Him? No, we never seen him before! We wouldn't hang around with long-haired weirdos like that, would we?
Peter: Dirty commie.

Production Notes
According to Jones's commentary track, Dolenz provided the voice of the parrot throughout the episode. (This matches his trifecta accomplishment in *Alias Micky Dolenz*: here, he plays Micky, the parrot, and Micky pretending to be the parrot.)

Cultural Clarification
The episode title is a pun: of the four Monkees, only Micky has the vocal range to hit the high C's.

Second Runner-Up Sight Gag Highlight
Micky chewing the scenery and miming his distress after he is caught leading a single-handed mutiny.

Runner-Up Sight Gag Highlight
Mike becoming instantly and visibly seasick upon consuming a seasickness pill.

Sight Gag Highlight
Micky hiding behind the tattered curtain in the captain's cabin.

Physical Comedy Highlight
Davy weaving and stumbling below deck while carrying the tray of food for the captain. (Other than a brief moment when Mike became seasick, this is the only sign of a Monkee having trouble getting his sea legs.)

Breaking the Fourth Wall
Davy: Tell me, who's ringing that bleedin' bell over there?

 Jones mentions on the commentary track that the bell was on another ship nearby, and had nothing to do with the episode.

Second Runner-Up Nitpick
In the final scene, the captain of the Queen Anne thanks the Monkees for saving his ship, her gold, and all her passengers. *Passengers?* The ship the pirates attacked was a cargo ship.

Runner-Up Nitpick
When Peter, Micky and Davy steal the cannon at the outset of the romp, the fuse has already been lit. Peter stands briefly in front of the muzzle as they lift the cannon off its base—an extremely risky move.

Nitpick
Mike is in fine form when he boards the ship, then goes below decks with a bad case of seasickness. Nobody mentions him from that point forward, and he doesn't appear on the pier when the captain of the *Queen Anne* thanks them for their heroics. Did his friends leave him behind on the pirate ship?

Not Necessarily a Nitpick
Does our sweet, innocent, peace-loving Peter actually run a pirate through with a cutlass? Sure looks like he does. Is this the only canonical homicide by a Monkee?

We're the young generation, and we have something to recycle.
- Recurring joke: transposing time and place. (See also Stage 1 at 2:00 in *The Picture Frame*.)
- Recurring music: the brief fanfare played while Davy juggles. (See also *Too Many Girls*.)

Runner-Up Monkee Magic
Davy, Micky and Peter conjure up sailor uniforms and various nautical props in the bar.

Monkee Magic
Peter and Micky enact a series of captain-related fantasies below decks.

What I want to know...
How was the script changed to accommodate Mike's unexpected absence?

Beverage to enjoy while watching *Hitting the High Seas:*
Barkeep! Three milks, straight-up.

Music
- *Tear the Top Right off of My Head:* acoustic fragment, performed live to camera.
- *Daydream Believer:* vaguely narrative romp.
- *Star Collector:* isolated performance.

Episode 2-12
Written by: Jack Winter
Directed by: James Frawley
Principal Filming Ended: 10/13/1967
First Airdate: 11/27/1967

Grading
- Mutiny on the Blarney. **B+**
- Captain Queer in the Head. **A+**
- The Texas Two-Aspirin and Call me in the Morning. **Incomplete**

And the ~~Cookie~~ Cracker Goes to...
Dolenz, for providing the voice of the parrot even when he wasn't providing the voice of the parrot.

One of the little people! I'm proud, and just a little bit humbled, to be able to give you this review of *I've Got a Little Song Here.*

The In-Which
Dreaming of success as a songwriter, Mike falls prey to a swindler.

As the episode begins, the camera is focused on the framed sampler on the wall: Money is the Root of All Evil. As Mike goes to answer the knock on the door, Peter cheats him at checkers. And as Mike contemplates success, the mailman tells him that High Class Music Publishers has already ripped him off by 6 cents. What foreshadowing! Not that we need to be told that Mike's road to fame and fortune will turn out to be a dead-end street, but I do appreciate these little touches.

As I worked on this review, I was surprised to discover that some of the best scenes in the episode are really not all that funny. They are poignant, amusing, surprising and heartwarming, but they are not packed full of yuks. And that's just fine with me! This is a tightly plotted, complex story with lots of character development, which makes it score very high on my usual criteria for grading. The episode also has an unusually realistic premise: as Nesmith points out on the commentary track, such parasites do attach themselves to hopeful show business neophytes. The solution to Mike's problem, despite being cloaked in an improbable invasion of a movie studio, is actually rather elegant. How delightful it is to watch the four guys exchange furtive winks, nudges and smirks as they swindle the swindler!

It wasn't easy to come up with a "Breaking the Fourth Wall" entry for this episode. There are no obvious instances of speaking to camera, or talking about THE MONKEES as a TV show, or making reference to production matters like scripts or props. But in a way, the entire

episode is a sly reference to Nesmith's professional accomplishments. Every twelve-year-old viewer clutching a brand new copy of the Monkees' first LP knew that Nesmith was a songwriter, so seeing Mike struggle to get his first break in that aspect of his career must have seemed downright biographical.

That said, Mike is a little bit out of character in this episode. Nesmith adopts some of the slack-jawed, wide-eyed expressions we usually see on Peter, his usual droll Texas accent pushed to a higher pitch with all sorts of 'golly, gee-whiz' babble. He turns in a bravura performance, touching and tender and sometimes just a little bit hyper, but he just doesn't seem to be the same level-headed, take-charge Mike that we're used to seeing.

Zingers

Bernie: You didn't come here to exchange pleasantries, Nipsmouth.
Mike: Nesmith.
Bernie: What can High Class Music do for you?
Mike: Well, uh, Mr....
Bernie: Class.
Mike: Oh, *you're* High Class!
Bernie: No no no, I'm Bernie. My brother's the one who started the business.
Mike: Oh, *he's* High Class.
Bernie: No, his name is Irving.
Mike: Irving? Well, then how come it's called High Class Music Publishing Company?
Bernie: Would you come to an Irving Class Music Publishing Company?

Davy: Hey man, will you remember us when you're rich and famous?
Mike: Aw, you know I will, Danny.
Davy: Davy!

Bernie: Three guys to tune one piano?
Micky: Yeah, well, he does the black keys, and he does the white keys, and I do the cracks.
Davy: It's a very tough union.

Clunkers

Micky: Oh, baby! It's going to be my biggest one yet. Three years in the making. 740 cast members, 350 crew members and 22,000 extras.
Guard: What was your greatest expense?
Micky: Coffee and donuts.

This was a weak joke, made weaker by the fact that "What was your greatest expense?" is not a logical question for a studio guard to ask. The same joke, featuring the director on the soundstage, would have been fine. Still weak, but not a clunker.

Production Note
Which came first: the chicken, or the egg? The song *Gonna Buy Me a Dog*—with all the jokes and goofs—was recorded on July 23 – 24, 1966. The episode was shot August 1 – 5.

In his autobiography, *They Made a Monkee Out of Me*, Jones described a game invented by James Frawley and played on the set by the four Monkees, Frawley and a few other members of the show's production team. At any time, even in the middle of filming a scene, one of them could "shoot" another by pointing a finger and making a gun noise. The "victim" would then be required to stop whatever he was doing at that moment and act out a spectacular death scene. I am convinced that Peter's catwalk death scene during the *Mary, Mary* romp is a little glimpse of this game, acted out for the benefit of the cameras. (For that matter, so is Micky's feigned death in the foxhole scene of *Head*.)

Third Runner-Up Sight Gag Highlight
Micky poking himself in the eye with his sunglasses.

Second Runner-Up Sight Gag Highlight
<div align="center">
High Class Music Publishers, Inc.

Greeting Cards

Storm Windows

Reconditioned Vacuum Cleaners

Magazine Subscriptions

and

Door Lettering Service
</div>

Runner-Up Sight Gag Highlight
Stagehands trying to please the mysterious MD by obediently painting the trees red.

Sight Gag Highlight
The "see no evil, hear no evil, speak no evil" transformation sequence for the Monkeemen.

Physical Comedy Highlight
Monkeeman Peter, bless his heart, really does look like he's trying to fly. When I was a little girl, I was absolutely heartbroken for him.

What's that name, again?
Nipsmouth, Nessmann, Nesselrude, Nashmurth, Nesbaum, Nishwash, Nishmash or Nesmuth.

What's that title, again?
The actual title of the Boyce & Hart song is *Gonna Buy Me a Dog*.

Breaking the Fourth Wall
As MD blusters, Peter slyly shows his "notes" to the camera.

Breaking a Different Series' Fourth Wall, Music Lyrics Edition
Micky: *[sings]* She used to keep me so contented, but I can teach a dog to do that. I'm gonna buy me a dog.
Davy: You couldn't teach a dog to do that, you can only train elephants.

That's a reference to Dolenz's first starring role, in *Circus Boy*.

Third Runner-Up Nitpick
Apparently, the Monkees' phone number has eight digits, Mrs. Nesmith's phone number has seven digits, and Mr. Conway's phone number has six digits.

Second Runner-Up Nitpick
Mike's payment to Bernie Class may have been a nickel short, but Class ripped him off 6 cents of missing postage on the letter. So Bernie owes Mike another penny. Karma's gonna get you, Bernie.

Runner-Up Nitpick
The pad's deck is usually high above the beach, overlooking the ocean. In this episode, the entire pad seems to have been either rotated or relocated. There's a ton of scenery beyond the deck that wasn't there in earlier episodes, and when Monkeeman Peter attempts to take off from the deck railing, he lands just a couple of feet away and starts walking.

Nitpick
"Inimitable"—you keep using that word, Micky. I don't think it means what you think it means. In fact, it means "incapable of being imitated."

Not Necessarily a Nitpick
Micky, Peter and Davy had no idea that Mike was writing songs. By extrapolation, this means that the *fictional* Mike could not have written *Papa Gene's Blues, Sweet Young Thing, All the King's Horses, The Kind of Girl I Could Love* or *You Just May be the One*—all of which had appeared on the show before this episode.

Conversely, Mike *did* write *I'm Gonna Buy Me a Dog*. (Which, of course, Nesmith didn't.)

Absolutely Not a Nitpick
The Monkees swindled $200 from Class and gave $100 of that to the old man who had been swindled at the same time as Mike. But if Mike had pawned his guitar for $100, it would take

$100 *plus interest* to get the guitar back. In other words, they still lost money on the deal. Nothing wrong with that—it just goes to show what honest guys they are.

We're the young generation, and we have something to recycle.
- Recurring prop: a whisk broom for the VIP. (See also *Royal Flush* and *I Was a Teenage Monster*.)
- Recurring gag: What's the name of the guy in the wool hat? (See also *Monkee Mayor* and *Monkees in Texas*.)
- Recurring plot device: a Monkee pawns, sells, or wagers an instrument. (See also *I Was a 99 Lb. Weakling*, *Don't Look a Gift Horse in the Mouth* and *Monkees Marooned*.)
- Recurring setting: Mammoth Studios. (See also *The Picture Frame* and *Mijacogeo*. Listen also to *The Monkees at the Movies*.)

Second Runner-Up Monkee Magic
Micky and Davy as a pair of Tin Pan Alley songwriters. This particular moment of Shared Imagination is intriguing, as it shows them seated casually in their original positions the moment the fantasy ends.

Runner-Up Monkee Magic
Micky, Davy and Peter conjures up piano-tuner disguises, and Micky conjures up a toolbox.

Monkee Magic
Monkeemen! Slower than a speeding bullet....

What I want to know...
How did the actors react when they first found out they'd be donning tights and capes?

Beverage to enjoy while watching *I've Got a Little Song Here:*
A milkshake. With two straws. One for me, one for my dog.

Music
- *Gonna Buy Me a Dog*: Not very narrative romp. With puppies. *Puppies!*
- *Mary, Mary*: Stand-alone romp.

Episode 1-12
Written by: Treva Silverman
Directed by: Bruce Kessler
Principal Filming Ended: 8/5/1966
First Airdate: 11/28/1966

Grading
- If it sounds too good to be true, it's probably a plot. **A-**
- Monkeemen to the rescue! **A**
- *Puppies!* **A (for adorable)**

And the cookie goes to...
Don Kirshner, for suggesting that songwriters/producers Tommy Boyce and Bobby Hart actually use that disastrously funny take of *Gonna Buy Me a Dog*. Additional cookies to Boyce and Hart for taking his advice, even though they didn't intend for it to become a novelty song.

I Got a Few Dozen Little Songs Here: the Music of THE MONKEES

THE MONKEES television show may have been the primary product of the Raybert entertainment juggernaut, but Monkees music was far more than just an incidental sideline. The evidence is in the timing: the debut single *Last Train to Clarksville* was climbing the US charts before the TV show ever made it onto the air. Record sales and radio airplay brought viewers to the TV show; musical performances and romps on the TV show sent listeners to the record stores. This dynamic feedback loop was driving profits long before the band began giving live performances to its legions of adoring fans.

One of the charms of THE MONKEES is that pop music—in mass quantities—was incorporated into the episodes in varied and unexpected ways. One might have expected that a series about a struggling rock band would include performances by the struggling rock band, but more often the songs were used as a soundtrack for plot-related action sequences. Or non-plot-related play sequences. Or semi-plot-related fantasy sequences.

Early on, music was integrated organically into the stories. Some episodes featured only one song, most had two, others had three or even more. Occasionally dialogue would continue over the music, or a song would be cut short to let the plot continue. (In one instance, a song was made *longer* to allow a romp to continue.) Musical interludes often popped up in the middle of episodes, or even near the beginning, though having a romp near the end of an episode was typical.

During the second season, the two-songs-per-episode pattern became more rigid, with one song usually accompanying a plot-resolving romp and a second song presented in the form of a performance tacked on just before the closing credits.

Romps

Some romps are distinctly narrative in nature, moving the plot forward in a specific direction. Many others—particularly those coming at the end of second season episodes—are only vaguely narrative, being a sequence of comic moments edited in no particular order, but hopefully leading in the direction some sort of conclusion. (Or just as often, *not*.) Others are pure nonsense, lending a sense of fun and joy to an episode without furthering the plot at all.

Narrative Romps

Take a Giant Step *(Royal Flush)*
One of the most focused of the narrative romps comes near the end of THE MONKEES' first aired episode. Davy crosses swords with the episode's villain, while Mike and Micky distract the henchman. As the song comes to an end, the scene continues seamlessly.

All the King's Horses *(Don't Look a Gift Horse in the Mouth)*
In another clearly narrative romp, the guys engage in some shenanigans before the start of the climactic horse race. The song—which doesn't really have anything to do with horses—continues through the race.

I'm a Believer *(One Man Shy)*
A tightly structured narrative romp at the heart of a tightly structured episode. Davy, Mike and Micky give Peter etiquette lessons on the verses; Peter and Valerie share moments of romantic bliss on the choruses.

Your Auntie Grizelda *(Monkee Chow Mein)*
This wacky romp starts out nonsensical, but ends with a very specific narrative resolution to the episode's spymaster plot. Many second season romps fail to show how the bad guys were actually defeated; here, we see it all.

No Time *(Monkee Mayor)*
What starts out as a rollicking summary of the grass-roots Nesmith mayoral campaign turns subtly into a documentary record of the corruption practiced by the incumbent mayor and his corporate backer. Blink and you'll miss it—and in this complex plot, if you miss it, the episode makes less sense.

Symphony No. 4 in F Minor *(Card Carrying Red Shoes)*
An unusual romp set to the music of Tchaikovsky, the orchestral accompaniment to the ballet-in-progress is a crucial element of the plot. Micky distracts one bad guy, Peter escapes from another, Natasha captures a third, while Davy takes extraordinary measures to prevent a deadly cymbal crash.

Valleri *(The Monkees Blow Their Minds)*
On the one hand, the antics of Micky, Davy and Peter in Oraculo's lair are completely random and silly. On the other hand, the activities of Mike and Oraculo back at the pad are completely narrative and essential to the plot.

Vaguely Narrative Romps

I'm a Believer *(Dance, Monkee, Dance)*
Foreshadowing a typical second season romp, the Monkees somehow manage to defeat the bad guy just by being supremely annoying. This one is notable for the cameo appearance of Nesmith's mother, Bette Nesmith Graham. (She's the tall lady in the dark blue dress.)

(I'm Not Your) Steppin' Stone *(The Case of the Missing Monkee)*
A slapstick caper up, down and across a short hallway and into an adjoining room full of exercise equipment, this high-energy, low-logic romp manages to be entertaining while not making one lick of sense. Apparently, the good guys won and the bad guys lost. I'm still not sure how.

Your Auntie Grizelda *(I Was a Teenage Monster)*
It's nominally a battle between the good guys and the bad guys, but it's awfully hard to see the danger when everybody seems to be having so much fun. You often can't tell which side the monster is on.

Mary, Mary *(The Prince and the Paupers)*
A combination food fight/sword fight, this romp recycles many of the images from the climactic scene in *Royal Flush*. Inexplicably, the royal wedding proceeds calmly at the other end of the room.

Randy Scouse Git *(Art, for Monkees' Sake)*
A fairly typical second season romp: comedy is foremost and the plot barely registers. Scenes of the Monkees and the art thieves chasing each other around the museum are intercut with clips from a Rainbow Room performance and outtakes from earlier scenes.

Love is Only Sleeping *(Everywhere a Sheikh, Sheikh)*
Daydream Believer *(Hitting the High Seas)*
These two fairly violent sequences are incongruously choreographed to music with wistful, romantic themes. Sleepy Jean probably never daydreamed about Peter running a pirate through with a cutlass.

Sunny Girlfriend *(I Was a 99 Lb. Weakling)*
I have absolutely no idea how this chaotic, crowded, disorganized intervention by the Monkeemen, augmented with exercise-related clips borrowed from other episodes, achieved either the defeat of the con man or the winning of Brenda's heart. It's fun to watch, though.

Goin' Down *(Monstrous Monkee Mash)*
The Monkees goof around with the various monsters in the castle crypt at midnight; the romp ends incongruously with a few clips of the guys running around outside in broad daylight. Dialogue in the next scene claims that the monsters were defeated, but no explanation is offered.

Salesman *(The Devil and Peter Tork)*
If it weren't for Peter's fear of "cuckoo," this could almost be called a playful romp. It's a surprisingly effective blend of humor and low-level horror, helped along by quick edits and the judicious use of a fisheye lens. Watch closely for a few clips from a Rainbow Room performance that was never shown in its entirety.

Playful Romps

I Wanna be Free *(Here Come the Monkees)*
The up-tempo version of the ballad accompanies the very first romp filmed, in which Davy and Vanessa imagine themselves cavorting around an amusement park while Peter, Mike and Micky lurk in the background playing the song.

Tomorrow's Gonna be Another Day *(Monkee See, Monkee Die)*
The guys try to cheer up the frightened heiress as they wait for the morning ferry to arrive and get them all away from the spooky mansion. So naturally, they run around the grounds disguised as monsters. The disorganized romp also incorporates a caveman, an Indian, orange wetsuits and footage lifted from a Yardley Black Label commercial.

Saturday's Child *(Monkee vs. Machine)*
Although the preceding scene shows the band contemplating Mike's new job in a toy factory, this romp is remarkably toy-free. There's playground equipment, various modes of transportation (including a dune buggy, motorcycles, unicycles and a horse) and lots of rambunctious kids.

Saturday's Child *(The Spy Who Came in from the Cool)*
Madame escapes from the discotheque with the wrong reel of microfilm. She subsequently presents her spymasters in China with a lively film of Monkees frolicking on the beach.

Gonna Buy Me a Dog *(I've Got a Little Song Here)*

This romp starts out as part of the plot, then quickly takes a turn toward nonsense. Ostensibly representing the first reading of Mike's composition by his bandmates, the recording's false starts, missed entrances and nearly constant stream of jokes seem perfectly natural for the situation. The delightful romp in the park with dozens of dogs, however, has nothing to do with the episode in progress.

I'll be Back Up on my Feet *(Dance, Monkee, Dance)*
Your Auntie Grizelda *(Captain Crocodile)*

These two romps, filmed in back-to-back episodes that were eventually aired months apart, share many of the same settings and costumes. In one case, the Monkees enjoy a Shared Fantasy dance lesson; in the other, the unruly children of the Crocodile Corps chase the Monkees through miniature versions of those same dances.

Laugh *(Monkees a la Mode)*

The Monkees wreak havoc in the offices of Chic Magazine, as the frustrated staff try to remake the band in the proper image of well-bred, well-mannered youth.

The Girl I Knew Somewhere *(The Monkees on Tour)*

Concert tours are just chock full of free time, right? Micky roller-skates and meets with fans, Davy hotdogs on a motorbike, and Mike goes shopping. What's Peter doing? It's a family show: let's just assume that he took a nap.

Papa Gene's Blues *(Hillbilly Honeymoon)*

The only song released in 1966 to appear in a second season episode, its country twang is a perfect fit for the circumstances: a hilarious romp in and around the Weskitt's cabin, augmented by some farm-chore footage borrowed from *Don't Look a Gift Horse in the Mouth*. The song is nearly doubled in length by repeating the verses.

Daydream Believer *(Monkees Marooned)*

In a rare exception to the usual playbook, the plot of *Monkees Marooned* wraps up before the music starts. What follows is a lighthearted, frothy frolic across the island: a sweet, romantic reunion for Kimba and his leading lady.

Self-Contained Romps

An especially rare variation is a romp that is completely self-contained, having its own internal story without any connection to the episode in which it appears.

Sweet Young Thing *(Success Story)*

Perhaps the Monkees should have performed for Davy's grandfather. But how would he have reacted to this frisky romp through the park with a crowd of surprisingly nimble senior citizens?

Mary, Mary *(I've Got a Little Song Here)*
Tacked onto the end of an episode, this playful scene features the four Monkees in a game of chase through the catwalks above their own soundstage.

Last Train to Clarksville *(The Monkees at the Movies)*
The band's first #1 hit appeared four times in the show, but this final appearance near the end of the first season was its masterpiece. Placed ingeniously in the middle of a cinema-themed episode, the romp is a miniature action film, featuring a pair of conniving villains, an innocent victim, a courageous hero and a very impressive steam train. The romp has plot, characters, setting, stunts and special effects; a beginning, a middle and a surprise ending.

Performances

No matter how many times the Monkees' music is used to accompany action sequences involving bad guys, at its core this is a show about a band. From time to time, the band is going to perform for an audience. Only a few performances are truly plot related, appearing as part of the story in progress, some even overlaid with dialogue. Most were filmed in isolation and integrated into an episode—or more often, just tacked on at the end to fill time.

Plot-Related Performances

Let's Dance On *(Here Come the Monkees)*
Right there in the pilot we have the Monkees playing for a room full of happy guests and one unexpectedly satisfied middle-aged customer. (He's in pain, but he likes it.) Not much of the song can be heard, as the music merely serves as a background for ongoing dialogue.

The Kind of Girl I Could Love
(I'm Not Your) Steppin' Stone *(The Spy Who Came in from the Cool)*
This episode features two performances on separate occasions in a discotheque, where the band appears to have a regular gig. The spy-vs-spy action of the episode continues during both songs.

Take a Giant Step *(The Chaperone)*
Oddly, the Monkees are able to perform this song for the guests at their own party, despite the fact that their drummer/lead singer is simultaneously attending the party in a dress. It's a surreal performance, with the band bouncing back and forth between a corner of the pad and the deck outside, and Micky bouncing back and forth between his true identity and his role as Mrs. Arcadian.

You Just May Be the One *(One Man Shy)*
Seamlessly integrated into the episode, this performance by the band at a private party is intercut with a fantasy romp involving Peter's rivalry with the repulsive Ronnie Farnsworth.

Sweet Young Thing *(The Audition)*
Twice the guys take up their instruments and play this song in and around a phone booth, hoping to catch the attention of a distracted TV producer—while Clark Kent fidgets anxiously nearby. The third time is the charm, when the producer finally tracks them back to the pad.

I'm a Believer *(Too Many Girls)*
We are meant to believe that this performance took place on the set of *Ted Hack's TV Amateur Hour*, but the performance was filmed in front of a plain curtain backdrop, with the guys wearing yellow 8-button shirts that were not evident in the scenes immediately before or after. A few clips from this performance would later appear in a romp in the episode *Son of a Gypsy*.

Sometime in the Morning *(Monkee Mother, Monkees at the Circus)*
The exquisitely scripted and lovingly staged twilight performance is so perfectly integrated into *Monkee Mother* that it seems horribly out-of-place when used at a circus. In the middle of the day.

Look Out (Here Comes Tomorrow) *(Monkee Mother)*
The band performs at Millie and Larry's wedding reception. A few clips from this performance were utilized during the retrospective clip-show sequence set to this same song in *Monkees in Manhattan*.

Valleri *(Captain Crocodile)*
The band finally makes its debut on television, and after a half-dozen false starts, manages to perform this song for the cameras. Which, unfortunately, were turned off.

What am I Doing Hangin' 'Round? *(It's a Nice Place to Visit)*
Technically a Rainbow Room performance, production took a few meager steps to make the colorfully striped set in Chicago resemble the cantina in El Monotono. A few continuity errors—Peter's banjo, Micky's curls, Mike's wool hat—cannot detract from the perfect thematic fit of this song to the plot of the episode.

The Door Into Summer *(Some Like it Lukewarm)*
It's hard to call this one a performance, as the band members are far too occupied blocking Davy's attempts to escape to actually play the song. The love-struck contest host provides a running commentary.

Isolated Performances

Unlike a plot-related performance, an isolated performance is shot in a relatively neutral setting and can be used as filler material, either intact or as clips in a romp. As the series progressed, these isolated performances became more and more visually creative, until they took on distinctive visual styles that were often as captivating as the episodes themselves.

Several isolated performances were filmed fairly early in the first season, including *Last Train to Clarksville, Papa Gene's Blues,* and *Sweet Young Thing*. These three performances in particular were never seen in their entirety, but were edited piecemeal into various romps. Similar performances of *(I'm Not Your) Steppin' Stone* and *I'm a Believer*—easily identifiable by the yellow curtain backdrop— were spliced into the episodes *The Spy Who Came in from the Cool* and *Too Many Girls* as plot-related performances.

She *(Monkees a la Carte, Monkees at the Circus)*
This same sequence was used twice on the series, supposedly as plot-related performances. But it's hard to pretend that the blank wall behind the band is either part of Pop's restaurant or a circus tent.

You Just May Be the One *(The Chaperone, Monkees a la Mode)*
Valleri *(The Monkees at the Movies)*
Plot-related performances lifted from *One Man Shy* and *Captain Crocodile*, these two sequences were placed at the end of other episodes without explanation or context.

Mary, Mary *(Alias Micky Dolenz)*
A performance (possibly meant to be perceived as a rehearsal) filmed on the pad set. Unlike many other such isolated performances from the first season, this one was never edited into any of the romps that utilized the same song.

On a rare day off in the middle of the Summer '67 concert tour, the Monkees were brought into the Fred Niles Studios in Chicago to film performances of eight songs from the albums *Headquarters* and *Pisces, Aquarius, Capricorn & Jones, Ltd.* in a candy-striped studio called the Rainbow Room. All but one of these performances would be dropped into episodes throughout the second season, and most would also be edited liberally into romps. I've mentioned some of the romps above; the episodes listed below feature the complete Rainbow Room performances.

- Randy Scouse Git *(The Picture Frame)*
- Daydream Believer *(Art, for Monkees' Sake; A Coffin Too Frequent)*
- Pleasant Valley Sunday *(Monkee Mayor)*
- Love is Only Sleeping *(I Was a 99 Lb. Weakling)*
- What am I Doing Hangin' 'Round? *(Monkees Marooned)*

- She Hangs Out *(Card Carrying Red Shoes)*
- No Time *(The Devil and Peter Tork)*
- Salesman (never shown in its entirety)

In the latter part of Season Two, even as the series outgrew its formulaic storytelling, it broke free of the static and predictable performance videos of the past. No more would they use the same set for multiple songs, or shoot the band playing in matching 8-button shirts on a make-believe stage. For that matter, it no longer seemed necessary to show the entire band performing; some of these later "performances" were vocal only, or very nearly so. By the end of 1967, the show's greatest creativity shone through a handful of distinctively beautiful music videos.

Cuddly Toy *(Everywhere a Sheikh, Sheikh)*
Cuddly Toy *(Monkees on the Wheel)*
Two different performances of *Cuddly Toy* were filmed in the same Vaudeville style: one with dancer Anita Mann, the other with instruments.

Star Collector *(Hitting the High Seas, The Monkees Mind Their Manor)*
Goin' Down *(The Wild Monkees, Monkees in Texas)*
These two songs were tied for the most appearances in the series, with five insertions each. Their visually arresting performance videos, however, were only used twice each: black light and smoke for one, jewel tones and special effects for the other.

Daily Nightly *(Fairy Tale, The Monkees Blow Their Minds)*
The most visually artistic video of any Monkees song—perhaps the most visually artistic two minutes of film in the entire series—notable for its colorless palette, unusual staging and cool, unruffled elegance. Shot in a black-draped corner of the pad set, with the Moog the only instrument in sight, the state-of-the-art technological wonder seems almost humble as it sits with the band on the floor. Micky is the only one to perform, as the others simply listen and show their appreciation in different ways: Peter dances, Davy air-drums, and Mike sits perfectly immobile.

Incidental Music

Most of the show's music was recorded in the studio and simply played back for the TV show—usually with one or more of the Monkees miming along to the track. But not always! Snippets of various songs were often performed right on the set.

(I'm Not Your) Steppin' Stone *(Too Many Girls)*
We only hear a few measures of this song being rehearsed in the pad before Davy freezes up and the others stop playing to investigate the problem. The scene is notable because this is the first time we see the Monkees singing and playing one of their hits on camera, rather than miming to a pre-recorded track.

Different Drum *(Too Many Girls)*
Clocking in at a mere forty seconds, Mike's delightfully comic, hyper-speed rendition of his own composition is barely recognizable. I would give good money to know whose idea it was.

Everybody Loves My Baby
Hi, Neighbor *(Monkees in a Ghost Town)*
Like her character, Bessie "The Big Man" Kowalski, actress Rose Marie started out her professional career as a singer. Here she's just in it for the laughs, hamming it up to the accompaniment of a rinky-dink piano.

Jesu, Joy of Man's Desiring *(Monkees in the Ring)*
As Mike delivers words of advice to Davy, Peter is in the background, quietly playing Bach on his banjo. At the first mention of that one notorious hotel that every city has—the one with the loose talk and fast women—Peter plays a dramatic chord in a minor key.

Don't Call on Me *(Monkee Mother)*
Peter and Mike serenade Millie and Larry with a delicate instrumental as the lovebirds dine *al fresco* on the deck. The song, composed by Nesmith with his friend John London, wouldn't be recorded until June of 1967—five months after the episode was filmed.

Zilch *(The Picture Frame)*
Tracks from the band's third album, *Headquarters*, don't get very much exposure on the TV show, but the spoken-word *Zilch* makes a brief appearance in this episode's interrogation scene.

Papa Gene's Blues *(Art, for Monkees' Sake)*
On a lazy day hanging out in the pad, Mike sings a silly rendition of his song for no apparent reason. It makes one wonder why the Monkees didn't sing spontaneously more often.

Tear the Top Right off My Head *(Hitting the High Seas)*
For thirty years, the only public exposure this song had was the brief acoustic performance by Peter and Micky in their bunks on the pirate ship.

Riu Chiu *(The Christmas Show)*
This sublime *a capella* chorale is the hands-down highlight of the episode. It's presented simply and elegantly, with the four Monkees seated comfortably on their set as though they were just singing carols at home.

Greensleeves *(The Monkees Mind Their Manor)*
Although Davy's performance is sweetened with echo effect and strings in post-production, both Jones and guest star Bernard Fox sang the song live to camera.
On the other hand...

I Wanna Be Free *(The Devil and Peter Tork)*
An anonymous musician provided the lush harp music for this episode; Tork freely admits that he was doing his best Harpo Marx imitation for the camera, but that he did not actually play the harp—nor can he, to this day. How ironic.

Placement and Timing

The most common position for a narrative romp is near the end of the episode, just as the action is reaching a climax. A romp usually encompasses some kind of fight or chase, or in a few cases, a celebration after a victory. Narrative romps did occasionally appear at other points in the plot, particularly in the first season when the storytelling formula hadn't yet settled in and calcified. Playful romps, on the other hand were almost always near the middle of the episode.

This Just Doesn't Seem to Be My Day *(Royal Flush)*
A rare mid-episode chase scene, this odd romp comprises a romantic interlude for Davy and Bettina, a chase scene for Micky and Sigmund, and some seemingly random busy work (digging a whole hole) for Peter.

Tomorrow's Gonna Be Another Day
Papa Gene's Blues *(Monkees in a Ghost Town)*
These two playful romps appear right smack in the middle of the episode, before and after the commercial break. A similar pair of mid-episode romps bracket the commercial break in *The Monkees Get Out More Dirt*.

Goin' Down *(The Wild Monkees)*
Isolated performances almost always appear at the very end of an episode, just before the closing credits. In this one instance, the performance is tacked on at the beginning, just before the opening credits.

Songs were most often utilized in episodes that first aired when the song would be in the record stores and on the radio. That simply makes sense from a marketing perspective. But the rule doesn't always hold:

(I'm Not Your) Steppin' Stone *(Your Friendly Neighborhood Kidnappers)*
This future B-side to *I'm a Believer* made its debut on the show a full seven weeks before the single was released.

Papa Gene's Blues *(Hillbilly Honeymoon)*
This song from the band's debut album was more than a year old when it made its third and final appearance on the show. It was a counter-intuitive choice from a business perspective, but a perfect fit for the episode.

Last Train to Clarksville *(The Monkees at the Movies)*
By way of contrast, the apparent late placement of this early song is simply due to the extraordinary delay in the airing of the episode. It was filmed in August of 1966, when the song was brand-new, and despite the delay there was no better song for the train-themed romp.

All the King's Horses *(The Spy Who Came in from the Cool)*
All the King's Horses *(Don't Look a Gift Horse in the Mouth)*
During the Kirshner era there was an abundance of songs available for use on the TV show. There may have been an intention to release this Nesmith tune eventually, but it never did see vinyl in the 1960's.

You Just May be the One *(One Man Shy, The Chaperone, Monkees a la Mode)*
I'll be Back Up on my Feet *(Dance, Monkee, Dance; Monkees in the Ring)*
These two songs were aired during the first season of the TV show, but different versions were recorded at a later time for release. And in a similar vein...

Valleri *(Captain Crocodile, The Monkees at the Movies)*
Valleri (version 2) *(The Monkees Blow Their Minds)*
Words *(The Monkees in Manhattan)*
Words (version 2) *(Monkees in Texas, The Monkee's Paw)*
These two songs were also recorded multiple times, with the earlier versions used on the show's first season, and a different version aired in the second season.

All of the preceding paragraphs have referred to the episodes as they were *originally* aired on NBC. But at the height of Monkeemania, the cross-promotional marketing monster had to be fed year round. As the show went into reruns during the summer of 1967, newer songs were often spliced into the episodes. Among the substitutions:

- Beach romps in *Royal Flush* and *Monkee vs. Machine* were accompanied by *You Told Me*.
- *Shades of Gray* replaced *I Wanna Be Free* for a contemplative scene in *Success Story*.
- The previously overlooked *A Little Bit Me, a Little Bit You* got a little summer rerun exposure in *Monkee See, Monkee Die*.

- *For Pete's Sake* was utilized as a substitute for *Mary, Mary* in the running-through-the-rafters romp at the end of *I Got a Little Song Here*, marking that song's debut appearance on the show—several weeks before it showed up in the closing credits.
- Perhaps the oddest substitution of all was *Forget that Girl*, replacing *I'm a Believer* without a hint of irony for a romantic sequence in *One Man Shy*.

The same marketing technique was utilized when the show was aired on Saturdays in 1969 and 1970, replacing the romp soundtracks with songs from *The Monkees Present* and *Changes*. Sadly, TV exposure on Saturday mornings no longer held the power to drive record sales as it did in prime-time.

Conclusions

Other than the pilot, all MONKEES episodes were filmed in the course of just 19 months, from June 1966 to December 1967. In that span of time, the romp became a victim of its own success, first blossoming into a joyful, unpredictable plot-propelling tool, then decaying into chaos and nonsense.

But as the romp lost its innovative spark, the show turned its creative energy toward the perfection of the isolated performance. From the early, static performances in front of a blank wall or plain curtain, to the playful exuberance of the Rainbow Room videos, to the sophisticated artistry of *Goin' Down* and *Daily Nightly*, these two-minute films demonstrate—as well as any scripted episode—the potential that was lost when the series was cancelled.

You better sign up for my complete health plan. That includes books, membership, and a review of *I Was a 99 Lb. Weakling.*

The In-Which
Micky is swindled by a health and exercise guru.

This would be a near-perfect example of a typical MONKEES episode, save for the absence of Mike. There's a pretty girl, a swindler and a matter of pride. There are schemes, plans, setbacks and a valiant rescue. There are lazy days hanging out in the pad, romance on the beach, a couple of running gags and plenty of silly shenanigans.

Unfortunately, it's also one of several episodes that is short a Monkee. We are never told why Mike is away, but at least in this case the absence is carefully acknowledged: again and again, Davy and Peter look to the camera and sigh, "I wish Mike were here." That's a welcome validation of Mike's position in the band, as the person who usually knows what to do and who can be counted on to stay calm in a crisis.

Although Micky is well-established as being agile, reckless and full of frenetic energy, there is also sufficient precedent for him to be believable as an insecure, undersized weakling. It would have been so easy for the writers to have the bully pick on little Davy instead of Micky, but Davy is already known to be a naturally self-confident athlete. Or the writers could have made sweet, innocent Peter the victim—of both the bully and the scam—but that would have been taking the easy way out. Besides which, there is nobody, NOBODY better qualified to slip, slide, flip, fall, fumble, stumble, careen and crash his way through this plot. Go, Micky! Go!

While Micky flails and fails, Davy and Peter have to take charge (usually Mike's job) and come up with some "underhanded" schemes (usually Micky's job) to save the day. They don't usually spend so much screen time together, and that's a pity—because they really do have lovely chemistry. Their brief conversation on the beach about the destination of the dir... dirig...blimp is adorable. Their exercise with the gray sweat suits is even better.

Brenda and the bulked-up bully are shallow, two-dimensional characters, but there's not a whole lot of room in this plot for character development. Shah-ku is not quite as delightful a con artist as Reynaldo, the dance-school owner in *Dance, Monkey, Dance*, but his sneering, judgmental attitude makes a great foil to Micky's earnest insecurity. The two actors play very well off each other, both in their dialogue and in their physical comedy.

Once we arrive at the Weaklings Anonymous meeting, the story begins to fall apart under its own weight. I get the impression that the writers simply couldn't figure out how to resolve the plot. There's a lot of shouting, a crowd of extras milling around and running into each other, then the music starts. *Something* apparently happens during the romp—I never did figure out just what—and Act II crashes to an end with Brenda happy in Micky's arms. It was nice to see the Monkeemen, though.

Zingers

Peter: I'm a doctor, in case you hadn't noticed. Oh my goodness, I hope I'm in not in time. I mean, I hope I'm in time.
Bully: What's the matter, Doc?
Peter: I've never seen a body in such an advanced state of decomposition. Let me see your back.... Not *your* back, dear.
Brenda: To each his own.

Peter: Well, there he goes.
Davy: Yeah. Where's that dir... dirig... blimp headed for?

Peter: ...and I'm awfully worried about him, Mr. Shah-ku. He's falling down from hunger.
Shah-ku: You have a very deep voice for a mother, Mrs. Dolenz.
Peter: I'm not Mrs. Dolenz.
Shah-ku: Oh. Micky came from a broken home.

We Do Our Own Stunts

Micky pratfalling all over the beach. Again and again. And again.

Runner-Up Physical Comedy Highlight

Peter and Davy putting on sweat suits in order to infiltrate the Weaklings Anonymous meeting.

Physical Comedy Highlight
Micky vs. a barbell.

Runner-Up Sight Gag Highlight
Peter's illustration of the word "underhanded."

Sight Gag Highlight
The tureen full of green fermented goat milk curd.

Third Runner-Up Nitpick
During the hilarious cutaway scenes in which Davy and Peter get dressed in sweat suits, they repeat the same two lines of dialogue ("Eating hot dogs," and "I was hungry, man,") three times.

Second Runner-Up Nitpick
Why did Mr. Schneider speak in Jones's voice? If they couldn't get James Frawley to come in for a little voice work (he didn't direct this episode) they could have gotten somebody else to do it. Even Tork (using his seldom-heard bass register) would have been a better choice.

Runner-Up Nitpick
How did Davy get the kite string attached to the dir— dirig— blimp?

Nitpick
It doesn't matter how odd a costume you dress Monte Landis in, there's no way to hide that pot-belly paunch. How is he supposed to be believable as a physical trainer?

We're the young generation, and we have something to recycle.
- Recurring physical comedy: getting tangled up with weight-training pulleys. (See also *The Case of the Missing Monkee* and *Monkees in the Ring*.)
- Returning actor: Monte Landis as Shah-Ku. (See also *Art, for Monkees' Sake; Everywhere a Sheikh, Sheikh; Monkees Marooned; Monkee Mayor; The Devil and Peter Tork* and *The Monkees Blow their Minds*.)
- Recurring plot device: a Monkee pawns, sells, or wagers an instrument. (See also *I've Got a Little Song Here, Don't Look a Gift Horse in the Mouth* and *Monkees Marooned*.)
- Recurring punch line: "I *am* standing up." (Listen also to *Royal Flush* and *Captain Crocodile*.)

Runner-Up Monkee Magic
Monkeemen!

Monkee Magic
Peter conjures up a telephone. *Literally*. It's very impressive.

What I want to know…
Where *is* Mike?

Snack to enjoy while watching *I Was a 99 Lb. Weakling:*
Fried fermented goat milk curd burned in a dash of lemon-seed oil, to a crisp golden-green. And scraped mountain moss *au gratin*, with a special peanut-shell base. (Do you think we can save the steak?)

Music
- *Sunny Girlfriend:* vaguely narrative romp intercut with exercise-themed clips from other episodes.
- *Love is Only Sleeping*: isolated performance.

Episode 2-6
Written by: Gerald Gardner, Dee Caruso, Neil Burstyn and Jon Anderson
Directed by: Alex Singer
Principal Filming Ended: 5/11/1967
First Airdate: 10/16/1967

Grading
- Micky is a bumbling, stumbling, crumbling ball of insecurity. **A+**
- Mike's not there, so Peter and Davy step up to save the day. **A-**
- Brenda. Yeah, annoying. **C**

And the cookie goes to…
Dolenz gets the cookie, a bottle of aspirin and a tube of Ben-Gay.

You are about to witness the world premiere of my latest invention, which you yourselves helped to create more than you know. And here he is—the Swinging Review of *I Was a Teenage Monster.*

The In-Which
A mad scientist steals the Monkees' musical talents.

I have just two points of high praise for this episode. First, Richard Kiel did an amazing job playing the role of the monster. He is this strange episode's saving grace, deftly straddling the line between frightening and funny, between terrifying and... well, *cuddly*. Burdened with layers of monster makeup and dialogue that ranges from wordless roars to affected, effeminate babbling, he turns in a remarkably sensitive performance.

Second, the central concept of the plot—a mad scientist strips the Monkees of their musical abilities—is positively brimming with dramatic possibilities. It strikes directly at the heart of the show's premise, and threatens to cripple the main characters, destroying the tie that binds them together and defines who they are. It's no coincidence that the first song they attempt after the transfer is the show's theme song; the four guys tentatively, hesitantly try to assert their collective identity as a band ("Hey hey, we're... the Monkees...?") and the monster then confidently claims that identity for himself while Mendoza and Groot break out in a happy jig.

Unfortunately, the show's delightfully horrific premise ends up as nothing but wasted potential. Each time the story gears up for maximum angst, something comes along to let all of the air out of the tires. Just moments after stripping them of their music, Mendoza erases their memories—there's no opportunity for them to deal with their loss. The next day, when they fully expect to perform and inexplicably *can't*, their reaction is half-hearted

puzzlement rather than horror. Confronted with a creature that sings *their* music with *their* voices, they just wander away shaking their heads. Their confusion lasts only a few minutes, because their amnesia suddenly and spontaneously dissipates. Precious minutes that could have been utilized for reflection, meaningful dialogue and character development are frittered away on meaningless padding, such as Mendoza's conversation with a magic mirror. The result is an uneven episode that leaves me frustrated and disappointed.

On a happier note: I often despair at musical romps that try to resolve irresolvable plots just by throwing a lot of nonsense action at them. In this case, I have to say that the goofy romp is exactly what this dark story needs—and despite containing a lot of silly shenanigans, this one actually makes a fair bit of sense. I particularly enjoy Davy's leap into the monster's arms, and Micky's turn "playing" the rack of scientific instruments with a pair of mallets (and the monster's enthusiastic demand to do the same.) Ultimately, it's Micky's mad scientist skills that saves their careers, and Peter's naïve willingness to make an unlikely friend that saves their lives. Nothing wrong with that!

Zingers

Micky: I'll tell you what's wrong with him. I'll tell you, man. It's his image.
Monster: Don't do that.
Micky: First, a Beatle haircut... Dark glasses... Some groovy clothes... And a guitar... Now, how does it look?
Mike: Looks like a long haired, nearsighted monster with a guitar.

Mendoza: Android, I am your master. Kill the Monkees!
Peter: Android! Andy! Andy, wait! I'm Peter—your friend. The doctor is an evil man. He wants to exploit you. You're only a pawn in his hands, a tool for his avaricious ambitions.
Mike: 'Avaricious ambitions'? Where'd he get that?
Davy: It's in the script.
Mike: Are you sure?
Davy: It's on page 28.
Peter: Besides, he wants sixty percent of your income.
Monster: Sixty percent!?
Mendoza: No, android! I am your master, and I only want twenty-five percent. Kill Peter!
Peter: No, android, wait! He's a *bad man*.

Clunkers

Mendoza: Do not be deceived by Groot's humble appearance. He is of a very ancient family.
Mike: Yeah, descended in a direct line from Jack the Ripper.

There is nothing the least bit scary about Groot. It makes no sense for Mike to compare him with a historical serial killer. Clearly, a joke is called for here—but this isn't it.

Mendoza: Gentlemen, when I retained you I thought you were musicians. Now I shall have to ask for my money back.

It's not this line that's the clunker. In fact, that line itself is *excellent*! The clunker is the wishy-washy response from the Monkees—a halfhearted grumble and a very quick refund from Mike.

Micky: Hey! I—I got it! I remember! The laboratory!

The guys should be tearing their hair out in desperate frustration, but their memories return spontaneously. They should have to struggle—and *work*—to figure out what was going on.

Cultural Clarification
The episode title refers to the 1957 Michael Landon horror film *I Was a Teenage Werewolf*.

"Rosebud" refers to a plot point in the film *Citizen Kane*. And that's all I'm going to say about that.

We Do Our Own Stunts
Davy's backwards somersault off the stage after doing The Bump with the monster.

Runner-Up Physical Comedy Highlight
Davy leaping up into the monster's arms.

Physical Comedy Highlight
The monster, swinging back and forth in confusion between "kill the Monkees" and "he's a bad man," until he just ends up dancing.

Sight Gag Highlight
The monster shaking hands (fingers?) with three Monkees at once.

Second Runner-Up Breaking the Fourth Wall
Davy makes a prayer motion with both hands as he pleads for his life—then remembers that he's supposed to be shackled. "Sorry."

Runner-Up Breaking the Fourth Wall
The mysterious Miss Mendoza, reading a MONKEES script. "Wait till you see the sequel. The vampire turns Davy into a werewolf."

Breaking the Fourth Wall
Mike: 'Avaricious ambitions?' Where'd he get that?
Davy: It's in the script.
Mike: Are you sure?
Davy: It's on page 28.

Third Runner-Up Nitpick
Seconds after Groot escorts the Monkees to their bedroom, the Monster is returned to his pedestal in the lab—and is back in the same plain gray jacket he was wearing before Micky performed his make-over. The next morning, when Mendoza brings the monster out to perform for the perplexed Monkees, he is back in his groovy, Monkee Magic outfit.

Second Runner-Up Nitpick
All those explosions going off in the lab, but Mendoza doesn't hear a thing until Micky knocks a flask onto the floor.

Runner-Up Nitpick
Immediately after the conversation with the magic mirror, Mendoza and Groot head through the door that leads to the lab. Mendoza even says that's where they're going, to check on the monster. But they never arrive at the lab. The next time we see them, they're back upstairs, taking a phone call about dance lessons.

Nitpick
Mike calls the police as the others tie up Mendoza and Groot. Where is the monster? Come to think of it, Peter did want to keep him as a pet....

Absolutely Not a Nitpick
I used to be bothered that the monster is able to "sing" with all four Monkees' voices and their instruments as well. But now I remind myself that the monster is actually a machine. Perhaps what was transferred was not skill, or talent, but *memories* of how the music is supposed to sound. The monster then opens his mouth and goes into "playback" mode. He's basically a 7-foot 2-inch iPod.

We're the young generation, and we have something to recycle.
- Recurring line: "Don't do that." (Too many references to count.)
- Recurring gag: a Monkee jumps into another character's arms. (See also Davy in *Monkees at the Circus, The Monkees at the Movies, Monkees Marooned* and *Monkee See, Monkee Die;* and Micky in *The Monkees Blow Their Minds.*)
- Recurring stock footage: *Reptilicus.* (See also *The Audition, Monkee Chow Mein, Monkees Marooned* and *The Monkees Mind Their Manor.*)

- Recurring prop: a whisk broom for the VIP. (See also *Royal Flush* and *I've Got a Little Song Here*.)

Second Runner-Up Monkee Magic
Davy conjures up a boxing glove.

Runner-Up Monkee Magic
Davy conjures up a sign: "A Sequel? You better believe it."

Monkee Magic
Micky conjures up a Beatles' hairstyle, groovy glasses, mod clothing and a guitar for the monster.

What I want to know…
Can Richard Kiel sing?

Snack to enjoy while watching *I Was a Teenage Monster:*
The peasants are toasting marshmallows outside the front door.

Music
- *Transylvanian Folk Song*: plot-related… um… performance?
- *(Theme from) The Monkees:* plot-related… um… experiment?
- *Tomorrow's Gonna Be Another Day:* plot-related… um… playback?
- *Your Auntie Grizelda*: playful, but decidedly narrative romp.

Episode 1-18
Written by: Gerald Gardner, Dee Caruso and Dave Evans
Directed by: Sydney Miller
Principal Filming Ended: 11/3/1966
First Airdate: 1/16/1967

Grading
- A terrific concept. **A**
- A ragged, half-hearted execution of said concept. **C-**

And the cookie goes to…
Richard Kiel, for his deft portrayal of the sweetest monster who ever wore granny glasses.

We've got what's-his-name over there, Glick, but the machine's still going. We gotta find the hypnotic Frodis, and write a review of *Mijacogeo*.

The In-Which
An evil wizard enslaves minds through the power of television—with a little help from a friendly weed.

You give Junior the keys to the family car, you can't expect him not to take it out on the highway and push it up to fifth gear. Dolenz got a chance to write and direct for the first time, and he had to push every button on the dash. At one point on the commentary track he actually apologizes for the "nauseating camera work." But what I notice most are the naked sets, the crude props, the frenetic acting, and the gimmicks. Oh, the gimmicks! Not satisfied with breaking the fourth wall once or twice, he does it on seven distinct occasions. And then there's the slow motion, fast motion, jump cuts, freeze frames, rewinds, extreme close-ups, multiple exposures, title cards, recycled footage, old newsreel footage and random footage inserted for no apparent reason.

I'm never sure what frame of reference to use when watching this episode. Dolenz says, on the commentary track, that he was trying to make a serious point about the manipulation of American minds by the media. And the episode also seems to be a thinly veiled joke about the mellowing effects of marijuana. But then, at the sixteen and a half minute mark (out of twenty minutes total) we suddenly take a screeching hard left into science fiction. Alien? *Spaceship?* Where the heck did that come from? With time rapidly running out, the Expository Houseplant breaks one of the fundamental rules of writing: *Show, Don't Tell*.

That said, I must acknowledge three moments of absolute genius in *Mijacogeo*. The first is a variation on the old stuck-in-a-door routine, this time in the form of three Monkees trying to escape from a phone booth. The second is the cereal-box-top chant that rouses Peter from his trance; the third is the devious plot twist that has the police arresting the Monkees for the crime of tying up Glick and his henchmen.

Near the end of the episode, the title card "Typical Monkee Romp" appears. What follows is a decidedly un-typical romp, and I use the word "romp" only because that is the traditional term in this series for a filmed sequence set to music. No actual romping occurs. Instead, we get a slow-motion hike with lots of multiple exposures and freaky camera angles. The three Monkees can't run or even walk very fast, as they have to carry Peter (who has been frozen for a second time) and an ~~enormous potted plant~~ friendly alien, who may be able to talk but apparently can't walk.

I have to wonder how this episode might have been different if Dolenz had taken on only one extra job. If he had co-written the script and then turned it over to an experienced director, might the odd story have been more fleshed out and dressed up? Or, if he had been assigned to direct from a more polished script, might all the gimmicks and razzle-dazzle have served as a welcome layer of frosting on a more substantial cake?

Zingers

Micky: A two-headed org!
Mike: That's no probl—a two-headed org?
Davy: What'll we do? What'll we do?
Mike: Look it up in the Monkeeman mens— man— manual.
Micky: What?
Mike: The— the— the book! The book! The instructions!
Micky: Oh yeah, the book! Let's see, it says here... uh, a three-headed glebe, a six-eyed kreebage, three-thighed snark, six-headed org, four-headed org, ah! Two-headed org.
Mike: Yeah, that's it!
Davy: Well, what's it say to do?
Micky: Oh, yeah! 'To dispose of a two-headed org, jump up-and-down three times, roll a head of cabbage, and giggle.'

Micky: We gotta concentrate really hard on Peter, and now we gotta repeat this chant that I learned.
Mike: A chant you learned while studying transcendental meditation under an Indian mystic. Right? That's it?
Micky: No, no, a chant that I learned when I sent in a cereal box-top.
Mike: Well, that makes a whole lot more sense.
Micky: Right. Sure. Nam-myoho-renge-kyo... nam-myoho-renge-kyo...
Peter: This is incredible! I feel as though I were being impelled to move by a chant from the transcendental meditations of an Indian mystic.

Micky: *[No, Peter, it's a chant I got with a cereal box-top.]*
Peter: Oh.

Cultural Clarification
The title "Mijacogeo" refers to the members of Dolenz's family when he was young: Micky, his mother Janelle, his sister Coco and his father George. "Frodis" is a Dolenz-coined code word for marijuana.

"*Nam-myoho-renge-kyo*" is a very real Japanese Buddhist chant meaning, "I devote myself to the Lotus Sutra."

Let's See if We Can Slip This Past the Censors
The entire episode.

Sight Gag Highlight
Mike leans forward and nearly strangles Micky with the chain that goes around both their necks.

Physical Comedy Highlight
Three Monkees trying to escape from a phone booth.

Breaking the Fourth Wall, Times Seven

1 Mike: You think that was something, you should see what happens after the commercial!

2 Mike: You know what? It's 7:30, 6:30 Central Time. It's time for THE MONKEES. I wonder if anybody around here has a television set?"

3 Micky: It's working… it's working…
 Mike: How do you know? How do you know?
 Micky: I saw the last scene. I saw the last scene.

4 Davy: Okay, that's good fellas, but we still got some work to do. We got what's-his-name over there—
 Micky: Glick.
 Davy: Right. Glick. Let's do it again… Okay, that's good fellas, but we still got some work to do….

5 Title card: FREEZE FRAME.

6 Title card: PROP.

7 Title card: TYPICAL MONKEE ROMP.

Runner-Up Nitpick
How does Mike manage to get untied?

Nitpick
Throughout the episode, they conflate television station KXIW with Mammoth Studios.

Absolutely Not a Nitpick
I was going to accuse them of ripping off the Kreebage card game from *Star Trek's* Fizzbin; it's the exact same plot device used in exactly the same manner. But a little research is a good thing! The *Star Trek* episode *A Piece of the Action* first aired in January, 1968—more than a month <u>after</u> *Mijacogeo* was filmed.

We're the young generation, and we have something to recycle.
- Recurring footage: clips of cheering fans from *The Monkees on Tour*.
- Recurring setting: Mammoth Studios (See also *I've Got a Little Song Here* and *The Picture Frame*. Listen also to *The Monkees at the Movies*.)
- Recurring setting: TV station KXIW (See also *Some Like it Lukewarm*.) Not to be confused with station KXIU (*Captain Crocodile*, *Too Many Girls* and *Monkee Mayor*.)
- Recurring actor: Rip Taylor as Wizard Glick. (He was also the croupier in *Monkees on the Wheel*.)

Second Runner-Up Monkee Magic
Shared Imagination, Lost and Found edition.

Runner-Up Monkee Magic
Shared Imagination, Transcendental Meditation edition. Bonus power: mental telepathy!

Monkee Magic
Jump up and down three times, (conjure up and) roll a head of cabbage, and giggle.

What I want to know…
During the slow-motion romp there's a brief shot of producer Bert Schneider lying on a stretcher. What happened to him?

Snack to enjoy while watching *Mijacogeo*:
A box of cereal with a mystical chant on the boxtop.

Music
- *Zor and Zam*: narrative, albeit slow-motion romp.
- *Song to the Siren*: isolated performance by Tim Buckley.

Episode 2-26
Alternate Title: *The Frodis Caper*
Written by: Micky Dolenz, Dave Evans and Jon Anderson
Directed by: Micky Dolenz
Principal Filming Ended: 11/29/1967
First Airdate: 3/25/1968

Grading
- Big Brother is Watching You Watch Big Brother. **B-**
- Pass the Frodis. **C**
- The alien will explain what's going on. **D**

And the cookie goes to...
Dolenz, for his successful career as a director. The first one has got to be the hardest.

Quit while you can, Nesmith. If you withdraw, I'll leave you alone. But if you don't, I'll write a review of *Monkee Mayor.*

The In-Which
When the Monkees' neighbors start getting eviction notices from the city, Mike tries to fight City Hall.

Pirates. Spies. Aliens. Gangsters. Vampires. *Campaign Finance Reform?*

No, seriously—THE MONKEES somehow managed to come up with a half-hour of comedy about Campaign Finance Reform. What's very strange is that the whole sordid mess seems quite relevant even today, in the world of *Citizens United* and Super PACs.

Okay, it's not *only* about Campaign Finance Reform. It's also about eminent domain, influence peddling and corruption in the media. Comedy gold. But mostly it's about corporate interests holding sway over the political process, making it necessary for even the most raw, honest, independent-minded candidate to kowtow to the people with the bucks. *Monkee Mayor* has an intricate but subtle plot, long on complexity and just a little bit short on clarity. One has to pay very close attention, and maybe squint just a little, to comprehend the dirty trick that sinks Mike's campaign.

In my review of *The Devil and Peter Tork*, I couldn't speak highly enough of Nesmith's hesitant, fumbling delivery of his magnificent courtroom speech. He may have actually outdone that performance in this episode, but it's a little hard to tell because his address to the voters is so unfocused and rambling. I'm already puzzled as I watch it, still trying to figure out exactly what it is that Mike has supposedly done wrong, and by the end of the episode I'm

equally baffled by the corrupt mayor's sudden turn of heart. The resolution comes too easily and too quickly to be entirely satisfying.

But before we get to the speech, there's a solid story with several comedic scenes, lots of sly wit, seasoned with a just pinch of political satire. Not many belly laughs, but plenty of chuckles and smiles. Best of all, there's a rollicking good romp right smack in the middle of the episode, one that actually moves the plot forward with a song that fits the urgent mood perfectly.

I had mentioned earlier that there are occasional moments in the series that may have been perfectly acceptable at the time, but today make me a bit uncomfortable. Well, there's one of those problems with *Monkee Mayor*, and it's something they could not have possibly foreseen in 1967. A pivotal scene shows the guys breaking into the mayor's office in order to rifle through his files—and we're supposed to perceive this as a courageous act. Five years later, a similar break-in at a campaign office would touch off the Watergate scandal, throw the nation into turmoil, and bring down a presidency.

Zingers

Micky: And now I present to you, the candidate and his campaign manager. And his aide-de-camp… and his campy aide.

Peter: I bet it was political sabotooge.
Davy: How'd you know that?
Peter: I'm not a campy aide for nothing.
Micky: Why would they want to sabotooge us?

Peter: Hey, look! It's a half a check for a hundred dollars!
Mike: It's two halves of a hundred dollar check.
Peter: It's a check for two hundred dollars!
Mike: …
Peter: It's two checks for fifty dollars.

Production Note

This was the last episode filmed on the set during the spring of 1967. The next episode to be shot would be *The Monkees in Paris*; filming would not resume in California until September.

This was the last episode Monte Landis filmed for the show. Most of his episodes were shot back-to-back-to-back, all of them during a two month stretch in the spring of 1967.

Cultural Clarification

Micky: Let me speak to the head of the newspaper.
Publisher: The president of the typesetters' union is not here today; I am just the publisher.

In the middle of the 20th century, the union representing typesetters was a major power in the world of print news. In 1962 a typesetters' strike halted publication of all seven of New York City's daily newspapers for three months.

Second Runner-Up Sight Gag Highlight
George Washington.

Runner-Up Sight Gag Highlight
Abraham Lincoln.

Sight Gag Highlight
Lyndon Baines Johnson.

Physical Comedy Highlight
Davy, Mike, Peter and a pair of rubber gloves.

How's that Name Recognition thing working for you?
Nesmeyer, Neswash, Nesbaum, Nishwash.

Runner-Up Breaking the Fourth Wall
Where is Mike's hat?

Breaking the Fourth Wall (and the Ceiling)
Davy and Mike teasing Micky into repeating and correcting his "watch fob for a giant" punch line.

Second Runner-Up Nitpick
The election is coming up on Thursday; how can Mike get his name on the ballot so quickly?

Runner-Up Nitpick
Malibu was not incorporated as a city until 1991. As an unincorporated township, it was under the supervision of the Los Angeles County Board of Supervisors in the '60's.

Nitpick
Jamestown was founded in 1607. The pilgrims landed in at Plymouth Rock in 1620. I'm sure somebody settled somewhere in 1612, but it wasn't a particularly auspicious date in US history.

Absolutely Not a Nitpick
The complete quotation Mike is reaching for is, "Hunker down like a jackass in a hailstorm and wait till the wind stops blowing." And despite Davy's protestations to the contrary, President Lyndon Johnson really did say that.

We're the young generation, and we have something to recycle.
- Recurring gag: helping a little old lady across the street: (See also *Here Come the Monkees* and *Hillbilly Honeymoon*.)
- Recurring actor: Monte Landis as Mr. Zeckenbush. (He also appeared in *Everywhere a Sheikh, Sheikh*; *I Was a 99 Lb. Weakling*; *Monkees Marooned*; *The Devil and Peter Tork*; *Art, For Monkees' Sake* and *The Monkees Blow Their Minds*.)
- Recycled footage: scenes from *Monkee See, Monkee Die* and from the Phoenix concert in *The Monkees on Tour*.
- Recurring gag: What's the wool-hat guy's name? (See also *I've Got a Little Song Here* and *Monkees in Texas*.)

Runner-Up Monkee Magic
Shared Imagination, Hall of Presidents edition.

Monkee Magic
Peter conjures up a camera.

What I want to know…
How do the Monkees manage to slip out of the Mayor's office unseen?

Snack to enjoy while watching *Monkee Mayor*:
Mike is carving the roast, and Peter has a bottle of champagne. Watch out!

Music
- *No Time*: narrative romp.
- *Pleasant Valley Sunday*: isolated performance.

Episode 2-4
Written by: Jack Winter
Directed by: Alex Singer
Principal Filming Ended: 6/8/1967
First Airdate: 10/2/1967

Grading
- Mr. Nesmith goes to City Hall. **A-**
- They Paved Malibu and Put up a Parking Lot. **B-**
- Violation of title VI, section 43, paragraph 7 of the Campaign Finance Law. **C+**

And the cookie goes to...
Monte Landis, for reaching the end of his streak of seven guest roles on THE MONKEES.

Don't get up! Finish convalescing. I can teach my bags to write a review of *Monkee Mother.*

The In-Which
The rent is still late, so the landlord rents the pad to a lonely widow.

I am torn about this episode. On the one hand, it is rich in one element that I would normally rate very highly: character development. On the other hand, character development is pretty much the only thing the episode has. The heart of drama is conflict, and that's woefully lacking here; the only "enemy" is Millie, and the only danger is that Millie will love the Monkees to pieces. The climactic battle is a tense bout of matchmaking.

I want to like it, really I do, but this episode did not get better with repeated viewings. While there are some hilarious comedic moments, it keeps veering back into quasi-dramatic treacle. Rose Marie is a terrific comic actress, absolute dynamite as the singing gangster in *Monkees in a Ghost Town*, but here her character can't seem to settle down between rampaging eccentricity (the inanimate pets Louis and Merton are charmingly weird) and cloying sentimentality.

So, despite my yearning for solid character development, I have to say that the highlights of this episode come when character development is pushed to the back burner. The scene in which four exhausted Monkees lie inert on the deck is absolute genius, and I have to give special props (pun intended) to the way James Frawley arranged the actors physically on the set. The mid-episode non-musical romp in which Millie's nieces and nephews wreak havoc in the pad is an unexpected treat; it's rare to see the Monkees defeated by the same chaotic tactics they usually use against their evil foes.

In an episode that is sometimes heavy-handed with the dowdy, middle-age female stereotype, I deeply appreciate that they cast two of the hellion children as girls. And dressed them as soldiers, and gave them weapons, and let them be just as noisy and destructive as their brothers. And especially that they made little Alice the toughest of them all.

And while we're on the subject of breaking molds, there's the game of Southeast Asia dominos. I'm not sure what (if anything) they were trying to say there, but it was just a little flash of geo-political relevance, and I approve.

I am glad that they found such a perfect showcase for *Sometime in the Morning*. I'm not sure there is any other Monkees song that could have worked in that scene, or for that matter, any other Monkees scene that could have worked so well with that song. It was choreographed magnificently, and captures an intensely emotional moment with a minimum of fuss.

A Mild Complaint

There are a series of scenes in Act I that vividly demonstrate how Millie is sweetly, lovingly emasculating each of the Monkees. I appreciate structure in a story, and these scenes form that kind of structure—up to a point.

1. Millie has a touching conversation with Mike. She has him dressed in a frilly apron and measures him for a new sweater.
2. Millie has a motherly exchange with Micky. She scrubs his face with her handkerchief and guilts him into doing a chore for her.
3. Millie unburdens herself to Davy and tries to find him a girlfriend. (Like he needs any help on that score.)
4. Um... and then she...never gets around to talking to Peter.

Maybe Peter's close encounter with Millie got left on the cutting-room floor. I wouldn't mind the missing piece of the structure so much if it weren't for the first scene after the commercial break, where the three dejected Monkees discuss their plight. Meanwhile, Monkee number four has been reduced to the status of an infant. *Millie* didn't do that to Peter. *Micky* did.

Zingers

Millie: Who did this?
Davy: Did what?
Millie: Who made this dust, this filth? You?
Micky: What's today?
Mike: Huh? Monday.
Micky: Monday. Uh, it's Peter. Peter puts the filth down on Mondays.
Peter: It was nothing.

Micky: My arms. I can't move my arms.
Mike: I can't move your arms, either.

Mike: Mmm mrrr mrrr mmm rrr mmmr rmmrrr.
Arthur: Yes?
Mike: Mm rrrm rmm mr mrmrrm
Arthur: Alice, sweetheart, loosen his gag—I can't hear what he's saying.
Alice: No, Daddy, he's my prisoner!
Arthur: Okay, honey, cookie. You make him talk.
Alice: Talk!
Mike: Mmm *myinn* moo.

Clunker
Larry: Your Herman. He must have been a pretty great guy, I guess—I mean, the way you talk about him all the time and all…
Millie: He was an angel.
Larry: An angel.
Millie: He was an angel, but a man. A very, very nice man.
Larry: Millie—
Millie: Hmm?
Larry: I'm not an angel.
Millie: But you're a nice man, Larry. A very nice man.

Dear God in heaven, is that insipid excuse for dialogue the best they could do? These two are definitely going to have twin beds.

Runner-Up Sight Gag Highlight
Mike in a frilly apron.

Sight Gag Highlight
The four guys rejoicing, in silence, as Millie and Larry fall in love.

Absolutely Not a Sight Gag
That is actually a lovely sweater Millie knitted for Mike.

Absolutely Not a Sound Gag
Peter and Mike serenading Millie and Larry. Exquisite! Why couldn't we hear so much more of this?

Physical Comedy Highlight
Alice, Mark, Adam and Michelle: I do believe the Monkees have met their match.

Second Runner-Up Nitpick
Why is Mr. Babbitt so nice to Mike at the wedding? (And why is Mike shouting?)

Runner-Up Nitpick
Look Out (Here Comes Tomorrow) may be the second least appropriate song for a wedding reception. (*YMCA* is worse.)

Nitpick
Mike washes a plate. He hands it to Davy, who dries it. Davy hands it to Micky, who hands it back to Mike with a sly grin. Mike recognizes it as the plate he has just washed, rolls his eyes and tells Micky, "Don't do that." *And then he puts the plate back in the soapy dishwater.*

We're the young generation, and we have something to recycle.
- Recurring actor: Rose Marie as Millie Rudnick. (See was also Bessie "The Big Man" Kowalski in *Monkees in a Ghost Town*.)
- Recurring gag: a food vendor wanders through the scene. (See also *Royal Flush* and *The Picture Frame*.)
- Recurring catch phrase: "Don't do that." (Too many examples to count.)

Runner-Up Monkee Magic
Shared Imagination, Rex Harrison edition.

Monkee Magic
Shared Imagination, Eviction edition.

What I want to know…
I would have given good money to see the scene at the grocery store, where Millie convinces Clarisse to come home with her.

Snack to enjoy while watching *Monkee Mother:*
A slice of Millie's homemade cheesecake. What? You were expecting cupcakes in a sea of sour cream?

Music
- *Sometime in the Morning*: plot-related performance/fantasy sequence.
- *Don't Call on Me*: suppertime serenade.
- *Look Out (Here Comes Tomorrow)*: plot-related performance/dance.

Episode 1-27
Written by: Peter Meyerson and Bob Schlitt
Directed by: James Frawley

Principal Filming Ended: 1/19/1967
First Airdate: 3/20/1967

Grading
- Sweetly Sentimental. **C+**
- Enthusiastically Eccentric. **B+**
- Chaotic Kids. **A**

And the cookie goes to...
Little Alice, for valor on the battlefield, and for successfully interrogating her prisoner.

This is a recording. I'm sorry I can't be with you, but I'm dead. Well, what can I say, except: wish you would write a review of *Monkee See, Monkee Die.*

The In-Which
The Monkees are stranded overnight in a dead man's mansion.

That police detective had better arrest Madam Rozelle first, because she steals every scene she is in. Grand Theft Script, seven counts. The four Monkees do their very best to hold onto their scenes, and as long as Madam Rozelle is not on the set, they succeed handily. But the minute the spiritualist walks into the room, look out! She's gonna get your wallet and your wristwatch, too.

Fortunately, she's not on the screen all the time. She stays discreetly off-camera for the best scene in the episode, one of the most delightful of the entire series: an elaborate, patiently developed, elegantly crafted joke built entirely out of nonsense and whimsy, capped off with the improbably perfect punch line, "There is a message for you on the pigeon."

The rest of the guest cast—butler, travel writer, mousy little Damsel in Distress—barely make an impression. Writer Treva Silverman's *homage* to Agatha Christie's *And then There Were None* is clever and witty, but she doesn't have enough comic material to supply all her characters. And in the end, the delightfully creepy plot limps to a dismayingly weak conclusion. Three murders? No, the bad guys were just trying to give Ellie a good scare.

The show was still woefully new at musical romps, and it shows. In particular, the first romp to *Last Train to Clarksville* makes no sense in the context of the episode, or even as a stand-alone video for the song. It's just a messy mashup of vaguely transportation-related clips, everything from experimental airplanes to unicycles to a carousel.

Micky gets two opportunities to utilize his mad scientist skills in this episode. Early on, he rewires a radio receiver with the microphone from an old telephone, to create a radio transmitter. I give mad props to Micky for the radio. On the other hand… there's the knock-out pills.

Yeah. *Knockout pills.*

There are some things in this show that may have seemed funny at the time, but leave me flabbergasted today. Knockout pills? Seriously? What in the Sam Hill is Micky doing, experimenting with knockout pills? For *shame*, Micky. For *shame*.

Zingers

Mike: Let's see, all we got to do is strap a message to its leg and… um… there's already a message here, strapped to its leg.
Peter: What does it say?
Mike: It says, "Please do not strap a message to my leg. I'm not a carrier pigeon."

Mike: Now, see, all I gotta do is uh… put a message around his neck, and we can get him to… uh… he's already got a message around his neck.
Davy: Yeah? What's it say?
Mike: There is a message for you on the pigeon.

Madam Rozelle: Are you a friendly spirit? Knock two times for yes, four times for no.
Spirit: Knock how many times for yes?

Production Note

Tucked into the middle of the *Tomorrow's Gonna Be Another Day* romp is a brief clip from a Yardley Black Label commercial. Mike (wearing a black jumpsuit) runs towards a girl with open arms, but she runs right past him. In the commercial, we would see that's she's headed for Davy instead, who's wearing the sponsor's product.

Cultural Clarification

An alcoholic drink laced with a knockout drug is called a "Mickey Finn," after the Chicago saloon manager who used that technique to rob his patrons. The act of adding a knockout drug to a man's drink is known as "slipping him a Mickey."

How very appropriate.

Runner-Up Sight Gag Highlight

Madam Rozelle: Mansion is to be mine.

What do you know—she *does* read palms!

Sight Gag Highlight
Peter twirling his "fastest hand in the West," and Mike carefully making sure it's pointed away from him.

Mr. Harris Kingsley's Library
- *Twelve Walking Tours Through the Sahara*
- *Beverly Hills on Five Shillings a Day*
- *Who's Whom on Ellis Island*
- *Utica: City on the Move*
- *Dining Out in Greenland*
- *Picnic Spots along the Ganges*
- *Philadelphia: Where to Find It*
- *Akron: The City Behind the Myth*
- *A Teenager's Guide to Tijuana*
- *South Dakota: Fact, or Fiction?*

Breaking the Fourth Wall
Title cards: Did General Sarnoff really start like this?
 Micky's knockout pills give fast, FAST relief.

Fifth Runner-Up Nitpick
Last Train to Clarksville does not have an organ part. Mind you, they couldn't have known what song would be used in the episode, as it was filmed a full month before *Last Train to Clarksville* was recorded.

Fourth Runner-Up Nitpick
During the *Last Train to Clarksville* romp, a sign in the desert points "12 miles to Clarkesville." The name of the town is spelled wrong.

Third Runner-Up Nitpick
Mad scientist Micky rewires that radio to make it into a transmitter with his bare hands. No tools, not even a screwdriver. Oh—and Micky? Next time, unplug the radio before you start messing around with the wiring. That's a good boy.

Second Runner-Up Nitpick
In the first bedroom scene, the room has a casement window with a lace curtain. In the second bedroom scene, the room has a double-hung sash window with heavy drapes.

Runner-Up Nitpick
The guys hear two gunshots. They walk into the drawing room and see lamps knocked over, papers on the floor, pictures askew on the walls. They also see half a dozen knives stuck into

the walls in various positions. What they do not see is a body. Not even a pool of blood. How do they conclude that somebody has been murdered?

Nitpick
Davy matter-of-factly tells the police detective, "So then we put Micky's knockout drops in the wine decanter, and that was that." And the detective sends them home. Hello? Davy just admitted to using *knockout drops!*

We're the young generation, and we have something to recycle.
- Recurring plot device: choosing fingers. (See also *Dance, Monkee, Dance*; *The Monkees on the Line*; *The Monkees Get Out More Dirt* and *The Devil and Peter Tork*.)
- Recurring plot device: Davy gets stars in his eyes. (See also *Here Come the Monkees* and *Some Like it Lukewarm*.)
- Recurring gag: calling for help. (See also *Monkees in a Ghost Town* and *Monkees in Texas*.)
- Recurring catch phrase: "She's gone!" (See also *The Audition, Monstrous Monkee Mash, Monkees Marooned* and *Monkees Race Again*.)
- Recurring physical comedy: a Monkee jumps into another character's arms. (See also Davy in *Monkees at the Circus, The Monkees at the Movies, I Was a Teenage Monster, Monkees Marooned*; Micky in *The Monkees Blow Their Minds*).
- Returning actor: Lea Marmer as Madame Rozelle. (She is also Mrs. Smith in *The Monkees on the Line*.)
- Recurring stock footage: creepy castle (the first one) from *Monstrous Monkee Mash*.
- Recurring stock footage: creepy castle (the second one) from *I Was a Teenage Monster*.

Runner-Up Monkee Magic
Shared Imagination, Sherlock Holmes edition.

Monkee Magic
Davy teleports into and out of the suit of armor in the parlor.

Absolutely Not Monkee Magic, Though God Knows I Wish It Were
Peter: You're looking at the fastest hand in the West.

What I want to know...
Whose wallet was it?

Beverage to enjoy while watching *Monkee See, Monkee Die:*
A glass of sherry, please, and hold the knockout pills.

Music
- *Last Train to Clarksville*: quasi-performance with random clips and stock footage about various modes of transportation.
- *Tomorrow's Gonna be Another Day*: not very narrative, playful romp.

Episode 1-2
Written by: Treva Silverman
Directed by: James Frawley
Principal Filming Ended: 6/24/1966
First Airdate: 9/19/1966

Grading
- And Then There Were Four. **B**
- Madam Rozelle Hears Dead People. **A+**
- Professor Plum in the Library with a Lead Pipe. **C-**

And the cookie goes to…
The pigeon and the St. Bernard.

You're a nail-biter. You're a nail-biter and your mother never, ever loved your review of *Monkee Chow Mein.* You are too short. You are too short and you have no ear for *Monkee Chow Mein.* You're ugly. You're an ugly episode. Ugly, ugly—ooh! are you ugly. Nobody likes *Monkee Chow Mein*, least of all me.

The In-Which
Peter stumbles into a spy plot involving Chinese fortune cookies and a super-secret Doomsday Bug.

There are a handful of episodes that have been causing me some distress. This one, so much so that I was astonished to notice that I had skipped right past it in the alphabetical order of episodes. (In my master list I had spelled it "*Monkees Chow Mein,*" putting it nine slots lower in the list, after *The Monkees Blow Their Minds*.) Anyway, the error has been discovered and, after reviewing *Monkee Mayor, Monkee Mother* and *Monkee See, Monkee Die,* I am finally facing up to the one I've been dreading.

The thing is, I would very much like to be able to dash off a few sentences about how horribly offensive the stereotyping is, not to mention the use of non-Asian actors in heavy eye makeup, then move on to the next episode. Don't think it hasn't occurred to me! But the truth is, mixed in with all the horribly offensive stereotyping is a lively plot, some solid character development and a handful of wonderfully entertaining moments. The question is, can I hold my nose and address the worthy material in the episode? Or must the entire exercise be condemned?

I must have watched this episode 15 or 20 times over a weekend. I considered writing in praise of the exquisite Monkeemen segment, and the heartwarming scene in which the guys

get ready for bed, and the strangeness of seeing future *M*A*S*H* doctor Mike Farrell as a straight-laced young spy. But with each successive viewing, the episode's many stereotype elements seemed to get worse and worse. Eventually I asked myself how I would have reacted if it had been an episode about African spies using comically exaggerated approximations of African costumes on white actors in blackface makeup, banging on drums and hamming it up with crude approximations of an "African" accent.

That settled it. The episode is intolerably racist; it automatically gets a failing grade. I'm not sure how I will proceed on other stereotype episodes; I'll have to take them as they come.

But before I move on, I will make one more positive observation about *Monkee Chow Mein*:

In the teaser, Mike says, "Orientals are a curious people." Taken in isolation, that's a fairly racist comment (not attributed to Nesmith, I hasten to add—it was in the script and he was doing his job.) A moment later, with a white man's gun to his head, he adds, "Occidentals are a curious people." This is both a sophisticated play on words and a profound philosophical statement. The most common meaning of *oriental* is *Asian*. But when used in juxtaposition with the antonym *occidental*, the word has a completely different meaning. The original definition of *oriental* is *eastern* and *occidental* means *western*; together, the two words encompass the entire world.

In other words, Mike observed that ALL humans are a curious people.

Zingers

Inspector: Speed is not as important as secrecy. In our business, secrecy is our most important weapon. Utter secrecy!
Monkees: Secrecy, secrecy, secrecy, secrecy....
Inspector: What are you doing?
Mike: Uttering "secrecy."

Dragonman: You expect me to believe you make money, singing like that?
Micky: I didn't say we make money. I said we sing.

Mike: This looks like a job for...
Mike & Davy: Monkeemen!
Davy: Up, up and away—
Mike: What is this "up and away" thing?
Davy: I wanna fly, man. Gonna fly.
Mike: Why? Why you gonna fly, man, the restaurant's a half a block.
Davy: Oh, is it?
Mike: Yeah.
Davy: We better walk, then, hadn't we?

Breaking the Fourth Wall
Micky: Hey, Dragonman! Call off your goon. I don't like the way he's acting.
Dragonman: You're no Lawrence Olivier yourself.

Second Runner-Up Nitpick
Concerned about their security, Mike takes care to secure the front door before going to bed. Why doesn't he bother locking the door to the deck?

Runner-Up Nitpick
Even today, in the age of DNA sequencing, you can't create a bug, or a germ, or any kind of living creature with a chemical formula.

Nitpick
Any fourth grader would be able to tell you that the Doomsday Bug is a spider.

We're the young generation, and we have something to recycle.
- Recycled catch phrase: "Don't do that." (Too many examples to count.)
- Recurring sight gag: *Reptilicus*. (See also *The Audition, I Was a Teenage Monster, Monkees Marooned* and *The Monkees Mind Their Manor*.)
- Returning actor: Joey Forman as Dragonman. (He was also the title character in *Captain Crocodile*.)

Runner-Up Monkee Magic
Mr. Schneider puts up a fight. Good for him! And later, in the Dragonman's lair, he turns his head and winks. (I don't know how he manages to escape, though.)

Monkee Magic
Monkeemen! Now with Super Psychological Warfare Powers!

What I want to know…
Did they even consider hiring Asian actors to play Dragonman and his sidekick Toto?

Snack to enjoy while watching *Monkee Chow Mein:*
A medium pizza, with anchovies, sausage, onions and a lotta cheese. And a large one, with prosciutto, peppers, and no anchovies because they're salty.

Music
- *Your Auntie Grizelda*: vaguely narrative romp.

Episode 1-26
Written by: Gerald Gardner and Dee Caruso
Directed by: James Frawley
Principal Filming Ended: 1/6/1967
First Airdate: 3/13/1967

Grading
- Overall Grade. **F**

And the fortune cookie goes to...
Inspector Blount of the Central Intelligence Service has seized the fortune cookie and stored it in his safe. Utter secrecy.

To preclude the variable factor inherent in the human equation, we have instituted this new electronic review of *Monkee vs. Machine.*

The In-Which
Mike gets a job at a toy factory where computers make the decisions.

When I first loaded this one into the DVD player, I thought I was in for a treat. After all, isn't this the episode with the hilarious interview between Peter and the computer? Mr. Notwatt Watt? Occupation: peat digger? Pure comedy gold.

And yet, before I even got to the first romp, my attention was wandering. No problem—I knew I would watch the episode many times over in the course of several days, plus a couple of extra times for each of the commentary tracks. And yet, no matter how many times I hit the rewind, I just couldn't bring myself to stay focused beyond those first few scenes. Where had it all gone wrong?

My first clue came when I sat down to transcribe dialogue for the Zingers, I didn't find much worth copying beyond that first, hilarious interview. The dialogue simply isn't all that funny. Legendary comic Stan Freberg brings little humor to the character of Daggart, who is snide, petulant and generally unpleasant, occupying a straight-man role against the Monkees and his scatter-brained boss. As it turns out, the scatter-brained boss is the highlight of the episode; Severn Darden's comedy is understated, but pleasantly loopy.

The episode pairs up three Monkees in drag with three different Monkees in knickers, in a very neat rotation. I normally applaud such tight structure in a story—and yet, the laughs are as artificial as the boo-track used earlier in the episode, punctuated with freeze frames and awkwardly unfunny title cards ("Possessive Mother" and "Send this boy to camp!"). The

whole mess is capped off with a fusty old gag in the form of an unattractive woman, a tear-away skirt and a large pocketbook.

The theme is driven home with a sledgehammer, over and over again: computers can't replace people. There are no twists, no surprises, no delights. The ending is pale and contrived, with a feeble final joke—the boomerang crashing through the window Peter had just closed—that is not funny at all. How could an episode about *toys* be so serious?

The two musical interludes reflect a startling contrast as the series continued to try to figure out how to use this new style of filmmaking. *Saturday's Child* is a joyful, if somewhat irrelevant day of goofing off on the beach. On the other hand, *Last Train to Clarksville* accompanies a slightly more narrative sequence, capping off the episode with bleak, colorless images and a theme of drudging physical labor.

Zingers

DJ61: Take a seat, please. To preclude the variable factor inherent in the human equation, we have instituted this new electronic personnel procedure, requiring...your name, please.
Peter: What?
DJ61: Thank you. Last name, Watt. And your first name, Mr. Watt?
Peter: N— it's not "what."
DJ61: Notwatt. Mr. Notwatt Watt.
Peter: Wait a minute—that's not my name at all. My name is—
DJ61: Occupation?
Peter: —Peter. You dig? Pete.
DJ61: You dig peat. Occupation: peat digger.

Clunker

Mike: Look, man, it's okay. Besides, you got something the machine don't have.
Peter: Hmm.
Mike: You got friends.
Micky: Hey—you got some friends, Pete? Bring them over someday!

When I was a very young viewer, I developed a vague dislike for Micky's character—because of lines like this one. Yes, I know he was kidding. But it was a cruel sort of humor, kicking a man when he's down.

Let's See if We Can Slip This Past the Censors

Mike: Tell me about your mother and father.
DJ61: My mother was a duplicating machine.
Mike: Sex?
DJ61: Dddrrrrrr. [smoke billows from vents]
Mike: Oh, I bet you're a real swinger when you're turned on.

DJ61: Rrrrrrrrr. [more smoke]
Mike: What a dirty old man.

Runner-Up Sight Gag Highlight
Mike tying Peter's tie in a square knot.

Sight Gag Highlight
The telephone's hiding place under the faux chessboard.

Breaking the Fourth Wall
Title cards: The Face of a Genius?
 Do you believe this?!?
 Will he lose his temper?
 Possessive mother.
 Send this boy to camp!
 You can't fool a Monkee!

Second Runner-Up Nitpick
The whole point of Pop Harper's toy is that it is *flexible*—an imaginative child could bend it into any shape. By the time the Monkees are done with the toy, it is fixed in a boomerang shape. That's not the same toy at all!

Runner-Up Nitpick
Peter is looking directly at the secretary when he asks, "Where is he?" She replies, "You're looking at him." At that moment, Peter is probably supposed to be looking into the room where computer DJ61 was waiting; as it appeared, the secretary is claiming to be the personnel director herself.

Nitpick
In order to preclude the human error, let me just point out that halfway through the interview, computer DJ61 transposes Mr. Notwatt Watt's first and last names.

We're the young generation, and we have something to recycle.
- Recurring catch phrase: "Don't do that." (Three times in this episode; other examples far too numerous to count.)

Monkee Magic
Unless you count Micky's brief lion-taming act, this episode is entirely Monkee-Magic free. Very sad.

What I want to know...
Did Guggins' toy company really invent the See 'n Say? Three different versions of that distinctive Fisher-Price toy appear in three different places in the toy company, including a display case in Mr. Guggins' office.

Snack to enjoy while watching *Monkee vs. Machine:*
Four and twenty blackbirds, baked in a BOOM!

Music
- *Saturday's Child*: playful, non-narrative romp.
- *Last Train to Clarksville*: laborious, non-narrative romp.

Episode 1-3
Written by: David Panich
Directed by: Robert Rafelson
Principal Filming Ended: 6/17/1966
First Airdate: 9/26/1966

Grading
- Open the pod-bay doors, Peter. **A**
- 7 Habits of Highly Distracted People. **A-**
- I don't want to work, I just want to bang on the drum all day. **C+**

And the cookie goes to...
Severn Darden as J.B. Guggins, Jr. With just a handful of lines and a bit of understated physical comedy, he steals the show from the big guest star, Stan Freberg.

Now, we're all friends here. Would you like some coffee? Cream? Sugar? Two lumps? Get this young man some coffee—and a review of *Monkees a la Carte*.

The In-Which
Gangsters take over a neighborhood restaurant where the Monkees have a gig.

Last time, it was a sober, serious episode about toys. Now it's a silly, slapstick outing that is, without a question, the most violent episode in the entire series. There are other shootouts on THE MONKEES—*Hillbilly Honeymoon* has two of them, for pity's sake—but only in *Monkees a la Carte* do we have an actual body count. Black humor? Mike and Davy play tic-tac-toe on the floor while the bullets are flying overhead and the gangsters are dying all around.

THE MONKEES had many memorable, eccentric, fun-to-watch villains in the course of its two-year run. Even cold-hearted gangsters—Bessie Kowalski and Babyface Morales come to mind—could be delightfully nutty. Perhaps, given their grisly destiny, it's just as well that Fuselli, Rocco, and the quartet of lesser hoods were never developed as characters so much as caricatures. We never get to know them, so we don't have to care when they all die.

Sadly, the elderly restaurateur Pops is just as two-dimensional as the hoods. And the cops aren't much better—although cops, like most authority figures on the show, never seem to be much more than obstacles. So it's up to the four Monkees to embody all the humor, hope and humanity in this episode. And they do! They carry the show by force of frenetic energy and boundless determination, if not by actual skill or expertise. They just keep trying one course of action after another, stumbling and bumbling and plugging away at the problem until the problem ultimately resolves itself.

The scene in which the Monkees don't actually discuss or vote on whether they want to help Pop is funny, but it seems very odd for the normally gallant Davy to be the one objecting to the dangerous mission. If only Pop had a beautiful daughter, Davy probably would have been leading the charge.

(I'm not Your) Steppin' Stone accompanies one of the best first season romps, a kitchen-themed frolic with a tight connection to the plot. The brief reprise after the shootout doesn't make a whole lot of sense, and is probably just filler—it would be nice to know how the Monkees get out of trouble with the police. The episode-ending performance of *She* would be much better if it were shot in front of a crowd of appreciative diners in Pop's restaurant and not in front of some anonymous blank wall.

Zingers

Mike: We have a motion to deal with Mr. Fuselli. Can I have suggestions from the floor?
Peter: The floor has nothing to say.
Micky: Try the wall.
Peter: The wall says... try the ceiling.
Mike: All right then, it's voted and agreed that we try and get the restaurant back from Mr. Fuselli.
Davy: What vote? Was I out of the room or something?
Peter: What do we do about Pop?
Mike: Peter—get down from there! We've already voted.
Davy: What vote?
Mike: Micky, will you please read him the minutes of the meeting?
Micky: A minute and twelve seconds. That's a new meeting record!

Rocco: Nobody leaves the meeting.
Peter: Oh yeah? Who says so?
Rocco: This gun says so.
Peter: Well, this gun says, "I go."
Rocco: Oh, yeah! Hurry back.

Clunkers

Micky slapping Peter once is bad enough. Yes, it's funny, but it's also uncomfortably cruel. Trying to do it a second time, in the police station, is no longer funny. This makes for two episodes in a row in the alphabetical order where I've had to single out Micky for picking on Peter. Don't make me do it again, Micky.

Runner-Up Physical Comedy Highlight

Davy vs. an onion.

Physical Comedy Highlight
Micky demonstrating how the Monkees deal with people they don't like. Okay, I admit it. It was funny. *Once*.

Sight Gag Highlight
Peter taking suggestions from the floor.

Oh, gross! There is no way I can ever un-see that.
Peter sneezing over a tray of salt and pepper shakers.

Breaking the Fourth Wall
Micky: The director thought we should have a pretty girl in the show.

Third Runner-Up Nitpick
When Peter says, "Is it true that that there are no two glove prints alike in the world?" he is badly out of focus. Well, okay—Peter is *often* out of focus; in this case, it's the *camera* that's out of focus.

Second Runner-Up Nitpick
At the outset of the shootout, Micky says that five people should be able to get along—then quickly revises that number to four when the first body falls. But there are six people shooting when he starts talking, and five after the first body falls.

Runner-Up Nitpick
What happened to the rest of Pop's restaurant staff? Did Fuselli fire the cooks, servers and other employees in order to hire the Monkees cheap?

Nitpick
Never put a time reference in front of me, it's like waving a red flag in front of a bull. From Mike's first gavel until Micky's reading of the minutes ("a minute and twelve seconds," he said) exactly 50 seconds elapse. Now *that's* a new meeting record.

We're the young generation, and we have something to recycle.
- Recurring gag: nobody knows how to use a tape recorder properly. (See also *Royal Flush* and *The Audition*.)
- Recurring gag: blowing up the wrong thing. (See also *Alias Micky Dolenz* and *Son of a Gypsy*.)
- Returning actor: Dort Clark as the Inspector. (He also played an LAPD sergeant in *The Picture Frame* and a Las Vegas police detective in *Monkees on the Wheel*.)
- Returning actor: Helene Winston as Big Flora. (She was also Mrs. Drehdal in *The Monkees on the Line*.)

Third Runner-Up Monkee Magic
Shared Imagination, *Day at the Races* edition.

Second Runner-Up Monkee Magic
Micky conjures up a yellow balloon ("Blow"). Later, Micky and Mike conjure up pompoms.

Runner-Up Monkee Magic
The band conjures up Purple Flower Gang disguises. Over and over and over again.

Monkee Magic
Peter conjures up a gun that says, "I go."

What I want to know...
How tough is it to find purple flowers?

Snack to enjoy while watching *Monkees a la Carte:*
A dish of spaghetti, and a side of ravioli with some grated cheese. And some red wine so we can have a toast.

Music
- *(I'm Not Your) Steppin' Stone*: Playful (albeit work-related) romp.
- *(I'm Not Your) Steppin' Stone (reprise)*: Collection of chase-scene clips from other episodes.
- *She*: Allegedly plot-related performance with random historical footage of bathing beauties and dancers.

Episode 1-11
Written by: Gerald Gardner & Dee Caruso and Bernie Orenstein
Directed by: James Frawley
Principal Filming Ended: 8/12/1966
First Airdate: 11/21/1966

Grading
- Like sands through the hourglass, so are the minutes of our meetings. **A-**
- Food, glorious food! **A**
- This town ain't big enough for the nine of us. **X - X - O**
- Our purple apple-dumpling flower-in-the-wall gang that can't shoot straight. **B**
- Another one bites the dust. **PG-13**

And the cookie goes to...
Whoever makes the coffee at the police station. Peter confessed to the sinking of the Lusitania!

Rob Roy! Melanie has turned in her review of *Monkees a la Mode.* It is accurate, truthful, and completely factual. Is she out to destroy us?

The In-Which
An innocent young writer recommends the Monkees for a feature article in a fashion magazine.

The usual pattern for a MONKEES episode is for the guys to be on the defense against some sort of evil antagonist. It's a bit of a stretch to say that's the case here; Madame Quagmeyer and Rob Roy Fingerhead may be pretentious snobs, and dishonest ones at that, but they are just doing what they do in the normal course of business. No crime is committed, except an assault on the band's dignity and the murder of Toby's innocence.

So the Monkees are cast as aggressors, cheerfully and enthusiastically exposing the arbiters of taste for the conceited charlatans that they are. The buildup is a delightful series of culture clashes, from Rob Roy's initial disdain of the pad to the chaotic romp that turns the magazine's office into a Monkees playground.

I can't claim to know anything about what was considered good taste in the 60's, and I'm not all that certain about what is considered good taste in the new millennium. But this would be the appropriate place to say that I've always been charmed by the eclectic collection of *stuff* that fills the Monkees' home. They may have collected all that stuff through months of applied dumpster-diving, but the pad definitely has style—not altogether different from the cluttered style of the *Chic* offices.

I do think the banquet scene goes a step too far, taking a clever but slender concept and milking it to death. There had been so much wonderful material in the several scenes pitting

the Monkees against the Chic staff; I believe the episode would have been better if they had cut the banquet scene by half and used the time for more person-to-person interactions.

Monkees a la Mode has another one of those story elements that may have been funny back in 1967, but today is in poor taste. The sight of a young man with no hair was once sufficiently shocking to be used for comedy; here it raises a gasp from the assembled guests, disgust from Madame Quagmeyer and from the rock, he tosses the rock on the floor a loud guffaw from the laugh track. Today, one would probably assume that Davy was seriously ill. Not all that unusual, and not funny in the least.

Zingers

Mike: Says here, necklines are plunging lower every year. This year, the V will go down to the tummy in something of a peek-a-boo effect. Get in the swing of fashion and have your own navel observatory.

Davy: You must be joking.

Mike: You're right, I am, it doesn't say that at all.

Davy: Hey, hey. Listen to this. "Why not take little metal bottle tops and nail them to your living room floor. It gives you the impression that you are walking upon little... metal... bottle tops."

Micky: The British are coming! The British are coming! Oh—three bells, lanterns for the... sea by tonight, two by the sea... The British are... the British are co... the British are coming... over to my house, for a party tonight.

Cultural Clarification

It was once quite common for magazines to publish novels in serial (Peter's joke: cereal) format, a chapter or two in each issue. This was a double-edged pun, as Kellogg's was the show's primary sponsor.

Let's See if We Can Slip This Past the Censors

Toby: You see, what we want to do is show what you are, and the way you live.

Davy: What, do you want to get us arrested?

Runner-Up Physical Comedy Highlight

Davy going nose-to-door while trying to look out the peephole. Twice.

Physical Comedy Highlight

Mike poking Micky in the cheek with his violin bow, prompting a fencing match.

Runner-Up Sight Gag Highlight

Peter trying to connect with a pair of gilded cherubs.

Sight Gag Highlight
The four Monkees striking a dramatic pose, just before Toby arrives with the magazine.

Runner-Up Breaking the Fourth Wall
Peter's impromptu Kellogg's commercial. (This month, it's cornflakes.)

Breaking the Fourth Wall
Clips from the show's closing credits flash on the screen every time the Typical Young Americans of the Year award is mentioned.

Second Runner-Up Nitpick
When Mike unwraps the note from the rock, he tosses the rock on the floor. He then reacts as if the rock landed on his foot—but it's clear from the direction he tossed it that it wouldn't have come anywhere near his foot.

Runner-Up Nitpick
Telegrams are not delivered by phone.

Nitpick
They keep a hatchet in an overhead light fixture? Okay, so they keep the lantern in the refrigerator, but at least the lantern in the fridge can't kill somebody during an earthquake.

Runner-Up Absolutely Not a Nitpick
Paul Revere was, indeed, captured by the British before he could finish his famous ride.

Absolutely Not a Nitpick
Many years later, Dolenz would become an avid polo player. I wonder what *else* Rob Roy Fingerhead got right?

We're the young generation, and we have something to recycle.
- Recycled costume: Rob Roy apparently bought that hideous plaid double-breasted suit with all the shiny brass buttons from the same discount rack at JC Penney where the Monkees found theirs. (See *Captain Crocodile*, then rinse your eyes with a mild saline solution.)
- Recurring gag: Mike topples over while frozen. (See also *The Spy Who Came in from the Cool*; *Art, for Monkees' Sake* and *Monkees on the Wheel*.)
- Recurring line: "Don't do that." (Too many references to count.)
- Recurring gag: the Monkees strike a "hello" chord. (See also *Everywhere a Sheikh, Sheikh*; *The Monkee's Paw* and *Some Like it Lukewarm*.)

Runner-Up Monkee Magic
Shared Imagination, US history edition.

Monkee Magic
Reverse conjuring: "We have nothing to lose but our shirts."

What I want to know…
As the guys wait for the magazine to arrive, Davy tries to feed a sandwich to a toy giraffe, then slaps it to the ground when it won't take a bite. Is there some cultural reference I'm missing here?

Snack to enjoy while watching *Monkees a la Mode*:
Pheasant under glass.

Music
- *Laugh:* playful, subversive romp
- *You Just May Be the One:* isolated performance (from *One Man Shy*)

Episode 1-24
Written by: Gerald Gardner and Dee Caruso
Directed by: Alex Singer
Principal Filming Ended: 1/12/1967
First Airdate: 2/27/1967

Grading
- *Better Pads and Gardens.* **A**
- *Cool Cats Quarterly.* **B+**
- *Lifestyles of the Impoverished and Obscure.* **A-**

And the cookie goes to…
Valerie Kairys, shining brightly in her one credited role on THE MONKEES. She appeared in thirteen episodes altogether.

Victor gets these sullen periods. He's upset because the crowds would rather read a review of *Monkees at the Circus.* (By the way, what do you do?)

The In-Which
The Monkees visit a circus that has fallen on hard times.

There are several episodes of this series that just look like they were done on the cheap. This one, for example, looks as though it were shot in a cramped corner of a soundstage. Which wouldn't be so bad if it were one of those episodes that takes place in and around the pad, or in an everyday indoor location like a restaurant or an office. But this episode is about a *circus*, for heaven's sake—you know, "It's great, it's terrific, it's the best show on earth!" Of course they didn't have the money or the time to do it right—on location, with an actual circus—but they should have at least taken extra care to apply the tools of illusion to make it *look* right.

What this episode has going for it is a moderately compelling story. Like *Captain Crocodile*, which follows right behind it in broadcast order, *Monkees at the Circus* focuses its attention on the changing face of entertainment, in particular rock and roll's growing share of the cultural landscape. Pop's old-fashioned circus is in dire straits, the performers unpaid and the animals unfed.

Unlike the vain TV host, Captain Crocodile, the circus performers are already on the down-and-out and are preparing to give up completely. There's no fight left in them—so in this instance, the Monkees have to supply all the energy and the impetus to continue. In an intriguing twist, the underlying "villains" of the piece are those awful, long-haired musicians entertaining the crowds in the discotheques. The Monkees must convince the dispirited and resentful circus performers that they're all together on the side of good entertainment, wherever it can be found.

Okay, that's the good part. And if the bad part is the cheesy, underfunded production values, what we're left with is a brave, earnest effort to put on a good show without a net. Richard Devon delivers a strong performance as the hard-hearted knife thrower Victor, but other performances range from forgettable to downright stilted. The nearly constant flow of Monkee Magic provides a bit of flash-bang distraction until the episode finally sputters to a close.

Zingers

Susan: He's upset because the crowds would rather watch the rock and rollers than him.
Monkees: Oh, that's terrible.
Susan: By the way, what do you do?
Monkees: We're brain surgeons!
Mike: Except in the summertime, I'm a cotton picker. It's a carryover of skills.
Micky: Say a few words to the folks.
Mike: This is Mike Nesmith with the farm report. How are you. Pigs is up twelve, hogs is down five and cows is fine like they are.

Victor: Who are these people?
Davy: Who are we? Would you say 'who are these people' to the Budapest String Quartet?
Victor: I still say, who are you?
Peter: We are the Budapest String Quartet.

Victor: What exactly is it that you do?
Peter: That is rich! What do we— We cross a tight wire at five hundred feet above the ground.
Victor: Do you use a net?
Peter: No, just a little spray.

Clunkers

Peter pretending that the ringmaster's megaphone is a machine gun. The circus provides enough material for a dozen little-boy fantasies; why bring violence into it?

Micky: Hey, we better look this place over. It doesn't look like it's going to be here too long.

Isn't that exactly what they're striving to prevent? Micky's cynical dismissal of the show's chances of survival is diametrically opposed to the episode's hopeful theme.

Strong Man: Hey, they're not too bad.
Sword Swallower: You know, they are like... I think they are show folks.
Juggler: You know, let's do a show.
Sword Swallower: You know, you folks, you look like real show folks to me.
Strong Man: Yeah. Let's all do a show.

The sentiment is golden, but the dialogue is plastic and the acting is wooden.

Cultural Clarification
"It's great, it's terrific, it's the best show on earth—" It's the theme song from Dolenz's first TV series, *Circus Boy* , which aired from 1956 to 1958.

Runner-Up Physical Comedy Highlight
The Mozzarella Brothers' high-wire act.

Physical Comedy Highlight
Micky making himself right at home at the circus. If only they could have brought an elephant into the story!

Sight Gag Highlight
Brain surgeons! And one part-time cotton farmer.

Runner-Up Breaking the Fourth Wall
Micky whispering Mike's lines to him in the first Mozzarella Brothers scene.

Breaking the Fourth Wall
Mike: What *is* that?
Micky: It's a theme song, from an old TV series.

Fourth Runner-Up Nitpick
Victor is quite incensed that the Mozzarella Brothers are not real trapeze artists. So much so, in fact, that he uses the word "trapeze" three times in just a couple of sentences. Mike had said that they were aerialists, but they had never described their routine as anything other than a tightrope act.

Third Runner-Up Nitpick
If one can believe the stock footage shown during the musical number *She*, the circus does indeed have a trapeze act.

Second Runner-Up Nitpick
Speaking of *She*: a crowd shot shows that the circus band is playing at the same time the Monkees are performing.

Runner-Up Nitpick
Various circus performers speak to Davy, Mike, Micky and Peter about the Mozzarella Brothers as though they do not know that Davy, Mike, Micky and Peter ARE the Mozzarella Brothers. But later, when Victor overhears the Monkees admitting to being a rock and roll

band, he exposes them to the other circus performers as though they are all aware of the aerialists' dual identities.

Nitpick
Davy actually throws a knife at Susan and Peter. He manages to stick it just a few inches away from Susan's left ear. (Victor's first throw, by contrast, hits about a foot away from Susan's head.) I don't know whether to be impressed that Davy did such a good job, or furious that he would even try.

Third Runner-Up Circus-on-the-Cheap Nitpick
Susan sits in daylight as she watches the Mozzarella Brothers rehearse their act, but they are shown against a solid black backdrop.

Second Runner-Up Circus-on-the-Cheap Nitpick
The stock footage of a real circus used in the second act does not match the footage shot on the soundstage. The lighting is different, the sets don't look anything alike, and the crowd shots show fashions from the 1950's. (The parking lot is full of 1950's cars, too.)

Runner-Up Circus-on-the-Cheap Nitpick
The least they could have done was have the actor who plays Pop record a new voiceover for the stock footage of the real circus. Instead, we have two completely different ringmasters' voices.

Circus-on-the-Cheap Nitpick
The two musical numbers (I'm not going to call them romps) are recycled from other episodes and are painfully out of continuity with the episode. They both were clearly shot in other physical locations, at the wrong times of day, with the Monkees wearing the wrong costumes.

We're the young generation, and we have something to recycle.
- Recurring gag: a Monkee jumps into another character's arms. (See also Davy in *The Monkees at the Movies*, *I Was a Teenage Monster*, *Monkees Marooned* and *Monkee See, Monkee Die*; also Micky in *The Monkees Blow Their Minds*.)
- Recycled prop: the knife-throwing rig from *Son of a Gypsy*.
- Recycled joke: Victor's sullen periods last two or three years. (See also Marco's sullen periods in *Son of a Gypsy*. These two episodes do not share any writers, but Dolenz himself may have remembered Maria's joke from the earlier episode.)

Monkee Magic (Special Report)
In the rarified atmosphere of the circus, the lines separating reality, imagination and magic are easily blurred. The circus is a Monkee Magic playground! The guys leap from one Shared

Imagination fantasy to another, conjuring props and costumes, teleporting, and playing fast and loose with the laws of gravity.

Perhaps it's Susan's innocence, or her nature as a child of the circus, but she is neither fooled nor fazed by any of the strange things these four young men can do. Nor do the Monkees seem at all concerned that Susan is in on their secrets. Pop and Victor are easily deceived by the Mozzarella Brothers' well-intentioned scam, but Susan recognizes the guys from the start—and is not the least bit surprised when they change back into their normal identities in the blink of an eye. Later, she frets as she watches them attempt a Monkee Magic approximation of a high-wire act, and is not startled when the exercise ends and the guys are instantly sitting beside her in their normal clothes.

What I want to know...
This episode was filmed 5 weeks <u>before</u> *Monkee Mother*. And yet, the softly lit twilight performance of *Sometime in the Morning* was clearly filmed for that episode, not this one. So what music was originally supposed to be used for the clowning scene?

Snack to enjoy while watching *Monkees at the Circus:*
We can't even afford to feed the animals. You could swallow a sword....

Music
- *Sometime in the Morning:* isolated performance (borrowed from *Monkee Mother*) interspersed with a clown act.
- *She*: plot-related performance (borrowed from *Monkees a la Carte*) interspersed with stock footage of some other circus.

Episode 1-22
Written by: David Panich
Directed by: Bruce Kessler
Principal Filming Ended: 12/13/1966
First Airdate: 2/13/1967

Grading
- Circus Boys. **A-**
- She's certainly not a Bimbo. **B**
- The Invincible Victor. **Redundant**
- There's no folk like show folk. **Wooden**
- Not particularly great, certainly not terrific, hardly the best show on earth. **C-**

And the cookie goes to...
Little Mickey Braddock, Bimbo the Elephant, and the cast and crew of *Circus Boy*.

No longer shall we suffer the slings and arrows of outrageous Catalina. On the morrow we shall show that popinjay a review of *The Monkees at the Movies.*

The In-Which
The Monkees are hired as extras for a teen beach movie.

I'm glad that this episode comes so soon after *Monkees a la Mode* in the alphabetical list. The two episodes have a similar theme: the Monkees are invited into a strange, new culture, where they endure insults and indignities from the snobs of the in-crowd before cheerfully deciding to wreak revenge—Monkees-style. Come to think of it, that's a natural feel-good theme to appeal to a fan base of teens and tweens.

By happy coincidence, a major difference between the two episodes is that the movie episode has far more *plot*. In *Monkees a la Mode* the guys were swept instantly from obscurity to the very center of the whirlwind; in *The Monkees at the Movies*, on the other hand, the story has a more measured pace. The guys start out as mere extras; they are introduced gradually to the world of movie-making, lurking on the edges of the set for a while before falling victim to the star's overblown ego. Then their schemes build up in layers: first to humiliate the pretentious Frankie, then to get Davy into the starring role, and finally to bring Davy back down to earth.

Director Kramm, his fawning assistant Philo and the self-centered Frankie Catalina are roughly drawn characters, rather two dimensional when compared to the delightfully bizarre Madame Quagmeyer and Rob Roy Fingerhead. I do give Bobby Sherman props for embracing the role of Frankie; if he had known how big a hit THE MONKEES was going to be

with the teeny-bopper set, he might not have been so eager to play a rude egomaniac who can't sing.

Finally, *Last Train to Clarksville* gets a decent romp! And it's a perfect gem for this episode: a scripted miniature movie complete with plot, characters, setting, stunts, special effects and a surprise ending. That mini-drama sits happily side-by-side with the delightfully playful, fully narrative romp set to *A Little Bit Me, a Little Bit You*.

The story is well structured, with several moments in the second act that gently mirror the first act. Lively dialogue, visual humor and character development are sprinkled throughout the show. It's not vying for top-notch honors among Monkees episodes, but it does have consistent quality from start to finish—and that's a good thing.

Zingers

Philo: Boys? Say hello to Luther Kramm. Mr. Kramm gave you *Beach Party Honeymoon*.
Peter: You didn't give it to us, we had to pay for it.
Mike: Yeah. It cost us 80 cents at the drive-in.
Kramm: Well, it was worth it, wasn't it?
Mike: Uh.... You owe me 60 cents.

Peter: Well, what do you want? I've offered you my Lovin' Spoonful collection, my Bob Dylan records, my Blind Lemon Jefferson records, and the prize of my collection— *Bobby Darin Sings His Bankbook*.

Davy: Watch where you're going, Shorty.
Kramm: Isn't he beautiful?
Peter: I used to know him!

Production Note

Although it was aired as the 31st episode of the first season, *The Monkees at the Movies* was actually the 11th regular episode to be filmed—and it was filmed way back in August 1966, before the show ever went on the air. Monkees episodes were often aired out of order, but only one other episode was bumped farther out of filming order than this one. I'll tell you which one...soon. Very soon.

Let's See if We Can Slip This Past the Censors

Micky: Here we are, in the land of make-believe. Look at that rock—it's a phony rock. Look at that fish—it's a phony fish. Look at that girl—oh, yeah.

Runner-Up Sight Gag Highlight

The names on the backs of the directors' chairs are Mr. Kramm and Yes, Mr. Kramm.

Sight Gag Highlight
One Monkee after another, walking away arm-in-arm with the lovely bathing beauties while Frankie waits impatiently outside the cabana.

Breaking the Fourth Wall
Producer Robert (Robby) Rafelson is briefly considered as a replacement for Frankie Catalina.

Fifth Runner-Up Nitpick
Two mysterious characters ("Girl" and "Mother") are listed in the credits but do not appear in the episode.

Fourth Runner-Up Nitpick
Micky is a California native. Why would he pick the call-sign W-GOGOGO for his make-believe radio station, rather than K-GOGOGO?

Third Runner-Up Nitpick
That very real *David Jones* album doesn't say "Davy" anywhere on it. But Kramm identifies it as *Davy Jones Sings*.

Second Runner-Up Nitpick
I've never lived near the ocean, so I could be mistaken—but it seems to me that the beach would be the last place you would ever want to take your record collection. Seeing Peter sitting on the sand with that stack of LPs in his lap just makes me think of how sand gets into everything.

Runner-Up Nitpick
"Mammoth Studios has been out of business for years!" Really? Mammoth Studios was still going strong three weeks earlier, when they filmed *I've Got a Little Song Here*.

Nitpick
While Frankie desperately tries to lip-synch to the variable speed record of *New Girl in School*, Kramm yells "CUT!" no fewer than five times. Nobody pays him any attention.

We're the young generation, and we have something to recycle.
- Recurring physical comedy: a Monkee jumps into another character's arms. (See also Davy in *Monkees at the Circus*, *I Was a Teenage Monster*, *Monkees Marooned* and *Monkee See, Monkee Die*; Micky in *The Monkees Blow Their Minds*.)
- Recurring fictional location: Mammoth Studios. (See also *I've Got a Little Song Here*, *The Picture Frame* and *Mijacogeo*.)

- Recycled costumes: Kramm wears two of the colorful shirts (brown and white polka dots and blue clouds) that Peter and Davy wear in the *Valleri* performance at the end of the episode. These shirts show up in other episodes as well, but it's jarring to see them recycled in the very same episode!

Second Runner-Up Monkee Magic
Micky conjures up a Hamlet costume and skull for his spiral staircase scene.

Runner-Up Monkee Magic
The Monkees erase Catalina from the footage of the beauty contest—and insert all sorts of other strange footage into Kramm's dailies.

Monkee Magic
All four Monkees conjure up matching red outfits and surfboards in order to do an impromptu audition for Kramm. (Micky also conjures up a clapperboard, complete with Kramm's name as director.)

What I want to know...
Why was this episode held back to the end of the season?

Snack to enjoy while watching *The Monkees at the Movies:*
With the extra-large tub of popcorn, you get a free Micky.

Music
- *A Little Bit Me, A Little Bit You:* Narrative romp.
- *New Girl In School (fragment):* Plot-related lip-synch.
- *Last Train to Clarksville:* Self-contained romp.
- *I Really Love You (fragment):* Plot-related recording.
- *Valleri:* Isolated performance (borrowed from *Captain Crocodile*).

During the shooting of this episode, Bobby Sherman spent an evening in the RCA studio, along with Jones, recording vocals for use in this episode. So that really is Bobby Sherman's voice being sped up and slowed down while Frankie lip synchs *New Girl in School*.

Episode 1-31
Written by: Gerald Gardner and Dee Caruso
Directed by: Russell Mayberry
Principal Filming Ended: 8/26/1966
First Airdate: 4/17/1967

Grading
- Monkees vs. Frankie. **B**
- Monkees vs. Kramm. **A-**
- Monkees vs. Davy. **B+**

And the cookie goes to...
Colpix Records, for producing that *David Jones* solo album in 1965. They may not have sold many records, but one of them made for a handy prop!

Rule number one of a great mentalist: when your psychic power deserts you, write a review of *The Monkees Blow Their Minds*.

The In-Which
A scheming mentalist turns all four Monkees into psychic slaves.

There's not a whole lot of story here. Once you subtract the credits, Mike's delightfully strange visit with Frank Zappa and the *video noir* presentation of *Daily Nightly*, the episode is left with only 17 minutes 40 seconds of story-telling time. Furthermore, if you subtract out the superfluously recycled puppy-romping footage from *I've Got a Little Song Here* you're down to just 16 and a half minutes of actual plot. And it shows.

What we're left with is a mere shadow of a story, in part a pale rehash of *The Monkee's Paw;* it would seem that every nightclub owner in Los Angeles is choosing between a music act and a magic act. All four Monkees end up frozen and expressionless; this is not a good formula for capturing the show's trademark hijinks. By sheer luck (and not through any action of their own) they are freed, and the story eventually stumbles to a close.

If *The Devil and Peter Tork* features Monte Landis at his finest, *The Monkees Blow Their Minds* has Monte Landis at his most annoying. I blame it in part on the makeup artist and costumer, who pulled out all the stops in making the character of Oraculo look about twenty steps beyond ridiculous. But Landis laps it all up, and then chews the scenery for good measure. I doubt there is a character anywhere under all that window dressing.

You know who's a real character? Rudy Bayshore, Oraculo's semi-enslaved sidekick. I was tickled to see James Frawley, THE MONKEES' regular director, improvisation coach and voice artist making an appearance in front of the cameras. Rudy actually has some semblance

of motivation, and over the course of the episode manages to display more emotional range than any other character. Sadly, they missed an opportunity to strengthen the story by having Rudy switch sides and free the Monkees on purpose rather than by mistake.

Nesmith's mutual interview with Frank Zappa is the best thing about this sorry episode. From the commentary track I learned that the identity switch was Zappa's idea; clearly he put a lot of effort into the role, and he is able to hold onto the illusion a little better than Nesmith can. Eventually both of them do a little bit of slip-sliding back and forth, which is much of what gives the interview its charm.

However, I'm of two minds when it comes to the portion of the interview where Nesmith and Zappa lampoon Jones's segment with Charlie Smalls (shown in the episode *Some Like it Lukewarm*). It's a finely honed bit of satire, but there's a thin line between satire and callousness. Jones's conversation with Charlie about accented beats may have been pretty basic stuff for Nesmith and Zappa, but it was informative for the many non-musicians in the audience.

Zingers

Oraculo: Sit down. Look into my eyes. Deeply, deeply, ever so deeply. Yes, deeply, deeply—what do you see?
Peter: Dishonesty, cowardice and a lack of scruples.
Oraculo: Too deep. Try again. Mr. Tork, why don't you join me in a cup of tea?
Peter: Do you think we'll both fit?

Mike: I'll stall Oraculo until you get back. Micky, are you ready?
Micky: Gosharoonie, yes. Boy, I've pored all over these mystical maps and charts and I've read every book in the public library.
Mike: So what have you learned?
Micky: The Dewey Decimal System.

Micky: Hold it, Oraculo! It is I, Captain Goodness and Junior Goodness!
Oraculo: Googly gobbly gobbly! You have lost your will.
Micky: You have lost your talent.

Clunkers

Micky: Bye, Pete! Later, Pete! Listen—don't forget to write, Pete! And, uh, remember the door is always open to ya, Pete, so you can come home to the pad and all your friends! But write first, because we're renting your room!

If Micky were under the mistaken impression that Peter had actually betrayed the band, this bitter diatribe wouldn't be so much of a clunker. But other dialogue in the scene makes it clear that the guys know very well that Peter is the victim here—and that he needs rescuing.

Production Note
The Monkees Blow Their Minds was officially the 25th episode of the second season, but it was the third episode in production order. Filmed April 18 – 20 1967, it was held back for nearly a year before being aired on March 11 1968. No other regular episode was delayed as long. (A full year passed between the filming of the pilot and its eventual airing as episode number 10, but that's a special case.)

The car Frank Zappa "played" was built like an anvil. They had to stop filming and rig the car so it could be demolished more easily.

Cultural Clarification
Frank Zappa appeared as a guest on the *Steve Allen Show* in 1963, when he was 22 years old. In that appearance he demonstrated his remarkable skill at playing a bicycle. (He did not demolish the bicycle. He used drumsticks and a bow, not a sledgehammer.)

Runner-Up Physical Comedy Highlight
Davy taking himself to his knees with the strength of his own grip.

Physical Comedy Highlight
Mike's spasms as he falls under Oraculo's magic potion.

Sight Gag Highlight
Peter with his nose up against the totem pole, mindlessly trying to walk back to Oraculo.

Breaking the Fourth Wall
I'm going to have to get literal this time. The pad set doesn't really have four walls; the wall to the left of the front door—opposite the kitchen—is not normally seen. For this episode, they have built a temporary wall there, complete with a circus poster and an improbable set of shackles. Even before Peter heeds the call of his master and rips out the shackles, one can see the outlines of the places where the make-believe plaster will separate. Those are the exact spots where Peter will… break the fourth wall.

Second Runner-Up Nitpick
What is Mr. Schneider doing at Oraculo's lair during the *Valleri* romp?

Runner-Up Nitpick
I like a good cameo as much as the next person—but a good cameo utilizes the guest star to some advantage. The appearance of Burgess Meredith in his role as Batman's nemesis the Penguin is a wasted opportunity. Remember Liberace's cameo in *Art, for Monkees' Sake*? He destroyed a grand piano with a golden sledgehammer! All Meredith does is watch Oraculo's act and cackle.

Nitpick
I do believe there's a major editing goof here, as these crucial events seem to take place in the wrong order:

- Oraculo tells Rudy to give the Monkees more potion and then come out front to help with the act.
- Rudy immediately appears out front and helps Oraculo with his act.
- Somebody who looks very much like Davy crawls out from under a table (which makes no sense at all) and tries to make Oraculo look stupid.
- Somebody who looks very much like Micky also tries to embarrass Oraculo, and actually leads the audience in a "boo!"
- Rudy checks on the Monkees' need for more potion and accidentally wakes them up.

If the Monkees are still entranced backstage while Oraculo does his act, *what is that 35-year-old lawyer doing hiding under a table?*

Absolutely Not a Nitpick
The youngest justice of the US Supreme Court was Joseph Story, who was appointed at the age of 32 in 1812. The Constitution does not specify a minimum age for appointment to the court.

We're the young generation, and we have something to recycle.
- Recurring physical comedy: a Monkees jumps into another character's arms. (See also *Monkees at the Circus*, *I Was a Teenage Monster* and *The Monkees at the Movies*.)
- Recurring actor: Monte Landis as Oraculo. (See also *Everywhere a Sheikh, Sheikh*; *I Was a 99 Lb. Weakling*; *Monkees Marooned*; *The Devil and Peter Tork*; *Art, For Monkees' Sake* and *Monkee Mayor*.)
- Recycled footage: romping with dogs from *I've Got a Little Song Here*.

Runner-Up Monkee Magic
Micky and Davy must have conjured up those shackles on the wall, right? Because otherwise, we would have to assume that *they have shackles on the wall.*

Monkee Magic
"Cowardice, dishonesty and a lack of scruples." Apparently Monkee Magic includes an eye-contact judge-of-character power. Pity they didn't learn to use it sooner.

What I want to know...
Why was this episode held back so long? (Which is the same question I asked about the previous episode, *The Monkees at the Movies*!)

Beverage to enjoy while watching *The Monkees Blow Their Minds*:
"Will you join me in a cup of tea?"

Music
- *Mother People* (fragment, by the Mothers of Invention): Playing a car.
- *Valleri:* Utterly nonsensical and yet occasionally narrative romp.
- *Gonna Buy Me a Dog* (instrumental): Narrative romp intercut with clips recycled from *I've Got a Little Song Here*.
- *Daily Nightly:* Isolated performance.

Episode 2-25
Written by: Peter Meyerson
Directed by: David Winters
Principal Filming Ended: 4/20/1967
First Airdate: 3/11/1968

Grading
- I am he and he is me. **A**
- Of Human Bondage. **B-**
- There ought to be a plot in here, somewhere. **C-**

And the cookie goes to…
Frank Zappa. No, I mean *Frank Zappa*. Give back the cookie, Michael, it's not for you. It's for *Frank*.

Don't Trust Anyone Over Thirty: Adult Characters of THE MONKEES

When reporters, columnists and interviewers try to describe The Monkees in a few short sentences, they usually mention the innovative storytelling techniques, the unconventional casting, the wacky humor and the music. Fans reminisce about the adorable guys, the strong friendships, the colorful fantasy and of course, the music. But when Tork speaks about the show, he often turns the conversation to its revolutionary social structure: four independent young men making their way in the world with no senior adult in the picture.

Of course, that's not *literally* true. There are scores of older adults in the picture. Nearly every episode has them: bloodthirsty gangsters, crafty spies, treacherous nobles, cruel employers, incompetent businessmen, overprotective daddies—and let us never forget that one irritable landlord. The four Monkees are adrift in a world full of heartless grown-ups, echoing the tumultuous times and a nation at war. Or, as Tork put it: "It represented what needed to be the truth for those of us who were that age at that time, which was: You couldn't *trust* the adults."

I started out writing an essay about the adult characters on the show, but ended up with an essay about *trust*—and more importantly, *untrustworthiness*. The Monkees' world is populated with dishonest grownups, and the hapless, innocent and too-honest-for-their-own-good Monkees are forever falling afoul of them.

Flim-Flam Artists, Back-Stabbers and Dirty Double-Dealers
Silver-tongued salesmen operating nine-tenths within the law are eager to lure the young men (and sometimes, elderly victims as well) into long-term financial commitments or dead-end deals. Given that the Monkees operate on the edge of poverty, with rent in arrears

and a nearly empty refrigerator, there's no money to spare for dance lessons (Reynaldo and Miss Buntwell, *Dance, Monkee, Dance*), a body-building program (Shah-ku, *I Was a 99 Lb. Weakling*), or get-rich-quick schemes (Leonard Shelton, *Monkees Marooned*). It's alarming how many times one of the musicians pawns, trades or otherwise puts an instrument at risk, imperiling the whole band's livelihood in the process.

The one-man operation run by Bernie Class *(I've Got a Little Song Here)* is particularly relevant and relatable, as the scam is tied directly to Mike's musical gift and professional pride. Mike can usually be counted on to lead the charge when adversity strikes, but after he pawns his guitar to pay for High Class Music Publishers' non-existent services, his surrender is complete and heartrending.

Behind the professional hustlers come the amateurs: folks who might provide a legitimate service under other circumstances, but eagerly take advantage of the Monkees' trust and innocence. The slimy mentalist Oraculo *(The Monkees Blow Their Minds)* is never going to win any Good Citizen awards, but he seems ready to provide Peter with a normal fortune-telling until Peter mentions a certain show business opportunity. Madame Quagmeyer and her sick leprechaun photographer Rob Roy Fingerhead are well-placed and well-respected in their profession, and nothing they do in *Monkees a la Mode* is illegal—just despicable. Mrs. Badderly *(Too Many Girls)* uses her legitimate tea-room business to run a very personal scam against Davy. But none of these comes close to the treachery practiced by a certain pawn shop owner with an extensive collection of dusty musical instruments and a deceptively generous payment plan (*The Devil and Peter Tork*).

The Monkees are perpetually in need of employment, and if musical gigs are not available, they'll take on any jobs they can find. But the employers can't be trusted either; even if the job is real—and usually it isn't—there's bound to be a hidden agenda. This is particularly well demonstrated by Blauner, the hotel manager in *The Wild Monkees*, who lures the band to a remote town with a bait-and-switch offer for a musical gig. Other job offers are nothing but empty shells for criminal schemes: teaching (Doctor Mendoza, *I Was a Teenage Monster*), boxing (Sholto, *Monkees in the Ring*), sailing (Frank and Harry, *Hitting the High Seas*) and acting (JL and Harvey, *The Picture Frame*).

Far worse than the professional swindlers and duplicitous employers are those who offer the open hand of friendship, only to attack with the knife that's hidden in the other hand. The cheerful fellow who offers free publicity (Nick Trump, *Your Friendly Neighborhood Kidnappers*) is playing dirty and possibly deadly tricks on behalf of the competition. The solicitous museum guards who nurture Peter's artistic muse (Duce and Chuche; *Art, for Monkees' Sake*) are merely exploiting him for illegal gain.

The gypsy matriarch Maria *(Son of a Gypsy)* violates every standard of hospitality; contest host Jerry Blavat *(Some Like it Lukewarm)* offers favorable treatment only if the band's most vulnerable member returns the favor; the butler of the Millionaires' Club (*Monkees in Manhattan*) offers to bankroll the Monkees' musical only if the Monkees aren't in it; ersatz heirs Madame Rozelle and Harris Kingsley (Monkee See, Monkee Die) give comfort and commiseration while conspiring to steal a young woman's inheritance.

When the Monkees visit Mike's aunt and cousins *(Monkees in Texas)*, they encounter the most upright and trustworthy of TV western heroes, Ben Cartwright—no, that's Ben Cart*wheel* and his sons. The audience is meant to recognize them, even in parody, but even if they don't, Aunt Kate sings the praises of her most honorable and caring neighbor. Of course, he's the one who's going to drive Kate off her land, or kill her trying.

Family ties are no guarantee of fair treatment. Thankfully, the Monkees are spared seeing their own relatives turn on them, but they are certainly witness to the most despicable blue-blooded betrayals: Archduke Otto *(Royal Flush)*, Count Myron *(The Prince and the Paupers)* and Sir Harold *(Fairy Tale)* each preparing to murder a person he claims to love.

The Calm, Competent, Courageous Voices of Authority

Where's a young man to turn when the forces of evil are arrayed against him? The voices of law—police, military, courts—must be waiting in the wings to play their role. Surely there is some order in the universe. Surely there is some competence in government. Surely there is some power in the law. *Surely...?*

The authority figures who appear in the series are not necessarily dishonest; rather, they are uniformly incompetent and ineffectual. The lesson is easy to read: you can't trust government to help you, protect you or make things right.

Character actor Dort Clark played three different police detectives over the course of the series *(Monkees a la Carte, The Picture Frame, Monkees on the Wheel)*. In each case, his gruff but inept character wastes time conducting a comical, Monkee-dominated interrogation. In two of the three, he recruits the Monkees to help with a criminal investigation—work the police department apparently cannot handle on its own. In a similar vein, the Captain *(Alias Micky Dolenz)* casually recruits Micky for a perilous undercover operation, then loses him just in time to put the defenseless drummer's life on the line.

America's spymasters were also eager to recruit the Monkees for dangerous missions, with predictably disastrous results. Gross incompetence is the order of the day, in particular when Inspector Blount *(Monkee Chow Mein)* boasts of the "utter secrecy" of his undercover base of operations, while babbling his plans over the phone to a total stranger and posing for a photo taken by a random intruder. The mild-mannered Agent Honeywell *(The Spy Who Came in from the Cool)* can't manage a simple, discreet surveillance—even Davy spots him talking to a popsicle. Meanwhile, the Department of UFO Information *(Monkees Watch Their Feet)* is run by a pompous but easily distractible bureaucrat and staffed by a certifiable nutcase.

Down at the courthouse, a judge *(The Picture Frame)* simpers like a schoolgirl the moment Mike turns on the charm; the D.A. who prosecutes the case and the defense attorney hired by Peter are equally incompetent. And at City Hall, the corrupt Mayor Motley is a puppet of the developer who is eagerly paving the city over for parking lots *(Monkee Mayor)*.

Even rank-and-file police officers were seldom much help to a Monkee in need. A go-getting patrolman in *Alias Micky Dolenz* just wants to sell tickets to the Policeman's Ball; a beat cop in *Monkees Marooned* tries to sell Peter the city of Cleveland. The officer who

rewards the band for capturing The Big Man and her henchmen *(Monkees in a Ghost Town)* turns around and cites the band for a host of trumped-up infractions. And the nervous rookie who tries to arrest the Monkees in their home *(The Picture Frame)* nearly demolishes the place in the process.

I'll Kill You; I'll Honestly Kill You

Perversely, one group of adult characters who *can* be trusted are the worst criminals. They are violent, oh yes, but essentially truthful. George and Lenny *(Monkees in a Ghost Town)* introduce themselves to the Monkees with a spray of bullets, and their mysterious boss The Big Man casually orders their deaths. Babyface Morales is the honest doppelganger; in *Alias Micky Dolenz* it's Micky who's telling all the lies.

Gangsters Fuselli and Rocco *(Monkees a la Carte)* state their nefarious purposes the moment they walk into the restaurant and are always perfectly frank with the Monkees regarding the terms of their employment. The four syndicate members who attend Fuselli's summit—Red O'Leary, Big Flora, Paddy the Fix and Benny the Book—not only introduce themselves but also helpfully list their criminal specialties.

The murderous gangs led by El Diablo *(It's a Nice Place to Visit)* and Big Butch *(The Wild Monkees)* are downright eager to brag about their criminal activities. But perhaps no opponents are more openly honest and cooperative than Madame and Boris *(The Spy Who Came in from the Cool)* as they repeatedly confess to espionage, even as they grow impatient. (And Peter grows daffodils.)

The Loony-Tunes Brigade

While dishonesty, corruption, incompetence and indifference are the order of the day, there are some adult characters on THE MONKEES who are too nutty to be judged by the usual standards. They are untrustworthy for a different reason; their disconnection from reality makes them unreliable, unpredictable or downright dangerous.

Major Pshaw *(Monkees Marooned)* and the Captain *(Hitting the High Seas)* have taken their grandiose delusions to an alarming level of fulfillment, placing the Monkees' lives in peril for no rational reason. The pirate captain seems to have a willing and equally deluded pirate crew; on the other hand, Pshaw seems to be holding his half-naked manservant hostage on the island. Meanwhile, the German auto racing team (Baron von Klutz and Wolfgang, *Monkees Race Again*) are nostalgic for the happy, heady days of the Third Reich.

(There is a brief indication in *The Chaperone* that General Vandenberg may fall into this category as well, as in one scene we see him dressed in jungle camouflage and playing with toy soldiers. However, this ambiguous scene may just be Micky's magical imagination at work as he speaks with the general on the phone.)

Less dangerous but no less annoying are the narcissistic nincompoops who hold the reins of authority in show business, effectively preventing the Monkees from ever achieving commercial success: Hubbell Benson on his motorized massage table *(The Audition)*, Lester

Kramm and his fawning nephew, Philo *(The Monkees at the Movies)*, and the scheming, paranoid Captain Crocodile.

Well Meaning Adults and the Redemption Arc

Even sympathetic characters with honest intentions can turn matters topsy-turvy or put the band in danger. I've already addressed the police detectives and government agents who recruit the Monkees for dangerous undercover work; how about Mrs. Drehdal, who hires them for her telephone answering service *(The Monkees on the Line)* and then abandons them with just the scantest excuse for training? Or Baker, the hapless producer who lures them 3,000 miles to New York *(Monkees in Manhattan)* in pursuit of the shakiest of show business dreams?

Millie Rudnik *(Monkee Mother)* is generous to allow the guys to remain in the pad when she takes over the lease, but her particular brand of smothering affection threatens to sap them of their will to live—or earn a living. And Davy's status-conscious and chaos-adverse grandfather *(Success Story)* very nearly breaks up the band in his effort to do what's right for his grandson.

Conversely, some antagonists enjoy a redemption storyline. The magician Mendrek, who callously sells his cursed magic talisman *(The Monkee's Paw)* to Micky, later relents and helps the Monkees find a more deserving buyer. Jud Weskitt, the hillbilly moonshiner who threatens to grind Davy up like sour mash, is redeemed by the power of true love. The pragmatic and unsentimental Farmer *(Don't Look a Gift Horse in the Mouth)* not only changes his mind about selling his young son's pet, but even admits that he had misjudged the Monkees and invites them to visit the farm again. (Not to do chores—oh no, just to visit.)

The stubborn, proud knife thrower, Victor *(Monkees at the Circus)*, is a particularly ambiguous character, actually justified in his efforts to organize the circus performers who, let us not forget, were not being paid. His pragmatic pessimism is unfortunate, but not unreasonable. By the time the episode ends, he is... well, still dour, stiff and grimly resolute. And yet, somehow ennobled. The story pivots around him and he emerges with his dignity intact.

J.B. Guggins, Jr. *(Monkee vs. Machine)* starts out as the epitome of the ineffectual bumbler, cowering behind the bombast of his go-getting executive, Daggart. In an episode-ending plot twist, Guggins stands his ground, seizes the reins of his own company back from Daggart and fires him.

I'll end where the series began: with an upright, uptight, well-heeled pillar of the community, blind and deaf to his teenage daughter's strange taste in music. "I hope they don't play too loud, I wouldn't want to lose my membership," says Mr. Russell, unimpressed. "Monkees, you say? Yes... there is something primitive about them." Throughout the pilot episode, Russell is cast as the antagonist, arguing with his carefree daughter and tearing her away from the young man she loves. And yet, as *Here Come the Monkees* ends, Russell risks both his reputation and his country-club membership to welcome the Monkees after all. Before long, he is dancing.

Do you realize, that all over the world there's a great reservoir of untapped dirt? How do we conquer that brave new world of dirt? I'll tell you: the answer is a review of *The Monkees Get Out More Dirt.*

The In-Which
All four Monkees fall madly in love with the owner of the neighborhood laundromat.

I don't ask for much from a MONKEES episode: substantial plot, character development, a touch of conflict, some lively dialogue and/or physical comedy and a meaningful romp. That's all. And if you can throw in some structure, I'll be pickled tink.

Structure! *The Monkees Get Out More Dirt* has so much structure, it's practically cubical. Four loads of laundry, four requests for soap, four lovesick musicians. Four disguises, four phone calls, four hobbies, four fantasies, four fish swimming, even four quarters of the pad, each with precisely one desirable feature (TV, icebox, front door, bathroom). It's as precisely drawn and tightly configured as the precision four-way pace the band executes as they ponder their four-way love for April.

But even without the structure, *The Monkees Get Out More Dirt* would score well on most of my usual standards. The plot is tidy—not all that complex, but sufficient. There's a measure of character development, including a rare romantic turn for Mike. Conflict is low-level, but it's among the Monkees themselves; internal conflict is an extremely rare approach for this series, and makes for a welcome change of pace from the usual bad guys/good guys dynamic.

Where the episode does fall short, I fear, is in the comedy. There's not much humor in the dialogue, and some of the physical comedy—especially in the two look-alike romps—is rather clunky. The episode is chock full of cultural references, only some of which I get: Dr. Joyce Brothers, the Addams Family's hand-in-a-box servant Thing, Maxwell Smart's shoe

phone. On the other hand, there are two or three jokes that are based (I think) on television commercials for various detergents that were running at the time; the laugh track thinks they are funny but they make no sense to me.

April Conquest is an intriguing character. I appreciate that she is an intellectual as well as a beauty, but I'm a bit annoyed by her squeaky breathlessness and the way she just takes to her bed with the vapors as soon as her delicate emotions are overwhelmed. Such a fragile little flower! As she lies there being all helpless and emotional, the Monkees play a game of chance to decide her future for her—so I'm glad she picks somebody else in the end.

Zingers

Davy: Oh, yes, it is true. Oh, it's terribly true. England does swing like a pendulum do.

April: Mike! Don't tell me you've given up... motorcycles.
Mike: Given 'em up? Are you kidding? Of course I've given 'em up. Horrible. No, I've—I've taken up skydiving.
April: Oh!
Mike: You like that. Uh—but, uh—I um, I—one, one problem. I'm afraid of airplanes. Oh, afraid, and um, I can't dive in the sky. So I use my living room and the parachute sits on the couch and the lamp and it's a drag... and you wouldn't want to do that so you're better off with Peter.

Clunkers

The accident at the end of the first act is actually pretty scary, and both Micky and Mike behave as though they are injured. April's delighted reaction is horribly inappropriate.

Production Notes

The Monkees' very first recording session as a band took place just a few days before this episode was shot, so I like to think that this was a hopeful, even happy time for them. They recorded a version of *The Girl I Knew Somewhere* in that first session, although not the version that is used in this episode. *That* recording (with Dolenz singing lead) was made about a month later.

Physical Comedy Highlight

Four Monkees pacing in a tightly choreographed pattern.

Runner-Up Sight Gag Highlight

A harpsichord mounted on a bicycle.

Sight Gag Highlight

At the exact moment April refers to "a great reservoir of untapped dirt," she is looking carefully at Davy's fingernails.

Breaking the Fourth Wall
Peter: Hey, wait! How do I get in if the door's locked?
Micky: Peter. You can't expect the writers to know everything. Improvise.

Second Runner-Up Nitpick
Peter makes a fist to start the choosing-fingers countdown before the subject of choosing fingers comes up.

Runner-Up Nitpick
Micky, Mike and Davy arrive at the laundromat in the opposite order of their departure from the pad.

Nitpick
This boxing thing, Davy...it just occurred to you? Just now, out of the blue, like you never ever thought about taking up boxing before? (This episode was both filmed and aired after *Monkees in the Ring*.)

We're the young generation, and we have something to recycle.
- Recurring punch line: "Why can't your doctor work on his own thesis?" (See also *The Prince and the Paupers*.)
- Recycled catch phrase: "A man in love has the strength of thousands." (Also demonstrated by Davy in *Too Many Girls*.)
- Recurring plot device: choosing fingers. (See also *The Monkees on the Line; The Devil and Peter Tork; Monkee See, Monkee Die* and *Dance, Monkee, Dance*.)

Runner-Up Monkee Magic
Micky, haven't we told you a thousand times—no flying indoors!

Monkee Magic
Peter teleports into a washing machine. I'm not exactly sure *why*.

Celebrity TV Psychologist Magic
Dr. Lorene Sisters can see and hear you *through your television set*.

What I want to know...
Didn't episode writers (and Script & Story Editors) Gerald Gardner and Dee Caruso realize that they had used the doctor's thesis joke already? Or that Davy had already been a boxer? In episodes that *they wrote*?

Snack to enjoy while watching *The Monkees Get Out More Dirt*:
Well, the dog can have some dog food.

Music
- *(Theme from) the Monkees:* Narrative romp.
- *The Girl I Knew Somewhere:* Strangely familiar narrative romp (*déjà vu* all over again).

Episode 1-29
Written by: Gerald Gardner and Dee Caruso
Directed by: Gerald Shepard
Principal Filming Ended: 1/27/1967
First Airdate: 4/3/1967

Grading
- This episode is *square*, man. **A-**
- Fish gotta swim, birds gotta fly; I gotta love ~~four men~~ one man till I die. **B+**
- The doctoral student/small business owner is over there on the fainting couch. **B-**

And the cookie goes to...
Actor Digby Wolfe, who spent most of the episode sitting in the laundromat reading a newspaper while his shirt tumbled dry for days and days on end.

In just a little while, we'll be far away in the Palladium up in the sky. But before we go, we'd like to do a review of *Monkees in a Ghost Town.*

The In-Which
The Monkees take a wrong turn and run out of gas in a ghost town that isn't as deserted as it looks.

When I watched this episode as a little girl, my cultural vocabulary was so scant that I didn't notice the strange juxtaposition of depression-era gangsters in a Wild West ghost town, never mind the musicians (and cops) from the 1960's. Nowadays I can see that the whole premise of this episode is delightfully kooky, giving it an off-kilter sense of humor that goes far beyond sight gags, slapstick and humorous dialogue.

I give the episode top marks for its lively plot, which despite the fantasy setting, is quite sensible. The Monkees rely on charm and respectful cooperation with their captors, and in the end it's their offer of friendship through music that tips the scales in their favor. The shootout that follows is unfortunately long, but the cartoon violence is softened by Bessie's ongoing karaoke act, the boys' shooting gallery game, and the sight of Lenny faithfully clutching Davy's red maracas.

Bessie "The Big Man" Kowalski is one of the more memorable villains of the series, and is also one of the show's best-written female characters. It's a testament to Rose Marie's versatility that she's entirely believable in both this role and her subsequent role in *Monkee Mother.* The subtly ambiguous reference to the fate of her ex-husband (late husband?) The Big Man is tantalizing and provocative.

This episode ends with the most delightfully funny interview segment, showcasing Nesmith's creativity and skill as he improvises a card trick with a handful of filters and gels. The episode's two playful romps are delightful as well, though it's a pity they had to be put so close together. The Shared Imagination baseball game (complete with caps, gloves, and an umpire uniform for Lenny) put the silly seal on the *Papa Gene's Blues* romp.

This is another episode that has an element that may have been funny back in 1966, but which is fully cringe-worthy today. (I'm a bit surprised by how often this comes up!) In this case it's Davy's first phone call from the saloon, which is received by a Native American seated in front of a teepee. The clumsily stereotyped dialogue ("Me cannot help. Me primitive Indian chief, know nothing about white man's problems.") is softened only slightly by the sight of his complex, modern telephone.

Zingers

Bessie: You boys singers? You ever work professionally?
Mike: Yes ma'am. We're a group. We're the Monkees.
Bessie: A chimp act, eh?

Peter: I'll bet you had a lot of heart, Bessie.
Bessie: Thank you, sonny. You're a nice, sensitive boy. Lenny? Take 'em out and shoot 'em.

Chester: Hello? This is Chester.
Davy: This is David Jones. We've got a serious problem!
Chester: Problem, huh? I better get Mr. Dylan.
Davy: Marshall Dillon?
Chester: No, Bob Dylan. He can write a song about your problem.

Cultural Clarification

The gangster characters of George and Lenny were modeled loosely on the main characters in John Steinbeck's *Of Mice and Men*. Lon Chaney, who plays Lenny in this episode, played the corresponding character Lennie in the 1939 film adaptation of that novel. Hence, the somewhat incongruous white mouse in Lenny's pocket.

Physical Comedy Highlight

The Monkees' behind-the-bar shooting gallery.

Runner-Up Sight Gag Highlight

It's either Peter emerging from the tunnel into a performance of *Papa Gene's Blues* by the Monkees, or Mike emerging from the same tunnel into an actual baseball game.

Sight Gag Highlight

Lenny clutching Davy's red maracas throughout the shootout.

Second Runner-Up Breaking the Fourth Wall
Micky: Now, this is the moment when the cavalry usually rides up.

Runner-Up Breaking the Fourth Wall
Title cards: Stay tuned for Micky's idea.
Stay tuned for Micky's next idea.

Breaking the Fourth Wall
Peter: First we get lost, and run out of gas, and then Mike and Davy disappear, and then somebody starts shooting off a machine gun, and now this guy is searching the town.
Micky: That's for the benefit of any of you who have tuned in late. And now—back to our story.

Second Runner-Up Nitpick
"Trudge through the desert" and "frolic on the beach" are two very different things. I'm all in favor of recycling footage—there's a whole category dedicated to recycling—but a little attention to detail is worthwhile.

Runner-Up Nitpick
The supposedly deserted town has electricity for its street sign, and telephone service, too.

Nitpick
When the guys arrive in town, they run out of gas in the middle of a wide street. When they leave, they have gas in the car and it's parked directly outside the saloon.

Absolutely Not a Nitpick
The symbol for a transistor does, indeed, look like an upper-case K. I thought Dolenz was the engineering geek in the band?

We're the young generation, and we have something to recycle.
- Recurring sight gag: a light bulb for a bright idea. (See also *Royal Flush* and *Your Friendly Neighborhood Kidnappers*.)
- Recurring gag: phoning for help. (See also *Monkee See, Monkee Die* and *Monkees in Texas*.)
- Recycled footage: the romp for *Tomorrow's Gonna Be Another Day* borrows heavily from beach romps in *The Monkees at the Movies* and *Monkee vs. Machine*.

Fourth Runner-Up Monkee Magic
All four Monkees conjure up their instruments (Mike in the cell, the others in the saloon.) Mike subsequently turns the piano into a karaoke machine.

Third Runner-Up Monkee Magic
Mike and Davy take a few moments off from exploring the town to share a Wild West fantasy. Mike *duplicates* himself, which is a new aspect to Shared Imagination.

Second Runner-Up Monkee Magic
Micky "The Big Man" Dolenz and his sidekick, Spider. Not only do they conjure up gangster disguises—Micky gives himself a huge scar down one side of his face. Nice touch.

Runner-Up Monkee Magic
Davy conjures up a block of ice.

Monkee Magic
Peter conjures up a light bulb—and enough electricity to make it light up.

What I want to know...
What *did* Bessie do with Mr. Big?

Beverage to enjoy while watching *Monkees in a Ghost Town:*
Meet me behind the bar. Davy brought ice.

Music
- *Tomorrow's Gonna Be Another Day*: Playful romp.
- *Papa Gene's Blues*: Narrative romp with a healthy dose of Shared Imagination.
- *Everybody Loves My Baby*: Rose Marie performance.
- *Hi Neighbor*: Rose Marie performance.
- *(Theme from) The Monkees*: Rose Marie karaoke.

Episode 1-7
Written by: Robert Schlitt and Peter Meyerson
Directed by: James Frawley
Principal Filming Ended: 7/15/1966
First Airdate: 10/24/1966

Grading
- The Monkees' very real problem. **B**
- The Monkees' very imaginary solutions. **A**
- Of Mice and Gangsters. **B-**
- Sing along with Bessie—and then take 'em out and shoot 'em. **A**

And the cookie goes to...
Whoever came up with the baseball-in-the-cell, digging-an-escape-tunnel romp set to *Papa Gene's Blues*. No other romp in the series is remotely like it.

Barging in on a man's case? I think the ethics practice committee would like to hear a review of *Monkees in Manhattan*.

The In-Which
The guys get a chance to appear in a Broadway show, but the producer has lost his financial backing.

The episode begins with a stock shot of Times Square, and Davy enters singing a snippet of *New York, New York*. But you can't fool me! There's nothing here that wasn't done on a soundstage or a back lot in Hollywood. I think that's what disappoints me most about this episode. Other than the premise of a Broadway play, there is nothing at all "Manhattan" about it. New York has an accent. New York has an ambience. New York has an *attitude*. None of which can be found here. Even in the romp, in which they make a halfhearted attempt to utilize a rooftop, a fire escape and a short stretch of sidewalk for atmosphere, they soon cut to images of the guys cavorting in a stark, modern structure with rugged mountains in the distance.

Mountains. Distance. *Rugged*, for Pete's sake. Have these people ever *seen* Manhattan?

Okay, I've gotten that off my chest. To my surprise, *Monkees in Manhattan* has improved with repeated viewings—a good thing. I've started to notice the kooky details a little more, and it's the kooky details that make the episode tolerable. Tiny comic touches outshine the plodding plot: Peter nibbling on a bullet, Micky trying on a song for size, Mike describing how the waiter's multi-syllabic name will look on a theater marquee. In contrast, some of the more conventional humor in the episode, such as the running gag about the intoxicated

rabbit breeder, or the sexual innuendo about the groom who "can't do anything," are painful to watch.

Overall, it's a fairly pedestrian story, with very little sense of urgency or danger. Perhaps if they had placed more emphasis on the risk the Monkees took in relocating to New York, and less emphasis on the need to occupy Baker's hotel room for a few hours, I would have cared more. Far too much focus is placed on the value of that hotel room; when the butler steps forward to invest in the project, I find myself thinking, "Baker can keep his hotel room!" rather than, "Let's put on a play!"

When a cruel twist of fate brings about actual conflict—the new backer will only fund the production if the Monkees aren't in it—Baker shows a glimmer of resistance that promises some actual drama. But there's no time left, and the Monkees drain all of the drama out of the scene with a quick self-sacrifice wrapped up in a moral about seizing the day, or some such pablum. Then we top it all off with a hackneyed joke about working to pay off the room service bill, but I find I no longer care.

The opening salvo of the interview segment was the most interesting four-way comment since the serious talk about the Sunset Strip riots at the end of *The Audition*. Rafelson's question, "If [success] were suddenly taken away, wiped out, where would you be today?" elicits three warm, humorously related responses and one very odd non sequitur, which makes me wonder whether Dolenz was not paying attention or if he just didn't want to play. He's usually much quicker with the wit. Overall, the three-part interview segment is charming, entertaining and informative, but I wish they had spread it out over three episodes and given *Monkees in Manhattan's* plot just a little more time to develop some heart.

Zingers

Micky: Hey guys, look at this. It's a song out of McKinley's play.
Davy: Let's try it on for size.
Micky: Doesn't fit.
Mike: No, E-flat never was my color.

Rafelson: Mike. This afternoon, we had lunch. And you said the one thing you really wanted was a house. Now, I want to know why that's so important to you, to have your own house.
Nesmith: Why do I want a house?
Rafelson: Yeah, why?
Nesmith: Why do you like that shirt, Bob? "Why do you want a house?" To keep the wind off me! This is unbelievable. Why do I want a house. Huh. Well, when it rains, you get wet if you live in a parking lot!

Clunkers

Mike: Aw listen, McKinley, you gotta accept his offer. You get a chance like this but once in your life, and you gotta get started somehow.

Davy: You'll have other shows that we can appear in. But you've gotta get started, and this is your big chance. And you gotta take it.
Peter: Right.
Micky: Right. And we have a bus to catch.

It's not the sentiment that makes it a clunker—where else could the plot end but with the Monkees returning to California, as unsuccessful as ever? It's a clunker because the emotional tone swings too rapidly from giddy success to noble self-sacrifice, making Mike's and Davy's lines sound preachy and even a little patronizing.

There was enough time at the end of the episode for three interview segments and an extra song—surely there was enough time for another minute or two of story. They could have shown the guys discussing matters among themselves and deciding to sacrifice their Broadway roles for the sake of their new friend, or they could have made adjustments to the entire story so the Monkees would have been worried about being trapped by their commitment to Baker's show—turning their eventual sacrifice into a happy solution for everybody.

Cultural Clarification
Micky: Actually, we came by bus—the Blim Line. You know... "It's such a pleasure to take Blim, and leave the driving to them."

This is a spoof of the advertising slogan for Greyhound: "It's such a comfort to travel by bus – and leave the driving to us."

Runner-Up Sight Gag Highlight
Baker glumly packing his clothes, while Mike, Micky and Peter quietly put everything away in another drawer.

Sight Gag Highlight
A bunny's ears poking out of the breeder's pocket.

Breaking the Fourth Wall
Mike: There's got to be more than one person in New York who's willing to produce a show that's written by an unknown and directed by an unknown, and starring the Monkees.

Except for the New York part, that's a pretty accurate description of Raybert's little miracle.

Oh, gross! There is no way I can ever un-see that!
I previously gave this award to a moment in *Monkees a la Carte*, in which Peter sneezes over a tray of salt and pepper shakers. Well, at least that time he was just acting and the shakers were just props. In this interview segment, Tork sneezes into his hand—for real—a hand in which he is holding a comb. Seconds later, he's combing Jones's and Keeva's hair. Same

hand, same comb. The worst part is, there was no reason to keep the sneeze in the final edit—they easily could have left it on the cutting room floor.

Third Runner-Up Nitpick
I don't usually nitpick the music videos, but this one makes me laugh. Even though it's delightful to see Davy playing the drums, during the first chorus of *Words* he starts pounding on a cymbal that isn't there. (Maybe it's supposed to be there. Maybe they moved it so Davy could be seen!)

Second Runner-Up Nitpick
When Weatherwax comes to tell Baker and the Monkees that their hour is up, the wrong room number is on the door. It should be 304 (the honeymooners are in 305). This wouldn't be significant, except that a room-number switch is an important plot point later in the episode.

Runner-Up Nitpick
Davy doesn't actually knock on Baker's door. (I'm guessing that the door was fake and they intended to add the knock sound in post-production, but somebody forgot.)

Nitpick
Just how many beds does Baker's hotel room have?

Absolutely Not a Nitpick
Come to think of it, *(Look Out) Here Comes Tomorrow* would make a decent plot for a musical play.

We're the young generation, and we have something to recycle.
- Recurring gag: a cork is stuck in a bottle of champagne. (See also *One Many Shy* and *The Wild Monkees*.)
- Recycled footage: just about everything in the second romp, except for the bunnies.
- Recycled footage: lots of stuff in the first romp, in particular the ladder-climbing footage (from *The Case of the Missing Monkee*), the carousel footage (from *Here Come the Monkees*) and the frolicking in fountains footage (*The Spy Who Came in from the Cool*).
- Recycled footage: Peter failing to catch the boomerang as it crashes through a window in *Monkee vs. Machine*.

Second Runner-Up Monkee Magic
Davy may have packed his wine-colored tuxedo jacket for the bus trip to New York, but the other three Monkees would certainly have to conjure up their millionaire disguises. Furthermore, they conjure up disguises during the romp (street sweeper, newsboy, popcorn vendor and cop) and Micky conjures up a belt, holsters, six-guns and ten-gallon hat for the High Noon confrontation in the hotel room.

Runner-Up Monkee Magic
Somebody—probably Micky—conjures up various pieces of medical equipment. (I don't usually credit Monkee Magic that takes place off-screen, but there's no other way Micky could get his hands on so much stuff without leaving Baker's room.)

Monkee Magic
Mike teleports, then conjures up a double-armful of bunnies. (I used to think that Peter conjuring a telephone in *I Was a 99 Lb. Weakling* was the most visually impressive example of Monkee Magic, but I'm starting to change my mind.)

What I want to know…
Why in the world would David Armstrong Jones bring a fuzzy white gonk to the Millionaires' Club?

Snack to enjoy while watching *Monkees in Manhattan:*
A lot of rye bread, some liverwurst, artichokes, potato salad… and don't forget the pickles.

Music
- *The Girl I Knew Somewhere:* Vaguely narrative romp.
- *Look Out (Here Comes Tomorrow):* The "plot" of the planned musical—recycled clips from the first season of THE MONKEES.
- *Words:* Isolated performance.

Episode 1-30
Written by: Gerald Gardner and Dee Caruso
Directed by: Russell Mayberry
Principal Filming Ended: 10/7/1966
First Airdate: 4/10/1967

Grading
- The Bronx is up and the Battery's down—and the rugged vistas are in California. **C**
- New York, New York: if they can make it there, they can make it anywh… oh, who am I kidding? **B-**
- Every bunny loves some bunny sometime. **100**

And the cookie goes to…
Greenwich Village. Tork performing folk songs with his banjo, Jones throwing some coins into the basket, and Nesmith lurking outside with a flaming torch.

How do I know what to put on the air? Put on a half hour of commercials, like the *Johnny Carson Show.* Or better yet, why don't you put on a review of *The Monkees in Paris.*

The In-Which
Bored with filming, the Monkees take an unscheduled vacation and flee to Paris.

A great deal of this review is going to be about what this episode lacks. So let me start out by sincerely praising what it *has*. First, it has a high concept. There is no other episode of THE MONKEES remotely similar to this one. There are few episodes of *any* scripted television show like this one. It is unique, and that is praiseworthy.

Second, it has a strong sense of place. This stands in stark contrast to the last episode I reviewed, *Monkees in Manhattan*, which obviously had come no closer to New York than possibly a garlic bagel on the craft service table. *The Monkees in Paris* is marinated in French wine, and even though not a word is spoken, the accent can easily be heard. It's not just the glimpses of Parisian landmarks, or the extended sequence of Monkees cavorting on the Eiffel Tower, it's the ancient streets and venerable market and most of all, the people—the merchants and the gendarmes and the children and the elders hanging from the upper story windows.

Third, it has whimsy, which helps to fill some of the wide gaps where clever dialogue and silly sight gags and physical humor would usually be.

Fourth, it has a structure. Not a very elegant structure, but a rigid exterior framework that tries to bind the chaos together in some form of order. The structure stands like four solid pillars, each one a scene back on the soundstage in Hollywood. One at the beginning, one at the end, and two spaced out evenly in between. Unfortunately, this rigid framework

surrounds a story that is fabricated out of cotton candy, flower petals, eiderdown and spider webs. Which brings me to what this episode lacks:

A plot.
It's entirely possible to tell a story without dialogue. Heck, the directors and editors of THE MONKEES are old hands at telling stories with silent movie techniques—for what is a romp, but a little silent picture? They should have been able to tell a story about how the four Monkees managed to meet and establish a tender, teasing, temporary relationship with four beautiful French girls. Instead, we get a mishmash of scenes that veer back and forth between pursuit, romance, escape and play. Costume changes make it clear that we are not seeing any kind of chronology. The action is non-linear and incomprehensible.

Characters.
I can't keep track of all the young women, and I never get a sense of who they are. They are never treated as individuals; in fact, I'd have to classify them as Eye Candy under the principle outlined in the upcoming essay about female characters ("Any time the show utilizes nubile young female extras in large quantities, the principle of Eye Candy is in effect.") This takes a potentially sweet romantic story and twists it into something wanton and cheap.

A happy ending.
The final pillar of the structure sees the Monkees back in Hollywood, shooting the same episode they were trying to escape in the first scene. They have had their vacation, they have blown off some steam, they have proved their independence and they have gotten a little nookie. By all rights, it's time for a happy ending. And yet, the episode ends with the stars still unhappy, still disgusted, still bored, still resentful. The audience gets one last finger in the eye: no matter how much we enjoy watching their show, the Monkees think it's dreck.

Zingers
You're kidding, right?

Clunker
Right in the middle of a high-revving rendition of *Goin' Down*, the action crashes suddenly into first gear as Micky and Davy take a few moments to wander around a cemetery, accompanied by a pipe organ. But only for 30 seconds, after which we are plunged abruptly back into *Goin' Down*. I have no problem with the slow, contemplative segment itself, but the whiplash editing is annoying.

Production Notes
Principal filming was done in June 1967, just before the band kicked off its epic summer tour in London. THE MONKEES had not yet aired in France, so the Parisian bystanders—including the hundreds caught in that very real traffic jam at the Arc de Triomphe—did not know

who these young men were. The wrap-around scenes on the Los Angles set were filmed the following December.

On his commentary track, producer/director Bob Rafelson says, "[The financiers] thought, well, the guys who are making this must know what they're doing. So they said, 'All right, we'll let you make one in 16mm and they'll just run around Paris.' I don't think they did a very good job, by the way. *I* certainly didn't do a very good job. I mean, look at this. It's just a shambles of girls chasing Monkees on motorcycles, Monkees chasing girls, who's chasing who—who cares? Just keep it lively, put the songs over it."

Whimsical Highlight
Four Monkees typing…well, I guess it would have to be *Hamlet*. Apparently the young ladies are more pleased with the second draft.

Second Runner-Up We Do Our Own Stunts
Davy jumps from the top of a truck into a tree, like a squirrel.

Runner-Up We Do Our Own Stunts
Micky climbs up a drainpipe to a 2nd floor balcony.

We Do Our Own Stunts
Did French authorities really let the four Americans climb around on the outside of the Eiffel Tower? Did Rafelson really let his four superstars climb around on the outside of the Eiffel Tower?

Breaking the ~~Fourth~~ Fifth Wall
Actor James Frawley playing the role of director James Frawley, making excuses over the phone to producer Bob Rafelson in an scene directed by Bob Rafelson. Space folds in on itself, up is down, black is white, and she's so far out, she's in.

Nitpick
The Monkees are already frolicking in Paris when James Frawley gets around to calling Bob Rafelson from the set to tell him that production of his TV show has stalled. Even if the guys had been able to leave immediately, that's a very long flight!

We're the young generation, and we have something to recycle.
- Recurring gag: Mike topples over while frozen. (See also *Art, For Monkees' Sake*; *Monkees a la Mode*; *The Spy Who Came in from the Cool* and *The Monkees on the Wheel*.)
- Recycled fourth-wall-breaking: Let's do that "scare" again—only better, next time. (See also *The Monstrous Monkee Mash*.)

What I want to know...
Was there a script?

Snack to enjoy while watching *The Monkees in Paris*:
"All right, you guys, give me the secret apple."

Music
- *Love is Only Sleeping*
- *Ride of the Valkyries*
- *Don't Call on Me*
- *Star Collector*
- *Goin' Down*
- *Toccata and Fugue in D Minor*
- *1812 Overture*

Episode 2-22
Written by: Robert Rafelson
Directed by: Robert Rafelson
Principal Filming Ended: 6/28/1967
First Airdate: 2/19/1968

Grading
- Concept. **A**
- Sense of Place. **A+**
- Whimsy. **B**
- Structure. **B+**
- Plot: **Incomplete**
- Characters: **Incomplete**
- Ending: **Unhappy**

And the cookie goes to...
The citizens of Paris, for watching the nonsense around them with humor and patience.

You'll find the Marshall in town. And try to act a bit more Western! 'Cause around here they don't take kindly to a review of *Monkees in Texas*.

The In-Which
The Monkees visit Mike's aunt, whose ranch is under attack by the dastardly Black Bart.

There's a recurring motif in THE MONKEES: when they go looking for adventure outside of Los Angeles, they sometimes manage to travel backwards in time as well. There were Depression-era gangsters in a ghost town, pirates on the high seas, and feuding clans in them thar hills. Nowhere is the time-travel motif more obvious than in Texas, where Mike's Aunt Kate is living comfortably in the last century. Was it *1854* when he last saw her?

More importantly, she and her daughters—I wonder where the homely Clara is during this adventure?—live in a perplexing mashup of *Gunsmoke* and *Bonanza* (which were set in Kansas and Nevada, respectively). I wonder how Nesmith, who was born and raised in Texas' two largest and most cosmopolitan cities, felt about making a shoot 'em up Western about a Texas that never progressed into the twentieth century?

If they had not made such a point of drawing the parallels between Kate's neighbor Ben Cartwheel and the beloved Ben Cartwright of *Bonanza*, the eventual plot twist would not be so surprising or delightful. But why not involve Ben's sons Mule (Hoss) or Little Moe (Little Joe) in the evil plot? If you're going to make a villain out of one of the most beloved good guys of the genre, why not go all the way?

While looking for Zingers I noted that while the dialogue is clever throughout the episode, it's not all that hilarious—it's more wry and referential than outright funny. There's lots

of slapstick and visual humor, though, which makes me wonder... oh, yes. James Frawley was the director. That explains a lot.

Words is a prime example of a romp that attempts to resolve an irresolvable plot simply by throwing lots of silly gags at it and hoping the audience won't notice. There is absolutely no reason for the bad guys to ride away, and Lucy was absolutely right to make her cynical observation that Black Bart will just come back again. I can't help but think that the abrupt cut into the unrelated video of *Goin' Down* was meant to distract the viewer from the total lack of resolution to what had been a fairly well developed plot.

Zingers

Peter: Bang! Bang bang bang bang! Bang bang bang bang!
Davy: What is this "bang bang bang" stuff?
Peter: Well, I hate violence. Besides, I have more shells than you.

Kate: Don't you remember your baby cousin Lucy?
Mike: Huh? Lu— Lucy!? Are you Lu—well, what, well what ever happened to the, the buck teeth and the uh knock-kneed, uh stringy-hair, bad complexion little girl I that used to hang around with?
Kate: That's your other cousin, Clara. She still looks the same.
Mike: Oh, merciful heavens.

Ben: Water m' horse, will you, son?
Davy: Water your horse—I'm not a stable boy!
Ben: I don't care about your mental condition, water m' horse!

Let's See if We Can Slip This Past the Censors

Just before the shootout/romp, Micky makes a two-finger gesture at Black Bart and his gang. It's not that well known in the US, but it's an obscene gesture in the UK. Perhaps when they shipped this episode to be broadcast on BBC, they had to put in an alternate gesture.

Runner-Up Physical Comedy Highlight

Peter, seated cross-legged in the saddle as he rides into Aunt Kate's house.

Physical Comedy Highlight

Davy, riding backwards on a very well trained stunt horse.

Not a Physical Comedy Highlight

Peter making the sorriest excuse for a pratfall in the entire series.

Second Runner-Up Sight Gag Highlight

Men with prices on their heads.

Runner-Up Sight Gag Highlight
All four Monkees passing weapons around and putting them back on the rack, then cocking the weapons they're not holding.

Sight Gag Highlight
Davy watering Ben Cartwheel's horse.

Runner-Up Breaking the Fourth Wall
Micky: Not now! This is a family show!

Breaking the Fourth Wall
Title card: For Emmy Consideration.

Fourth Runner-Up Nitpick
The same short piece of film, with Cousin Lucy saying, "I wouldn't be too happy 'bout that. They'll be back," appears in the episode twice.

Third Runner-Up Nitpick
Just because I call something a nitpick, doesn't mean it should have been done. Davy's backwards ride is a highlight of the show! That said, it's also a nitpick, because Davy was established as a skilled rider all the way back in episode 1-8, *Don't Look a Gift Horse in the Mouth*—a fact that was clearly reinforced in *Here Come the Monkees* and *The Monkees on Tour*.

Second Runner-Up Nitpick
When Micky gives the two-fingered salute to Black Bart and his men at the outset of the romp, he has some kind of rolled-up document in his back pocket. A script? Perhaps. But it wasn't there moments earlier, when he did a flip over the hitching post.

Runner-Up Nitpick
Mike must have made some purchases on the way home from town. When he breaks the good news to Aunt Kate, the jar of crude is half empty.

Nitpick
It's more than 800 miles from Malibu to El Paso, the closest corner of Texas. Golf carts have a top speed of about 15 miles per hour. If they drove 18 hours a day, they just might be able to make it from Malibu to El Paso in 3 days.

But... seriously. I can understand why they wouldn't want to bring the Monkeemobile into a story where it would have to be made unusable, but they could have come up with a better substitute than a golf cart!

Absolutely Not a Nitpick
James Arness was nominated for a Best Actor Emmy three times for his role as Marshall Dillon on *Gunsmoke*, but never won.

We're the young generation, and we have something to recycle.
- Recurring gag: hand over hand competition for a prop. (See also a paintbrush in *Art, for Monkees' Sake*; a spear in *Monkees Marooned*; a shotgun in *Hillbilly Honeymoon* and a telephone in *Too Many Girls*.)
- Recurring gag: Monkees stuck in a door. (See also *The Case of the Missing Monkee*; *The Picture Frame*; *The Christmas Show*; *Everywhere a Sheikh, Sheikh*; *The Monkees Watch their Feet* and *Monstrous Monkee Mash*.)
- Recurring plot point: calling for help. (See also *Monkee See, Monkee Die* and *Monkees in a Ghost Town*.)
- Recurring punch line: "Isn't that dumb?" (See also *Monkees on the Wheel*, *The Wild Monkees*, *A Coffin Too Frequent* and *Hillbilly Honeymoon*.)
- Returning actor: Len Lesser as Red. He also played George in *Monkees in a Ghost Town*.
- Returning actress: Bonnie J. Dewberry was not credited for her role as cousin Lucy; she wasn't credited for her earlier role as Doctor Mendoza's beautiful daughter in *I Was a Teenage Monster*, either.

Second Runner-Up Monkee Magic
Peter conjures up a bottle of champagne and party supplies.

Runner-Up Monkee Magic
Davy conjures up some water in a disconnected kitchen faucet.

Monkee Magic
Micky and Peter conjure up Lone Stranger and Pronto disguises for their trip into town.

Wild West Magic
The assayer's office is open for business.

What I want to know…
Why aren't Mule and Little Moe involved in Black Bart's gang?

Beverage to enjoy while watching *Monkees in Texas*:
"Milk. And leave-um bottle."

Music
- *Words:* Vaguely narrative romp.
- *Goin' Down:* Distract-the-audience-from-the-unresolved-plot isolated performance.

Episode 2-13
Written by: Jack Winter
Directed by: James Frawley
Principal Filming Ended: 10/19/1967
First Airdate: 12/4/1967

Grading
- *Bonanza.* **A-**
- *Gunsmoke.* **B-**
- *The Lone Ranger.* **Adorable**

And the ~~Cookie~~ Emmy Award Goes to...
Davy's very well trained stunt horse.

Oh, what an exciting fight this is, fight fans. There's a right to the head by the champ. And a flurry of lefts and rights by Jones. And a yawn by—I mean, a review of *Monkees in the Ring*.

The In-Which
A dishonest boxing manager promotes Davy as an up-and-coming featherweight prize fighter.

I had mentioned in the review of *I Was a 99 Lb. Weakling* that Davy was well established as a naturally self-confident athlete. There is evidence sprinkled throughout the series, but this entire episode is devoted to that premise. *Davy is absolutely believable as a boxer.* There's a moment early on in the training sequence romp, when he's working the punching bag in a nice, steady rhythm, his brows knitted and his jaw patiently working on a wad of chewing gum, and suddenly he's no longer *cute*—he may be small, but he's also strong and focused and coordinated and perfectly capable of kicking your ass.

What a delightful bit of character development! Davy's willingness to go along with Sholto's plan is so much more than a massive delusion. He's not just along for the ride; he wants it, he believes in it, and he works for it—far more than he does in his brief experiences as an actor *(The Monkees at the Movies)* and as a prince *(Everywhere a Sheikh, Sheikh)*.

One of the best elements of the episode is the strong portrayal of the champ by D'Urville Martin, in one of only two major roles for African-American actors in the entire series. Borrowing Muhammad Ali's trademark rhymes and "I am the greatest!" catch phrase, the champ strikes just the right balance of cocky charm and indignant rage, and his interpretation of boxing under the influence of a sleeping pill was a visual delight. Sadly, he disappears from the story just when he should be making mincemeat out of the inexperienced Davy;

when Peter grabs the microphone to deliver a mock-victory declaration for Davy, I'm surprised the champ doesn't knock them both out cold.

The episode is long on character development and short on plot; once we know the details of Sholto's plan, fairly early in the first act, the story unfolds pretty much exactly as expected. There are a few funny lines, but most of the humor is in Davy's physical clowning and Mike, Micky and Peter's delightful reaction shots.

Zingers

Davy: Don't you want me to be rich and famous?
Peter: I'd rather have you alive and well.
Mike: Yeah. Besides, you don't know anything about boxing.
Davy: That's not so. I used to be quite a scrapper at school, you know. There was this one big bully, always used to be picking on me. So one day I went whammo with the right, and whammo with the left.
Mike: What happened?
Davy: She never bothered me again.

Sholto: Do you know the thing closest to my heart?
Monkees: Your lungs.

Clunker

Sholto: If Davy doesn't win his first three fights by knockouts, you can have him back. Okay?
Micky: Okay.
Mike: Yeah. That sounds pretty fair.
Micky: Pretty fair.

That's a *terrible* bargain! It may have seemed necessary to move the plot along, but it's totally out of character for Mike and Micky to agree to such a commitment. The whole emotional flow of the episode so far has been to prevent Davy from taking up such a dangerous sport. They could have avoided the clunker, and improved character development, by having Davy assert his right to make decisions for himself. There's something inherently respectable and dignified about a man making his own choices, no matter how wrong-headed.

Cultural Clarification

Announcer: The fighters have now been told that, in the event of a knockdown, each man must go to a neutral corner.
Micky: I wish he'd go to the corner of Crescent Heights and Sunset.
Peter: He'd be safe.

Ironically, the intersection where Peter thinks Davy would be safe was the site of the Sunset Strip Riot in November, 1966. This event must have weighed on the Monkees' minds

while this episode was being filmed in early December; Bob Rafelson would conduct an unexpectedly serious interview segment on the topic right on the gymnasium set, for use in the episode *The Audition*.

The wise words of that old Yugoslavian philosopher ("Haber reeber robo sober...") are adapted from a comedy routine by Bill Cosby, *A Nut in Every Car*. Similar nonsense words would find their way into the song *No Time*, and the second season episode *It's a Nice Place to Visit*.

Let's See if We Can Slip This Past the Censors
Mike: Listen, man. You're gonna be going to a lot of strange cities. There's always one hotel, with a lot of gambling and drinking, a lot of fast women, and a lot of loose talk. You know what you do when you get into town.
Davy: Find that hotel.
Mike: You'll do fine.

Mike, are you sure that isn't fast *talk* and loose *women*?

Runner-Up Physical Comedy Highlight
Davy vs. an exercise bike. (Why this bit of comedy gold was not used in *The Case of the Missing Monkee* is beyond me.)

Physical Comedy Highlight
Mike and Micky trying to climb over/under the ropes to enter the ring.

Sight Gag Highlight
Davy's glass jaw.

Breaking the Fourth Wall
Davy makes a cheeky comment about the American Revolution, then glances at the camera: "No letters on that, please. Thank you."

Second Runner-Up Nitpick
Right there in Sholto's office, with half a dozen sports reporters standing nearby, Mike tells Davy that his three fights were fixed. *Nobody* else hears this?

Runner-Up Nitpick
They make quite a point of showing Davy put his mouth guard in. Twice. So when he says, "Don't do that" to the champ, why do we see all those beautiful teeth?

Nitpick
The biggest plot hole of all: Davy *knows* he never landed a blow in those first three fights. Even if he is too naïve to figure out that the fights were fixed (and I don't believe for a minute that he's that naïve), why would he be so cocky about fighting the champ?

Absolutely Not a Nitpick
Vernon: The horizontal hold sounds all right to me.

Yes, Vernon, indeed. In fact, the picture on that portable TV with the rabbit ears is crisp and clear. *Remarkably so.*

We're the young generation, and we have something to recycle.
- Recurring plotline: keeping the Monkees on ice in the pad. (See also *Royal Flush* and *Your Friendly Neighborhood Kidnappers*.)
- Recurring catch phrase: "Don't do that." Too many examples to count.
- Recurring motif: Davy as a boxer. (See also *The Monkees Get Out More Dirt, The Monkees Mind Their Manor* and of course, *Head*.)
- Recurring physical comedy: defeated by the weight-lifting pulleys. (See also *The Case of the Missing Monkee* and *I Was a 99 Lb. Weakling*.)

Second Runner-Up Monkee Magic
Davy conjures up a lead pipe.

Runner-Up Monkee Magic
Micky tries to institute some Shared Imagination, "Listen to Your Papa" edition, but Davy doesn't want to play along. Which is rather sad.

Monkee Magic
Davy and his shadow don't seem to like each other all that much, do they?

What I want to know…
How much boxing experience—if any—did Jones have?

Snack to enjoy while watching *Monkees in the Ring*:
Leave a trail of bloody pistachio nuts, all over the city. If you commit a crime, the police will find you in two minutes.

Music
- *Laugh:* Playful, yet very narrative romp.
- *I'll be Back Up on My Feet:* Narrative romp.

Episode 1-20
Written by: Gerald Gardner and Dee Caruso
Directed by: James Frawley
Principal Filming Ended: 12/8/1966
First Airdate: 1/30/1967

Grading
- Davy can box! **A-**
- Oh no, he can't. **B-**
- The champ knows how to rhyme and rant. **B**

And the cookie goes to...
Jones, along with a healthy measure of respect for his physical fitness and athleticism.

If you're within the sound of my voice, let me warn you: your time is almost up! And if you're not within the sound of my voice… then why in the blazes am I writing a review of *Monkees Marooned?*

The In-Which
Peter trades his guitar for a treasure map.

Let's go ahead and deal with the 10-ton elephant in the room: the grossly stereotyped character, employing a fake accent, silly costume and exaggerated mannerisms, depicting his foreign character as a buffoon.... How *could* we be so offensive to the Australians?

Of course, I'm referring to Monte Landis' portrayal of the paranoid Major Pshaw, not Rupert Crosse's portrayal of his put-upon sidekick, Thursday. And I'm exaggerating a little bit to make a point: THE MONKEES as a TV show was an equal-opportunity offender. There were two Australian characters in the course of the series (the other was the captain in *Hitting the High Seas*) and both were certifiably insane.

Meanwhile, there's Thursday. A black man in a bizarre mock-up of an African costume, carrying a shield and a spear and obediently following the Great White Nutcase around a make-believe jungle. I was fully prepared to fly into high dudgeon about Thursday, but then one telling detail broke through and got my attention.

He's wearing a *kilt!*

Thursday isn't an American actor portraying an African warrior. He's an American actor portraying an American guy who's been forced to wear a silly costume by a crazy employer. He's been stranded for ten years on that furshlugginer island, and he seizes the opportunity to quit his job as soon as it presents itself. I'm not letting the episode off the hook completely, as there's still something vaguely uncomfortable about the role of a snarky but obedient black

servant, but this one role does not rise anywhere near the disturbing racism of some other episodes.

The story begins, as so many MONKEES episodes do, with Peter walking headlong into a swindle. Thank goodness, no precious time is wasted setting up a long and improbable backstory for the con; the treasure map changes hands before the opening credits roll, and we have plenty of time for *two* richly detailed plots. The smooth, gradual introduction of the B-plot, in the form of a stealthy Kimba watching the Monkees' progress from the underbrush, is a delightful and unexpected bit of suspense.

There are a couple of minor comic bits that go on a little too long: Davy's "Launch the ship!" routine and the business about Micky's insect spray come to mind. But that's a small complaint for an episode that keeps the jokes, sight gags and slapstick coming from start to finish. James Frawley was in the director's chair, and that's no surprise.

In an unexpected change of pace, the plot is resolved *before* the music starts, turning the *Daydream Believer* romp into random play—no need to further the story, just let everyone have some fun. It's a perfect sort of frolic for that effervescent song: a little romantic coda for Kimba and his leading lady.

Zingers

Pshaw: If I catch those blaggards, I'll kill 'em! I'll show 'em. I didn't spend ten years on this bloody island looking for buried treasure to have someone come up and steal it from me.
Thursday: Has it been ten years, sir?
Pshaw: Yes, ten years. And the only good day was that Tuesday I hired you, Thursday. Yes, you're a magnificent Man Friday, Thursday. You've made every day a Sunday, Thursday.

Kimba: You come with Kimba. Kimba know jungle like palm of hand.
Mike: Well, where do we go from here?
Kimba: Follow long line to callus. Turn right, go all the way down to wrist, then back to finger.
Mike: He's really some kind of nut.
Davy: Let's go, then!
Micky: We can't use your hand, Davy. It's in meters.

Clunker

Mike: What kind of insect spray is that?
Micky: Attracts insects.

This is a feeble joke in an episode that is blessed with top-quality humor. Worse; from that moment on there is no sign of anybody being bothered by insects.

Third Runner-Up Sight Gag Highlight
Kimba's jungle friends: a chicken, a bunny, a cat and a puppy.

Second Runner-Up Sight Gag Highlight
Three Monkees hiding behind Mike.

Runner-Up Sight Gag Highlight
Micky, getting a thorough tongue-lashing.

Sight Gag Highlight
Hey, look! A footprint!

Third Runner-Up Breaking the Fourth Wall
Thursday watches THE MONKEES on TV. Who writes that stuff?

Second Runner-Up Breaking the Fourth Wall
Thursday: There's only one safe place.
Micky: Where's that?
Thursday: Well, I can't tell you now. That's in the next scene.

Runner-Up Breaking the Fourth Wall
Pshaw: This is the end; the die is cast.
Davy: You know, I always wondered what that meant.
Pshaw: The cast shall die!

Breaking the Fourth Wall
Micky: Wait! Our footprints! Great Scott, that means we're lost, we've been going around in circles—
Davy: Micky, Micky, it's a small set, man. We have to use the same place, you know, different bushes...
Mike: Like the Lone Ranger, and the big rock. Remember?

Second Runner-Up Nitpick
Mike says that it's really nice to be with all his aunts. Where is his Aunt Kate?

Runner-Up Nitpick
Thursday watches the episode *Monkees in Manhattan*—specifically, the romp that includes that particular mashup of clips from *The Chaperone*, *Captain Crocodile* and *Monkee See, Monkee Die*. But the music should be *Look Out (Here Comes Tomorrow)*.

Nitpick
Mike claimed to be an Eagle Scout (*Monkees a la Mode*)—but I don't think he got an orienteering badge. When they land on the island it's a bright, sunny day at 10 minutes past noon. It must be near midwinter to account for their fairly long shadows at midday—shadows that would be pointing due north, because the sun would be in the southern sky at noon. Based on the shadows, the direction Mike calculates as "due north" is actually due *west*.

Hang on, wait a minute...
Actually, the episode was shot in mid-May—so the nitpick is that it could not possibly be 10 minutes past noon when Mike checks his watch. At midday in mid-May their shadows would be like dark puddles at their feet. On the other hand, if it's the middle of the afternoon, their shadows would be pointing east. In that case, Mike's sense of direction would be correct (but his watch must be broken).

We're the young generation, and we have something to recycle.
- Recurring gag: closing Peter's mouth. (See also *I Was a Teenage Monster* and *The Monkees Blow Their Minds*.)
- Recurring catch phrase: "It's gone!" (See also *The Audition*; *Monkee See, Monkee Die*; *Monstrous Monkee Mash* and *Monkees Race Again*.)
- Recurring shtick: hand over hand competition for prop. (See also *Art, for Monkees' Sake*; *Monkees in Texas, Hillbilly Honeymoon* and *Too Many Girls*.)
- Recurring plot device: a Monkee pawns, sells, or wagers an instrument. (See also *I've Got a Little Song Here, Don't Look a Gift Horse in the Mouth* and *I Was a 99 Lb. Weakling*.)
- Recurring costume: the animal print/caveman look. (See also *Dance, Monkee, Dance; The Chaperone* and *One Man Shy*.)
- Recycled baby photo from *The Picture Frame*.
- Recycled footage from the occupations romp in *Monkee vs. Machine*.
- Recycled stock footage: *Reptilicus*. (See also *The Audition, I Was a Teenage Monster, Monkee Chow Mein* and *The Monkees Mind Their Manor*.)
- Recycled stock footage: traffic far below. (See also *The Case of the Missing Monkee* and *The Picture Frame*.)
- Recurring silliness: "Buh-du-bum. Here we come..." (Hear also *The Monkees' Paw, Fairy Tale* and *Monstrous Monkee Mash*.)

Runner-Up Monkee Magic
Micky conjures up a can of insect spray. (Why couldn't he conjure up a can of insect *repellant*?)

Monkee Magic
Davy conjures up a Union Jack flag.

What I want to know...
Who writes that stuff?

Beverage to enjoy while watching *Monkees Marooned:*
Some refreshing coconut milk, if you can get the bottle open. Here's a hammer.

Music
- *Daydream Believer:* Playful romp.
- *What am I Doin' Hangin' 'Round:* Isolated performance.

Episode 2-8
Written by: Stanley Ralph Ross
Directed by: James Frawley
Principal Filming Ended: 5/18/1967
First Airdate: 10/30/1967

Grading
- Take the A-plot: Major Pshaw and his Man, Thursday. **A-**
- The Boogie-Woogie Bugle Boy of Plot-B: Kimba and his Leading Lady. **A**
- Keep away from the Wrap-Around Plot: Leonard Shelton still pitches. **B**

And the cookie goes to...
Actor Ruppert Crosse, for instilling the character of Thursday with both dignity and humor.

Lance Kibbee, the estate is now yours. Yours to sell down the river to some money-grubbing land developer, while you go off and rot your brains and your liver writing a review of *The Monkees Mind Their Manor.*

The In-Which
Davy inherits a manor—but to save it and the adjoining village from being torn down, he must move back to England.

On his commentary track, Tork says that he chose the best of the leftover Season One scripts for his directorial debut. If this was the best of the lot, I shudder to think what the rejects were like. I note that this episode was written by Coslough Johnson, who also penned the scripts for *Art, for Monkees' Sake*; *Monkees Watch their Feet*; *The Monkee's Paw* and *Monkees on the Wheel*. That's a pretty good track record! And yet, the most apt adjective I can think of for this episode is...insipid.

The episode suffers from three major weaknesses. First, it has a woefully complicated premise—a legal tangle so snarled that it has to be restated several times over the course of the episode, for fear the audience would be left behind. Second, it is almost as strongly a Davy solo story as *Alias Micky Dolenz* is a Micky solo story. The other three Monkees are present, sort of, but are pretty much non-participatory. They lurk around the edges of the action, occasionally providing a suggestion or a pithy comment, but they don't actually *do* anything.

Third, it has strong signs of being done on the cheap: the airport doesn't look anything like an airport, and the odd wintertime Medieval Faire appears to have been shot in front of a dozen extras on the same little postage-stamp park where the Monkees frolicked with puppies in *I've Got a Little Song Here*, and with senior citizens in *Success Story*. They couldn't

even be bothered to come up with a proper venue for the competitions that make up the Grand Championship—Davy and Sir Twiggly just fight it out on a random patch of grass, with background music baldly borrowed from *Fairy Tale*.

I often despair over Monkees episodes that have too much frantic action and not enough sensible plot. Here we have the opposite problem; the plot makes sense but is too conventional, too conformist, too reasonable. The Monkees never romp, never rebel, never work their trademark magic. Heck, there's an entire scene where all they do is sit and talk about how bored they are! The wildest conceit in the entire episode, the shipping of three live Monkees disguised as three dead Egyptians, doesn't raise an eyebrow from anybody.

I am torn about the story's climax. On the one hand, Mary's disdainful diatribe is one of the best speeches of the series, and I'm pleased that it was given to such a unique character. On the other hand, it essentially takes the resolution to the plot out of the Monkees' hands, making their presence in the story seem useless and pointless. Worse, Lance's sudden declaration of love, and Mary's reciprocation, come across as sleazy rather than romantic. (The same basic scene, performed in 1983 by Ted Danson and Shelley Long on the show *Cheers*, was a comedy masterpiece built on thoroughly and patiently developed chemistry between the characters.)

Zingers

Mary Friar: Ah, don't condemn poor Lance. You mustn't make fun of the drunkard.
Mike: Sot.
Mary Friar: Sot. It happened during the war, you see. Everybody was getting bombed then.

Mr. Friar: Ah! Sir Toppen Middle-Bottom. On behalf of all the villagers, I'd like to make a little wager on the Grand Championship.
Sir Twiggly: You're on. Large?
Mr. Friar: Larger.
Sir Twiggly: Enormous.
Mr. Friar: Bigger.
Sir Twiggly: Monumental.
Mr. Friar: It's a deal.

Clunkers

Lance Kibbee: I love you!
Mary Friar: And I love you!

Pardon me while I sob onto my keyboard.

And while we're on the subject of clunkers, let me add every instance of Mr. Friar fainting and every joke about the nearsighted butler. Far too much conventional humor, far too little Monkee Business.

Cultural Clarification
Property Man/Customs Man Jack Williams does a smooth rendition of the closing of *The Dean Martin Show*. "Just keep those letters and cards comin' in."

Runner-Up Physical Comedy Highlight
Davy's graceful dance across the pad to answer the door.

Physical Comedy Highlight
Jack Williams' home improvement advice. You stick the cord in the mummy's nose, and the bulbs in the eyes!

Absolutely Not a Physical Comedy Highlight
The nearsighted butler leading the entire cast in a "follow me/go where you go" parade through the manor.

Runner-Up Sight Gag Highlight
Micky's semi-cross-eyed rage look. With a menacing drumstick. Mike just barely stops him in time!

Sight Gag Highlight
Davy making a sincere attempt to catch his epee in his boxing-gloved hand.

Character Name Highlight
It's a tie between co-conspirators Lance Kibbee (the Sot) and Sir Twiggly Toppen Middle-Bottom.

Audio Highlight
Jack Williams' solo as a crooner.

Runner Up Breaking the Fourth Wall
Caption: In the Sticks, Call Hayseed 7-4000.

Breaking the Fourth Wall
Customs Man: Look, sweetie. I might be Jack Williams, the property man to you, but to twenty million teenagers, I'm the customs man.

Fourth Runner-Up Nitpick
Friar calls Sir Twiggly "Sir Toppen Middle-Bottom." While I suppose it's funny to hear the name spoken, it's the wrong manner of address. "Sir" goes with the first name, not the family name.

Third Runner-Up Nitpick
What's the teepee doing on the grounds of the Medieval Faire?

Second Runner-Up Nitpick
The will's crucial clause says, "Do hereby bequeath Kibbee Estate to one Davy Jones, provided that he remains permanently at the manor for a period of no less than five years." I guess this is a new definition of the word "permanently."

Runner-Up Nitpick
Why does the British Customs agent have an American accent?

Nitpick
Davy fenced (badly) in *Royal Flush* and (well) in *The Prince and the Paupers*. But there's no rational explanation for dressing him up for a fencing match in his satin boxing duds from *Monkees in the Ring* when the future of Kibbee Manor is on the line.

Absolutely Not a Nitpick
Although it was to be broadcast in February 1968, the episode was shot in early December, 1967—so Peter's Christmas message is actually rather timely.

We're the young generation, and we have something to recycle.
- Recurring plot point: Mike wants to look at that contract. (See also *Dance, Monkee, Dance* and *The Devil and Peter Tork*.)
- Recycled location footage: the same small airport—even the same gate, gate #3—appeared in *Success Story*.
- Recycled prop: sarcophagus from *Monstrous Monkee Mash*.
- Recycled costume: green satin "Dynamite Davy Jones" robe from *Monkees in the Ring*.
- Recurring stock footage: *Reptilicus*. (See also *The Audition*, *I Was a Teenage Monster*, *Monkee Chow Mein* and *Monkees Marooned*.)
- Recurring sports theme: Davy fences (*Royal Flush* and *The Prince and the Paupers*).

Monkee Magic
Davy's singing voice comes with reverb, strings and flute.

What I want to know…
What other second season episodes (if any) were made from rejected first season scripts?

Beverage to enjoy while watching *The Monkees Mind Their Manor*:
There's booze in the radio. "Here's to the Pound Sterling."

Music
- *Greensleeves:* Narrative singing contest.
- *Star Collector:* Isolated performance.

Episode 2-23
Written by: Coslough Johnson
Directed by: Peter H. Thorkelson
Principal Filming Ended: 12/7/1967
First Airdate: 2/26/1968

Grading
- The Party of the First Part: Davy Jones, heir apparent. **B**
- The Party of the Second Part: Lance Kibbee (the Sot). **C**
- The Party of the Third Part: Sir Twiggly Toppen Middle-Bottom. **10% Commission**
- The Party of the Fourth Part: Mary Friar. **A+ for elocution, D for taste in men**

And the cookie goes to...
Director Peter H. Thorkelson, for stretching his wings and trying something new.

Nothing could be easier! The phone rings, ding-a-ling-a-ling; you plug it in the hole, you answer it, you write down the message. When the client calls in you give him a review of *The Monkees on the Line.*

The In-Which
The Monkees get jobs at a telephone answering service.

There's an elegant structure here, one that could easily have supported a full hour of top-quality television or even a feature film. The answering service is simply a plot device, a central point for a trio of independent short stories: a melodrama, a domestic drama and a crime drama.

But... THE MONKEES is not a drama. Oh, they can easily convert the domestic drama into a domestic farce, and the crime drama into a crime caper, but it's a monumental challenge to squeeze laughs out of Mike's experience staffing a suicide hotline. And yet, the episode succeeds in wringing buckets of black comedy out of Mike's heroic efforts. The audience doesn't learn that Ellen is just playacting until halfway through the episode, and Mike doesn't learn the truth until the episode is over—which means that Ellen's cries for help never cease to be a truly serious matter. And that makes for a delightfully discomfiting viewing experience.

Unfortunately, the B and C plots—the domestic farce and the crime caper—don't measure up. Compared to Ellen's compelling tale, the stories are crude and uninspiring. Compared to Ellen herself, the characters are two-dimensional clichés. In the end, all that can be done is bring everyone together in one room and just make them all romp it out. Sadly, it's a pretty pale excuse for a romp.

I have some dim, distant memories of watching THE MONKEES as a child. There's very little specific detail to those memories, just vague impressions for the most part—but this episode does evoke just one crystal-clear image. It's that *bed!* That incongruous, impractical,

infernal red roll-away bed behind the half-height doors. Press the button and get sucked right into the wall, trapped in some kind of outer darkness until and unless somebody else happens to press the button and set you free. Or maybe not—during the romp, sometimes the bed emerges with *somebody else on it*. It was a deeply disturbing image to my childlike imagination, and at some level it disturbs me still.

Zingers
Mike: Hold it! Wait a minute. Let's decide this democratically.
Peter: We'll choose fingers.
Mike: Yes. I choose this one. Oooh! I won! That means, I got the city in my fingertips!
Peter: How come Mike always wins?
Micky: He has six fingers on that hand.

Mike: Well, we're looking for Miss Ellen Farnsby. We have reason to believe that she's here.
Director: Yes! Yes, yes. She just departed.
Micky and Mike: What!?!
Director: For her apartment.
Mike: Oh. Well, uh, how was she acting? You know—
Director: How was she acting? She was nervous, tense, depressed, like she wanted to end it all!

Clunkers
Davy: Is he alive?
Micky: Was he ever?

Production Notes
This was the last episode filmed for the first season. There would be a two-month hiatus before filming would begin for the second season, during which the Monkees would travel to England, and record *Headquarters*.

Let's See if We Can Slip This Past the Censors
During the nonsensical and non-musical romp, a pretty young woman wearing nothing but a towel dashes into the Smiths' apartment. Seconds later, Davy emerges from the apartment wearing the towel.

Second Runner-Up Physical Comedy Highlight
Just about any scene involving the mass answering of telephones.

Runner-Up Physical Comedy Highlight
Mike squeezing between the two thugs to answer the phone.

Physical Comedy Highlight
Mike's impersonation of a California Condor.

Runner-Up Sight Gag Highlight
Micky, Peter and Davy sliding sideways as Mike gradually demolishes the table with his gavel.

Sight Gag Highlight
Mike: In there! She's in there.
Micky: She must be awful skinny.

Breaking the Fourth Wall
Mike: Hat, please? Thank you, babe.
Micky: Where'd you get that?
Mike: From wardrobe!

Fifth Runner-Up Nitpick
The extension phone Micky uses when he and Davy call Mike to report Peter missing is cordless. Which, in 1967, is a *bug*, not a feature.

Fourth Runner-Up Nitpick
Despite its name, the California Condor is not the California state bird. That honor belongs to the Valley Quail.

Third Runner-Up Nitpick
Peter gets a lead on a $10,000 gig for a vocal group and he gives it to the *Pelicans*? Why doesn't he give the gig to the Monkees?

Second Runner-Up Nitpick
At the theater, Micky and Mike realize that one of them will have to go relieve Peter. How do they know that Davy had left Peter alone?

Runner-Up Nitpick
When Davy delivers Zelda's message to Mr. Smith in the doorway of apartment 6, Smith is half-shaven and wearing an undershirt. When he emerges from apartment 7 a few seconds later, he is fully shaven and dressed in his police officer's uniform.

Nitpick
Davy assumes that the first person named "Smith" in the index is the intended recipient of the message from Zelda. Which might be a believable error of judgment from just about anybody else—but certainly not from somebody named *Jones*.

We're the young generation, and we have something to recycle.
- Recurring plot device: choosing fingers. (See also *Monkee See, Monkee Die*; *The Monkees Get Out More Dirt*; *Dance, Monkee, Dance* and *The Devil and Peter Tork*.)
- Recurring catch phrase: "Don't do that." (Too many references to list.)
- Returning actress: Helen Winston as the manager of the answering service. She also played Big Flora in *Monkees a la Carte*.
- Returning actress: Lea Marmer as Mrs. Smith. She also played Madame Rozelle in *Monkee See, Monkee Die*.

Monkee Magic
Shared Imagination, Surgical Consult edition. "Don't do that!"

Answering Service Magic
That bed will attack you, knock you unconscious, and hold you prisoner inside the wall. *Will your friends find you in time?*

What I want to know...
What kind of sick leprechaun came up with the idea for the bed?

Snack to enjoy while watching *The Monkees on the Line:*
Here's ten thousand dollars—I'll have a popsicle. No, I said *POPSICLE!*

Music
- *Look Out (Here Comes Tomorrow):* Vaguely narrative romp.

Episode 1-28
Written by: Gerald Gardner, Dee Caruso and Coslough Johnson
Directed by: James Frawley
Principal Filming Ended: 2/2/1967
First Airdate: 3/27/1967

Grading
- Suicide Hotline Hijinks. **A-**
- Misdirected Message Madness. **C-**
- Wasted Wager Wackiness. **C-**
- Frenetic Phone Follies. **B**

And the cookie goes to...
Ellen Farnsby would like to thank her agent, her director, her parents, and all the little people at the Urgent Answering Service.

Everybody cool it, because I want to get through this. Hey, wow. That's a groovy review of *Monkees on the Wheel.* What's it say?

The In-Which
The Monkees visit Las Vegas, where they stumble into a roulette-wheel-rigging scheme.

Late in Season Two—episodes shot in the fall of 1967, after the long summer tour—THE MONKEES began to indulge in a certain amount of pretentious navel-gazing. Episodes became more and more self-referential, not so much breaking the fourth wall to wink at the audience, as encouraging the audience to pick up a sledgehammer. Nowhere is this trend more evident than in *Monkees on the Wheel*, an inconsequential crime caper that would be instantly forgettable except for the constant flow of 'aren't we clever' gimmickry.

As I transcribed dialogue for the Zingers section, I noticed that the dialogue is not the source of humor here. Quirks of delivery—deadpan, affectations, spoonerisms and funny voices—provide the laughs while the dialogue merely delivers information. And there's that constant flow of meta-humor: Peter speaking one of Davy's lines in a foppish British accent; Micky engaging the bad guy in a huffing, finger-poking, neck-rolling James Cagney contest; Mike drolly explaining the dramatic structure of the tag sequence. Meanwhile, the editors slice and dice the film with jump cuts, flash cuts, and inverted images.

In a way, *Monkees on the Wheel* is a soft-focus mirror of the wrap-around segments of *The Monkees in Paris*. In that episode, the guys bitterly denounced their show's formulaic nature; here, they give a cheeky, knowing grin and we can all believe they think the formula is still working.

Despite the delightful barrage of loopy humor, the episode is seriously lacking in warmth. The Monkees move together in the same direction, but on parallel tracks, managing to execute

a fairly elaborate plan without ever really talking to each other. Other than a gentle pat on the head from Mike when Micky realizes that his fingers are not really magic, there are few signs of friendship; for the most part they upstage each other, jump on each other's lines, and generally carp, compete and criticize. Apparently they had come to Las Vegas for a gig, but other than a few offhand comments about the need to rehearse there is no evidence of the show's core premise that they are struggling musicians. They could have been any gang of clever horndogs on a weekend jaunt to gamble and pick up chicks.

The lone romp gets off to a leisurely start, a bit like the orderly, slow-motion circle-chase from *The Monkees on the Line*. Fortunately, it soon breaks into rapid-fire snippets of whimsical nonsense, which is almost enough to distract the viewer from noticing that the plot is never actually resolved. (This is a problem in several of these later episodes, including the episodes immediately before and after *Monkees on the Wheel* in filming order: *Monkees in Texas* and *Monstrous Monkee Mash*.)

The episode ends in the same, self-referential spirit, with an oddly edited music video that draws attention to Nesmith's cheerfully deliberate failure to lip synch, followed by the delightful "Save the Texas Prairie Chicken" blooper reel, featuring bizarre costumes from an episode that would not air for another four weeks. Viewers must have been baffled.

Zingers

Croupier: Sixteen red. You won again.
Micky: I won again. I won again! It's magic fingers, magic fingers—I really won? I can't believe I really won. Magic fin—oh, magic fingers hurt!
Biggy: See? I told you it was unlucky.
Mike: He did mention it.

Micky: Hey, uh—don't bother the professor when he's thinking.
Biggie: Who are you?
Micky: I'm, uh, the Insidious Strangler. I'm the boss of this gang.
Biggie: Well my boss wants to know what your gang is doing in town.
Micky: Well...me boss says my gang is here for robbery, extortion and murder.
Mike: Sort of your regular tourist activities.
Peter: Actually, we're here to play a gig.

Clunkers

I've hated the line "Isn't that dumb?" every time it appears, and I've said so. But it's ever so much more of a clunker in this episode, because both times it is uttered, Peter has just been uncharacteristically clever.

Young man: Take this, Wizard Glick!
Mike: Ooooh! Who?

Young Man: Wizard Glick.
Mike: Man, I'm not Wizard Glick.
Young Man: Oh, you're not. Oh, I'm sorry.

 I am puzzled as to how this feeble *non sequitur* made it into the episode. Not only would the reference make no sense at all to the viewers, but *Mijacogeo* hadn't even been filmed yet. Dolenz may have been working on the script at the time, but neither he nor any of his collaborators were involved in the writing or directing of *Monkees on the Wheel*.

Let's See if We Can Slip This Past the Censors
Micky as a slot machine: pump him up, and he'll pay off.

Runner-Up Physical Comedy Highlight
Mike, frozen as a scale, eventually tipping over. He did this shtick in several episodes, but this was the best.

Physical Comedy Highlight
Dueling James Cagney impressions. "You're a Yankee Doodle Dandy!"

Second Runner-Up Sight Gag Highlight
Seven plus five = twelve.

Runner-Up Sight Gag Highlight
Peter did two years in solitary, standing on his head.

Sight Gag Highlight
How to make a capital M. The illustration provided is actually pretty true to the description!

Second Runner-Up Breaking the Fourth Wall
Peter: You must be joking.
Davy: That's my line.
Peter: Oh, sorry.
Davy: You must be joking!

Runner-Up Breaking the Fourth Wall
Micky: Della, sweet as any fella...
Davy: Wait, wait wait wait. Micky, Micky! She has a line. She has a line.
Della: No.
Davy: You don't have a line?
Micky: Della....

Breaking the Fourth Wall
Mike: Now then. (Over here, Kenny. Yeah.) For all practical purposes, you see, the show is over, but we have in the television industry what they call a 'tag,' which is some sort of just complete laugh riot at the end of a show, so that y'all will tune back in next week, you see, because it's so hilarious. Now, the tag we're going to do this week is called a 'here we go again' tag....

Second Runner-Up Nitpick
At the end of the "here we go again" tag, Mike calls for a pained look to camera. Peter obliges, but Davy stays frozen, staring blankly.

Runner-Up Nitpick
Um... sir? Wizard Glick is over there—the babbling croupier at the roulette wheel.

Nitpick
Zelda comes up two lemons and a crabapple with Micky's last quarter, then flounces off in a sour snit. Frustrated, Micky pulls the one-armed-bandit's one arm and scores a jackpot. *Without putting any money in.* Magic fingers, indeed!

We're the young generation, and we have something to recycle.
- Recurring physical comedy: Mike topples over while frozen. (See also *The Spy Who Came in from the Cool*; *Monkees a la Mode*; *Art, for Monkees' Sake* and *The Monkees in Paris*.)
- Recurring catch phrase: "Isn't that dumb?" (Glare disapprovingly also at *Hillbilly Honeymoon*, *A Coffin Too Frequent*, *The Wild Monkees* and *Monkees in Texas*.)
- Recycled gag: the Monkees hold a mumbled "rhubarb, rhubarb" conference. (Listen also to *Hillbilly Honeymoon*; *Dance, Monkee, Dance* and *Your Friendly Neighborhood Kidnappers*.)
- Returning actor: Rip Taylor as the croupier. (He's going to babble twice as much as Wizard Glick in *Mijacogeo*.)
- Returning actor: Joy Harmon as the air-brained Zelda. (She was also the air-brained bank teller in *The Picture Frame*.)

Monkee Magic
I'm betting the bank on 212 Green!

What I want to know...
Why did they find it necessary to film a second Vaudeville-style performance for *Cuddly Toy*?

Beverage to enjoy while watching *Monkees on the Wheel*:
The Equalization of Ratios cocktail. Two glasses, the same amount in both. Drink together, and they are now unequal. Add a little 16 redeye, and... *[thud]*.

Music
- *The Door into Summer:* Vaguely narrative romp.
- *Cuddly Toy:* Isolated performance (the one without dancer Anita Mann).

Episode 2-14
Written by: Coslough Johnson
Directed by: Jerry Shepard
Principal Filming Ended: 10/27/1967
First Airdate: 12/11/1967

Grading
- The guys. **B-**
- The dolls. **C**
- The cops. **C-**
- The robbers. **B**
- The fourth wall. **Demolished**

And the cookie goes to...
The doubly inimitable James Cagney.

Your life when you go out on the road turns into an endless review of *The Monkees on Tour.*

The In-Which
The Monkees enjoy a little bit of free time in Phoenix before a concert.

There's a curious dichotomy to this quasi-documentary, a half-hour film that is at war with itself. I call it a quasi-documentary because Bob Rafelson can hardly be called an objective filmmaker; he not only has a story to tell, he also has a product to sell. It's in his vested interest to depict the concert-performing Monkees as a mirror reflection of the television-acting Monkees. See? They're having a good time. They're telling jokes. They're goofing around with their fans. They may be coming to your town; wouldn't that be fun?

Three of the Monkees have jaunty little solo scenes depicting their leisure activities before the concert: Davy plays slow-motion tag with an irritable swan; Micky roller-skates around the hotel and signs autographs; Mike drives the Monkeemobile into town and goes shopping in a sporting goods store. Other activities take place in groups of three: breakfast (Davy, Peter and Mike), a trail ride (Davy, Peter and Micky) and a radio station takeover (Davy, Micky and Mike). The implication is that the Monkees enjoy a lot of free time on the day of a concert.

And yet, there's the contradictory view, succinctly and vividly expressed by not one but two Monkees, in the form of Michael quoting Peter: "Your life when you go out on the road turns into an endless tunnel of just limousines and airplanes and hotel rooms. And all of a sudden there's one brief period of light—and that's when you walk out there on the stage, you know. And it all seems worthwhile."

What a stark image! What a lonely, cold, sad vision of the Monkees on tour—a vision matched by the bleak, colorless footage shot at the airport in the dark of night, in the bowels of the arena between sets, in the starkly lit garage with its wailing sirens. And it's over that last image that the filmmaker put his signature: Written and directed by Robert Rafelson.

The Monkees on Tour may have a *cinema vérité* style, but there's a reason that producer/director Rafelson gave himself a writer's credit as well. He wasn't merely recording the events as they unfolded; he was manipulating them, too. Tork's commentary track gives the viewer a peek behind the curtain, as his younger self strolls across the hotel's manicured grounds, accompanied by an introspective voice-over. The older Tork says wearily, "Another one of Rafelson's fake things. 'Let's have you walking alone. Say something about the green, Peter.'"

The concert itself is almost an anti-advertisement. What little bit of music that can be heard over the screams sounds rough and raw. The images of hysterical girls, some being wrestled by security guards, are disturbing rather than inviting. They may be coming to my town…but do I really want to be there?

All in all, I'm very glad this episode exists. It's *interesting*. It's a convenient, accessible record of the Monkeemania phenomenon, however staged and manipulated. (Perhaps it's a truthful record specifically *because* it's staged and manipulated.) In the end, I feel more informed for having watched it—but it's not something I would want to watch very often.

I Heard it on the Commentary Track (Bobby Hart Edition)
"They also shot the next show, the next following night in San Francisco at the Cow Palace. Which, as you know, is a giant arena. The thing I remember about the Cow Palace, one of them, was it was kind of an eye-opener for a number of THE MONKEES' Los Angeles production team, who flew up to witness for themselves this Monkeemania they'd been hearing about. 'Cause they'd stayed behind and hadn't seen it firsthand—but San Francisco was close enough that a bunch of the people from the show… including Bert Schneider, flew up to see it. And I remember Bert just sitting there, shaking his head, not believing what he had created."

Musical Highlight
I can't hear anything above all the screaming, so I'll focus on something that *looks* impressive: Davy picking up a pair of sticks and taking over the drumming in the middle of a song. If it hadn't been captured on film here, I might not have believed it.

Physical Comedy Highlight
Davy getting tough with a swan. Or…maybe not.

Sight Gag Highlight
Micky in auto-autograph mode.

We Do Our Own Stunts
Davy hotdogging recklessly on a motorcycle. Helmet? He's not even wearing a shirt!

Runner-Up Nitpick
Peter puts on his white sweater backstage, then an instant later he takes off his white dress shirt.

Nitpick
After the Monkees ride in the Monkeemobile to the radio station, we see Mike unchaining the Monkeemobile from its shipping container.

We're the young generation, and we have something to recycle.
- Recurring shtick: Mike gives the radio farm report. The javelina hogs is just fine like they is. (See also *Monkees at the Circus*.)

What I want to know...
What other "spontaneous" moments in the documentary were prompted by Rafelson?

Snack to enjoy while watching *The Monkees on Tour*:
"I am picking the sandwich up. I am putting the sandwich in my mouth. I am biting the sandwich."

Music
- *(Theme from) The Monkees:* Played at radio station.
- *The Girl I Knew Somewhere:* Background music.
- *Last Train to Clarksville:* Concert performance.
- *Sweet Young Thing:* Ditto.
- *Mary, Mary:* Likewise.
- *Cripple Creek: solo performance.*
- *You Can't Judge a Book by the Cover: solo... oh, you know.*
- *I Wanna Be Free*
- *I Got a Woman*
- *(I'm Not Your) Steppin' Stone*
- *I'm a Believer:* Background music.

Episode 1-32
Written by: Robert Rafelson
Directed by: Robert Rafelson
Principal Filming Ended: 1/21/1967
First Airdate: 4/24/1967

Grading
- Candy-colored capers of a band that's having a ball. **B-**
- That long, dark tunnel of limousines, airplanes and hotel rooms. **C**
- The concert. **What's that? I can't hear you over all the screaming.**

And the cookie goes to...
The swan. Because if the swan wants the cookie, you give the swan the cookie.

I walked for ten thousand miles through burning dands and seserts. Uh, sands and deserts. I was looking for the secret unknown Tibetan review of *The Monkee's Paw.*

The In-Which
Feeling sorry for an unemployed magician, Micky purchases a bad-luck talisman from him.

*D*avy raises his hand beside the raised hand of a cigar-store Indian and asks, "How?" Then he dissolves into a fit of giggles while Mike and Peter shake their heads in *sympathetic bemusement.*

If you were to look for this episode online, you would find that scene. And while you're at it, you might also find the blooper of director James Frawley patiently calling three of his young stars to take their positions. Take their positions. Be *in* position. *Already in position.* And you'd see them wander back into the shot, loose and unfocused and not quite ready to work.

You might get the impression that the entire episode is one long hazy, dreamy, self-indulgent trip. After all, it was filmed during those hazy, dreamy, self-indulgent days of late 1967, when many Monkees episodes took on tinges of sloppy, slapdash spontaneity. But you'd be mistaken. Giggle fit and blooper aside, this is a tightly plotted story with sterling performances from all four Monkees.

The tale of a curse that can only be broken by passing it on to a more deserving victim is not exactly new. But Coslough Johnson's script decks it out in delightfully elegant and silly details, not the least of which is the unexpected silencing of the Monkees' most voluble member. Dolenz is at the top of his game here, miming his lines with gusto and never failing to communicate exactly what his character is thinking.

The episode does get bogged down in spots, especially in scenes involving the magician and the club manager—representatives of a generation that doesn't understand or appreciate these long-haired kids. But these scenes are thankfully short, and are interspersed with gems like the young Mendrek's encounter with the Regular Lama and the Monkees' cheerfully enthusiastic interpretations of an inkblot.

There's only one musical romp, one that is specifically related to the plot to a degree that few romps ever reach. The variety of colorful, magical moments is laudable, but I do wish they had shot just a few more seconds of usable hijinks rather than recycling pale, stilted footage from Peter's disastrous magic act in *Too Many Girls*.

Zingers

Mike: All right, now that we've got this all down: Apple, Cat, Hare Krishna, Legalize Wisdom, Frodis and, of course, Save the Texas Prairie Chicken, we go on to our next lesson, which is speech. Now, Micky, I want you to repeat after me. What is that? It's a pencil. Right? Come on, Mick. Say it. Pencil. Pencil.
Peter: C'mon, um, lo—
Davy: Say pencil.
Peter: Pencil.
Davy: Peh. Peh. Show 'im that P.
Peter: P. P. P. P. P. P.
Davy: Pencil. Pencil. Ah, it's no good. He won't be able to sing tonight. He can't even say pencil!
Mike: Suppose that has anything to do with the fact that this is a crayon?
Micky: Now 'crayon,' I can say.

Clunkers

Mendrek: Excuse me, Mr. Manager, but what about me?

Mendrek: Don't feel bad, daughter. At least today I made a quarter.

IRS Agent: Are you the manager who just wished for a million dollars?

If a character is going to be on screen long enough to be addressed by name, it doesn't take but a few seconds to come up with a name for the character. Call the manager Mr. Wiggenlooper. Call the lovely daughter Leticia. See how easy that was?

Mike: Aw Micky, come on! You can talk, there's nothing wrong with your voice!
Peter: Are you kidding? Have you ever heard him sing?

Micky has made digs like this at Peter a number of times, so it's only fair for Peter to get a zinger in when Micky's down. But besides being wildly inaccurate, it's also out of character for Peter to throw an insult like this.

Cultural Clarifications
The episode title is taken directly from the source material: a 1902 short story *The Monkey's Paw*, by William Wymark Jacobs.

During their Marx Brothers routine at the club, Mike tells Micky, "Say the magic word, you get a hundred dollars." He's borrowing a phrase from Groucho's 1946 – 1960 game show *You Bet Your Life*.

While answering the phones for Mendrek, Peter fields an offer from *The Tonight Show*. ("No no, Mr. Carson. Mr. Mendrek wants you on *his* show.") Meanwhile, Mike turns down an invitation from the White House. ("Well, I don't care who you are, he can't come. Well, because he don't like barbecue, I guess. Oooh! What a pushy guy.")

Let's See if We Can Slip This Past the Censors
The High Lama is out back, sleeping it off. Yeah, that's how he got his name.

Physical Comedy Highlight
Mendrek, Micky and a card trick.

Second Runner-Up Sight Gag Highlight
Micky's escalating argument with Mr. Schneider.

Runner-Up Sight Gag Highlight
Micky's ~~dirty~~ tender conversation on one of Mendrek's telephones.

Sight Gag Highlight
Any shot of Micky using the monkey's paw as a third hand—scratching his head, wiping away a tear…

Enunciation Highlight
I'm no lipreader, but it's pretty clear that Micky's first two attempts to speak after the commercial break are the opening words of Lincoln's Gettysburg Address. "Four score and seven years ago…"

Breaking the Fourth Wall
Daughter: I think you spell 'monkey' with a Y.

Third Runner-Up Nitpick
When Micky "performs" *Goin' Down* in the club, he shakes a tambourine—but there's no tambourine audible in the instrumental track.

Second Runner-Up Nitpick
Micky's first reaction to the monkey's paw is utter disgust; Mike thinks it's groovy. So why does Micky end up with the paw? (Seriously, though. How hard would it have been to have *Mike* say "Bleecchh! What is that?" and for *Micky* to say "Oooh! I think it's kind of groovy"?)

Runner-Up Nitpick
So what if Micky can't sing? Put him back on the drums, somebody else sings. Doesn't solve the underlying problem, but sure makes more sense than doing a Marx Brothers routine.

Nitpick
It's a pity that, in the waning moments of a well-constructed plot, they had to resort to such a ridiculously implausible *deus ex machina* as an IRS agent arresting the bad guy for unpaid taxes on a windfall that only just fell a few seconds earlier.

We're the young generation, and we have something to recycle.
- Recurring shtick: the Monkees strike a "hello" chord. (See also *Monkees a la Mode*, *Everywhere a Sheikh, Sheikh* and *Some Like it Lukewarm*.)
- Recurring shtick: "Buh-du-bum. Here we come...." (See also *Monkees Marooned*, *Fairy Tale* and *Monstrous Monkee Mash*.)
- Recycled footage: Peter's magic act from *Too Many Girls*.
- Recurring catch phrase: "Well, that's show business!" (See also *Monkees in a Ghost Town*.)
- Recycled prop: the Chinese gong from *Monkee Chow Mein*.

Runner-Up Monkee Magic
Micky's a pretty good magician. Conjures up a pretty girl, even. Peter, on the other hand, hasn't gotten any better at stage magic since he murdered his first dove in *Too Many Girls*.

Monkee Magic
When Davy finds the answer in the Book of Mystery, he teleports himself, the magician's daughter, the book and its display stand out to the living room.

What I want to know...
How many takes had been wasted before guest star Hans Conreid lost his temper—as seen in the episode-ending blooper?

Snack to enjoy while watching *The Monkee's Paw:*
A spaghetti dinner big enough to feed all four of us. Hey, look—food!

Music
- *Goin' Down:* Audition fragment.
- *Goin' Down:* Plot-related, inadvertently instrumental fragment of a performance. With footwork.
- *Words:* Vaguely narrative, semi-playful romp.

Episode 2-19
Written by: Coslough Johnson
Directed by: James Frawley
Principal Filming Ended: 11/15/1967
First Airdate: 1/29/1968

Grading
- The High Lama is sleeping it off. **A+**
- How? **A**
- I hate these @#$% kids. **B**

And the cookie goes to...
The High Lama will probably wake up with the munchies.

Brainwashing. Solitary confinement. Starvation. Nothing you can do to me will make me want to write a review of *Monkees Race Again.*

The In-Which
The Monkees are asked to help a British auto-racing team that is being sabotaged by their German rivals.

And here's where it ended, just a few days before Christmas, 1967. Production of THE MONKEES limped to the second season's last filming day, and then shut down—not just for the holidays, but forever. In a few months they would start filming *Head*, and NBC would quietly pull the plug on its rebellious, reckless, revolutionary little rock 'n' roll TV show.

Some episode had to be the last one made, and *Monkees Race Again* is it. And oh, my merciful heavens, it *shows*. It's not just a lousy episode, it's an epic failure on three fronts: badly conceived, badly written and badly made. The flat, cold tone is set in the very first scene, which plods along in an emotional vacuum—Mike, Peter and Davy barely speak to each other until 45 seconds in, at which point Davy delivers a few sentences of dry exposition.

The episode proceeds herky-jerky through two painfully humorless acts, introducing protagonist characters who do little but sit, stand, and stare, and antagonist characters who monopolize valuable screen time with painfully unfunny ethnic shtick.

It must be the cultural influence of *Hogan's Heroes* that made them think it would be fun to depict the evil German racing team as a pair of anachronistic Nazis. Baron von Klutz and his henchman Wolfgang are clearly cheap knockoffs of Colonel Klink and Sergeant Schultz, in a clumsy *homage* that is neither impressive nor funny. *Monkees Race Again* has a place of dishonor on my list of stereotype episodes, just a step below *Monkee Chow Mein*.

Eventually we are subjected to two and a half uninterrupted minutes of a loud but not terribly fast two-car road rally, accompanied by jazzy horns playing background music that could have been cribbed from any *Batman* episode. Because *Monkees Race Again* was shot in December, the location scenery is a dull, dusty brown, subtracting any possible visual interest from the grainy footage.

As Davy celebrates his improbable win, there's an abrupt cut to a half-hearted romp in which Davy and Peter prance around the Klutz Motors set with a few of the guest stars. Micky's and Mike's participation in the romp is mostly limited to clips edited in from other scenes in the show.

Zingers
Clunkers
I'm not even going to try. Far too few of the one; far too many of the other.

Cultural Clarification
"Put a tiger in your tank!" was a venerable advertising campaign for Esso Gasoline. There was a time when you could purchase a souvenir tiger tail—much like the one Micky plays with—to dangle from a car's gas cap.

Let's See if We Can Slip This Past the Censors
Mike: Well, how's that?
Davy: I think I'm a little high.

Runner-Up Sight Gag Highlight
The motorized telephone has more character than Crumpets and von Klutz combined.

Sight Gag Highlight
As the romp limps to a close, producer Bob Rafelson appears and is identified as the World's Oldest Flower Child. As an in-joke it's mildly amusing to a dedicated fan, who might know who Rafelson is and what he looks like, but it would make no sense at all to a casual viewer. In any case, if you've made it this far, be sure to watch for Mike's precious reaction as Rafelson starts to munch on the flowers.

Third Runner-Up Breaking the Fourth Wall
Baron von Klutz: So, Crumpets! I see you're having some trouble with your car!
T. N. Crumpets: I see you're having some trouble with your accent.

Second Runner-Up Breaking the Fourth Wall
Baron von Klutz: Gag him.
T. N. Crumpets: There are enough gags in this show already.

Runner-Up Breaking the Fourth Wall
Mike: Now hold it. Hold it. Before this scene goes any farther, man, what is this gun thing?
Wolfgang: Well, now, just a minute. We got to have the gun. After all, it's a prop.
Mike: That's horrible.
Peter: Put that away.
Mike: It's bad enough that you're with the uniform and—
Peter: And all the guns on television and everything? Bad enough we have a tuning fork!

Breaking the Fourth Wall
Micky: You flew all the way to Hollywood for this part?

Fourth Runner-Up Nitpick
When they are overcome by the knockout gas, some characters go limp, some go stiff, the butler collapses to the floor but nobody drops a single teacup. And for bonus points, Micky and Crumpets give their kidnappers an assist by walking as they're being dragged from the shop.

Third Runner-Up Nitpick
When Micky pulls the tail off the tiger in the tank, the sound effect is of a whining *dog*.

Second Runner-Up Nitpick
During the race, there are several shots of Davy shifting gears on what is obviously an automatic transmission. At one crucial moment, he slams it into PARK.

Runner-Up Nitpick
Micky isn't gagged inside that stack of tires. Why doesn't he cry out while his friends are in the shop looking for him?

Nitpick
That tuning fork isn't a B-flat *or* an A. It's a C. For pity's sake, people, why do you have to make nitpicking so easy?

We're the young generation, and we have something to recycle.
- Recurring catch phrase: "They're gone!" (See also *Monkee See, Monkee Die*; *The Audition*; *Monkees Marooned* and *The Monstrous Monkee Mash*.)

Monkee Magic
Micky conjures up a radio in the Klutzmobile. Well, at least the *radio* works.

What I want to know...
What *am* I doing hangin' 'round?

Beverage to enjoy while watching *Monkees Race Again*:
A spot of tea. (Peter already has several.)

Music
- *What am I Doing Hangin' 'Round?:* Feeble excuse for a playful romp.

Episode 2-21
Written by: Dave Evans, Elias Davis & David Pollock
Directed by: James Frawley
Principal Filming Ended: 12/20/1967
First Airdate: 2/12/1968

Grading
- T. N. Crumpets & the British racing team. **D for Dull as Dishwater.**
- Baron von Klutz & the German racing team. **F for Fail to go Führer.**

And the cookie goes to...
Me. For sitting through enough repeats of this stinker to write a review.

Mary, Mary, Valleri and the Girl I Knew Somewhere: Female Characters of THE MONKEES

This is not the essay I originally intended to write. My first impulse was to chide the writers for not utilizing more female characters—and *better* female characters—in more complex roles. My inspiration came from a casual first viewing of the DVDs; what I took away from the experience was a vague impression that women on the series were mostly relegated to minor roles as secretaries, comic villains and starry-eyed nymphets.

Once I sat down and started building a list of characters, I quickly made two discoveries:

1. There are a lot more female characters on THE MONKEES than I thought there were.
2. There really aren't all that many *male* characters on THE MONKEES.

Oh, don't get me wrong: male characters easily outnumber female characters on the series. Judging from my informal list, I estimated that the male/female ratio might be as low as 4 to 1 or even 3 to 1. (I had been expecting the ratio to be something closer to 10 to 1.) Clearly, my preconceptions were somewhat skewed.

Determined to start off with a proper ratio of male to female characters, I decided to use an arbitrary method for counting: I used the show's closing credits. If the character got a credit, he or she was included in the count. Sadly, that method cut out some memorable female characters, such as the little girl who captures and interrogates Mike in the episode *Monkee Mother*, while including such bland non-entities as the salesgirl in *The Christmas Episode*.

The final tally of characters is 225 men to 83 women, for a relatively low ratio of 2.7 to 1. That's a lot closer to a real-world ratio of 1 to 1 than I had expected just from watching

the DVDs casually. That said, my raw numbers do not express the relative *importance* of the various roles; for example, the despicable toy company executive Daggart *(Monkee vs. Machine)* counts as one male character, and the stout woman whose skirt Daggart rips off counts as one female character.

There are a dismayingly large number of episodes with no credited female characters at all: *Your Friendly Neighborhood Kidnappers*; *Monkees in the Ring*; *Monkee Chow Mein*; *Art, For Monkees' Sake*; *Hitting the High Seas*; *The Devil and Peter Tork*; *Monkees Race Again*; *Monkees Blow Their Minds* and *Mijacogeo*.

People Come and People Go
More astonishing to me than the ratio of men to women is the realization that there are only five recurring characters in the entire series: Micky, Mike, Davy, Peter, and Mr. Babbitt. I do believe this is significant: more than 300 people wander into the Monkees' lives, then wander back out again and never come back. Not a girlfriend, not a neighbor, not a relative, not a colleague, not a rival, not an employer, not a friend. In a way, the four Monkees are terribly isolated in their fictional existence, and this can only be by design. They never have any other person to rely on but each other. There is no one else they can call in a crisis, no one else to turn to for a loan or a job or a little bit of emotional support.

In a similar vein, there could never be a steady girlfriend on the show. At first, I assumed this was because the Monkees have to remain "available" in the imaginations of their legions of starry-eyed female fans. But in light of the harsh reality that *no* supporting character (other than Mr. Babbitt) ever reappears on the show, I conclude that the lack of recurring love interests is also intended to keep the four guys focused exclusively on each other. So the women they encounter along the way, no matter how desirable, no matter how compatible, also have to be *disposable*, or at least, *disposed of*, before the next adventure begins.

A Field Guide to Female Characters
What follows is an organized classification of the types of female characters that appear on THE MONKEES. It is not meant to be an exhaustive list, although it's more than just a random sampling. The first few sections refer mainly to the young, attractive... let's face it, *datable* women in the show. Later sections deal with older characters, villains and other non-romantic prospects.

As I studied and organized the list of characters, I noticed that most of the young women on the show fall into one of two categories: Damsels in Distress and Unattainables. There are a handful who straddled the two categories, but in most cases I could figure out where they belonged by examining how the relationship would end: either with a Monkee being *thanked*, or a Monkee being *depressed*.

Damsels in Distress
You can usually spot a Damsel in Distress right away—she is the one Davy gravitates towards. Little animated stars in the eyes are optional. She is there to be rescued, with nothing but

noble intentions and chivalry on Davy's part. With his small stature, toothy smile and charming British accent, Davy is the logical choice to play Sir Galahad. Romantic, yes... but oh, so safe.

Princess Bettina *(Royal Flush)*
Right off the bat, we have a Damsel in very real Distress, and Davy plunges into the crashing surf to save her life. You might think that a princess would be Unattainable, but in order for her to be an Unattainable, there would have to be Monkee yearning for her—and Davy is never anything other than a perfect gentleman where the princess is concerned.

Ellie Reynolds *(Monkee See, Monkee Die)*
Susan *(Monkees at the Circus)*
Angelita *(A Nice Place to Visit)*
Do you see the pattern? When I started working on this project, I assumed that the Damsels in Distress would be fairly evenly distributed among the four Monkees, but as it turns out, it's nearly always Davy.

Colette *(Everywhere a Sheikh, Sheikh)*
Ella Mae Chubber *(Hillbilly Honeymoon)*
An unlikely pair! Two lovely girls, each the treasured child of a tradition-bound patriarch, each raised in a culture that (apparently) values daughters solely for their marriage prospects. Both instinctively latch onto Davy as acceptably safe husband material. In each case, Davy hangs in there just long enough to get himself—and her—off the hook.

Vanessa Russell *(Here Come the Monkees)*
It might be unseemly for a 19-year-old guy to be sneaking a 15-year-old girl out of her house against her parents' wishes, but Davy just wants to help her study for the big history test. What a guy!

Fern Badderly *(Too Many Girls)*
She does have some villain-ish tendencies, but I have to squeeze Fern in here among the Damsels because she genuinely wants Davy's help, and because Davy gallantly tries to help her. Not to say that Fern is nice, or honest, or even worthy of his help, but from Davy's point-of-view she is in distress—so how could he possibly resist?

Ellen Farnsby *(The Monkees on the Line)*
As far as Mike is concerned, Ellen is a Damsel in Distress. But she is never actually in any distress; as far as she is concerned, Mike is just an employee of the answering service, of no particular consequence except as a rehearsal aid. Mike reacts gallantly to her imaginary plight, and she shows up in the last scene for a thank you speech.

Leslie Vandenberg *(The Chaperone)*

I struggled a bit about where to classify Leslie. She has one of the primary identifying characteristics of an Unattainable, in that the episode starts with Davy obsessing over her while she doesn't even know he exists. On the other hand, she also has one of the primary identifying characteristics of a Damsel in Distress, which is... well, *Davy*. What's so very odd about Leslie is that her relationship with Davy doesn't end with a "thank you" or a bout of depression, either one. If anything, the episode ends with a hint that an ongoing relationship is likely. But there's no denying these two hard, cold facts:

1. With Davy's help, Leslie Vandenberg's life takes a turn for the better.
2. When the show resumes a week later, Leslie Vandenberg is nowhere to be seen.

Marcia Brady *(The Brady Bunch: Getting Davy Jones)*

Non-canonical, I grant you, but it certainly fits the pattern. Marcia needs Davy's help, and his intentions are pure. It all ends with a thank you.

The Unattainables

On those rare occasions when a Monkee expresses something stronger than chivalry toward a young woman, she usually turns out to be too remote a goal for his modest reach. These confident, sophisticated ladies might be friendly, even encouraging, but in the end they always turn out to be too much for any of our boys to handle. Sadness ensues.

One easy-to-spot characteristic of the Unattainable character is that she is often replaced quickly by a consolation prize—an equally pretty girl who is clearly more attainable.

April Conquest *(The Monkees Get Out More Dirt)*

She isn't exactly playing hard to get; all four Monkees figure out how to get her pretty easily. So how does she end up in the Unattainable category? Quite simply, when all is said and done, she remains completely unattained. And guess what! A quartet of lovely young consolation prizes arrive at the pad, just in the nick of time, to cheer up Peter and his friends.

Valerie Cartwright *(One Man Shy)*

She is gracious and classy, but there is not a trace of doubt in my mind that her kindness to Peter is a bemused expression of tolerance and sympathy, rather than genuine affection. He never really has a chance with her. That said, the point of the episode is not to start a deathless romance; the point of the episode is to bring Peter out of his shell and give him some confidence. The consolation prize in this case is a bevy of cheerful, willing girls who gladly join Peter for a spirited game of Spin the Bottle.

Wendy Forsythe *(The Prince and the Paupers)*

Davy may be the one to woo her, but an impoverished tambourine player doesn't have a chance with this wealthy Princess Grace wannabe. She's there to decide whether to marry the

prince or not marry the prince—all Davy does is help her decide to say "yes." *To the prince.* Davy gets the consolation prize, though, in the form of a kissable young reporter.

Brenda *(I Was a 99 Lb. Weakling)*
Not much of a prize, I admit. But Micky desperately wants her and can't have her; when the episode ends, she is in another man's arms and Micky is depressed.

Joanie Janz *(I've Got a Little Song Here)*
Mike goes all fan-boy for this glamorous actress; she professes to be honored and just a little bit humbled to rubber-stamp an autograph for him. Depression ensues.

Miss Collins, Miss Osborne and Miss Dilessips *(Monkees a la Mode)*
Queenie, Nan, Jan and Ann *(The Wild Monkees)*
Snobbery comes in all shapes and sizes, and these self-confident women all humiliate the Monkees at every opportunity. So naturally, the Monkees desire them all the more.

Clarisse *(Monkee Mother)*
The moment Davy declares his love, Clarisse doesn't care. 'Nuff said.

Eye Candy

Her function in the story is not to be rescued or adored; it is to be pretty and inconsequential. She may get a chat-up line or a kiss from one of the guys, but with no emotional significance attached.

Ruby *(Alias Micky Dolenz)*
I actually like Ruby a great deal, and give her props for bringing a needed touch of sweetness to what is otherwise a dark and depressing episode. But in the end, she is nothing to Micky but an easy (!) obstacle to his mission.

Zelda *(Monkees on the Wheel)*
Della *(Monkees on the Wheel)*
There's no real connection between these two characters, except that they both appear in the same episode. Zelda is far too annoying to be an Unattainable, and Della is a heapin' helpin' of Eye Candy in a French Maid's uniform.

Cashier *(The Picture Frame)*
Played by the same actress who pouts and whines her way through *Monkees on the Wheel* as Zelda, the bank teller could have slipped quietly among the list of secretaries and other minor functionaries had it not been for the fact that she is a sexy, blithering idiot. Davy asks her out to dinner, but there are no stars in his eyes for her.

Too Many Girls *(Too Many Girls)*
The Four New Neighbors *(The Monkees Get Out More Dirt)*
Actresses and Extras *(The Monkees at the Movies)*
The Nahoodian Harem *(Everywhere a Sheikh, Sheikh)*

Any time the show utilizes groups of nubile young female extras, anonymous and interchangeable, the principle of Eye Candy is in effect. One particularly offensive example is the bevy of beautiful maidens offered as a bribe by the Nahoodian king. Micky, Mike and Peter seem eager to choose wives from among them, but during the romp we see all three of them take turns making out with the same girl.

The Doctor's Beautiful Daughter *(I Was A Teenage Monster)*

A terrific bit of surrealism in the middle of a Gothic Horror spoof, she isn't mentioned in the credits, so she doesn't get officially counted in my statistics. Surreal she may be, but she is also Eye Candy; you can tell, because she and Davy start making out in the middle of a romp.

Pretty Girl *(Monkees a la Carte)*

Not credited and therefore not part of the count, I have to include this young lady because Micky actually stops a scene to bring her out. His exact words: "The director thought we should have a pretty girl in the show." Eye Candy, defined.

Villains!

I have to give THE MONKEES credit for this: considering the era in which the show was made, they created some juicy villain roles for women, and hired terrific actresses to play them. They didn't hesitate to put women in positions of authority over men, and let them be just as vicious and violent as the guys—or, in some cases, *worse*.

Bessie "The Big Man" Kowalski *(Monkees in a Ghost Town)*

I give her top marks in the villain category. Not just in the female villain category—she's right up there with the best of the worst of the men. Despite her eccentric willingness to get distracted by a song, she never once relents from her murderous intentions. "Thank you, sonny. You're a nice, sensitive boy. Lenny? Take 'em out and shoot 'em."

Madame *(The Spy Who Came in from the Cool)*
Lorelei *(Monstrous Monkee Mash)*

The same actress—did you notice? I didn't, not until I started working on this project. As a vampire, Lorelei is necessarily seductive; she could easily be an Unattainable, except that nobody gets depressed over losing her. (And most certainly, Davy does not get thanked.)

On the other hand, Madame is delightfully exotic, sophisticated and glamorous without ever once being objectified by spies, counterspies or Monkees. Like the alien woman in *The Monkees Watch Their Feet*, Madame is clearly the one in charge of her two-man operation.

Maria *(Son of a Gypsy)*
She plays a lively game of good cop/bad cop, with her sadistic son Marco in the role of the bad cop. But beneath the warm façade of indulgent mother and gracious hostess lies a stone cold heart. I do believe she would slit Peter's throat with a smile and a steady hand if that's what it took to get her way.

Mrs. Badderly *(Too Many Girls)*
Madame Quagmeyer *(Monkees a la Mode)*
I keep coming up with odd pairs of characters. These two sat together in the list for days before I noticed the parallels between them. Unlike most Monkees villains, Mrs. Badderly and Madame Quagmeyer are firmly grounded in reality. In a list of monsters, gangsters, aliens and spies they stand out as perfectly normal people. They don't threaten anybody with violence; they don't even do anything they could be arrested for. Perhaps it's their veneer of respectability that renders their offenses so despicable.

Assistant *(Monkees Watch Their Feet)*
Given the character's official name (as reflected in the credits) it was a challenge not to classify her with the Employees, Assistants and Also-Rans. But I can't shake the feeling I have every time I watch this episode: *she* is the one in command of that spaceship. Even now, having learned that the male alien is called "Captain" in the credits, it seems clear to me that *she* is the one giving the orders. Perhaps "Captain" is Zlotnikian (Zlotnikese? Zlotnikish?) for "respectful underling."

Broads and other Joke Characters

The Monkees is a comedy, so I certainly can't object to female characters being used in comedic roles. Especially not when the comedic role is original, or clever, or silly, or daring. There are some of those here. Unfortunately, there are also some stock characters based on stereotypical behavior. And some are just not very well written.

Madame Rozelle *(Monkee See, Monkee Die)*
As a villain, she's not all that much—her crime is merely a one-third share of a fairly feeble hoax. But as a character, she is top-notch comedy, walking a fine line between genuine psychic and two-bit charlatan. The fact that she does actually have some sort of psychic ability (she is able to contact the Spirit of Christmas Past) makes her just creepy enough for the episode. Mostly, though, she is just hilarious.

Maw *(Hillbilly Honeymoon)*
Too rip-roaring funny to be a true villain, Maw has a sort of internal integrity that I can't help but admire. Good manners, too, after her own fashion. I only regret that I never get to hear her accompany Clem on garbage.

Big Flora *(Monkees a la Carte)*
One of the members of the gangster cartel who plan to divvy up the greater Los Angeles area, Big Flora might be a respectable minor villain if it were'nt for the running joke of her stuffing her face at every turn, even when the she is dying of a gunshot wound.

Judge *(The Picture Frame)*
For just one moment there, I thought there may just be some Women's Liberation going on. The judge is a woman. *The judge is a woman!* Unfortunately, she is also a simpering imbecile.

Hilda *(I've Got a Little Song Here)*
Mrs. Smith *(The Monkees on the Line)*
A pair of old broads, with broad comedy in mind. Hilda apparently likes talking dirty on the phone behind her husband's back; Mrs. Smith chases her henpecked husband around with a rolling pin. Stock characters, both, and neither particularly well done.

Bride *(Monkees in Manhattan)*
Her whiny, off-color joke about the groom's inability to get the cork out of a bottle of champagne went straight over my head when I was younger. Now, it just seems crude.

Mrs. Weefers *(The Chaperone)*
The extended *homage* to *My Fair Lady* grows a bit tired after a while, and it defies credibility to believe that the Monkees could afford a cleaning lady. Mrs. Weefers is simply a drunk, and while that may have been funny in 1966, it doesn't seem so funny now.

Society Dames and Little Old Ladies

Mrs. Russell *(Here Come the Monkees)*
Madame Rantha *(Son of a Gypsy)*
Mrs. Vandersnoot *(The Christmas Show)*
Older, upper-class ladies on the show tended to be written as sympathetic, indulgent employers. Mrs. Russell isn't directly responsible for the band's employment in the pilot (they are hired by her husband) but she seems quite happy to dance to their music. Madame Rantha hires the Monkees for a society event in her home; Mrs. Vandersnoot hires them as babysitters and even hightails it home from a holiday cruise on their say-so.

Mrs. Purdy *(Don't Look a Gift Horse in the Mouth)*
Mrs. Filchok and Mrs. Homer *(Monkee Mayor)*
Lady from 1444 N. Beechwood *(Your Friendly Neighborhood Kidnappers)*
These friendly neighbors, kind and tolerant, serve the purpose of giving a vicarious seal of approval to the long-haired kids. Incidentally, the lady from 1444 N. Beechwood (who first

gives the kidnappers directions to the Monkees' pad and then delivers a pot of hot tea to the kidnapping) is not listed in the credits.

Mrs. Weatherspoon *(A Coffin Too Frequent)*
It was a challenge, deciding where to classify Mrs. Weatherspoon. She nearly fits the bill for a Damsel in Distress—in particular, because it is Davy who figures out that she is being swindled and Davy who decides to take up her cause. But Mrs. Weatherspoon is never a dating prospect, and thus, could not properly be grouped with the Damsels. Like most of the other little old ladies on the show, she can't help but feel motherly toward those four adorable boys, so it's with the little old ladies she goes.

Employees, Assistants and Also-Rans

Chambermaid *(Royal Flush)*
The only thing that saves the Chambermaid character from complete irrelevance is the episode-ending tag scene, when she returns in triumph as the new owner of the hotel and kicks the Monkees out of their hijacked room.

Old Woman *(Success Story)*
I'd bet 39-year-old character actress Ceil Cabot appreciated being credited as "old woman" for her work as a star-struck autograph seeker in *Success Story*. A step up, or perhaps a step down from being credited as "Chambermaid" in *Royal Flush*.

Miss Buntwell *(Dance, Monkee, Dance)*
Miss Chomsky *(The Audition)*
These two memorable dames are not easy to relegate to the Employees, Assistants and Also-Rans category, but they really don't fit anywhere else. They fill similar roles in their respective episodes, as amusing sidekicks to insufferable bosses.

Daughter *(The Monkee's Paw)*
There is a brief bit of chaste flirting on Davy's part, but the nameless Daughter never amounts to much more than an attractive assistant for the magician.

And speaking of characters with no names:
Secretary *(Monkee vs. Machine)*
Secretary *(Captain Crocodile)*
Salesgirl *(The Christmas Show)*
Nurse *(The Case of the Missing Monkee)*
Secretary *(Monkee Mayor)*
Functionaries in traditional women's occupations, they mostly get in the Monkees' way. Some are indifferent, others are callous or even cruel. None has a name.

Mrs. Zuckerman *(Monkee vs. Machine)*

"Who?" I asked myself. There she is, in the credits, and I couldn't remember her at all. Turns out she is the woman who gets half her dress ripped off by the toy company executive, Daggart.

Genie *(The Spy Who Came in from the Cool)*

I had to go back and watch the episode again to be reminded of this character. Genie might be Eye Candy of a sort, in her skimpy costume, but not even Davy seems particularly impressed by her beauty. She's there just to set up a Breaking the Fourth Wall punch line.

Class Acts and Classy Dames

The Fairy of the Locket *(Fairy Tale)*
Dr. Lorene Sisters *(The Monkees Get Out More Dirt)*

Minor but memorable roles in their respective episodes, they are women of intelligence, authority and charisma, giving the band useful advice bordering on marching orders. The fairy is a purely magical creature, but even Dr. Sisters possesses an certain element of magic, as she is able to carry on a conversation with the Monkees through their television set.

Aunt Kate and Cousin Lucy *(Monkees in Texas)*

They may be in trouble, but they aren't in distress. These two classy ladies are calm in a crisis; they know where the guns are kept and they know how to use them. Besides which, they are *family*—a rare distinction in the series, shared only by Davy's grandfather. Theoretically that's an ongoing tie that violates the principle that the four Monkees are all alone in the world, but Kate and Lucy seem to be separated from Malibu not only by a thousand miles of distance, but also by about 70 years of US history.

Natasha Pavlova *(Card Carrying Red Shoes)*

The prima ballerina-turned-political refugee, by all normal practices Natasha should be a Damsel in Distress. However, she seized her place here among the Class Acts because she stubbornly refuses to *stay* in distress, and because she soundly rejects the role of pure, virginal damsel to *anybody's* chivalrous knight—she is a mature, sexually charged being and she knows exactly what she wants. She takes command of every situation she falls into, spurs Micky and Davy to action with a rousing speech, and actively participates in the capture of the bad guys and the winning of her own freedom.

In an interesting twist on traditional gender roles, Peter plays the role of Unattainable in this episode, and Natasha comes away with the consolation prize—a yummy piece of Eye Candy named Alexei.

Millie Rudnik *(Monkee Mother)*

The *Monkee Mother* herself, Millie defies classification. She is the closest thing her odd episode has to a villain, but in order to defeat her, the guys have to help her. She is an interloper and an irritant; a take-charge powerhouse with a soft, sad streak; both a force of nature and a source of pathos. Busybody, romantic, nuisance, matchmaker, manipulator, dreamer—she may well be the most fully realized female character in the entire series.

Friends

This final category of female character is a rare jewel in the series. In fact, I can think of only two good examples: women of the Monkees' age who are not damsels in distress, or unattainable ideals, or disposable eye candy. They aren't there to flirt, or fall in love, or ask for help, or put anybody down. They are simply kind and friendly to the guys—all four of them—and help to make their lives a little better.

Friends! In a show where the principal characters are intentionally portrayed as sexually desirable and yet sexually unavailable, there is no room for girlfriends—much less, girl *friends*. In a show where no man or woman ever forms a lasting relationship with any member of the band, friends of either gender are completely out of the question. And yet, against all the odds, there are two such female friends.

I'll get to them in a minute. Before I do, here is a trio of Honorable Mentions. They aren't exactly friends, but you get the feeling they easily could be.

Daphne and The Westminster Abbeys *(Some Like it Lukewarm)*

Daphne is primarily a love interest for Davy, and vaguely fits the Damsel in Distress model, but she and her three bandmates get an honorable mention in this category for also being fellow musicians. Not only are they peers; they score just as well in the band contest as the Monkees do. What a revolutionary concept: females as professional equals!

Sadly, the Westminster Abbeys' initial contest performance is simply a ridiculously sped-up version of *Last Train to Clarksville*. (What a waste: have you heard Deana Martin *sing*?) Despite the promise that the two mirror-image bands would perform together in the episode's last scene, the talented Abbeys are reduced to the role of go-go dancers.

Mary Friar *(The Monkees Mind Their Manor)*

A rarity on the show, Mary is a *young* joke character. But she is also an ally to the band in this particular episode, and despite her homely appearance, she is never made the target of derision. Mary slyly delivers some clever lines ("…everybody was getting bombed, then…") and ultimately saves the day with a spectacular diatribe.

The Hungry Neighbor *(Success Story)*

This spunky young lady, who cheerfully barges into the pad to raid the Monkees' refrigerator, isn't listed in the credits. If her role had been expanded just a bit in that one episode,

or if (miracle of miracles) she had appeared in a *second* episode, she easily could have been called a friend.

And finally, the two Friends:
Toby Willis *(Monkees a la Mode)*
An aspiring fashion journalist, Toby met the band a week before the episode begins. She seems to have a great deal of admiration for the Monkees, without any sign that her respect is colored by personal attraction toward any of them. There is no evidence that her nomination of the band as Typical Young Americans of the Year is anything other than an honest evaluation of their unique qualities. She later proves her friendship by quitting her job when she realizes that the band had been double crossed by Madame Quagmeyer.

In an devilish twist in the episode's tag sequence, she turns her coat and adopts the role of bitchy antagonist that was previously held by her boss. But before that surprise ending, she had been both a friend and an advocate—and despite her beauty, is never once treated as a possible love interest by any of the Monkees.

Jill Gunther *(Here Come the Monkees)*
Jill appears in only two brief scenes, and is never clearly identified. I had always assumed that she is Vanessa Russell's older sister—they look like they might be related, and Jill is apparently privy to Vanessa's activities. But as I was working on the episode review for the pilot, I learned that Jill is actually the daughter of the Monkees' manager, Rudy Gunther. The manager's role was edited out of the series, so her potentially ongoing role was eliminated along with it.

Suddenly, Jill's two scenes in the pilot take on a remarkable significance. She isn't acting on *Vanessa's* behalf at all! She is acting as the *Monkees'* ally, providing them with essential information about their precarious employment situation and standing up to defend them when trouble threatens.

I have to admit, I was not altogether pleased with Tucker and Mazursky's work on the pilot, but they won back my respect with this one character. They could have written Jill as Rudy's kind, sympathetic wife. They could have given Rudy a spunky ten-year-old son, or even a spunky ten-year-old daughter. But they wrote Jill as a beautiful, intelligent young woman. They put her out on the beach with the four guys—all of them in bathing suits, no less—and had them converse matter-of-factly, about important matters, with no hint of stars in anybody's eyes.

I'm glad they got rid of Rudy, but I sure wish Jill could have stuck around.

Conclusion

I grew up watching the growth of female characters on television. My primetimes were filled with confident, assertive, professional women. My daytimes, on the other hand—the after-school reruns, the Saturday morning cartoons, the long summer afternoons—were occupied

by the domesticated women of an earlier generation. I straddled the divide comfortably, without even realizing it.

Consider this: When *The Mary Tyler Moore Show* first appeared in September 1970, it was considered revolutionary. The television-viewing public was astonished by Mary Richards. She was single, she was employed, *and she was happy.* (They would have been even more astonished if, as the creators originally intended, she had been divorced. The network forbade that one element of the show's premise; they said it was because the television-viewing public would jump to the conclusion that she had gotten a divorce from Dick Van Dyke.)

I was eight years old when *The Mary Tyler Moore Show* made its debut. It didn't seem all that remarkable to me, growing up in the 70's, that a woman could hold down a professional position with authority over male colleagues, have a satisfying dating life without feeling pressured to get married, and fill her life with a circle of supportive, caring friends. Looking back from my comfortable perch in the 21st century, I have to remind myself that the producers, writers and directors of THE MONKEES were firmly planted on the far side of that revolutionary change. And furthermore, Mary Tyler Moore's revolution wasn't their fight. They were fighting the battle of the long hair, and the battle of the loud music, and the battle of New Hollywood.

But still, it rankles. Watching the end of *The Christmas Show* recently, I was astonished—no, horrified—at the uniform *maleness* of the show's crew. (They were uniformly white, as well, but that's a different essay.) I know, it was the sixties, there were fewer women in the workforce back then, but it was jarring to me to see so many men and not a single woman—not one makeup artist, not an assistant to the assistant director, not *anybody*—until Tork and Jones called for silence in order to introduce the "Monkee Girls." Who, I gather, worked together in the front office, though their actual jobs were not made clear.

But I have learned to look beyond what's on the screen. While working on this essay, I made note of the writers and directors who created all these wonderful and terrible and silly and sexy and troublesome characters. The directors were all men, but I did discover that there were two female writers credited during the run of the series.

Stella Linden wrote just one episode: *A Coffin Too Frequent.* She created that wacky, magical force of nature, Mrs. Weatherspoon.

Treva Silverman, on the other hand, was a regular member of the writing staff. She has sole writing credit for four episodes: *Monkee See, Monkee Die*; *I've Got a Little Song Here*; *A Nice Place to Visit* and *Card Carrying Red Shoes* (the last, under the pseudonym Lee Sanford). She also co-wrote *One Man Shy* and *Son of a Gypsy*. We can thank her for Madame Rozelle the greedy spiritualist, Joanie Janz the glamorous movie star, Valerie the gracious debutante, and (God bless her!) Natasha Pavlova the courageous prima ballerina. And would you care to guess what Treva Silverman did after her time as a writer for THE MONKEES?

She won two Emmy Awards, writing for *The Mary Tyler Moore Show.*

I am mankind's friend. Tender, kind and loving. Truthful to the end. This is a review of *Monkees Watch Their Feet*.

The In-Which
Aliens kidnap Micky and replace him with a Micky-shaped robot.

Dolenz often says that THE MONKEES had such lasting power because the show's humor was not focused on current events and controversial topics. I have to wonder: Has he seen *Monkees Watch Their Feet* recently? Not just the parts he appeared in, but the running commentary by comedian Pat Paulsen? As a routine 'Monkees versus the bad guys' episode, this is rather a rather weak outing. But from open to close, Paulsen's narration is as biting a satire of contemporary society as any editorial on *The Colbert Report*. It wasn't just topical, it was downright subversive.

> "Take the war, for example. Whose fault is it? Certainly not our fault. We're not fighting. It must be those crazy kids."

I was absolutely flabbergasted the first time I heard that line. I'm still astonished by it: that Coslough Johnson wrote it, that Pat Paulsen said it, that Alex Singer filmed it, that Raybert left it in the finished episode and NBC put it on the air. Keep in mind that the four Monkees were forbidden to speak their minds in public about Vietnam, and three of them were eligible for the draft. (Nesmith had already served in the military.)

But it's not just the war that gets the skewer. Within an overall tone of derision for government officiousness and McCarthyistic witch-hunting, Paulsen's rambling narration manages to take on segregation and prejudice as well:

"Yes, ladies and gentlemen. The universe is trying to move into your neighborhood."

"It is not the backward feet in themselves—although seen close up they are quite ugly—that are the menace. It is the implication of what backward feet mean in a frontward feet society."

The whimsical sci-fi spoof of Micky, Peter and Davy, the robot and the aliens and the incompetent boobs at Civil Defense is just candy-colored window dressing for Paulsen's droll satire. Dolenz's performance as the robot is sweetly spastic, and occasionally profound. ("My feet aren't on backwards. *Yours* are.") Mike's steadying, level-headed presence is sorely missed; as in the episode *Card Carrying Red Shoes*, the high-stakes plot calls for all Monkees on Deck. Davy and Peter do their best to cope, but it stretches credulity just a little to have them both dismantling AND outwitting the alien robot.

In 1967, I doubt anybody would have put fifteen consecutive minutes of Pat Paulsen's wooden delivery on the air, no matter how topical. I doubt I'd be able to sit through fifteen consecutive minutes of Pat Paulsen's deadpan. But as "serious" commentary interspersed around an equal amount of nearly random Monkee hijinks, it's a perfect fit.

"The time has come for us to stop sticking our bayonets into each other, and start sticking our bayonets into space."

Not bad for a bunch of long-haired weirdos, huh America?

Zingers

Robot: Hello, Zlotnik. I'm here in enemy headquarters. They have harmonic destructors here. Like we do on Zlotnik. And when they use them they make terrible and—ah! Horrible sounds. They also have insufferable tortures here. Whenever a pussycat cries, they tear off its head.
Davy: [on the phone] Definitely not.
Robot: Then they holler in its ear.
Davy: Bye.
Robot: Then they put the head back on the body. I don't know how it stays alive.

Davy: Let's check the list. Ready?
Peter: Silly grin.
Davy: Slouchy shoulders.
Peter: Total lack of muscles.

Davy: Knobbly knees.
Peter: Feet on backwards.
Davy: Feet on—
Peter: Feet on—
Davy: Feet on backwards?
Peter: His feet are on backwards!
Robot: No. My feet aren't on backwards. *Yours are.*

Clunkers
During the second hot-lights interrogation scene, just after Peter and Davy see the electronics inside the robot's eyes, Tork starts mouthing Jones's lines along with him.

Production Note
Much has been made about the nine month delay between the filming of *The Devil and Peter Tork* and its initial broadcast on NBC. The initial broadcast of *Monkees Watch Their Feet* was delayed nearly as long—eight months.

Cultural Clarification
By the time this episode aired in early 1968, Pat Paulsen had been appearing weekly on *The Smothers Brothers Comedy Hour* for nearly a year, delivering topical editorials in this same droll, dry-as-dust style that was seen in *Monkees Watch Their Feet*.

Second Runner-Up Sight Gag Highlight
The robot chatting up a refrigerator.

Runner-Up Sight Gag Highlight
The robot cradling and petting the telephone. "Nice kitty. Nice kitty."

Sight Gag Highlight
The slow camera pan down the robot's long legs to those backwards feet.

Runner-Up Breaking the Fourth Wall
Mike: Ladies and Gentlemen, this evening Raybert Productions and Screen Gems, with its usual lack of cooperation from the National Broadcasting Company, is pleased to present this special report from the Department of U.F.O. Information.

Breaking the Fourth Wall
Paulsen: You see before you three average, typical, young American teenagers. With their own television series.

Second Runner-Up Nitpick
Not that I expect much to make sense in a second season romp set in a flying saucer, but... what is the significance of the exploding grandfather clock?

Runner-Up Nitpick
Every time somebody enters or exits the flying saucer, it is by way of transporter beam; they simply disappear from one spot and reappear in another. So... why does the spaceship have stairs and a door?

Nitpick
In the closing credits, the male alien (played by Stuart Margolin) is listed as "Captain" and the female alien (Nita Talbot) is listed as "Assistant." Obviously the people writing the credits got this backwards, because the female alien is clearly the one in command of that spaceship.

Absolutely Not a Nitpick
Near the end of Davy and Peter's encounter with the puffed-up government bureaucrat, the bureaucrat says, "People think, oft times, that they see things that they don't really see at all." As he speaks that line, he puts on a hat—the fourth hat he's worn in that scene—a nondescript brown cap with the word "Doorman" on it.

The next time we see that cap, *the male alien is wearing it.*

We're the young generation, and we have something to recycle.
- Recurring gag: Monkees stuck in a door. (See also *The Case of the Missing Monkee*; *The Picture Frame*; *The Christmas Show*; *Everywhere a Sheikh, Sheikh*; *Monkees in Texas* and *Monstrous Monkee Mash*.)
- Recurring shtick: snap off the end of a prop. (See also *Royal Flush*, *The Spy Who Came in from the Cool*, *The Prince and the Paupers* and *A Coffin Too Frequent*.)

Monkee Magic
It's a bit hard to spot, because the aliens have transporter technology, and because the romp doesn't make a whole lot of narrative sense. But this much I'm sure of: just before *Star Collector* begins, Peter says, "We better get out of here if it's the last thing we do alive." Then he grabs Micky by the arm (he is presumably holding onto Davy with his other hand) and teleports them out of danger.

What I want to know...
What (if anything) did Raybert have to do, say or edit out of the final product in order to get it on the air after an eight month delay?

Beverage to enjoy while watching *Monkees Watch Their Feet*:
"I'll... er... get some milk from the lamp."

Music
- *Star Collector:* Disorganized, but definitely narrative romp.

Episode 2-17
Written by: Coslough Johnson
Directed by: Alex Singer
Principal Filming Ended: 5/26/1967
First Airdate: 1/15/1968

Grading
- Candy-Colored Sci-Fi. **B-**
- Shades of Gray Satire. **A+**

And the cookie goes to...
Perennial presidential parody candidate Pat Paulsen.

What has Dracula ever done for you? All those pictures together: *Dracula Leaves*, *Dracula Returns*—you know, you've made over thirty movies with him, and you haven't even got a review of *Monstrous Monkee Mash*.

The In-Which
The Monkees fall into the clutches of a pair of vampires and their monster friends.

Filmed a week after *Monkees on the Wheel*, this episode echoes some of that episode's hyperactive, self-referential satire. Filmed a week before *Fairy Tale*, this episode shares some of that episode's colorful storybook fantasy. What sets *Monstrous Monkee Mash* apart, not only from those two episodes but many of the late Season Two episodes, is its sense of *normalcy*.

Yes, I said normalcy. If you can call this *normal*, of course! The episode starts with Davy on a date and his friends back at the pad, unable to sleep because they're worried about him. What could be simpler? What could be more comforting than three Monkees coming to the rescue of a fourth? *Monstrous Monkee Mash* has a refreshing sense of camaraderie and caring that is absent from so many episodes filmed as production wound down in late 1967.

It also has a strong structure, recalling the quadrilateral rigidity of *The Monkees Get Out More Dirt*. Four Monkees match up with four monsters, with the friends being separated one from another from another as the story progresses. There's a corner knocked off the square, however, because Mike never does get the magic necklace kiss from Lorelei—and because he is never in any peril of being mummified. In fact, the only apparent danger involving the mummy is its advanced case of body odor.

Few moments of the series are as chilling as the Count's hijacking of Micky and Davy's Shared Imagination exploration of their inner monsters. Building up the tension layer by

layer, he first demonstrates that he can interrupt their game, then seizes control of the fantasy and traps them in their monster forms. Finally he breaks through the fourth wall—seated in a director's chair, with the camera beside him, he haughtily refuses to let the scene end.

As is true for so many Season Two episodes, the plot is never resolved. The disorganized, slow-paced romp goes absolutely nowhere and ends, incongruously, with a few snippets of daylight, fresh-air running and jumping through fountains recycled from the first season. In the tag we are treated to an expository summary of a "victory" that we didn't actually get to see.

Zingers

Micky: I told Davy a thousand times: Man, stop hanging around with vampires!
All: VAMPIRES!!!!
Peter: What a time to be caught without a turtleneck.

Micky: I'm scared I'm scared I'm scared let's get out of here.
Mike: We can't leave now, man, we haven't found Davy.
Micky: We could form a trio...
Mike: Nah—c'mon, lets go look in the library. You and me.
Micky: Okay.
Mike: Peter!
Both: He's gone!
Micky: Maybe we make it a duet?
Mike: No.
Micky: If you get lost, I'll be a single!
Mike: Buh-duh-bum.
Micky: Here I come...
Mike: Micky.
Micky: ... walking down the street...
Mike: Micky.
Micky: ... I get the funniest looks from all the people I meet...
Mike: Micky.
Micky: ... Hey, hey, I'm a Monkee!
Mike: Micky.

Clunker

Bat: I want to drink your blood.
Peter: That's not at all nice to say.
Bat: I want to sip your blood.
Peter: Much better.

Don't get me wrong, it's an adorable exchange made even better by Peter's affectionate stroking of the bat's nose. It's also perfectly in character, recalling Peter's naïve willingness to befriend the android in *I Was a Teenage Monster*. But just seconds earlier Peter had described the bat as disgusting, and Micky was just having a very loud meltdown about vampires. (I wonder whether this may have been an editing error.)

Wolfman: I love hot dogs!

This is the only line the Wolfman has in the episode. Not only is it out of character for him to speak, and unnecessary, it drews the viewer's attention to the fact that the Wolfman's "mouth" is just a non-functional part of his inflexible mask.

Davy: Mike???

Right after Mike realizes that he is alone in the secret passage, he yells for Micky (who apparently has just disappeared), then for Davy (who has been missing all evening), then for Peter (who is also missing). That's when we hear this faint cry for help. But Mike pays it no attention—he peeks inside a nearby sarcophagus, finds a mummy inside, then runs away.

Cultural Clarification
The episode title is a reference to the 1962 Bobby Pickett Halloween novelty song *Monster Mash*.

We Do Our Own Stunts
Mike stumbling down a flight of stairs.

Runner-Up Sight Gag Highlight
Micky and Mike, conferring and making plans by whispering in (through?) Peter's ears.

Sight Gag Highlight
Mike posing in the magic picture frame.

Third Runner-Up Breaking the Fourth Wall
Count: Here we are in my beautiful laboratory, in my beautiful castle, in the dungeon with the beautiful fake backdrop—

Second Runner-Up Breaking the Fourth Wall
There's no invisible man—it's just thin black wires. Or, as Micky put it, "Tinsel and fabric."

Runner-Up Breaking the Fourth Wall
Micky: That was my medium scare. Would you like another one? A smaller one? Ahh!

Breaking the Fourth Wall
Davy: We're the *Monkees*. You see, in every show we do a fantasy sequence, where we romp around and jump and do funny things—and nobody interrupts us. *Nobody*.

Fifth Runner-Up Nitpick
In the opening scene, Lorelei takes off her magic necklace twice.

Fourth Runner-Up Nitpick
Considering how quickly Mike dials the six (yes, six) digits, the Count's phone number must be 111-111.

Third Runner-Up Nitpick
In the episode *The Monkees at the Movies*, somebody did an excellent werewolf makeup job on Frankie Catalina—and that was just for one sight gag. Why couldn't they have done a comparable makeup job for the Wolfman and Micky's fantasy Wolfman? Those masks were atrocious. And they couldn't find a set of fake fangs for Vampire Davy?

Second Runner-Up Nitpick
When Micky starts to examine the suit of armor in the library, its battle ax is already lowered. But in the close-up shot, its battle ax is raised—so it can be swung down again behind Micky's back. (This was a weak sight gag in the first place; the least they could have done was get the continuity right.)

Runner-Up Nitpick
Micky wastes a lot of time trying to barricade a door that opens *outward*. Okay, so he's in a panic and he's not familiar with the house. Fine. But why does Wolfman pound on the library door in frustration, when all he needs to do is turn the knob and pull?

Nitpick
While posing in the picture frame, Mike asks the Count for an eraser. But he was writing with a quill pen—in ink! An eraser wouldn't do him any good. What he really needs is... some kind of fast-drying opaque correction fluid. Hmm....

Runner-Up Absolutely Not a Nitpick
Count: The underground crypt at midnight, at the height of the full moon!

A crypt is, by definition, underground. And the full moon would always be at its height at midnight. A bit redundant, Count, but not inaccurate.

Absolutely Not a Nitpick
Count: The last time I did this, New York went out!

The last time the Count tried to reanimate his ultimate monster must have been November 9, 1965 That was the date of the Northeast Blackout.

We're the young generation, and we have something to recycle.
- Recurring catch phrase: "He's gone!" (See also *Monkee See, Monkee Die*; *The Audition*; *Monkees Marooned* and *Monkees Race Again*.)
- Recurring physical comedy: Monkees stuck in a doorway. (See also *The Case of the Missing Monkee*; *The Picture Frame*; *Everywhere a Sheikh, Sheikh*; *The Christmas Show*; *Monkees in Texas* and *Monkees Watch Their Feet*.)
- Recurring spoof: "Buh-duh-bum. Here we come…." (See also *Fairy Tale*, *The Monkee's Paw* and *Monkees Marooned*.)
- Recycled romp footage: running and jumping across a fountain. (See also *The Spy Who Came in from the Cool* and *Monkees in Manhattan*.)
- Returning actor: Arlene Martel as Lorelei. (She was also Madame in *The Spy Who Came in from the Cool*.)

Runner-Up Monkee Magic
Mike conjures up a quill pen and notepad.

Monkee Magic
In addition to initiating a Shared Imagination exploration of their inner monsters, Micky and Davy apparently teleport out of their shackles—because the Count has to order the Wolfman to chain them up again.

What I wanted to know…
Where did they film that romp footage with the band running around and jumping over a fountain?

What I have since learned…
At the same time this section of the book was being reviewed by my editor, I learned that the fountain romp—bits of which were also used in *The Spy Who Came in from the Cool* and *Monkees in Manhattan*—was filmed at The Castaway Restaurant in Burbank. The courtyard has been repaved in brick, and the fountain has been replaced with a gazebo, but the view is unmistakable.

Beverage to enjoy while watching *Monstrous Monkee Mash:*
"Relax, relax. It's only tomato juice. To get you used to the color."

Music
- *Goin' Down*: Vaguely narrative romp.

Episode 2-18
Written by: Neil Burstyn & David Panich
Directed by: James Frawley
Principal Filming Ended: 11/2/1967
First Airdate: 1/22/1968

Grading
- Dracula, reborn. **B+**
- Clap for the Wolfman. **B**
- The Ultimate Hippie. **C**
- MummyMan! **A-**

And the cookie goes to...
Dolenz, for his mournful solo rendition of the theme song.

All right now, Gringos—play, play until you can't play anymore. Play until you think you will drop. And then, write a review of *It's a Nice Place to Visit!*

(A personal note: This episode review is out of alphabetical order, because I had somehow convinced myself that the title was *A Nice Place to Visit*. It isn't *A Nice Place to Visit*. That is, it may very well be a nice place to visit, but it isn't *A Nice Place to Visit*. It's *It's a Nice Place to Visit*.)

The In-Which
The Monkeemobile breaks down in a remote Mexican village.

Actor Pedro Gonzalez Gonzalez sometimes got criticized for playing stereotyped Mexican characters, usually grinning, subservient bumblers, in dozens of movies and television shows. But he also earned a good living at his craft, and paved the way for other Hispanic actors in Hollywood. Born into poverty and never formally educated, he was working as an itinerant entertainer in his native Texas when he was discovered by a talent scout and sent to Hollywood to appear on the game show *You Bet Your Life* in 1953. John Wayne spotted him on that show, ably matching wits with Groucho Marx, and signed him to a long-term contract with his production company.

It's because of Pedro Gonzalez Gonzalez that I am giving the episode *It's a Nice Place to Visit* a passing grade, despite its uncomfortably high level of stereotyping. I had flunked the episode *Monkee Chow Mein* for its crude depiction of Chinese culture and its use of Caucasian actors in heavy makeup and thick, make believe Chinese accents. I'm not claiming

that *It's a Nice Place to Visit* is blameless on those counts; although I can't *prove* that Cynthia Hull (Angelita) and Peter Whitney (El Diablo) are not Hispanic, I did notice that they both manage to mispronounce their own characters' names.

But then there's ol' Pedro Gonzalez Gonzalez, decked out in a ragged sombrero and a sweet, ingratiating grin, playing that same old character he played in so many John Wayne westerns, the one that used to make people tut with disapproval. Subservient. Bumbling. And then... *he fixes the car.* Bumbler? Heck, no! He rebuilds the Monkeemobile's engine in a matter of hours for the extravagant sum of $14.95.

So no failing grade this time! *It's a Nice Place to Visit* doesn't exactly cover itself in glory when it comes to cross-cultural sensitivity, but at least it employs several Hispanic actors in significant roles. And it manages to populate its mythical Mexican village with a variety of residents, many of whom come to the cantina to appreciate some live music. There's much more to El Monotono than just a band of swarthy, hairy, drunk, foul-tempered bandits.

Sadly, there *are* an awful lot of swarthy, hairy, drunk, foul-tempered bandits. The scenes in the bandit camp go on a bit longer than necessary, but do deliver a few nice comic moments. Most of the humor, however, comes when the Monkees are on their own—in particular, Davy's patient, step-by-step instructions on how to untie a square knot. And Godfrey Cambridge's surrealist turn as an improbable parking lot attendant is a nice touch.

What am I Doing Hangin' 'Round? provides an apt, self-referential soundtrack for both the cantina scene and the episode-ending romp. The romp itself makes excellent use of the plaza setting and the various buildings, balconies, pillars and porticoes, as well as a virtual playground of props, scenery and other playthings.

The episode begins with a retread of a motif that is as old as the series. Thankfully, it's no longer necessary to actually animate the stars in Davy's eyes—we recognize the signs, the stars are understood. There is something very charming about Micky's patient, half-hearted protest: "Oh, true love strikes again. Davy, don't. Not this time..."

Too late, Micky. Too late.

Zingers

El Diablo: You will be taken by horseback to the bandito camp. If you try to resist, you will suffer indescribable torture.
Davy: And if I don't resist?
El Diablo: *Describable* torture.

El Diablo: They call me El Diablo! Also known as the bandit without a heart.
Micky: They call me El Dolenzio. Also known as the bandit without a soul!
Mike: And they call me El Nesmito, also known as the bandit without no—without any conscience.
Peter: And they call me El Torko, the bandit... uh, without a nickname.

Angelita: If you leave, he will punish the entire town!
Micky: Baby, if I don't leave, he gonna punish my entire body!

Clunker
Davy: Angelita. That's a very pretty name. It means "little angel." My name's David.
Angelita: What does "David" mean?
Mike: David means *business*, baby.

This remark may be funny, but it's also rather crude—and it's out-of-character for Mike, who is usually very well mannered. It's *especially* out-of-character for Davy, who is always the perfect gentleman. (For the record, the name David really means "beloved." Insert your own joke here.)

And while we're on the subject… does Davy really think Angelita needs to be told what her Spanish name means?

Production Notes
Principal filming for this episode ended on June 2, 1967. The Beatles' album *Sgt. Pepper's Lonely Hearts Club Band* was released on June 1, 1967. During the shootout romp, Davy can be seen carrying a copy of the brand-new album.

The performance of *What am I Doing Hangin' 'Round?* was shot in Chicago on August 2, 1967, in the same filming session that also produced performances of *Daydream Believer*, *Pleasant Valley Sunday*, *Randy Scouse Git* and several other songs. This was the only song filmed that day that did not use the candy-striped Rainbow Room setting. Instead, a blank backdrop was dressed with a decorative valance and *serape* meant to resemble the cantina set in the episode, which had been filmed two months earlier.

Cultural Clarification
The iconic line "Badges? We don't need no stinkin' badges!" is widely believed to have originated with the 1948 film *The Treasure of the Sierra Madre*. But the line from that movie was, "Badges? We ain't got no badges! We don't need no badges! I don't have to show you any stinkin' badges!" It was Micky's line from this Monkees episode, written by Treva Silverman in 1967 and later used by Mel Brooks for his 1974 parody film *Blazing Saddles*, that has entered the cultural vocabulary.

Just after the opening credits (and the first commercial break) there's a clever mashup of the Monkees theme song with the theme from *The Magnificent Seven*.

Runner-Up Physical Comedy Highlight
Micky and a lariat.

Physical Comedy Highlight
Davy, a horse and a loose saddle.

Left-to-the-Imagination "Sight Gag" Highlight
Davy's running commentary on Peter's ongoing attempts to untie him.

Sight Gag Highlight
Micky, weighed down with his lucky holster (the one with a gun in it), his lucky .45, his lucky .38, and his three lucky .40 hoberseebers, ready to meet El Diablo but unable to move.

Second Runner-Up Breaking the Fourth Wall
Davy uses his hand to describe a figure eight, to help Peter figure out how to untie Davy's hands.

Runner-Up Breaking the Fourth Wall
Mike: That's very good! I didn't know you could do that. You usually play the dummy.

Breaking the Fourth Wall
Peter: Are you scared?
Micky: No, I'm not scared. I welcome this duel. Symbol of good, against the symbol of evil. And I know I'm gonna be the victor.
Davy: Because the symbol of good always wins?
Micky: No. Because the lead in a television series always wins.

Fourth Runner-Up Nitpick
I'm not sure about the parking lot attendant's "*Haltiamo*," but "*per favore*" is definitely Italian, not Spanish.

Third Runner-Up Nitpick
Why is the "Welcome to El Monotono, Mex." sign written in English?

Second Runner-Up Nitpick
When the bandit José threatens the guys because Davy was chatting up Angelita, he doesn't give any reason other than "El Diablo's orders!" In the very next scene, Mike "reminds" Davy that Angelita is El Diablo's girl. How did he know that?

Runner-Up Nitpick
Why does Lupe quote the price for the car repairs in centavos? The basic unit of Mexican currency has been the peso since 1866. It would be like an American saying, "Fifty thousand pennies for the parts, and forty thousand pennies for the labor...."

Nitpick

Given the effort put into matching the background and costumes for the *What Am I Doing Hangin' 'Round?* performance to the cantina scene in the episode, they got the instruments 100% wrong.
- Performance: Blonde 12-string guitar, banjo, four red maracas and black drums
- Episode: Dark 6-string guitar, bass, two blue maracas and gold-colored drums

Absolutely Not a Nitpick

After several bandit-camp scenes in which all the characters speak English with crudely overemphasized *faux* Mexican accents, Peter suddenly breaks into Spanish—not very *good* Spanish, but at least he was trying—with no make-believe accent at all.

We're the young generation, and we have something to recycle.
- Recycled footage: Davy "ringing the bell" with his head. (See *Here Come the Monkees* and the first season opening credits.)
- Recycled prop: the rococo brass clock face from *The Monkees Watch Their Feet*.

Runner-Up Monkee Magic

Peter conjures up a shoe shine kit.

Monkee Magic

Peter, Mike and Micky conjure up bandit costumes (but no stinkin' badges) and teleport one by one into the plaza.

What I want to know…

Given that Bob Rafelson's first inspiration for the series came from a period of time he spent traveling with itinerant musicians in Mexico, how much (if any) input did Rafelson have on this episode?

Beverage to enjoy while watching *It's a Nice Place to Visit:*

"When El Diablo drinks, everybody drinks!"

Music
- *What am I Doing Hangin' 'Round?:* Fragment of a plot-related performance.
- *What am I Doing Hangin' 'Round?:* Narrative romp intercut with clips from that performance.

Episode 2-1
Written by: Treva Silverman
Directed by: James Frawley

Principal Filming Ended: 6/2/1967
First Airdate: 9/11/1967

Grading
- I thought love was only true in travelogues. **B-**
- I wanna be free (no, Peter, that's my finger). **A**
- I don't think you know Mexico at all. **D**

And the cookie goes to...
The Beatles, for scoring the free product placement.

Frauds! Every one of them. Yachtsmen. Brokers. Tailors. Ha! This is just a fifth rate review of *One Man Shy*.

The In-Which
Peter falls in love with a wealthy client, but he's too shy to do anything more than admire her (stolen) portrait.

A while back, I praised the episode *The Monkees Get Out More Dirt* for its highly structured, foursquare plot. Never did I expect to see another MONKEES episode with such a precisely machined, symmetrical framework.

One Man Shy is so firmly structured, it's almost a captive in a triangular prison. If there's a plot development to be had, it has to be done three times: three voices for Cyrano. Three pranks. Three sports. Three etiquette lessons. And finally, three desperate, last-minute attempts to make Peter look like a wealthy playboy.

Unfortunately, the frequent triple plays weigh the episode down with unnecessary business and busy-ness. Some of the comic bits are much weaker than others, and could have been edited out in favor of longer, richer, funnier scenes. For example: take out the park plumbing and the baby dolls, and all three of Peter's friends could work together to humiliate Ronnie at the sidewalk café.

The plot and theme echo that of the series' pilot *Here Come the Monkees*: an audition for a wealthy patron leads to a romantic entanglement that is welcome to the girl but abhorrent to her male protector. In a way, this is the episode that the pilot *should* have been; it focuses on the emotional growth of one of the show's principal characters and illuminates the relationships among all four of them. It's notable that Peter's loyal friends never berate him

for his ill-advised theft, nor do they tease him about his fear. The camaraderie they display is both reassuring and appealing. (In contrast, the pilot focused primarily on the emotional growth and relationship of Vanessa Russell and her father, leaving the Monkees under-utilized and undeveloped.)

Valerie and Ronnie are two-dimensional types rather than fully realized characters, one a purely noble and generous soul, the other a heartless, classless snob. Lacking emotional depth, they recede into the background and leave the stage clear for Peter and his friends to strengthen their mutually supportive friendship. Valerie serves her purpose, and will not be seen again. In the end, we have a sweet, heartwarming bit of character development with no strings attached.

Zingers
Mike: I don't like him at all.
Davy: I don't like him, either.
Micky: I don't even like him that much.

Davy: Hey, Peter—didn't you ever have a crush on anybody?
Peter: Yeah, once.
Davy: So what did you do about it?
Peter: I took her to a Cub Scout meeting.
Micky: Didn't anybody ever have a crush on you, or nothin'?
Peter: I once got some threatening valentines.

Micky: Tell me your problems, my boy.
Peter: Well, when I was very young, I used to be embarrassed about kissing. But now I can talk very openly about... S-E-X.

Clunkers
Mike: Come on, Pete, cheer up. We'll do something.
Micky: Don't worry, babe.
Mike: We'll fix it—we'll sell candy or something. Or greeting cards.
Micky: Pencils.

Coming on the heels of the *I'm a Believer* romp, in which Peter and Valerie spend a great deal of time together in soft-focus bliss, this exchange and its somber, depressive mood leave me scratching my head. Even if most (if not all) of the romp was purely imaginary, the brief scene makes no sense.

Runner-Up Let's See if We Can Slip This Past the Censors
Mike and Ronnie compare the size of their combs. (Ronnie's is bigger, but Mike is not intimidated.)

Let's See if We Can Slip This Past the Censors
Speaking of the size of Ronnie's comb, what exactly is Davy-the-tailor "measuring" when he calls out "eighteen"?

Physical Comedy Highlight
Mike trying on a bow for size.

Sight Gag Highlight
Peter taking a careful look around before whispering very openly about S-E-X.

Breaking the Fourth Wall
Mike: Would you believe that the Peter we all know and love has now turned into a wolf in sheep's clothing?

Micky: Which just goes to prove: you can make a silk purse out of a sow's ear, if you have enough good silk.

Davy: Which proves, more than ever, it's not how you play the game; it's whether you win or lose.

Fourth Runner-Up Nitpick
Why did Peter go to the party by bus? Why didn't he ride in the Monkeemobile with the rest of the band and all their equipment?

Third Runner-Up Nitpick
I don't think it's such a good idea to shoot skeet (or anything!) in a small public park in the middle of a residential neighborhood.

Second Runner-Up Nitpick
As Peter fantasizes during the performance of *You Just May Be the One*, Valerie is wearing the same yellow dress in the fantasy that she wore to the party. But in the subsequent shots of the band playing the song at the party, Valerie is suddenly wearing a sleeveless black turtleneck.

Runner-Up Nitpick
Mike: Hello everybody. We're the Monkees, and for the first song this evening we'd like to do *You May Just Be the One*.

Mike mixes up the words in the title of his own song. (It's backwards in the closing credits, too.)

Nitpick
You have to hide the stolen portrait, fast! You're in your own home, which has two bedrooms, a bathroom, a closet and a deck. Pick a proper hiding place, for pity's sake.

We're the young generation, and we have something to recycle.
- Recycled gag: cork stuck in a bottle of champagne. (See also *Monkees in Manhattan* and *The Wild Monkees*.)
- Catch phrase that didn't catch on: "You do, and I'll be sorry!" (See also *Monkees at the Circus*.)
- Recycled costumes: the animal print/caveman look. (See also *Dance, Monkee, Dance*; *The Chaperone* and *Monkees Marooned*.)
- Returning actor: George Furth as Ronnie. (He will also play Henry Weatherspoon in *A Coffin Too Frequent*.)

Second Runner-Up Monkee Magic
Micky, Davy and Mike conjure up stockbroker, tailor and yacht captain costumes and related props during Valerie's party.

Runner-Up Monkee Magic
Shared imagination, "Ronnie's Got a Lot of Very Redeeming Qualities" edition. "We attack!"

Monkee Magic
When Peter really wants to impress a girl's portrait, he shows off how well he can teleport.

What I want to know...
What plot element was edited out of the episode, leaving just a couple lines of dangling dialogue about selling candy, or greeting cards, or pencils?

Beverage to enjoy while watching *One Man Shy*:
"Only one who is born to the grape knows the proper way to open champagne."

Music
- *You Just May be the One:* Fragment of plot-related performance.
- *I'm a Believer:* Narrative romp.
- *You Just May be the One:* Plot-related performance intercut with narrative romp.

Episode 1-13
Alternate Title: *Peter and the Debutante*
Written by: Gerald Gardner, Dee Caruso and Treva Silverman
Directed by: James Frawley
Principal Filming Ended: 10/3/1966
First Airdate: 12/5/1966

Grading
- Peter, pathetic. **A-**
- Valerie, virtuous. **B+**
- Ronnie, repulsive. **C**
- Monkees, manic. **extra credit**

And the cookie goes to...
Nesmith, as compensation for snapping himself in the neck with a bowstring. That's got to hurt. Comedy is *hard*.

Today, pussycats, we are shooting the bank stick-up scene. I got everything arranged down at the Ninth National Bank. All you gotta do is walk in and write a review of *The Picture Frame.*

The In-Which
Three of the Monkees are tricked into robbing a bank; Peter is left alone to find some evidence while the others stand trial.

Enjoying THE MONKEES requires a willing suspension of disbelief. Even before Monkee Magic is invoked, even before the fourth wall is breached, even before the first cartoon villain makes the first cartoon threat, the premise of the show requires us to believe that four out-of-work musicians can afford a souped-up custom GTO and a beachfront house in Malibu.

In this fantasy world, *The Picture Frame* stands out as an episode in which every character—from the Monkees themselves to the villains, the victims, the cops, the lawyers and the judge—has been struck with the stupid stick. In fact, if any one character *doesn't* get swept up in the relentless flood of dim-wittedness, it's Peter! He misses the initial swindle and spends much of the second act working independently, trying to rescue his friends.

Micky, Mike and Davy are completely taken in by the villains' absurd proposal. The customers and employees of the bank are oblivious to the absurdity of the Monkees' nakedly incompetent robbery. A police officer lets himself be coached by Micky, and his sergeant patiently plays along with the Monkees' snarky interrogation games. The judge and prosecutor lose all dignity and decorum in the courtroom, and the villains themselves are unable to

either capture or harm Peter, despite the fact that they are both armed and Peter is never more than a few steps ahead of them during the chase.

In the face of all this foolishness, the most remarkable moment in the episode comes at the police station, when Mike (and Mike alone) becomes intellectually *aware*, his face sliding through half a dozen different expressions of horror and physical illness as the shadow of confusion lifts and the enormity of the situation hits him. Nesmith's silly faces are usually good for a laugh, but here they take on dramatic significance, to excellent effect.

Jack Winters' five MONKEES episodes were not generally notable for hilarious dialogue. That's certainly the case here; the humor is all in the absurd situation itself—as long as the viewer is willing to suspend disbelief all the way from Halifax to Hamasaka.

Zingers

Sergeant: All right, my fine feathered Monkees, start talking!
Mike: Mr. Dobalina, Mr. Bob Dobalina…
Davy: China Clipper calling Alameda…
Micky: Never mind the furthermore, the plea is self-defense….
Sergeant: About the robbery!
Mike: Well, well you see, see, it's like I told you: we thought we were, we were doing a movie!
Sergeant: Still sticking to that story, huh? Well, if you know what's good for you, you'll change your tune!
Mike: [blows into pitch pipe] Well, it's like I told ya! We thought we were doing a movie!

Harvey: Hey—what are you doin' here?
Peter: I can't tell you that.
Harvey: I'll make you a big movie star.
Peter: No, I still can't tell you.
Harvey: I get it. You're snooping!
Peter: You guessed!

Clunkers

Peter: You didn't do it, did you?
Davy: Even Peter thinks we're guilty.
Peter: I don't think you're guilty! I just don't see how you could possibly be innocent.

It may have been necessary, for the purpose of the plot, to keep Peter isolated from his friends during the initial heist. But this kind of suspicion, even coming from the band's most clueless member, is uncomfortably out of character.

Production Notes
This was the first episode filmed for the second season, beginning just a few days after the completion of recording for *Headquarters* and a pair of live performances in Canada.

Physical Comedy Highlight
Peter cautiously crawling to the door, in order to deliver an overdue library book to the cops.

Runner-Up Sight Gag Highlights
The Monkees' impulsive, satirical reactions to each of the sergeant's interrogation techniques.

Sight Gag Highlight
The entire security film screening scene at the police station, with its imaginary movie theater audience, culminating with Mike's spectacular facial display as he realizes that the robbery was real.

Breaking the Fourth Wall
Micky: Cut, print, that's a wrap! Thanks—thanks, everybody, we'll see you back at the studio. Bye. Come in tomorrow 7:30 for 8:00, in hairdressing.

Third Runner-Up Nitpick
There's a valuable painting—or, at least a copy of one—decorating the jail cell. How nice.

Second Runner-Up Nitpick
The D.A. objects to Mike's testimony about the stick of dynamite, and then the stick of dynamite goes off in his hand. Why does the judge overrule his objection? Seems like the defense's stunt has... well, backfired.

Runner-Up Nitpick
The robbery takes place during business hours, so the vault should be *open*. The time lock the manager mentions is activated only at closing time, to prevent the vault from being opened while the bank is closed.

Nitpick
When the police come to the pad, the four guys are all standing near the bay window area where they rehearse. There's not an instrument in sight; just a plain wooden lectern and an enormous sword. Was there a yard sale?

Absolutely Not a Nitpick
Say what you will about the dimwitted judge; apparently she does know who led the American League in doubles in 1937. (For the record, it was Beau Bell of St. Louis. Halifax is the capital of Nova Scotia, and *Hamasaka* doesn't "mean" anything—it's the name of a town in Japan.)

We're the young generation, and we have something to recycle.
- Recycled gag: transposing time and place. (See also "3 o'clock, pier 6" in *Hitting the High Seas*—another episode written by Jack Winter.)
- Recycled gag: Davy can't see out the peephole in the door. (See also *Monkees a la Mode*.)
- Recycled gag: Monkees stuck in a door. (See also *The Case of the Missing Monkee*; *The Christmas Show*; *Everywhere a Sheikh, Sheikh*; *Monkees in Texas*; *The Monkees Watch their Feet* and *Monstrous Monkee Mash*.)
- Recycled prop: a baby photo also used in *Monkees Marooned*.
- Recycled footage: traffic far below. (See also *The Case of the Missing Monkee* and *Monkees Marooned*.)
- Recycled footage: smashed antique statue footage from *Art, for Monkees' Sake*, and random disaster-related clips originally used during a romp of *Last Train to Clarksville* in *Monkee See, Monkee Die*.)
- Recycled setting: Mammoth Studios. (See also *I've Got a Little Song Here* and *Mijacogeo*, and listen to *The Monkees at the Movies*.)
- Returning actor: Dort Clark as the Sergeant; he also played cops in *Monkees a la Carte* and *Monkees on the Wheel*.
- Returning actor: Joy Harmon as the dim-witted bank teller; she also played the annoying gambler Zelda in *Monkees on the Wheel*.
- Returning actor: Henry Beckman as the D.A.; he also played the club manager in *The Monkee's Paw*.

Fourth Runner-Up Monkee Magic
Apparently Davy, who is too short to see through the peephole, can see *through* the door.

Third Runner-Up Monkee Magic
During the interrogation, the accused bank robbers conjure up three degrees, sunglasses, suntan lotion, cans of beans and an overdue library book.

Second Runner-Up Monkee Magic
Shared Imagination, Crowded Theater edition.

Runner-Up Monkee Magic
Micky, Mike and Davy conjure up gangster costumes and guns—and Micky conjures up the biggest Polaroid camera I've ever seen.

Monkee Magic
Mike accelerates time in order to bypass the time lock on a bank vault.

What I want to know...
What is Van Gogh's *La Berceuse (Woman Rocking a Cradle)* doing on the wall of the Monkees' jail cell?

Snack to enjoy while watching *The Picture Frame:*
Popcorn, peanuts, hot dogs. (No mustard. Sorry, Your Honor.)

Music
- *Zilch:* fragment, live-to-camera as part of an interrogation scene.
- *Pleasant Valley Sunday*: narrative romp, intercut with Rainbow Room performance.
- *Randy Scouse Git:* isolated performance.

Episode 2-2
Written by: Jack Winter
Directed by: James Frawley
Principal Filming Ended: 4/7/1967
First Airdate: 9/18/1967

Grading
- Crime and Punishment. **B-**
- Law and Order. **C+**
- Truth or Consequences. **A-**

And the cookie goes to...
Editor Mike Pozen, for matching Peter's sassy stroll in front of the movie studio's painted backdrop to the *Pleasant Valley Sunday* lyric, "I need a change of scenery."

We must keep Ludlow away from all women. And the few that will slip through our net will be driven off by a review of *The Prince and the Paupers.*

The In-Which
Davy is mistaken for a bashful prince in need of a bride.

I have to admit, this one caught me off-guard. I saw it coming up in the alphabetical list, and remembered it vaguely as a lightweight knock-off of *Royal Flush*. Or as the Davy Jones version of *Alias Micky Dolenz*. So when the time came to load the DVD and watch the episode with a careful eye, I figured this review would be easy-peasy.

Before the second viewing was done, I had a very different opinion. I had filled out the lower section of my review with nitpicks—and had yet to identify anything I could call a highlight. As I watched for a fifth time, and a sixth, the list of plot holes, inconsistencies and blunders just got longer and longer. And I still didn't have a handle on what to say about it. Ten repeats. Twelve. Zingers? Not much. Monkee Magic? Nary a twinkle.

It could have been such an elegant story, if only they had stuck to just one plot! The prince has to get married; the evil count doesn't want the prince to get married; the girl doesn't want to marry the prince. Two Monkees charm the girl while the other two Monkees teach the prince to be charming. See how it all holds together? Nice and neat and tidy. And it's got a built-in moral dilemma: once the girl has fallen in love with Davy, how do you get her to fall in love with Ludlow instead?

But just when the lighthearted romantic comedy should be sweet and earnest, it takes a hard right turn into the darkness. The henchman tries to double cross the Count, then follows that up with an over-complicated murder attempt. When the Count comes back into

the story, there's suddenly a dungeon and a death threat. With all the violence and palace intrigue, there's no time for Davy to actually be charming, and no time for Peter and Micky to help Prince Ludlow develop enough confidence to win Wendy's heart. Instead of a storybook happy ending, we get an awkward mid-wedding substitution. And a food fight.

Poor Ludlow. Poor *Wendy*.

Perhaps no element of the story irritates me more than the creepy character with the knife and the fire and the bubbling flask of something that ain't French dressing. In an embassy full of elegant people with militaristic uniforms and exotic (albeit mismatched) accents, he is dressed in rags, has filthy hair and speaks with a backwoods American accent. Is he really necessary? And if he is, why have him doing his nefarious dirty work in the same richly furnished room where the nobles practice their fencing? Apparently this embassy has a dungeon; wouldn't he be more at home there?

There were a few wry moments in the episode, usually involving Davy, Mike, and adjustments to the royal regalia. And Mike's nonsensical speech at the end about the butterfly and the apple seed was definitely worth a chuckle. On the other hand, the running gag involving the elderly footman and his endless supply of breakaway canes is not funny in the least. Most of the jokes seem forced, leaving only the absurd premise and Davy's winning personality to provide a gentle layer of humor to the unfocused plot.

Zingers

Ludlow: I'm very hungry. Is there anything to eat in there?
Peter: Well, there's some limburger cheese, and a can of sardines, and some liverwurst that's been here for two weeks. What shall I open first?
Ludlow: How 'bout the window?

Wendy: Ludlow, I'm so happy. There's no one in the world like you.
Mike: I wouldn't be too sure about that.

Mike: Your sash is crooked!
Davy: You're not my real mother!
Mike: Will you please relax, man? You're not the one getting married.
Davy: Yeah, but suppose Ludlow doesn't show up on time? I might end up marrying the beautiful girl and ruining a nation of millions.

Clunkers

Here are the sum total of words spoken by Davy to Wendy, between her chilly "I came to tell you that I don't think I can see you again," and her enthusiastic "Oh, yes. Oh yes, I will!"

- Oh. You must be Cindy.
- *Wendy*. Oh. That's what I said. Wendy, I'd like to know all about you—where you were born, and what you were like when you were a little girl, you know, things like that, you know.

- Ooh!
- You know, if Van Gogh had a girl like you, he'd still have both his ears.
- Oh, call me 'High!' Course you can. I'll make it a royal decree. Decree. Is that it?
- Miss Forsythe? I mean Wendy. Will you marry me?"

Now I don't mind a quick turnaround—they've only got about 20 minutes to tell a story—but it would have helped the episode immensely if Prince Charming had actually been, you know, *charming*. To make matters worse, Davy delivers all that clumsy dialogue while sprawled casually on a throne, with the poor girl standing there with her coat on.

Cultural Clarification

The episode title refers to the Mark Twain novel *The Prince and the Pauper*.

Davy's fencing poem is a parody of *Casabianca* by Felicia Dorothea Hemans. Once used as a memorization exercise in British schools, it has often been lampooned. The actual first stanza of the epic poem is:

The boy stood on the burning deck
Whence all but he had fled;
The flame that lit the battle's wreck
Shone round him o'er the dead.

Physical Comedy Highlight

Any moment involving Davy and a heavy crown.

Breaking the Fourth Wall

Ludlow: Under the terms of my nation's constitution, if I'm still unwed by my 18th birthday, my throne passes to Count Myron.
Davy: That sounds crazy to me.
Ludlow: I know. That's what I told the producers.

Nitpicks (There are so many, I'm not going to try to rank them.)

- Peruvia would not have an embassy in Los Angeles. The embassy would be in Washington DC.
- Where are your manners, Davy? Get up off that throne, young man, and find a place where you and the lady can both sit down.
- Thanks to a time check in the previous scene, we know that the fencing lesson takes place sometime after 6:00 pm. After the lesson, Davy proposes to Wendy. Mike then tells Micky to get Ludlow down to the embassy around 8:00 pm for his wedding. So we are to believe that all the preparations for a royal wedding—guests, dress, food, impressive clergyman—happen in less than two hours?
- Speaking of 6:00 pm, Davy hasn't had anything to eat since breakfast, and he's famished. Why won't Mike let the poor guy have a piece of salami?

- While Wendy walks down the aisle in her wedding gown, the impressive clergyman inexplicably takes a stroll in the opposite direction to have a chat with the footman.
- When the Count announces that Ludlow has rushed off to Peruvia and left her at the altar, Wendy stands perfectly still with her back to the camera, showing no reaction at all. (For all we know, that might be Rodney Bingenheimer standing in for the bride.)
- Bob Hope and Bing Crosby used the patty-cake routine in several of the Road films, but in *The Road to Morocco* the trick didn't work.
- When Davy shows up to marry Wendy, the bad guys don't do anything. When *Ludlow* shows up to marry Wendy, the bad guys attack. That is, they attack Micky and Peter. Why? What about that marriage they're supposedly trying to prevent?
- The wedding ceremony proceeds uninterrupted, despite the food fight/sword fight in progress at the opposite end of the room.
- Wendy apparently doesn't have any problem marrying a different Ludlow than the one she fell in love with.

We're the young generation, and we have something to recycle.
- Recycled plot: a royal teenager comes to Los Angeles for a coming-of-age event. (See also *Royal Flush* and *Everywhere a Sheikh, Sheikh*.)
- Recycled plot: Davy gets dragged to the altar. (See also *Hillbilly Honeymoon* and *Everywhere a Sheikh, Sheikh*.)
- Recycled gag: snapping off the end of a prop. (See also *Royal Flush*, *The Spy Who Came in from the Cool*, *A Coffin Too Frequent* and *Monkees Watch Their Feet*.)
- Recycled romp: Davy crosses swords with an evil nobleman at the royal party, while a great deal of fancy food goes to waste. (See also *Royal Flush*.)
- Recycled thrones: in this instance, Model 309 (The Usurper) is just a pair of side chairs; Prince Ludlow's throne is the first model that the Monkees showed to Archduke Otto in *Royal Flush*. (Apparently the Peruvians didn't pay cash, because they don't have the tufted footstool, cunningly sculpted in the form of a servile flatterer.)
- Recycled joke: Why doesn't her doctor work on his own thesis? Gerald Gardner and Dee Caruso, Script and Story Editors, were writers for both this episode and *The Monkees Get Out More Dirt*, which was filmed a little more than a month later. Did they forget that they had already used that joke?

Monkee Magic
Oh, I only wish.

What I want to know....
Did anybody stop and say, "Hey, wait a minute—didn't we do this exact same romp in *Royal Flush*?"

Snack to enjoy while watching *The Prince and the Paupers*:
Limburger cheese, sardines, two-week-old liverwurst and a huge bowl of potato chips. Shhh!

Music
- *Mary, Mary:* Vaguely narrative déjà vu.

Episode 1-21
Written by: Gerald Gardner, Dee Caruso and Peter Meyerson
Directed by: James Komack
Principal Filming Ended: 12/19/1966
First Airdate: 2/6/1967

Grading
- One Prince Shy. **B**
- Everywhere a Count, Count. **C**
- Royal Putsch. **C-**
- Alias Davy Jones. **C+**

And the cookie goes to…
Rodney Bingenheimer, for the thankless job of standing with his back to the camera whenever Davy and Ludlow had to be in the same shot.

We'll infiltrate the compound under the cover of daylight, and set up an observation post here, in the room next door. Which will serve as a jumping-off point to our primary objective: a review of *Royal Flush*.

The In-Which
After Davy saves a princess from drowning, the Monkees invade her hotel to save her life again.

This is the episode that won director James Frawley an Emmy Award. Who am I to argue? It must be significant that the Academy recognized both the show's first episode and its most prolific director. *Royal Flush* established the tone for the series, and it also set a standard for quality. The episode moves at a brisk pace through an elegant, yet subtle structure, from beach to pad to hotel, then after the commercial break, from beach to pad to hotel.

While there are no truly hilarious moments, the episode is consistent in warmth, intrigue and humor from start to finish. Most of the principal characters are given a chance to shine, making it a better pilot than the actual pilot. Most importantly, it exemplifies the show's wildly eclectic style, borrowing as much from Elmer Fudd as from Errol Flynn.

In his commentary track, director James Frawley proudly points out the cartoon elements of the episode—from the animated light bulb to the sped-up action sequences to the Sigmund-shaped hole in the royal suite's doors. Frawley himself makes an appearance in the episode, as the mysterious voice on the telephone when Sigmund dials a wrong number. (He would be the show's regular voice actor throughout both seasons, notably providing the voices of Mr. Schneider, computer DJ61 and the Dragon of the Moat.)

The romps suffer somewhat from a lack of randomness and variety. On the beach, Davy spends all his time being romantic with Bettina, Micky is the only one to be chased by

Sigmund, Peter spends the whole song digging a whole hole and Mike is missing altogether. And while I don't agree with Tork's comment during the post-episode interview that he could have done a better swordfight scene than Jones did, I do wish that the other three Monkees (and the princess too, for that matter) had more to contribute in that climactic scene.

Zingers

Mike: Well, I guess it'll do. It'll do. Get everything monogrammed.
Peter: Everything monogrammed.
Mike: What time does the sun come through that window?
Peter: What time does the sun come through that window?
Maid: 'Bout twelve noon, I think.
Mike: No good. I want it here by ten-thirty in the morning.
Peter: Right, W.H. Ten-thirty in the morning.

Sigmund: The streetcar… is going… up… the hill.
Otto: Sigmund, you dummy! Where have you been?
Sigmund: They built for me this hole, from which I ran out, and I followed them to the house, and the house, and they were there in the house. Believe me, it's the truth, I followed them to the house, and the house—
Otto: Slowly, slowly! From the beginning.
Sigmund: The streetcar… is going… up… the hill.

Rafelson: Tell me, Mike, what did you think of the show you just did?
Nesmith: I thought it was one minute short.

Clunkers

Jones: He's always picking on me, because I'm small!
Dolenz: He's not short. Stand up Davy, and show them how tall you are.
Jones: **I am standing up.**

It's not the joke that's a clunker. In fact, I rather like this old chestnut, especially as it seems to illustrate Jones's positive attitude and easygoing acceptance of the teasing that naturally seemed to come his way. No, the clunker is in the fact that his last line is noticeably louder than the rest of the dialogue in the scene. That, combined with the incongruous cut to Nesmith's reaction, makes me suspect that Jones's answer was looped in afterwards—perhaps edited in to replace some other, less pleasant response to the teasing.

Production Note

This was not the first episode filmed (that was *Don't Look a Gift Horse in the Mouth*) but it was the first episode aired, on September 12, 1966.

Cultural Clarification
The slim, stylish Princess Phone was introduced in 1959, and was indeed available in many colors. The dial would light up when the handset was lifted, a notable new feature of this luxury phone. The telephone used by Otto in the Royal Suite and the one used by Peter at the birthday ball are both Princess Phones.

The name W.H. Woolhat is an allusion to F.W. Woolworth, which was the original, eponymous name of the iconic five and dime store.

Let's See if We Can Slip This Past the Censors
One couple at the royal reception gets very, very passionate over a plate of cream puffs and petits fours.

Physical Comedy Highlight
Davy trying to swing his way out of danger on a conveniently placed rope. (It always worked for Errol Flynn.)

Runner-Up Sight Gag Highlight
The caution signs on Peter's excavation project:
- Danger Hole Started
- Watch Out Half a Hole
- Caution Whole Hole

Sight Gag Highlight
A tufted footstool, cunningly sculpted in the form of a servile flatterer.

Breaking the Fourth Wall
Title card: It always worked for Errol Flynn.

Third Runner-Up Nitpick
If the princess becomes queen at midnight, why would the archduke wait until after the reception to "render her unconscious"? Seems like she is fully prepared to go all regal on his ass at the stroke of twelve.

Second Runner-Up Nitpick
Davy never does get his jacket back.

Runner-Up Nitpick
Otto: Unyamit trin dolomaton, trabucco sini.
Davy: Oyanka kimbo cuwumba, cumba sini.

I totally get that Davy wouldn't be able to remember Otto's threat exactly, but wow! He was off by a mile!

Nitpick
Why would Davy call Directory Assistance to find out where the visiting royals are staying? How would the phone company know that?

Absolutely Not a Nitpick
This early in the series, Monkee Magic sometimes requires the application of shears, gold spray paint and a purloined red velvet drape. It's a lovely throne they reupholster, one that would eventually get good use in *The Prince and the Paupers*. The rococo Model 309 (The Usurper), on the other hand, is just a borrowed side chair from the hotel hallway. An identical chair can be seen in the edge of the frame while the Monkees and the princess make their escape from the hotel.

We're the young generation, and we have something to recycle.
- Recycled plot: a young royal comes to Los Angeles for a coming-of-age moment. (See also *The Prince and the Paupers* and *Everywhere a Sheikh, Sheikh*.)
- Recycled romp: Davy crosses swords with an evil nobleman at the royal party, while a great deal of fancy food goes to waste. (See also *The Prince and the Paupers*. Didn't we just do that one?)
- Recycled plot point: nobody can use a tape recorder properly. (See also *The Audition* and *Monkees a la Carte*.)
- Recycled prop: a whisk broom for the VIP. (See also *I Was a Teenage Monster* and *I've Got a Little Song Here*.)
- Recycled furniture: Model 309 (The Usurper). (See also *The Prince and the Paupers*, *A Coffin Too Frequent*, *The Devil and Peter Tork* and *Head*.)
- Recycled punch line: "I am standing up." (See also *Captain Crocodile*, *Son of a Gypsy* and *I Was a 99 Lb. Weakling*.)
- Recycled gag: snap off the end of a prop. (See also *The Spy Who Came in from the Cool*, *The Prince and the Paupers*, *Monkees Watch Their Feet* and *A Coffin Too Frequent*.)
- Recycled sight gag: a light bulb for a bright idea. (See also *Your Friendly Neighborhood Kidnappers* and *Monkees in a Ghost Town*.)

Second Runner-Up Monkee Magic
The throne may have needed manual reupholstering, but Peter and Mike easily conjure up a pair of trumpets for "King Otto."

Runner-Up Monkee Magic
Shared Imagination, Battle of Britain edition.

Monkee Magic
Shared Imagination, Errol Flynn edition.

What I want to know...
Why would the Queen of Harmonica celebrate her accession to the throne in a hotel in Los Angeles?

Snack to enjoy while watching *Royal Flush:*
That couple at the reception? I'll have what they're having.

Music
- *This Just Doesn't Seem to be my Day:* narrative romp.
- *Take a Giant Step:* very narrative romp.

Episode 1-1
Written by: Peter Meyerson and Robert Schlitt
Directed by: James Frawley
Principal Filming Ended: 6/10/1966
First Airdate: 9/12/1966

Grading
- From Here to Midnight Tomorrow **A-**
- Puttin' on the Ritz Swank **A**
- The Count of Monkee Cristo **A-**
- Get Shorty **B**

And the cookie goes to...
The Academy of Television Arts & Sciences, for recognizing excellence in innovative direction when they see it.

Never in my life have I, the Geator with the Heater, snapped over a fox such as you. You are devastating—it must be the mini. It must be something about you that makes my mind crave a review of *Some Like it Lukewarm.*

The In-Which
The Monkees enter a band contest for mixed groups—so somebody's got to wear a dress.

This is the only MONKEES episode written by Joel Kane and Stanley Z. Cherry. Perhaps, then, I should overlook the way the episode doesn't quite feel like the usual fare—how it fails to deliver the random magic, clever dialogue and overall good cheer that typifies the series. On the other hand, perennial MONKEES director James Frawley was at the helm, and if anybody should have been able to salvage this one, it would be him.

Well, at least he tried.

This was the second-to-last episode filmed, and as in a few other late Season Two episodes, the guys behave as though they don't like each other very much. Even though it's a character-driven story, there's no sign of the warmth and depth of such early character-driven episodes as *I've Got a Little Song Here* or *Success Story*. Notably absent are the band's usual decision-making techniques; Davy is pressured into taking on the "chick" role without choosing fingers, drawing straws or consulting any other manifestation of the Fickle Finger of Fate. Money is the band's paramount motivation—more than success, integrity or friendship—and nobody gives a flying fig about Davy's feelings in the matter.

Jones gamely carries all the episode's emotional load and most of the comic relief. The closest thing the episode has to a conflict is Davy's reluctance to play slap and tickle with the contest emcee—who is himself the closest thing the episode has to a villain. The underlying moral quandary is resolved on the spur of the moment by Davy alone; heaven forefend the

four friends might actually discuss the matter, much less work together toward a resolution. The episode ends abruptly, as contest, girl and romance all disappear at the end of *She Hangs Out*.

There isn't a romp in sight, but the two musical numbers are much livelier than the usual stand-in-front-of-yellow-curtain performance. The guys are relaxed enough to abandon the pretense that they are actually playing the instruments; they just use the opportunity to goof off and be silly. In contrast to these happy interludes, the Westminster Abbeys' earsplitting "performance" of *Last Train to Clarksville* is annoying and unnecessary. What a contrast to the summer of '66, when guest star Bobby Sherman spent an evening in the studio recording a cover of *New Girl In School* to be used in the episode *The Monkees at the Movies*.

Jones's guest segment with Charlie Smalls is earnest and informative, in marked contrast to the clever, biting satire of Nesmith's interview with Frank Zappa in The Monkees Blow Their Minds.

Zingers

Jerry: The rules clearly state that it's a contest for mixed groups only.
Mike: Oh, basses and baritones.
Jerry: Girls.
Micky: Uh, peas and carrots?
Jerry: Girls!
Micky: Republicans and democrats.

Davy: So... how do I look?
Micky: Like a raggy, hairy bone.
Mike: Hairy, bony rag.

Peter: Sign us up, we're the Monkees.
Mike: Yes sir.
Micky: Hello...
Peter: Hello...
Davy: ... goodbye.

Production Notes

Philadelphia disc jockey Jerry Blavat (a.k.a. the Geator with the Heater, a.k.a. the Big Boss with the Hot Sauce) played himself in this episode. I was quite surprised by this; although I had known that the part of the contest emcee had been played by a real-life DJ, I had assumed that the sleazy fellow who chased "Miss Jones" around the pad was a fictional character. I was astonished to learn that Blavat (like the Monkees themselves) used his own name on the show, not to mention both of his professional nicknames, while pretending to pressure an unwilling girl to put out in exchange for preferential treatment.

Cultural Clarification
The episode title is taken from the 1959 film *Some Like it Hot*. (Jack Lemmon and Tony Curtis did the cross-dressing.)

The phrase "a rag, a bone and a hank of hair" comes from the opening verse of Rudyard Kipling's *The Vampire*:

A fool there was and he made his prayer
(Even as you and I!)
To a rag and a bone and a hank of hair
(We called her the woman who did not care),
But the fool he called her his lady fair
(Even as you and I!)

Let's See if We Can Slip This Past the Censors
Jerry: Cash? You guys don't even qualify. Where's the girl?
Davy: "Where's the girl?" What are you—a contest manager, or a house detective?

Did Davy learn about house detectives at those disreputable hotels (the ones with all the loose talk and fast women) that Mike warned him about back in *Monkees in the Ring*?

Physical Comedy Highlight
Davy learning to be a feminine female by moving his hips east to west while walking north to south.

Breaking the Fourth Wall
Davy: I always wondered what the noise was at our house. It was me three sisters, learning how to walk.

Third Runner-Up Nitpick
Peter and Micky (and Davy too, for that matter) wear the same clothes backstage on the second day of the contest that they wore on the first day. When they perform *She Hangs Out*, they're wearing different clothes.

Second Runner-Up Nitpick
It's entirely likely that Jerry would remember the three guys who made such a fuss at the registration table. Wouldn't it make more sense to put Peter in the dress? (Or conversely, for Peter to appear instead of Davy in the teaser scene?)

Runner-Up Nitpick
If Mike, Micky and Peter took the Monkeemobile to the restaurant, how does Davy get there? More to the point, how does he get there *first*?

Nitpick
As Davy runs away from the secluded booth at Some Little Out of the Way Place That Nobody Goes (Southside Branch), his right high heeled boot spills out of his paper bag onto the table. When he gets home, his left boot is on his left foot and his right foot is clad only in a sock. At what point between the restaurant and the pad did Davy take off the two shoes he wore to the restaurant and put on the one boot?

Not Really a Nitpick
Jerry Blavat lists the names of the Westminster Abbeys as Melody, Harmony, Cacophony and William the Conqueror. According to the credits, William is really named Daphne, so the band has a full lineup of rhyming names. (Or it would, if Jerry knew how to pronounce "cacophony." He pronounces it "KAK-a-phone." It should be "ka-KOFF-a-nee.")

Sadly, the word "cacophony" refers to an unpleasantly discordant sound.

We're the young generation, and we have something to recycle.
- Recycled plot point: Davy gets stars in his eyes. (See also *Monkee See, Monkee Die* and *Here Come the Monkees*.)
- Recycled shtick: the Monkees strike a "hello" chord. (See also *Monkees a la Mode*; *Everywhere a Sheikh, Sheikh* and *The Monkee's Paw*.)
- Recycled footage of Monkees in drag: borrowed from *The Chaperone*, *Fairy Tale* and *Monkee vs. Machine*.

Monkee Magic
Other than the stars in Davy's eyes... not a twinkle. What a pity!

What I want to know...
What happened to *Girl Named Love*, and all those other songs Jones and Charlie Smalls were writing together?

Snack to enjoy while watching *Some Like it Lukewarm:*
Will you bring me a tuna fish sandwich? And for heaven's sake, don't leave it out on the kitchen table overnight. Do you want to give me food poisoning?

Music
- *Last Train to Clarksville:* Ridiculously sped-up "performance" by the Westminster Abbeys.
- *The Door into Summer:* Ridiculously distracted plot-related performance.
- *She Hangs Out:* Plot-related performance, with ridiculously underutilized extra musicians from rival band.
- *Girl Named Love:* Work in progress by Davy, in collaboration with guest Charlie Smalls.

Episode 2-24
Written by: Joel Kane and Stanley Z. Cherry
Directed by: James Frawley
Principal Filming Ended: 12/13/1967
First Airdate: 3/4/1968

Grading
- Victor/Victoria. **B+**
- Cinderella. **B-**
- Malibu's Got Talent. **C**
- White Men Can't Clap on 2 and 4. **C+**

And the cookie goes to...
Jerry Blavat, the Geator with the Heater, for being such a good sport.

Don't look startled, just look straight ahead. Pretend we're having a normal conversation. Good. Now, after I tell you this, I want you to walk calmly out of this place and write a review of *Son of a Gypsy*.

The In-Which
After the Monkees beat out a band of gypsies for a performing gig at a prestigious private party, the gypsies take their revenge.

And finally we reach the last of the stereotype episodes. As with *Monkee Chow Mein* and *It's a Nice Place to Visit*, we are dealing with a very real culture, albeit one that is far less well known and understood by your average Hollywood screenwriter than the cultures of China and Mexico.

Here, we have a pastiche of romantic and prejudiced notions, tied together with vague eastern European accents and brightly colored costumes. Certainly the writers drew on the standard Hollywood image of what gypsies are—but just as certainly, they focused almost exclusively on the most negative aspects of the stereotype. Gypsy music? Marco doesn't have pitch or rhythm. Gypsy spiritualism? Nothing but a con job. But violence and theft? Oh yes, we have plenty of that! Even the episode title, a play on the phrase "son of a bitch," is unnecessarily ugly.

The strangest omission in the story is the reason why Maria and her sons want the Maltese Vulture in the first place. Perhaps they want to steal it because it was first stolen from their ancestors. Perhaps they want to steal it because it has significance in their culture. Perhaps they want to steal it because... well, because they're professional thieves, disguised as a nomadic clan of really, really bad musicians. A little bit of background information would have lent a layer of emotional depth to the episode—depth that was sadly missing.

Because we never find out why the gypsies want the Maltese Vulture, the only motivation driving the action in the second act is the threat against Peter's life. Sadly, this approach leaves Peter with nothing to do as the plot heats up. As in several second season episodes (*Monstrous Monkee Mash*, *The Monkees Blow Their Minds*, *Mijacogeo*) he's rendered inert and inconsequential while the other three Monkees run the caper. And run it they do! The distraction techniques practiced by Mike and Micky, together with Davy's patient attempts to open the safe, represent the best humor in the episode.

Son of a Gypsy is a simply a weak story. Perhaps if they had spent less time hanging around the camp and more time wreaking havoc inside the Rantha mansion, it would have been more memorable. High-stakes art heists can make for first rate entertainment; why not milk the dramatic and comedic potential for all its worth?

Zingers

Micky: Sir, this is an emergency. Don't look startled, just look straight ahead. Pretend we're having a normal conversation. Good. Now, after I tell you this, I want you to walk calmly out of this place and call the police. Sir, there are thieves here that are going to steal the Maltese Vulture.
Guest: Yugoslavia.

Micky: All right. Stick 'em up!
Mike: Help, help. Help. Robbery. Who is this masked man, anyway? Help, help. Gun. Oh, terror, terror, burglar. Burglar help? Help, help. Wallet mine; his now.
Maria: If they don't drop that vulture in five minutes, it's curtains for you!
Peter: Oh! For a minute, I thought you were going to kill me.

Cultural Clarification

Kiko: When you think of gypsy, you think of a dancer!
Peter: I think of Ethel Merman.

Ethel Merman had the starring role in the 1959 – 1961 Broadway musical *Gypsy*, as the mother of striptease artist Gypsy Rose Lee.

Physical Comedy Highlight
Davy pulling an endless supply of large tools out of his burglary tool bag.

Runner-Up Sight Gag Highlight
The painting of a wall safe, sandwiched between the landscape painting and the actual wall safe.

Sight Gag Highlight
When three Monkees peek around the corner into the hallway where the guards are standing, Davy's face is above the other two—at the level of somebody of Mike's height.

Runner-Up Breaking the Fourth Wall
Davy's stethoscope picks up *Last Train to Clarksville* coming from the safe door.

Breaking the Fourth Wall
Mike: Wait, no! Not that! You leave us little choice. All right, we will steal the Maltese Vulture. (How was that? That sound good?)
Micky: Oh, yeah. Yeah, yeah.
Peter: Great.

Third Runner-Up Nitpick
Marco is much taller and heavier than Peter. Where did his well-fitted blue eight-button shirt and grey pants come from?

Second Runner-Up Nitpick
After failing to blow the safe open, Davy gets out a stethoscope and puts on some gloves, apparently intending to open the safe that way. But when Madame Rantha enters the room, Davy is back over in the corner holding the detonator.

Runner-Up Nitpick
Madame Rantha doesn't notice that the pictures have been removed from the wall, or that the vault containing her precious Maltese Vulture is already unlocked.

Nitpick
The floor plan of the Rantha mansion shows only one straight corridor down the middle of the main floor. But the hallway where Mike and Micky distract the guard turns a corner near the bedroom where the Maltese Vulture is kept.

We're the young generation, and we have something to recycle.
- Recycled gag: blowing up the wrong thing. (See also a desk in *Monkees a la Carte*, and a piano in *Alias Micky Dolenz*.)
- Recycled joke: "I don't like the way he's acting." (See also *Monkee Chow Mein*.)
- Variation on a recycled punch line: "We are standing up." (See also *Royal Flush*, *Captain Crocodile* and *I Was a 99 Lb. Weakling*.)
- Recycled prop: the knife-throwing backdrop/rig from *Monkees at the Circus*.
- Returning actor: Vincent Beck as Marco. (He also played Sigmund in *Royal Flush* and Ivan in *Card Carrying Red Shoes*.)

- Returning actor: Victor Tayback as Rocco. (He also played George in *Your Friendly Neighborhood Kidnappers* and Chuche in *Art, For Monkees' Sake*.)
- Returning actor: James Frawley as the Yugoslavian guest. (He also played Rudy Bayshore in *The Monkees Blow Their Minds*, Dr. Schwartzkopf in *Monkees Marooned*, and himself in *The Monkees in Paris*.)

Second Runner-Up Monkee Magic
Peter conjures up a jar of good-luck salt.

Runner-Up Monkee Magic
Shared Imagination, Davy on the Rack edition. (We *are* standing up.)

Monkee Magic
Davy conjures up a bottomless bag of burglary tools, a lit candle (by mistake), a flashlight and a couple of extra hands. And a bunny.

What I want to know…
Is "grubchick" a real word? And if it is, how the heck do you spell it?

Snack to enjoy while watching *Son of a Gypsy:*
"Do have some hors d'oeuvres. They're imported!"

Music
- *Let's Dance On:* fragment of a plot-related performance.
- *I'm a Believer:* vaguely narrative romp.

Episode 1-16
Written by: Treva Silverman, Gerald Gardner and Dee Caruso
Directed by: James Frawley
Principal Filming Ended: 10/27/1966
First Airdate: 12/26/1966

Grading
- Camping for fun and profit. **C-**
- Ocean's Three. **B+**

And the cookie goes to…
The Maltese Falcon, which was nominated for a Best Picture Oscar, and Ethel Merman, who was nominated for Best Actress Tony for her role in *Gypsy*. Ain't nobody getting a cookie for this episode.

Remember: your contact is a short man. He will ask you for some red maracas. You will reply, "I have some—for six dollars." He will say, "But I can only give you a review of *The Spy Who Came in from the Cool.*"

The In-Which
The Monkees are swept into international intrigue after Davy buys a pair of maracas containing a hidden spool of microfilm.

Tonight, in a very special one-hour episode of THE MONKEES....
What? *The Spy Who Came in from the Cool* isn't a one-hour episode? With two romps, two plot-related performances, two other songs performed live to camera, a double length Shared Imagination sequence, several solid guest characters, a lively plot, and fourth walls crashing down all around? How in the world could that all fit into twenty-three minutes of airtime?

A huge part of the secret is in the efficient and effective use of music. The action continues seamlessly throughout all four Monkees tunes, which are models of integration between story and song. Davy even finds the microfilm in his maracas while playing the maracas in the opening bars of a song that actually has maracas in it! The performances are realistic performances, presented realistically; the romps are crucial to the plot and never for one second fail to make sense. Bob Rafelson's direction during the discotheque scenes is far more dynamic than the usual fare; the camera swoops and weaves among the dancers and even behind the Monkees as they play.

Strip away the music and the Shared Imagination sequences, and there's not much plot to speak of. Once Davy has the microfilm, it's just a matter of giving it back under favorable conditions. But dress up the thin plot with such compelling characters—the earnestly

incompetent Honeywell, the cool, exotic Madame and the sweetly bumbling Boris—and I don't mind at all.

The dialogue isn't all that funny; the humor is more visual and situational. But there are a handful of extremely well crafted long-form jokes, noticeably the meticulously layered "Are you really foreign spies?" sequence. That repetitive scene has the potential to devolve into tedium, but the Monkee-flavored nonsense (including Peter's conjured daffodils and Micky's "take four") keep it buoyant. In contrast, Honeywell's series of hidden camera interviews earlier in the episode does start to get a little tiresome.

Most impressive is the subtle setup provided by Yakimoto's karate lesson and Madame's disdain for the decadent American teens all copying dance moves from each other. "Sheep!" We have to wait several more minutes for the delicious payoff, as the dancers spontaneously take up the Karate Chop to add innocent chaos to the fight scene romp.

Even as the episode ends with a seemingly supererogatory romp cobbled together from clips largely borrowed from other romps, the plot continues and *the romp makes sense*. It's cobbled together from clips because that's exactly what it *is*—a random substitute for the secret American weapon plans that Madame thought she was smuggling.

Elegant.

Zingers

Micky: All right, Nesmith. Tell me about your special cigarette lighter.
Mike: Well, this cigarette lighter is very special. It's got a miniature Japanese camera in it—
Micky: Right.
Mike: —and also, a miniature Japanese cameraman.
Miniature Japanese Cameraman: Yahhh!
Mike: Oh, scorched you again there, Yamashita.

Honeywell: All you have to do is sit down there and wait till they make their contact. There's a 12 decibel microphone hidden in the lamp; they'll never suspect a thing.
Mike: What about that big black wire?
Honeywell: That's always been a problem.

Madame: I grow impatient.
Peter: I grow daffodils!

Clunkers

Chief: It's not as bad as all that. Why, we may even be able to save even three of you.
Micky: Three? Three.
Mike: [to Peter] Well, I guess we're just going to have to form a trio. We're gonna miss you, ol' buddy.

This, aimed at a guy who cries at card tricks. Offhand jibes like this were not uncommon in the early episodes; fortunately, the practice faded after a while.

Cultural Clarification
The episode title is taken from the 1963 novel *The Spy Who Came in from the Cold* by John le Carré, and the 1965 film adaptation of the same title.

Physical Comedy Highlight
Yakimoto's increasingly aggressive attacks—and Micky's absolute deadpan reaction to them. "Thank you, Yakimoto. We'll call you."

Absolutely Not a Physical Comedy Highlight
Those training wheel unicycles can be lots of fun to watch... once they're moving. From a standstill, as they are when Micky and Mike decide it's time to meet the CIS agents at the disco, they're surprisingly clumsy and slow. The scene would have been better without them.

Sight Gag Highlight
Honey and the Bear. They've got to be kidding.

Runner-Up Breaking the Fourth Wall
Micky: Spy confession, take four.

Breaking the Fourth Wall
Genie: Do not fear, Master. Your genie will help you.
Davy: Huh. Imagine that. Wrong show.

Fourth Runner-Up Nitpick
Micky guesses that Boris is a shoemaker, based on the calluses on his hands—hands that are not visible in the photograph.

Third Runner-Up Nitpick
When Honeywell interviews Micky, his "hidden" camera is inside the pad.

Second Runner-Up Nitpick
The closing credits list *Last Train to Clarksville*, *I'm Not Your Stepping Stone* [sic] and *The Kind of Girl I Could Love*. Never mind the spelling and punctuation errors in *(I'm Not Your) Steppin' Stone*; *Last Train to Clarksville* wasn't even in the episode! On the other hand, *All the King's Horses* and *Saturday's Child* were in the episode, and weren't included in the credits.

Runner-Up Nitpick
Wide-angle shots of the band playing *(I'm Not Your) Steppin' Stone* without dancers in the foreground must have been shot at a different time; the large, colorful "Frug to our Discotheque Music" sign behind the band is missing and Mike is playing a different guitar.

Nitpick
The film that Madame shows to the Chinese spymasters, which was developed from the reel of microfilm that she had in her hand when she escaped from the disco, includes footage of the Monkees and Honeywell capturing Boris—all of which happened after Madame left the scene.

Not Necessarily a Nitpick
Mike patiently counts $380, then tells Madame and Boris that the payment is short $1.90. Are we then to assume that the agreed-upon price for the microfilm was $381.90?

We're the young generation, and we have something to recycle.
- Recycled gag: snapping off the end of a prop. (See also *Royal Flush*, *The Prince and the Paupers*, *Monkees Watch Their Feet* and *A Coffin Too Frequent*.)
- Recycled physical comedy: Mike topples over while frozen. (See also *Monkees a la Mode*; *Art, for Monkees' Sake*; *Monkees on the Wheel* and *The Monkees in Paris*.)
- Recycled punch line: "Brazil is nice." (Listen also to "Vampires are nice," in *I Was a Teenage Monster*. Same writers.)
- Recycled music: Davy does a soft-shoe to *The Old Folks at Home*. (See also the admitting nurse's station at the Remington Clinic, *The Case of the Missing Monkee*.)
- Recycled romp footage: running and jumping across a fountain. (See also *Monkees in Manhattan* and *Monstrous Monkee Mash*.)
- Returning actor: Lee Kolima as Yakimoto. (He was also Gengis Khan in *The Devil and Peter Tork*.)

Runner-Up Monkee Magic
Peter grows daffodils. Instantly.

Monkee Magic
About 007 minutes of Shared Imagination.

What I want to know...
What is the protest song that Honey and the Bear perform (under duress) in the disco? Was it made up for the episode, or is it a real song?

Snack to enjoy while watching *The Spy Who Came in from the Cool*:
You can talk to a popsicle.

Music
- *The Kind of Girl I Could Love:* fragment of a plot-related performance.
- *The Old Folks at Home*: brief plot-related soft-shoe solo.
- *(I'm Not Your) Steppin' Stone*: plot-related performance.
- *All the King's Horses*: narrative romp.
- *Saturday's* Child: playful romp.

Written by: Gerald Gardner and Dee Caruso
Directed by: Robert Rafelson
Principal Filming Ended: 7/1/1966
First Airdate: 10/10/1966

Grading
- Spy recruitment. **M**
- Spy training. **Q**
- Are you *really* foreign agents? **KAOS**

And the cookie goes to...
Director Bob Rafelson, for the dynamic camera work in all the discotheque scenes.

Mr. Jones, I just want to tell you that my family sleeps a little better every night, knowing that you're out there singing. You're a great person. It's wonderful to have you— uh— (*Success Story* is next.)

The In-Which
Davy's grandfather comes to visit.

A common observation in many of the recent reviews—in particular, reviews of episodes from the latter half of the second season—is that the characters don't seem to like each other very much. A certain level of sarcasm and disdain that is usually directed outwardly, toward the harsh world and the hypocritical people running it, would occasionally leak over into the interactions among the Monkees themselves. Now that I'm getting close to the end of the alphabetical list of episodes, I've reached a cluster of episodes in which all that cynicism is melting away in a great big fuzzy blanket of friendship and love.

There aren't many MONKEES episodes that focus tightly on the brotherly ties among the four characters, and most of them are clustered fairly early in the first season: *Success Story*, *I've Got a Little Song Here*, *One Man Shy*, perhaps *Too Many Girls*. In the second season, only *The Devil and Peter Tork* approaches the depth of affection and caring seen in these early episodes.

Aside from the emotional wallop, this episode's best feature is its patient, elegantly structured pace. Act I slowly builds both tension and tempo from scene to scene until just after supper. At that moment you can almost imagine the words *molto accelerando* written in the script, as one character after another after another bursts into the scene. Soon there are no fewer than ten agitated people milling around the pad at once, with the volume increasing and increasing until Davy's grandfather finally explodes with righteous anger.

After the commercial break, Act II dials the pace all the way back to contemplative, with the slowest romp of the series. Quiet dialogue is interspersed with long, meaningful pauses. This continues until the "weeping" scene on the deck, at the end of which Mike trips a switch ("Well... well... he just may never make that plane!") and the pace plunges straight into overdrive. Instead of a small space crowded with characters, the second act climaxes in a large space with a great deal of hectic motion.

This was the twelfth episode filmed, but only the sixth episode aired. That's worth noting, because a plot like that of *Success Story* could have had a greater impact later in the show's run. Breaking up the band—actually saying goodbye to a main character—is a bluff you can only use once, so why not wait until the audience has invested many more months in the show? The awkwardness of using this ploy so early in the series is underscored by Davy's reminiscent walk on the beach: the flashbacks are taken from just a handful of romps.

In order to set up the merry melee at the end of Act I, the script briefly depicts the Monkees as con artists and petty thieves. In other instances, the guys would have simply conjured the props and costumes needed for their innocent con job on Davy's grandfather—and, in fact, they do just that for the airport caper in the second act. But after the show had gone to such lengths week after week to demonstrate that these long-haired musicians are honest and friendly, it's somewhat disconcerting to see them actively swindling the neighbors. This slight erosion of the characters' virtue works perfectly for this episode; Davy's grandfather is rightly and righteously outraged to be confronted with so many aggrieved victims. But I'm not so sure it works for the series.

Zingers

Davy: Micky—as my chauffeur, how would you help a lady into the back seat of a car?
Micky: As quick as I can!
Davy: Mike—as my personal chef, what will be your three main dishes?
Mike: Well, uh, we'll start off with a vicky—vitchyswats, then we're goin' to uh, uh, chat—uh, chat-oh breeyand, and then we'll go into... chocolate mouse!
Davy: But you can't cook those dishes!
Mike: Yeah, I know. I can't say 'em, either.
Davy: Peter—as my devoted houseboy, what will be your main function?
Peter: I am born to serve my master, and live only to perform his bidding.
Davy: Right. Now get me my comb.
Peter: Get it yourself.

Mike: Hi! Are you late for your plane, sir?
Grandfather: Aye, I am.
Mike: Where you goin'?
Grandfather: London, England.
Mike: Fine! We'll take the freeway.

Production Note

This was the last episode filmed in the summer of 1966, before the show premiered on NBC.

Physical Comedy Highlight
Davy, giving his meatball three bounces before he'll believe that it's rubber.

Sight Gag Highlight
Peter in his role as Icarus. "Don't fly! Don't fly!"

Runner-Up Breaking the Fourth Wall
Thought Balloon: That lady was a lady!

Breaking the Fourth Wall
As in the similarly character-driven episode *I've Got a Little Song Here*, the story takes on a biographical quality that would have appealed to an audience eager to know Davy better. The fourth wall is nudged aside gently as the interview segment sets the record straight—Jones is *not* an orphan, no matter what the story said, and he has been home recently to visit his family in Manchester.

Fourth Runner-Up Nitpick
If Davy's grandfather practically raised him, wouldn't they have similar accents?

Third Runner-Up Nitpick
Near the end of the first act, the hungry neighbor can be seen dashing across the pad from the kitchen to the door—after she had already left.

Second Runner-Up Nitpick
Grandpa arrives with two red suitcases. He returns to the airport with the same two red suitcases. Where is Davy's luggage?

Runner-Up Nitpick
When the action resumes at the airport on the second day, the middle-aged autograph seeker is still there—and she's still wearing the same dress.

Super-Sized, Multi-Part Nitpick
During the scene at the airport counter, the chalked-in departure times and gate numbers change between shots. For much of the scene, the board lists two flights—one to London, the other to Clarksville—departing from Gate 9 at the exact same time. Despite the shifting information, the 3:00 flight to London remains constant at Gate 9, and a PA announcement says the same thing: "Passengers to London Airport, report to Gate 9, now boarding."
 After all that, Grandpa meets Davy at Gate 3.

We're the young generation, and we have something to recycle.
- Recycled footage: Jeremy the horse from *Don't Look a Gift Horse in the Mouth*.

- Recycled footage: happy beach memories from the pilot, *Monkee vs. Machine* and *The Spy Who Came in from the Cool*.
- Returning actor: Donald Foster as the owner of the Rolls Royce. (He was also the courtier with the breakaway cane in *The Prince and the Paupers*, and the bank Vice President in *The Picture Frame*.)

Second Runner-Up Monkee Magic
Shared Imagination, "I Could Eat a Horse" edition.

Runner-Up Monkee Magic
Micky teleports under the Rolls Royce and conjures up a Monkees Car Conditioners disguise and business card.

Monkee Magic
After recovering from their good cry, Peter, Mike and Micky teleport to the airport and conjure up disguises. They get there while Davy's grandfather is still outside the building!

What I want to know…
Did Tork—or any of the Monkees, for that matter—really know how to surf?

Snack to enjoy while watching *Success Story:*
Vitchyswats, chat-oh breeyand and chocolate mouse. *Your* serving is rubber.

Music
- *I Wanna Be Free*: contemplative romp.
- *Sweet Young Thing*: self-contained romp.

Written by: Gerald Gardner, Dee Caruso and Bernie Orenstein
Directed by: James Frawley
Principal Filming Ended: 8/30/1966
First Airdate: 10/17/1966

Grading
- How to Succeed in Show Business (Without Really Trying). **B+**
- I Wanna Stay Here. **B**
- I don't know why you say goodbye, I say hello. **A+**
- Airport '67. **A**

And the cookie goes to…
Whoever it was who scouted out that airport and got permission to film there. Because there are some locations you just can't recreate on a soundstage. (I'm looking at you, *Monkees at the Circus*.)

Before we present our first gifted amateur of the evening, remember that it's your phoned-in votes that's going to give this amateur a win tonight, and give him a big review of *Too Many Girls*.

The In-Which
A conniving stage mother tricks Davy into performing with her daughter in a TV talent competition.

There are too many Ferns.
 That's the problem, I finally figured out. Too many different, contradictory Ferns. She's the only girl of consequence in the episode, after all—the quintet of lovely extras fawning over Davy in the opening scene are merely beats in a well-crafted joke. No, the "too many girls" in this thinly plotted episode are Fern, Fern, Fern and Fern: a timid and submissive daughter, a sassy con artist, a sexy seductress, a whiny brat.
 Don't get me wrong: I love a well-rounded guest character. But Fern isn't so much well-rounded as she is un-grounded. Her character never gets a chance to develop a central core, so she ends up being a string of random situational imperatives. She's seldom on screen for more than a few seconds at a time, almost always in some kind of disguise; for her longest and most emotionally evocative scene she is rendered nearly unrecognizable by a long wavy wig and a heavy-handed censor.
 If Fern is too much of a chameleon, her mother is a two-dimensional villainess, painted in broad strokes of primary colors on stiff paper. She's such a heavy-handed stage mother, and Fern sounds so dejected and forlorn in her presence, I find it hard to believe the girl had any real desire to break into show business—right up to the moment she starts having hysterics on stage.

In stark contrast to Fern's capricious characterization, Davy stands in rock-solid dependability. Again and again, through all the well-intentioned abuse that he takes from his friends, he insists that he is not going to leave the group. His three friends, temporarily hoodwinked by Mrs. Baddery's transparently fraudulent psychic powers, demonstrate an astonishing lack of faith in Davy's good sense, not to mention his honesty and friendship.

There's an abrupt and jarring break in the narrative between the faux beauty pageant in the tea shop and the onset of the talent show. Logic dictates that at least two days must have passed between scenes, as Fern referred to the TV show being on "Sunday," not "tomorrow." I suppose we are meant to believe that there was no communication between opposing camps during those days, while Davy rehearsed with Fern and his three best friends imagined the worst and made their battle plans.

An audience watching this episode when it first aired would have seen three relatively comparable acts in the Monkees' sabotage of the talent show. There was an incompetent magician with a couple of disastrous tricks, an abysmal comedian with a handful of offensive jokes, and an inept country music singer babbling something about saying goodbye. Linda Ronstadt's Stone Poneys wouldn't hit the charts with their recording of *Different Drum* until September 1967, which means that we, watching the episode today, have a vastly different view of Nesmith's hilarious performance than the original MONKEES audience had in 1966.

Zingers

Peter: Poor Davy.
Mike: He's helpless. Trapped by his own staggering good looks.
Micky: I myself am deeply jealous.

Mrs. Baddery: Oh, I see you're a musician… composer… raconteur….
Micky: He also contains lanolin and won't upset your stomach.

Mrs. Baddery: Now, young man. You. Well, well, well! I see that within 24 hours you're going to meet a girl and fall in love.
Mike: Well, yeah, he does that every day.

Production Notes

NBC censored the original broadcast of this episode, to hide Fern's revealing bikini (and everything that was revealed by it) while she seduces Davy at the tea shop. The censored scene is pretty much limited to close-ups of Fern's face, with everything below her neck heavily blurred. An uncensored version of the episode was distributed in some syndication packages in the 70's and 80's.

Cultural Clarification
The ABC drama *The Iron Horse*, which Davy watches for a few minutes while chained to his chair, was another production of Screen Gems. It premiered on the same night as THE MONKEES: September 12, 1966.

The Original Amateur Hour, hosted by Ted Mack, ran on television from 1948 to 1970. During its heyday, one of its sponsors was the laxative Serutan, which had the slogan "Read it Backwards" printed right on the packaging.

Physical Comedy Highlight
Peter, Mike and Micky scrambling to occupy Davy's chair.

Runner-Up Sight Gag Highlight
The table collapses moments after the four "knock wood" to ward off bad luck.

Sight Gag Highlight
Monkee stand-in David Price, wearing a yellow sweater identical to Davy's, chained to a chair identical to Davy's. That sort of thing must happen all the time in Los Angeles.

Breaking the Fourth Wall
Hack: Ladies and gentlemen, we'll return with one more act after a word from our sponsor.
Micky: Their sponsor?
Peter: Our sponsor.
Mike: *Our* sponsor.

Third Runner-Up Nitpick
When did Fern have time to tell Davy about her upcoming appearance on *The Amateur Hour*?

Second Runner-Up Nitpick
The chain between Davy's ankle and the chair is only about two feet long, until Davy picks it up to break it in two. At that point, it expands to about six feet.

Runner-Up Nitpick
How does Micky know to check the refrigerator for girls?

Nitpick
Thanks to the pepper on his jacket, Peter sneezes. *Once*. Nobody notices that he never actually gets sick.

Not Necessarily a Nitpick
When Davy first meets Fern in the tea shop, she towers over him. Later in that same scene, they're the same height. What can't be seen is the platform Fern is standing on as she presents

herself to Davy as a beauty pageant contestant. The censored scene is cut to focus only on Davy's and Fern's faces; the uncensored version shows Fern in all her glory, from the top of her head all the way down to her high heels.

We're the young generation, and we have something to recycle.
- Recycled gag: hand over hand with a prop. (See also a shotgun in *Hillbilly Honeymoon*, a spear in *Monkees Marooned*, a rifle in *Monkees in Texas* and a paintbrush in *Art, for Monkees' Sake*.)
- Recycled gag: Micky does his imitation of the inimitable James Cagney (See also *I've Got a Little Song Here* and *Monkees on the Wheel*.)

Third Runner-Up Monkee Magic
Mike, Micky and Peter conjure up a telephone.

Second Runner-Up Monkee Magic
Mike, Micky and Peter conjure up old-fashioned costumes for a publicity photo—costumes that vanish as soon as the photo is taken.

Runner-Up Monkee Magic
Mike conjures up a length of rubber tubing (presumably with a proper tire valve at one end) and inflates a flat tire. *With his breath.*

Monkee Magic
Davy: A man in love has the strength of thousands.

What I want to know...
What in the world was so scandalous about Fern's bikini that demanded the wholesale re-editing and censoring of the scene? There were bikinis every bit as itsy-bitsy in the episode *The Monkees at the Movies*.

Snack to enjoy while watching *Too Many Girls:*
Girl Scout cookies. Mmmmm...Thin Mints.

Music
- *(I'm Not Your) Steppin' Stone:* brief plot-related rehearsal, live-to-camera.
- *Different Drum:* high-speed parody, performed live-to-camera.
- *Undecided:* butchered and blessedly abbreviated plot-related performance.
- *I'm a Believer:* plot-related performance.

Episode 1-15
Written by: Dave Evans, Gerald Gardner and Dee Caruso
Directed by: James Frawley
Principal Filming Ended: 9/22/1966
First Airdate: 12/19/1966

Grading
- Yes, mother. Whatever you say, mother. **A-**
- Hi! I'm a little Girl Scout. **C+**
- You touched me, and I heard music (censored). **B-**
- You touched me, and I heard music (uncensored). **B+**
- Waahhh! You messed it all up! **C**

And the cookie goes to...
Nesmith, for sacrificing one of his own songs (anonymously—it wasn't listed in the credits) for the 40 funniest seconds of country music *ever*.

We pledge to obey the laws of dirt and violence, to curb our desire for a bath, and to offend all living things. This afternoon we're having a special course in obscene tattooing, ear piercing, and a review of
The Wild Monkees.

The In-Which
A gig in a remote town turns ugly when the Monkees get caught between four motorcycle mamas and their killer boyfriends.

The previous episode *(Too Many Girls)* belied its title by focusing on one young female character, feckless and inconsequential, who ultimately fails to have any impact on events. In contrast, *The Wild Monkees* is dominated by a quartet of Valkyries who drive the plot from the moment they roar into town and shroud the perplexed Monkees in a cloud of dust.

Lost, swindled, smitten, intimidated, rejected, threatened and defeated; at no point in this episode do the Monkees have any control over the story or their own fates. They just keep struggling to turn circumstances in their favor, stymied at every turn by the domineering and manipulative wiles of Queenie and her three princesses. The ladies' minds are fixed on convincing their boyfriends to give up their wanderin' ways, and every Monkee-mesmerizing turn of events—every kiss, come-on, cutting remark and double cross—is a step toward achieving that goal. Perhaps the oddest turn of events is that Queenie goes to the trouble of rescuing the Monkees from Big Butch's wrath before issuing her ultimatum.

Fortunately for us viewers, the Monkees are often at their best when things are at their worst. And in a late second season episode (shot in mid-October 1967 and aired just a month later) it's a rare treat to see all four of them in both an extended Shared Imagination sequence

and a group meeting. Those two scenes are the highlights of the episode, sparkling with wit, clever dialogue, precision comedic timing and genuine warmth. (Or if not *genuine* warmth, at least *well-acted* warmth.)

The episode begins with a four-minute isolated performance of *Goin' Down*; the plot doesn't get started until after the opening credits. This unique cold opening must have been quite startling and perhaps even a bit confusing to viewers in November 1967, when *Goin' Down* had only just been released on the B-side of *Daydream Believer*.

Zingers

Micky: I get it. The old badger game. If you think for one minute, you're gonna get us 'cause we're broke and browbeat us into working like slaves in this slum, you're—
All Four: —dead right!

Mike: We, the Order of the Chickens (buck buck buck) have been challenged. I will now throw the meeting open to the floor for any suggestion. Mr. Tork—
Peter: I move we fight. Our honor has been smeerched.
Mike: What?
Peter: Uh, smurfed.
Mike: What?
Peter: Be-dirtied.
Mike: What?
Peter: Well, they hurt my feelings.
Micky: Fight? Fight? Gentlemen, may I remind you as fellow chickens (buck buck buck) that fighting is #1 unconstitutional, #2 it is very fruitless in solving a problem, and #3 you can really, really get hurt.

Clunkers

Peter: What kind of people have you got coming up here—senior citizens visiting their grandparents? Ha-ha-ha-ha-ha!

Peter: I dunno. Your *guest* is as good as mine!

There's plenty of genuine humor in the dialogue—it's unnecessary and out of character for Peter to make such terrible jokes on purpose.

Cultural Clarification

The episode title refers to the 1953 Marlon Brando biker movie, *The Wild One*.

Henry Cabot Lodge, Jr. was a US Senator from Massachusetts and the Republican nominee for Vice President in 1960. He was the grandson and namesake of another Senator Henry Cabot Lodge.

Unintentional Sight Gag Highlight
Micky struggling to free a pistol from his back pocket. "Keep coughing!"

Runner-Up Physical Comedy Highlight
There's something about those stairs....

Physical Comedy Highlight
Davy's had enough—and *he's gonna tear you apart*.

Second Runner-Up Breaking the Fourth Wall
Mike: Well folks, looks like we've done it again. Another rung up the never-ending ladder of success.

Runner-Up Breaking the Fourth Wall
Micky: Now, let's take the pledge. It says here in the script—
Mike: Handbook.
Micky: —handbook...

Supplementary Runner-Up Breaking the Fourth Wall
Micky: It says here, in the handbook—
Mike: Script.

Breaking the Fourth Wall
Monkee stand-in David Pearl strolls casually into in the middle of the motorcycle race in order to brush Micky clean with a feather duster.

Second Runner-Up Nitpick
The closing credits only list three of the four wild women: Jan, Ann and Nan. For some reason, actress Corinne Cole was not credited for her work as Queenie, even though hers was the most substantial guest role in the episode.

Runner-Up Nitpick
In the opening scene, the Black Angels roar past the Monkees just seconds behind their girlfriends. So why did they arrive at the hotel so much later?

Nitpick
The four ladies are together on the reviewing stand at the moment Big Butch wins the race—but they can also be seen in the crowd surrounding Peter at curbside in the very next shot.

We're the young generation, and we have something to recycle.
- Returning actor: Henry Corden as Blauner. (He was also the beloved landlord Mr. Babbitt in *Monkee Mother, The Chaperone, Don't Look a Gift Horse in the Mouth* and *Monkee See, Monkee Die.*
- Recurring catch phrase: "Isn't that dumb?" (Sigh resignedly also at *Hillbilly Honeymoon, A Coffin Too Frequent, Monkees on the Wheel* and *Monkees in Texas.*)
- Recycled gag: cork stuck in a bottle of champagne. (See also *One Man Shy* and *Monkees in Manhattan.*)
- Recycled location: the pocket-sized urban park. (See also *Gonna Buy Me a Dog, Sweet Young Thing* and *Greensleeves.*)

Second Runner-Up Monkee Magic
How many motorcycle gangs can actually lay eggs?

Runner-Up Monkee Magic
Shared Imagination, School of Hard Knocks and Bruises edition. The leather jackets and caps aren't imaginary—they wear them off and on for the rest of the episode.

Monkee Magic
The Monkees conjure uniforms—waiter, bell captain, gardener and strolling musician—and Mike conjures a mandolin. In his mouth.

What I want to know...
What is going on with Peter during the race scenes? His face is mostly obscured by helmet, chinstrap and goggles, and during the race he is only seen as a tiny figure in the background, surrounded by a dozen other tiny figures and shot through a cloud of dust. I'm not entirely convinced he isn't a stand-in.

Snack to enjoy while watching *The Wild Monkees*:
A jug of bread, a loaf of wine, and Peter beside you in the wilderness.

Music
- *Goin' Down:* isolated performance, before the opening credits.
- *Star Collector:* narrative romp.

Episode 2-10
 Written by: Stanley Ralph Ross and Corey Upton
 Directed by: Jon Andersen
 Principal Filming Ended: 10/6/1967
 First Airdate: 11/13/1967

Grading:
- The Mild Ones. **B+**
- Difficult Riders. **E – Z**
- She-Devils on Wheels. **B-**

And the cookie goes to...

Nesmith, who is at the top of his game with the goofy voices and facial expressions. Way to let go of the inhibitions, sir.

Part of the contest rules: every applicant must submit to exploitation, publicity, and a review of *Your Friendly Neighborhood Kidnappers.*

The In-Which
The manager of a rival band sabotages the Monkees.

MONKEES episodes can be roughly divided into two categories. On the one hand, there are stories that focus on the band's struggles to succeed in show business, or at least earn enough money to pay the rent. On the other hand, more than half the episodes throw the band into some kind of perilous situation at the mercy of a villain. So many episodes follow this pattern, in fact, that an early working title for this book was *Four Out-of-Work Musicians & Pirates, Spies, Aliens, Gangsters and Vampires.*

Your Friendly Neighborhood Kidnappers, the last episode in the alphabetical list, happily straddles both categories. Most of the action takes place in the Monkees' pad, between rounds of a local band contest, with a couple of side trips to a nearby dance club. A mood of lighthearted giddiness prevails, mainly because the guys have absolutely no idea how much danger they are in. The audience knows, to our discomfort, because we see a crucial piece of the puzzle: a gruesome murder-in-progress being committed by Horace and George even as they casually negotiate their next job. Perhaps the kids watching in 1966 wouldn't have recognized the significance of a man's feet in a washtub of cement, but cartoon sound effects and a laugh track can't distract me from the disturbing image.

Were it not for that one alarming detail, this episode would be a sweet pile of marshmallow fluff. Very funny fluff, sweetened with comic routines and silly details, but essentially an overly complicated practical joke. Horace and George are patently incompetent as hoods,

and if it weren't for the Monkees' earnest cooperation they never would have gotten anywhere with their plot.

Let's take just a moment to appreciate the inexplicable circumstances in which we find the four musicians relaxing at home. Micky is working on his Groucho Marx impression, Davy is doing a headstand on a chair, Mike is practicing his pogo stick technique and Peter is washing his socks in a cocktail shaker. I wish I knew whether all that whimsical nonsense was in Dave Evans' script, or if it was director James Frawley's eye for improvisation that filled that scene with visual delights.

One thing's for certain: both Evans and Frawley share credit for the elaborate scene in which Mike and Micky act out a customer service call. The dialogue would be clever enough even without the ingenious staging, but Frawley's choice to film the guys on either side of a mirror gives the scene a visual depth that suggests the effect of their magical imaginations.

Zingers

Micky: Well, how should we dress for this thing? Is it formal?
Trump: Of course! Dress. Dress!
Davy: Black tie or white tie?
Trump: For a daytime kidnapping... black tie.
Mike: Hey—what about the newspapermen?
Trump: They wear business suits.

Davy: Boy. Lester's doing all right.
Mike: Yeah. But I never even heard him sing.
Micky: He doesn't have to sing. He never gets a chance.
Peter: Gee. It seems all it takes in this world to be a big star is to have your clothes ripped off.
Micky: That's all it takes....

Clunkers

Tork: The universe is permeated with the odor of turpentine!

The tag interview provides a rather somber insight into Nesmith's soft spoken, self-effacing personality, as producer Rafelson asks him a series of probing, almost intrusive questions. Tork's meaningless outburst is a jarring interruption, although Dolenz and Jones grinning for the camera while Nesmith bares his soul doesn't help matters. Because the show was filmed with only one camera, the blame for this discordance likely goes to the editor who assembled the shots.

Cultural Clarification

No, no, the title is not a reference to your friendly neighborhood Spider-Man. The phrase is much older, often referencing services provided by "your friendly neighborhood grocer" or "your friendly neighborhood policeman."

 The exotic and glamorous Grauman's Chinese Theater has been the home of Hollywood's footprint, handprint (and occasional pawprint and hoofprint) ceremonies since 1927. The generic "Chinese theater" seen in this episode is definitely not Grauman's.

Physical Comedy Highlight

Mike and the pogo stick.

Physical Fitness Highlight

Davy's very impressive dismount from his headstand on the easy chair.

Second Runner-Up (albeit Culturally Insensitive) Sight Gag Highlight

The marquee on the Chinese Theater lists the names Dourantse, Dork, Nazemize and Juhan.

Runner-Up Sight Gag Highlight

Micky nervously checking his equipment when Beethoven's Fifth starts playing. Does he really think the symphony is coming from the drum kit?

Sight Gag Highlight

Mike's green wool hat stretched over an astronaut's helmet.

Second Runner-Up Breaking the Fourth Wall

Micky: I got an idea!
Mike: What what what what?
Micky: I can't think with this bulb hanging over my head.

Runner-Up Breaking the Fourth Wall

Peter: And it's 7:40.
Title Card: 6:40 CENTRAL TIME.

Breaking the Fourth Wall

Emcee: Thank you, Monkees! And in a moment, the results of our contest.
Peter: What he means to say is, we'll be right back after the commercial.

Fourth Runner-Up Nitpick

Micky starts his countdown only 15 seconds after Mike says it's three minutes before eight.

Third Runner-Up Nitpick
At the Chinese theater, the quick-drying cement is hardening all lumpy and uneven. When Trump breaks them out with his sledgehammer, the cement is smooth—and Peter's hands have somehow turned the corner.

Second Runner-Up Nitpick
No matter how charming Mike's pogo-stick conversation was, there's the one little distracting detail that gives away the secret: Mike is not really using the pogo stick. He's just holding it while he jumps around; you can hear the sound of his feet hitting the floor with each bounce.

Runner-Up Nitpick
Despite the best efforts of the four actors, the sped-up film and the sound effects of tearing cloth, it's painfully obvious that not a stitch of those matching red eight-button shirts was harmed during the filming of the final scene.

Nitpick
After the kidnapper George practices those new dance moves, a title card cautions, "Cassius Clay watch out." Heavyweight champ Cassius Clay had changed his name to Muhammad Ali two years earlier, in 1964.

Not Necessarily a Nitpick
Horace originally quotes a rate of $1,000 per kidnap victim, but agrees to do the job for $360 each. Later in the episode, he estimates a revised total of $12,000 at that same rate of $360 each. What the heck—he doesn't have a calculator on hand, so maybe he doesn't realize that $12,000 divided by $360 is a nice, tidy 33 and 1/3 victims.

However, in the next scene he does have a calculator, and he quotes a new total of $19,420 for 38 victims. Which again, is not necessarily a nitpick, because he may have just raised his per-victim rate to the improbable amount of $511.05.

We're the young generation, and we have something to recycle.
- Recycled plot point: keeping the Monkees "on ice" at the pad. (See also: *Royal Flush* and *Monkees in the Ring*.)
- Recycled sight gag: a light bulb for a great idea. (See also: *Royal Flush* and *Monkees in a Ghost Town*.)
- Recycled gag: The Monkees hold a mumbled "rhubarb, rhubarb" conference. (Listen also to *Dance, Monkee, Dance; Hillbilly Honeymoon* and *Monkees on the Wheel*.)
- Recycled stock footage: a rocket launch. (See also: *The Case of the Missing Monkey* and *Card Carrying Red Shoes*.)
- Recurring bad-guy-blunder: kidnapping Mr. Schneider in place of a live Monkee. (He—it?—was kidnapped in place of Peter in *Monkee Chow Mein*.)

- Returning actor: Victor Tayback as George. (He was also Rocco in *Son of a Gypsy*, and Chuche in *Art, for Monkees' Sake*.)
- Returning actor: Val Kairys as Davy's girlfriend, the most substantial of her twelve uncredited roles. (She finally got proper credit as Toby Willis in *Monkees a la Mode*.)

Second Runner-Up Monkee Magic
Micky conjures up a spare telephone.

Runner-Up Monkee Magic
This is only episode #4, and apparently Micky is still learning how Monkee Magic works. He conjures up a vial of nitroglycerin, tells the kidnappers that it's a vial of nitroglycerin, but somehow doesn't comprehend that the vial is full of… *nitroglycerin*. Believe in the magic, Micky. Believe!

Monkee Magic
The exquisite "getting dressed" scene. "No, Peter."

Apparently Not Monkee Magic
In any other episode, Micky would conjure a Groucho Marx disguise for his well-timed "tribe of African Pygmies" joke. But in this case, he is already dressed as Groucho before the scene begins.

What I Want to Know…
How did Nesmith, whose right ring finger was permanently damaged by a childhood accident with a hammer, manage to get through the scene with the sledgehammer without flinching?

Snack to enjoy while watching *Your Friendly Neighborhood Kidnappers*

You're welcome to dance at the kidnapping, as long as you bring your own pretzels. Or hot tea.

Music
- *Let's Dance On* and *(I'm Not Your) Steppin' Stone*: plot-related dance to music played on the pad's jukebox.
- *Pennies from Heaven*: plot-related evacuation to music played on the pad's jukebox.
- *Last Train to Clarksville*: narrative romp.

Episode 1-4
Written by: Dave Evans
Directed by: James Frawley
Principal Filming Ended: 7/29/1966
First Airdate: 10/3/1966

Grading
- Groucho, Pogo, Socko and the One Who Just Wants to be Revered by a Small Minority: **A+**
- No, Peter: **C+**
- No, Peter: **C-**
- Yes, Peter: **A**
- Party at Davy's! **Thirty-eight and counting**
- Nitroglycerin: $C_3H_5N_3O_9$

And the Cookies Goes to...
Director James Frawley, for the chaotic energy, lively blocking and dynamic camera work for the Kidnap Dance scenes.

> "Now, this is not the end. It is not even the beginning of the end. But it is, perhaps, the end of the beginning."
>
> —*Winston Churchill*

As 1967 drew to a close, everyone involved in the Monkees project was eagerly gazing at the tantalizing vision of What's Going to Happen Next. The last episode of the second season was in the can, and they could not see, or perhaps they did not care, that their fiery rocket was beginning to consume itself as it crested the dizzying heights of multimedia saturation and began the long plummet to earth.

The Monkees might have managed a third season with some sort of comedy-variety format, something they had been testing out by inviting musical guests—Frank Zappa, Charlie Smalls and Tim Buckley—to appear on the show. But NBC wasn't interested in a retooled series, and neither the Monkees themselves nor Raybert Productions was interested in turning out any more of the same old stuff. With just two seasons done, The Monkees was quietly, unceremoniously cancelled.

Most cancelled TV shows just cease production. There might be syndication packages to sell, residuals to collect, but that's no reason for the cast to continue to operate as a creative unit. Not so with The Monkees. Even after NBC pulled the plug, the "show" kept on going, powered by its own magical creative engine. There were still records to make. Concert tours to plan. Australia and Asia were beckoning.

So why not make a movie?

After all, Rafelson and Schneider had intended, from the start of their partnership, to break into the movie business. They had unflinching ambition, innovative techniques, a proven track record, and (thanks to The Monkees) a hefty bank balance. The four young men who personified the mythical band were keen to show what they could do, freed from the constraints of a three-day filming schedule, a teeny bopper premise and the narrow-minded corporate standards of their former network overlords.

There's something ironically fitting that the film *Head* premiered on November 6, 1968: one day after the presidential election that swept Richard Nixon into office. In the fading weeks of a tumultuous year, the public was not eager to revisit the merry antics of the TV band. Too complex and avant-garde for kids who loved the Monkees, and too "Monkees" for adults who might appreciate a complex, avant-garde film, *Head* sank like a stone.

Meanwhile, NBC had asked for three Monkees TV specials. Only one was made, filmed in November 1968 at roughly the same time that *Head* was dying at the box office. NBC aired *33 and 1/3 Revolutions Per Monkee* in April 1969, on the same night as the Academy Awards, and that ended Raybert Productions' participation in filming the adventures of the fictional band they had created and launched into reality. The group released three more albums, made a few guest appearances on other TV shows, knocked out some commercials for Kool-Aid, and disbanded.

But the plucky little franchise would not go away. THE MONKEES' 58 episodes achieved television immortality almost immediately, first as a Saturday morning staple on CBS, and then on ABC. The show was later syndicated for the weekday after-school market, on independent channels up and down the dial. In 1986, the young cable network MTV launched both the show and the band—now a trio of Tork, Jones and Dolenz—on a second rocket ride. Meanwhile, the popular tastes gradually caught up with the once derided film *Head*, which slowly but steadily grew cult status of its own.

To the astonishment of just about everybody, all four Monkees reunited in 1996 and began to work again as a performing unit. They recorded the album *Justus* ("just us") during that summer, and released it in October of that year. The miracle continued, as a new one-hour TV special was made in January 1997 and aired in February. The revitalized quartet toured the United Kingdom in March 1997...

... and that was the last time all four Monkees ever worked together.

MONKEE MAGIC is a book about a TV series that only lasted for 58 episodes in its initial run. But the four actors, who were also musicians and show business professionals of the most enduring sort, appeared together in front of the cameras for three more productions under that brave banner. I could not end the book without reviewing, honoring and nitpicking each of those three quirky epilogues.

Head (1968)
33 and 1/3 Revolutions per Monkee (1969)
A Lizard Sunning Itself on a Rock (1997)

Pleasure: the inevitable byproduct of our civilization. The tragedy of your times, my young friends, is that you may get a review of *Head*.

The In-Which
Time folds in on itself as the Monkees are herded through a series of film-genre vignettes in search of some kind of meaning to their artificial existence—or, at the very least, an escape from the sinister black box. Or the menacing Victor Mature. Or a trio of silver balloons and a huge bloodshot eye. (I'm not really sure...)

From the very start, one thing was certain: *Head* would not be a long-form version of THE MONKEES. This feature film barely acknowledges the TV universe where four impoverished musicians once auditioned for local gigs and private parties in order to pay the rent. These big-time Monkees live in a luxurious version of their beachfront pad, from which they venture forth to perform in a huge arena full of screaming girls.

But all is not well. The TV-show Monkees may have been down on their luck, but they were carefree and content and capable of meeting every challenge and defeating every foe in thirty minutes or less—with plenty of time left over for a second song or an after-show interview. They wielded their unique brand of magic to tame the capricious universe to their own whims, secure in the knowledge that no force on earth or in "cuckoo" could separate them.

The Monkees of *Head* don't use magic, can't control anything, and the brotherly ties that once bound them together have frayed to brittle threads. They bicker, snap and quarrel as the plot drives them mercilessly through their fickle un-reality, from scene to scene, from

soundstage to back lot to commissary, from daydream to nightmare and again and again and again into a mysterious black box.

The film is structured in a circle, with the opening scene and closing scene neatly doubling one another—only not quite, because the closing scene is weighed down with context, bearing the emotional wreckage of all that has passed. Between the first plunge and the last, the story spills out in a series of sloppy loops; we return again and again to places and plots we have seen before.

The Monkees are effectively helpless, buffeted from scene to scene by the winds of fate and capricious culture. They are actors in somebody else's production, characters in somebody else's script, mere images on a screen being watched—and often ignored—by an indifferent public. They retain the power to break the fourth wall, but there's no adoring audience behind the fourth wall. There's just a camera crew and a capricious director with a schedule to meet. Nobody listens, nobody helps, nobody cares.

Head is occasionally beautiful, intermittently funny, sporadically inspirational, and deeply, deeply disturbing. It is not fit for children, nor is it particularly suitable for the innocent of heart. It is cynical and sardonic and bleak. Its best features are its musical interludes, seven unique and distinct visual presentations that embrace and celebrate the wildly disparate musical styles as only THE MONKEES could do. I have to admit, there comes a time during the lush, vivid beauty of *As We Go Along* that I am sorely tempted to turn off the TV and follow Carole King's and Toni Stern's excellent advice:

Open your eyes, get up off your chair,

There's so much to do in the sunlight...

Zingers

Mr & Mrs Ace: Well, if it isn't God's gift to the eight-year-olds.

Mike: I'd like a finger sandwich, please, and hold the mold.
Davy: And I'd like a glass of cold gravy with a hair in it, please.
Mr & Mrs Ace: One of your own?

Peter: Everybody's where they want to be.
Micky: That is a particularly inept thing to say, Peter, considering that we are in a vacuum cleaner.

Frank Zappa: The song was pretty white.
Davy: Well, so am I. What can I tell ya?
Frank: You've been working on your dancing, though.
Davy: Oh—yeah, yeah. Well, I've been rehearsing it lately, y' noticed that.
Frank: Yeah. It doesn't leave much time for your music. You should spend more time on it, because the youth of America depend on you to show them the way.

Cultural Clarification
Mylar (BoPET) was invented in the '50's, but wasn't used for party balloons until the '70's. It may seem a little silly to our eyes for Mike to be menaced by shiny, silver, pillow-shaped balloons, but they would have been a strange sight indeed in 1968.

The surreal art installation "Back Seat Dodge '38" by Edward Kienholz makes a brief appearance at Mike's birthday party. This voyeuristic sculpture depicts a young couple—the man is sculpted from chicken wire—using the back seat of a car for the sort of thing that the back seat of a car wasn't really designed for.

Second Runner-Up Black Humor Highlight
Micky vs. an empty Coke machine. My money's on Micky.

Runner-Up Black Humor Highlight
Davy topping off his super-heroic fight in the factory by tearing his way through the backdrop of a Western movie set and knocking an extra off his horse.

Black Humor Highlight
Mike, with the suicidal woman safe in his arms, calmly collecting on his $10 bet that she would jump.

Double Runner-Up Breaking the Fourth Wall
Micky quits a scene and tears a hole in a painted backdrop, stomping off the set. "I don't wanna do this anymore, man. Aw, these fake arrows and this junk and the fake trees, Bob, I'm through. It all stinks, man."

Moments later, Mike and Micky arrive on the back-lot street set, where Davy is playing the violin for an enraptured audience. They interrupt the scene in progress; even though Davy hands his prop violin off to Annette Funicello, the music continues as the camera pulls back to reveal a confused crew.

Breaking the Fourth Wall
Immediately after Peter punches a waitress, director Bob Rafelson calls "Cut!" and the studio commissary abruptly turns into a mere set, rapidly filling with cast and crew and various hangers-on. Screenwriter Jack Nicholson wanders into the shot as Peter argues with Rafelson about the level of violence in the scene he has just completed.

Nitpick
I very nearly deleted the nitpicks category for this film. How in the world can one nitpick a random, stream-of-consciousness plot? Almost nothing about *Head* makes sense; that's the way it was designed. However, I did decide to list just one nitpick, for the one element of the movie that seems senseless in a particularly senseless way. After the cop catches a glimpse of Victor Mature in the magic mirror and faints, there's a title card indicating that what follows

is "The Cop's Dream." Nothing that follows from that moment on has anything to do with the cop, or anything that he might dream about.

Not Necessarily a Nitpick
Mike and Davy apparently do not have the same birthday. (Both Nesmith and Jones were born on December 30.)

We're the young generation, and we have something to recycle.
- Recycled gag: Monkees stuck in a doorway. (See also *The Case of the Missing Monkee, The Christmas Episode, Monkees Watch Their Feet, Monstrous Monkee Mash* and *Everywhere a Sheikh, Sheikh*.)
- Recycled plot: unsuccessful as a musician, Davy takes up boxing—and the fix is in. Mike and Micky climb into the ring and start a melee.
- Returning actor: Vito Scotti as the surrendering Italian soldier, I. Vitteloni. (He was also Dr. Marcovitch in *The Case of the Missing Monkee*.)
- Returning actor: William Bagdad as the Black Sheikh. "Pssst!" (He was also the evil henchman Curad in *Everywhere a Sheikh, Sheikh*.)
- Recycled odds and ends: a character dressed in a Captain Crocodile costume, and a huge telephone prop from *The Monkees on the Line* appear on the studio street.

Yeah, I know I said there isn't any Monkee Magic in *Head*. So sue me.
There is just the one instance, but it's not the blithe, whimsical magic of the TV series. Late in the film, when Davy is at his most belligerent, he conjures up a loaded cannon. And fires it.
 At people.

What I want to know...
Who has the audiotapes of Rafelson, Nicholson and the four Monkees in Ojai, spontaneously contributing ideas for the screenplay while stoned to the gills? And when do we get to listen?

Snack to enjoy while watching *Head*:
Peter's got a strawberry ice cream cone he's not going to finish.

Music
- *Porpoise Song:* Narrative dive and swim with mermaids.
- *Ditty Diego:* Spoken-word parody voice over.
- *Circle Sky:* Performance. A real one, filmed in Salt Lake City on May 17, 1968.
- *Can You Dig It?:* Well, the dancing girls are romping.
- *As We Go Along:* Slow-motion, non-narrative romp.
- *Daddy's Song:* Double performance, including live-to-camera verse.
- *Long Title: Do I Have to Do This All Over Again?:* Narrative rave.
- *Porpoise Song (reprise):* Narrative dive and swim with Monkees.

Written by: Bob Rafelson and Jack Nicholson
Directed by: Bob Rafelson
Principal Filming Ended: 5/17/1968
Premier: 11/6/1968

Grading:
- A manufactured image, with no philosophies. **B+**
- The big Victor holds the remote control. **C**
- Give me a W! Give me an A! Give me an R! **RAW**
- Never mind the metaphor, this movie makes no sense. **A-**
- Just watch the music videos and listen to the band. **A+**

And the cookie goes to…
Raybert Productions, for coming out of this commercial disaster with enough capital to fund their next film, *Easy Rider*.

And now, my masterpiece of evolution. And here they are: the sum of the hat of the film of the book of the triumph of the telephone directory of the review of *33 and 1/3 Revolutions per Monkee!*

The In-Which
A pair of mad scientists (possibly sorcerers, it's never made clear) set out to create the ultimate pop music act.

Nearly a year after filming ended for the weekly television series, and a full six months after principal filming wrapped up for the Monkees' feature film *Head*, production resumed for what was supposed to be the first of three one-hour MONKEES television specials for NBC. If they had gone into the creation of *Head* determined to not make a 90-minute version of the television show, for *33 and 1/3 Revolutions per Monkee* they must have been doubly determined to leave the show behind in the dust. This not-so-special is stripped of every last element that made *The Monkees* loveable and loved: its premise, its characters, its clever dialogue and its loopy, self-deprecating humor.

The special has all the abstract symbolism of *Head*, but none of the slick production values. Weighed down by the ponderousness of its pretensions, *33 and 1/3* trudges and slogs and groans its way to make two salient points:

1. Rock and roll music has an illustrious history, and
2. THE MONKEES ain't it.

There's a storyline, of sorts, but it's performed almost entirely by guest stars Brian Auger and Julie Driscoll, two Brits not particularly known for their acting. While they do add a

distinctive musical flavor to the proceedings, they also do a horrendous amount of scenery-chewing. (One wonders how much better the special might have been if these major roles had been cast for actors rather than musicians.) Meanwhile, the Monkees are called upon to sing—and even play just a little bit—but never to act. Here, lovingly transcribed, are the sum total of lines spoken in *33 and 1/3* by the four young actors whose special this supposedly was:

Micky: I am Micky Dolenz! No, I am— I am Monkee number one.
Peter: I am Peter Tork! No, I— I am Monkee number two.
Mike: I am Michael Nesmith. No, I'm— I am Monkee number three.
Davy: David Jones! No, I'm— I am Monkee number four.
Micky: Hey, man. Dig that crazy chick!
Peter: Hi, Mike.

Note that the last line, Tork's apparently spontaneous "Hi Mike," can barely be heard. Note also that those are the only words that are spoken by one Monkee to another. The devolution of the fictional band is very nearly complete.

Darwin may have taught us that us that you've got to evolve microbes into apes before you can invent rock and roll, but it was Einstein who taught us that time is relative. A minute on a hot stove can seem like an eternity, but a pop song performed by four grown men in mangy white monkey suits can seem like at least half an hour. These are the actual running times of some of the major segments of the special:

The Monkees' four fantasies	9:50
Quartet for stacked pianos	0:50
The interpretive dance of evolution	3:40
The 50's sock-hop medley	10:15
Listen to the Band/freak-out finale	8:40

NBC aired the special once—on a Sunday night, up against the Academy Awards. The other two Monkees TV specials were never made.

Zingers
Mike: Bend over, let me see you shake it, baby.
We Three: *You* bend over, let me see *you* shake a tail feather!

Yes, it's just a song lyric. But the ladies of We Three didn't get much camera time, and this one line was delivered with more heart, soul and sass than all of the material from Auger and Driscoll put together.

Clunker
Sign: He's really playing this.

One last dig at the festering wounds of the band's origins, the sign is a feeble attempt at humor rendered impotent by the fact that no Monkee is visible in the shot—who is the "he" the sign is referring to?—and because this is not exactly a virtuoso instrumental performance of *Listen to the Band*. Of all the musical segments in the show, the finale has the poorest sound quality and the beleaguered song doesn't gain any traction until the Monkees are joined on the cavernous soundstage by Buddy Miles, Brian Auger and a dozen or so other musicians.

Production Notes
Tork officially quit the group during the taping of the special. By the time *33 and 1/3 Revolutions per Monkee* aired in April 1969, the Monkees had been recording, touring and making television appearances as a trio for several months.

Cultural Clarification
The title refers to the standard turntable speed for an LP (long-playing) record.
 Turntable? Ask your parents.

Highlight
Nesmith's split-personality, split-screen duet *Naked Persimmon* packs more humor, emotion, symbolism and moral relevance into two and a half minutes than the rest of the special packs into the rest of the hour.

Breaking the Fourth Wall
Auger: Wait a minute, Jack. Hold on a minute. Stop the show. Look—this brainwashing bit has gone completely out of hand. Now look. I'm Brian Auger, and this is Julie Driscoll. And we don't want any more of this brainwashing business—what we want is complete and total freedom. Complete and total freedom. Now do you realize what that means?

Driscoll: Yeah. Utter bloody shambles.

Third Runner-Up Nitpick
I don't know which was less convincing: Micky's attempt to mime blowing a wolf-whistle, or the insipid wolf-whistle sound itself. Both, along with Micky's subsequent line, "Hey, man. Dig that crazy chick!" were out of context and added nothing to the proceedings.

Second Runner-Up Nitpick
Davy sings *String for My Kite* while standing miles from the camera, in shadow, at the top of a long, but purposeless flight of stairs—all the while, holding a coil of rope in his hand. He sings hopefully, about sky and clouds, and dreams and goals. As the song ends, he tosses the rope... down. *Down!* He lets go of it, too, so the entire thing flops unceremoniously to the floor.
 Way to get the imagery backwards, folks.

Runner-Up Nitpick
After the four fantasy sequence songs, Auger orders that the subjects be returned to their tubes. Just before the commercial break, he laughs maniacally—but in his yet-to-be-seen alternate persona as Charles Darwin.

Nitpick
Darwin: Evolution can do no more. This is where science takes over.

We're the young generation, and we have something to recycle.
- Returning personnel: Jack Good, who co-wrote the special, played Lance Kibbee (the Sot) in *The Monkees Mind Their Manor*.

Snack to enjoy while watching *33 and 1/3 Revolutions per Monkee*:
You may have exactly one bite of the apple.

Music
- *I'm a Believer*
- *(I Prithee) Do Not Ask for Love*
- *Naked Persimmon*
- *Goldie Locks Sometime*
- *Wind Up Man*
- *I Go Ape*
- *Come On Up* (Julie Driscoll, Brian Auger & The Trinity)
- *At the Hop*
- *I'm Ready* (Fats Domino)
- *Whole Lot of Shakin' Goin' On* (Jerry Lee Lewis)
- *Tutti Frutti* (Little Richard)
- *Shake a Tail Feather* (Monkees and We Three)
- *Blue Monday* (Fats Domino)
- *Little Darlin'*
- *Long Tall Sally* (Little Richard)
- *Peppermint Twist*
- *Down the Line* (Jerry Lee Lewis)
- *Dry Bones* (Clara Ward Singers)
- *String for My Kite*
- *Solfeggietto*
- *Listen to the Band*
- *California, Here it Comes*

Written by: Jack Good and Art Fisher
Directed by: Art Fisher

Principal Filming Ended: 11/27/1968
First (Only) Airdate: 4/14/1969

Grading
- Evolution. **C**
- Magic. **C+**
- Monkee solos. **B+** (*Naked Persimmon* pulled the average way up.)
- Monkee group performances. **C-**
- Brian Auger & Julie Driscoll. **D+**
- Other musical guests. **A** for Awesome

And the cookie goes to…
Dolenz, for his hilarious commentary track on the DVD. It's the only thing that makes this special bearable.

Postscript
Piling one final indignity onto the dying franchise, NBC aired the segments of *33 and 1/3 Revolutions per Monkee* in the wrong order. Acts I and II were swapped, making the already nebulous plot even hazier. To be honest, I am not certain what the correct order *is*. Judge for yourself: if you have the special in the 2nd season DVD set, use the menu to rearrange things:

1. Start at the beginning.
2. As soon as Auger takes his first bite of the apple, go to the menu. (This is the end of the teaser, where the first commercial break would have been.)
3. Jump to #6, *Wind Up Man*. Theoretically, this would be the beginning of Act I.
4. Enjoy the magic carpet ride through the wonders of evolution.
5. At the end of Driscoll's solo *Come on Up*, as soon as Trinity drummer Clive Thackery says, "I don't believe it!" for the second time, go to the menu. (This would be the end of Act I, the second commercial break.)
6. Jump back to #2, *I'm a Believer*.
7. Rewind back to the moment Auger took a bite of the apple. Listen to Driscoll's nails-on-the-blackboard monologue and look forward eagerly to *Naked Persimmon*.
8. After Davy finishes his song and dance number, *Goldie Locks Sometime*, stick around until Charles Darwin laughs maniacally, and then go to the menu. (This is the end of Act II, where the third commercial break should have been.)
9. Jump to #11, *At the Hop*. This is the start of Act III, so it's smooth sailing to the end of the special.

Does the story make any more sense in that order? I don't see much improvement. It clears up one continuity error (the premature appearance of Charles Darwin) but introduces another (Auger calls for the brainwash to continue, then immediately declares it complete).

What I want to know...
How in the Sam Hill does a venerable mega-media corporation like the National Broadcasting Company manage to scramble... well, a national broadcast? Even on a Sunday night during the Oscars? We're not talking about a teenage projectionist mixing up the reels at a neighborhood movie house, after all. Or... just perhaps....

Did Raybert Productions deliver the special to the network with the acts already scrambled?

A happy ending—and no story! No stupid chases, and no silly scenes of exposition. Just stacks of goofy jokes, silly special effects, and a review of
A Lizard Sunning Itself on a Rock.

The In-Which
Fast-forward to 1997: the Monkees are still living together and playing small gigs.

Way back near the beginning of the book, I awarded *The Christmas Show* ten points for free, just for the thankless job of being a Christmas episode. If ten points is the extra credit due to a Christmas episode, then how many automatic points should be awarded for something brave enough to be called a 30th anniversary reunion special?

Let's face it, the best thing about *A Lizard Sunning Itself of a Rock* is that it actually got made. That's no small miracle: all four Monkees together again on the small screen, taking up their fictional roles and facing down their ghosts with a wry grin and a ready quip. There are so many different directions this one-off program could have gone! They'd already done cynical *(Head)* and meaningful *(33 and 1/3)* and they learned all the lessons. Turning back to the formula that won America's heart in the first place, the aging Monkees are content to run right up to the edge of the surf and yet stay safe and dry on the beach.

Taking a cue from such delightfully self-referential episodes as *Monkees on the Wheel, The Monkees in Paris* and *Mijacogeo*, Nesmith crafted a story that cheerfully pokes fun at the show's history while respecting and restoring its premise. The Monkees are still living together, in a large, bright, tastefully decorated version of the 60's pad, where the refrigerator is well stocked and the rent is all paid up. Their banter is witty and their arguments are gentle

and their mutual affection is palpable. They hang out in the pad and relax on the beach and rehearse just a little—and steadfastly refuse to get drawn into anything resembling a plot.

Sadly, sentimentality makes a poor substitute for substance. By sacrificing tangible plot in favor of high concept, Nesmith ends up with an episode noticeably lacking in forward momentum. The story floats and meanders its way through an hour in which the characters spend far too much time talking about the plot they supposedly don't need; it ends with the band coming to the aid of a wealthy guy who manages the very sort of private, exclusive club that used to toss long-haired weirdoes out on their keisters.

They don't even rescue the pig.

Scattered in among the plot-avoidance debates are a handful of delightfully surreal moments. Davy admits to occasionally having a stars-in-the-eyes relapse, while resignedly swatting at a rogue sparkle that has just escaped from his right ear. Micky lectures a pair of amorous teens about the dangers of kissing. Davy distracts a security guard with an alarmingly sexy Ethel Merman impersonation. Peter hosts an infomercial to hawk the band's new CD. Best of all, Mike demonstrates the newest features of the Monkeemobile: he's turned the GTO into an inter-dimensional low rider.

I suppose it would have been undignified to film any new romps in the grand tradition of The MONKEES, with four middle-aged men running around and acting goofy on the beaches and back lots and soundstages of 1997, but the slick music videos that present the three tunes from the band's new album, *Justus*, are sadly disappointing. The isolated performance of *You and I*, with the guys cavorting gracefully on an ice rink, is the most tolerable of the three. *Circle Sky* is simply an annoying jumble of static-ridden TV sets; the long, bleak, slow camera pan that accompanies *Regional Girl* turns the song's cynical mockery back on the Monkees in general and poor Davy in particular.

Zingers

Micky: What's the name of that other band, the one with the blood and the makeup. Um—
Davy: Kiss?
Micky: No thanks. You know, they have high heels, and the guy has a nine-foot tongue. What is their name...?
Mike: Kiss?
Micky: No, but Davy wants one.

Chuck: And this is my drop-dead beautiful daughter, the Princess Entwined.
Davy: A princess?
Princess: Not a real princess. That's just what Daddy calls me to be nice, because he seems to think I've lost a few tiles on re-entry.
Davy: 'Scuse me?
Princess: He says I didn't quite come through the rocket ride and I'm a little bats.

Peter: And Martha, when did you first notice that cheese wouldn't stick to your eyebrows when—are you *really* Martha Stewart?
Micky: Er... yeah.
Peter: Well, how do you make a wedding gown out of whipped cream frosting?
Micky: Well... uh... it depends on the flavor.

Clunkers
Peter: There's a lot of funny euphemisms for dumb.

Even if Nesmith intended to turn Peter into a random euphemism generator for this special (a trait the character never displayed in the series), it's dismaying to hear Peter mocking somebody else for being a few cards short of a deck. (One oar in the water. One brick shy of a load. Up the river without a clue.)

Production Notes
This special was promoted under the rather generic title *Hey, Hey, It's the Monkees*; however, the title does not appear on-screen (neither did the titles of any of the original 58 episodes). As the special is not available for sale, I decided to use the title that appears in the records of the US Copyright Office. It certainly seems more likely that *A Lizard Sunning Itself on a Rock* would be Nesmith's title for his script. (This is, after all, the man who wrote *Tapioca Tundra*, *Naked Persimmon* and *The Long Sandy Hair of Neftoon Zamora*.)

The distressed young lady who bursts in on the Monkees' rehearsal is played by Jones's daughter, Sarah.

Cultural Clarification
Mike quotes from the song *I Believe*: "I believe for every drop of rain that falls, a flower grows."

Davy misremembers an Anthony Newley song he occasionally sang in Monkees concerts in the 60's, *Gonna Build a Mountain*.

On the wall of the pad are a pair of framed pictures inspired by René Magritte's 1929 painting *The Treachery of Images*. On Magritte's painting, the inscription is "Ceci n'est pas une pipe." The Monkees' pictures are inscribed "This is not a pipe" and "This is not a band."

Let's See if We Can Slip This Past the Censors
Only one of the two instances of the word "bitch" in the song *Regional Girl* got changed to "witch."

Second Runner-Up Sight Gag Highlight
Chuck: How many of you remember going to school with your Monkees lunchbox and getting beaten up?
Peter: [raises hand]

Runner-Up Sight Gag Highlight
Midway through Peter's infomercial, the number of *Justus* CDs sold increases from 1 to 2—and then quickly falls back to 1.

Sight Gag Highlight
Ethel Merman-Jones and her tear-away pants. *Work* that hot pink jacket, girl!

Sentimental Highlight
Peter: Don't you think playing for little kids would be fun?
Davy: I think playing for little kids *is* fun. But I don't think we have to do any more than play our music. I mean, maybe a few dance steps, but other than that—we're the Monkees. And that's all we need to be.

Fourth Runner-Up Breaking the Fourth Wall
Micky: Remember, back at the beginning of the show, when Davy asked me for that kiss? Now, that was as dangerous as it was bizarre.

Third Runner-Up Breaking the Fourth Wall
The laugh track is broken. (The pad also has a boo track and a wild applause track.)

Double-Barreled Second Runner-Up Breaking the Fourth Wall
Mike: A lizard sunning itself on a rock.
Micky: What?
Mike: Stock footage. I think the show may be a little short of film and they're having to put in this stock shot that they're getting from a film library.
Davy: Well, it's really annoying.
Micky: Aw, let's get out of here. Go to the beach or something.
Peter: Suits me. I'm starting to get thought balloons.
Thought Balloon: I Think, Therefore I Thwim.

Runner-Up Breaking the Fourth Wall
Mike: That confetti's a special effect, isn't it?
Micky: Yeah—
Mike: It's not throw-up.
Micky: Nope.
Mike: That's why we keep running out of production money, and having to cut to a lizard sunning itself on a rock.

Doubly Self-Referential Breaking the Fourth Wall
Chuck: I get my lease renewed for 99 years, and there's absolutely no dialogue about it. No stupid chases, and no silly scenes of exposition.

Super-Duper, Once and for All Final Demolition of the Fourth Wall
Micky: I wonder if the general public knows that TV shows like ours never die, that they just go on and on even though they're not being broadcast.

Second Runner-Up Nitpick
When the Monkees start rehearsing *You and I*, the pad is filled with young fans. The "rehearsal" morphs into a video shot at a skating rink; when the last notes of the song fade away, the band is once again alone in the pad. Where did all the fans go?

Runner-Up Nitpick
After the skating-rink video of *You and I*, the band (now back at the pad) plays a final coda to the song—but in a different key.

Nitpick
The Monkees prepare to leave for the country club gig after dark. Just before they go, the pad is plunged into darkness as they share a dramatic moment under a bright spotlight. But the bay window overlooking the beach is brightly lit with a blue-sky backdrop throughout that scene.

We're the young generation, and we have something to recycle.
- Recycled plots: haunted mansion/inheritance *(Monkee See, Monkee Die)*; farmer wants to get rid of son's pet *(Don't Look a Gift Horse in the Mouth)*; searching for buried treasure *(Monkees Marooned)*; struggling to make the rent payment (pick one); guard tries to keep them out of a country club *(Here Come the Monkees)*; Davy gets starry-eyed with a princess *(Royal Flush* and *Everywhere a Sheikh, Sheikh).*
- Recycled plot point: Davy gets stars in his ears. Eyes. He gets stars in his *eyes*. (See also *Here Come the Monkees*; *Monkee See, Monkee Die* and *Some Like it Lukewarm*.)
- Returning personnel—sort of: John Brockman, whose face was prominent in the incomprehensible advertising campaign for the 1968 film *Head* ("What is *Head* all about? Only John Brockman's shrink knows for sure.") appears in this special as a mild mannered estate attorney.
- Recycled footage: romp clips from many, many different episodes.
- Recycled shtick: running toward the surf and then running away.

Fourth Runner-Up Monkee Magic
Shared Imagination, professional wrestlers edition.

Third Runner-Up Monkee Magic
Shared Imagination, *Antarctica* edition.

Second Runner-Up Monkee Magic
Shared Imagination, "We Really Have to Promote Our New CD" edition.

Runner-Up Monkee Magic
Mike conjures up a piano on the beach.

Monkee Magic
Forget the piano. Davy conjures up an entire bandstand, fully equipped with instruments and amps, on the beach.

Absolutely Not Monkee Magic
Magic Monkee Dust. Or call it Magic Monkee Hurl. Either way, it's just weird science, a special effect—not magic.

What I want to know…
When—if ever—will this special be made available for purchase? (Please?)

Beverage to enjoy while watching *A Lizard Sunning Itself on a Rock:*
"There's drinks in the microwave!"

Music
- *You and I:* Plot-related rehearsal—er, isolated performance—oh, who am I kidding? It's a video.
- *Circle Sky:* Video.
- *Antarctica:* Bizarrely non-narrative transition between scenes.
- *Dance with Me:* Plot-related drag performance by Ethel Merman-Jones.
- *Regional Girl:* Video.
- *Medley of Monkees Hits:* Plot-related performance.
 - Last Train to Clarksville
 - Daydream Believer
 - (I'm Not Your) Steppin' Stone
 - I'm a Believer
 - Pleasant Valley Sunday

Episode 781
Alternate Title: *Hey, Hey, It's the Monkees*
Written by: Michael Nesmith
Directed by: Michael Nesmith
Principal Filming Ended: 1/28/1997
First (Only) Airdate: 2/17/1997

Grading
- Monkee See, Monkee Die Another Day. **B-**
- Don't Look a Gift Pig in the... Blechhhh! **B**
- Monkees Marooned in Search of the Rent Money. **A-**
- This Pilot is Coming in for a Landing at the World's Most Prestigious Country Club. **C**

And the cookie goes to...
Nesmith, Jones, Dolenz and Tork for opening their hearts to this final chapter to their television show, putting their dignity on the line just one more time.

Postscript

One prominent and innovative feature of the Monkees' very first concert tour, in the winter of 1966 – 1967, was a large projection screen above their heads. They were a TV show first, and the images from the TV show, combined with still photographs, added a lively visual component to their concerts.

Throughout the band's history, the enduring appeal of the television show has served to keep the music, and the musicians, close to the hearts of the fans. The synergy that fueled the white-hot fires of Monkeemania has never quite faded away, and it flares to life from time to time when the conditions are right.

As I write this, the Monkees have just completed their third concert tour in three years: 2011, 2012 and 2013. Forty-five years after the TV show's debut, forty-five years after their triumphant "we play our instruments" album *Headquarters*, forty-five years after their groundbreaking big-screen experiment, *Head*. In the midst of the joy, came tragedy: Jones died suddenly of a heart attack in February 2012. In the wake of the tragedy came hope: Nesmith emerged from his retirement and rejoined the band.

Post hoc is not *propter hoc*. Dolenz and Tork have been quick to point out that Nesmith's return to the band was being discussed well before Jones's death. It could have been... it might have been... but now, it can never be.

And yet, the 2012 and 2013 concerts did happen. Tork, Dolenz and Nesmith—oh, heck, enough of that artificial distinction! *Peter, Micky* and *Mike* were together again. Real. Live. Being silly. Making music. And above their heads, on concert stages across America, a lovingly edited montage of clips, stills and photographs of THE MONKEES filled a giant video screen.

It was magic.

For Further Reading and Viewing

Books

The Monkees: The Day-by-Day Story of the 60s TV Pop Sensation (2005)
Andrew Sandoval

The definitive Monkees reference book. Meticulous in research and exhaustive in detail, it mostly focuses on the recording sessions but includes information about filming, performances, and significant personal events. If you're only going to have one Monkees book, this is the one Monkees book to have. Bypass the usual booksellers and buy it directly from the author at monkeesbook.com.

Monkee Business: The Revolutionary Made-for-TV Band (2011, updated 2013)
Eric Lefcowitz

A narrative history of the whole Monkees entertainment phenomenon, from inception through the many reunion efforts. The most recent edition includes the abrupt end of the 2011 tour, the death of Davy Jones and the unexpected 2012 reunion of Dolenz, Tork and Nesmith. (Note that this is a revised and expanded version of Lefcowitz's earlier book *The Monkees' Tale*.)

Monkee Music (2011)
Andrew Hickey

A track-by-track description, analysis and critical commentary spanning the band's catalog from *Last Train to Clarksville* to *Justus*. Although it covers some of the same territory as Sandoval's epic reference book, *Monkee Music* is more conversational in tone and is more

conveniently organized: all the information about a song is under a single entry, rather than scattered among many different recording, mixing and publishing dates.

Hey, Hey, We're the Monkees (1996)
Harold Bronson

Assembled as a companion book to the TV documentary of the same title, it's a slick picture book with fascinating first-person anecdotes provided by all four Monkees, producers, directors, writers, songwriters and fellow musicians. Although out of print, it's available and affordable on the used book market.

They Made a Monkee Out of Me (1987)
Daydream Believin' (2000)
Davy Jones

Neither of Jones's autobiographies is currently in print, and used copies tend to be prohibitively expensive. Fortunately, the two books are very nearly identical in content, so there's no need to purchase both. Jones is blunt, self-deprecating and occasionally bitter. An unexpected bonus is a substantial number of reproduced business letters, memos, invoices and financial reports scattered among the publicity photos.

An abridged audio version of *They Made a Monkee Out of Me* is also available. Compared to used copies of either book, the audio version is a bargain.

I'm a Believer: My Life of Monkees, Music, and Madness (1993, updated 2004)
Micky Dolenz

This lively autobiography is much lighter in tone than Jones's, a breezy, easy read. Dolenz relates many pivotal moments in script format, an odd but telling quirk from a man who has lived much of his life in front of or behind the camera.

Total Control: The Monkees Michael Nesmith Story (1997, updated 2005)
Randi Massingill

This unauthorized biography, which spans both Nesmith's solo career and his entrepreneurial achievements, can be an uncomfortable read at times. Absolutely not a hagiography.

Fans should keep an eye out for promised books from Monkees' historian Gary Strobl and photographer Henry Diltz.

Videos/DVDs

THE MONKEES: *Season One*
THE MONKEES: *Season Two*

The official DVDs are reasonably priced and well worth the investment, if for the commentary tracks alone. The second season set includes the TV special *33 and 1/3 Revolutions per Monkee*—and a commentary track by Dolenz that is twice as entertaining as the special itself.

Head

The Monkees' feature film is currently available in two editions. This reasonably priced DVD from Rhino Entertainment has the movie, along with some ads and trailers, but no commentary track. But there is also...

America Lost & Found: the BBS Story

The Criterion Collection's box set includes *Head* and four other Raybert/BBS films, including *Easy Rider* and *Five Easy Pieces*. The disc for *Head* includes a single commentary track featuring all four Monkees, apparently recorded separately and then expertly edited together.

Hey, Hey, It's the Monkees (A Lizard Sunning Itself on a Rock)

Sadly, the Monkees' second television special is not available for sale in any format. Perhaps coincidentally, it is the only recorded product bearing the Monkees' name that does not have a Rhino Entertainment copyright. To my knowledge, any copies that exist are made from personal recordings of the 1997 broadcast.

Hey, Hey, We're the Monkees

This 1997 documentary was made during the *Justus* era and aired on the Disney Channel just a few weeks before the Nesmith-penned special with the similar title. It features narration by all four Monkees and interviews with many other eyewitnesses, including pilot co-writer Paul Mazursky, music supervisor Don Kirshner, music producers Bobby Hart and Chip Douglas, and (for some reason that escapes me) singer Peter Noone of Herman's Hermits. Clips from the TV show are used to illustrate real-world events.

Biography: The Monkees

This 2007 documentary features narration by Dolenz, Jones and Tork, and comments by Andrew Sandoval and Bobby Hart. It can be viewed (with brief commercial interruptions) on the Biography Channel's website.

Biography: Davy Jones

The Biography Channel aired this documentary as an obituary, the day after Jones's death in 2012. It also can be viewed for free on the Biography Channel's website.

Daydream Believers: The Monkees' Story

This made-for-TV biopic offers a highly condensed and heavily sanitized version of events, with an abrupt and uncomfortably implausible happy ending. Insubstantial but cute: buy it for the interviews and commentary tracks by Tork, Jones and Dolenz.

The history of the Monkees seems to be ready-made for television, perhaps because there is such a deep supply of film footage and photographs of the group. TV documentaries include *E! The True Hollywood Story* (1999), *VH1 Behind the Music* (2000), Smithsonian Channel's *Making the Monkees* (2007) and ITV's *We Love the Monkees* (2012).

Appendix I: Episodes Titles in Chronological Order

(Bolded episodes are the four aired farthest out of order.)

Season One Filming Order
Here Come the Monkees
Don't Look a Gift Horse in the Mouth
Royal Flush
Monkee vs. Machine
Monkee See, Monkee Die
The Spy Who Came in from the Cool
Monkees in a Ghost Town
The Chaperone
Your Friendly Neighborhood Kidnappers
I've Got a Little Song Here
Monkees a la Carte
The Monkees at the Movies
Success Story
Too Many Girls
The Audition
One Man Shy
Monkees in Manhattan
Dance, Monkee, Dance
Captain Crocodile
Son of a Gypsy
I Was a Teenage Monster
The Case of the Missing Monkee
Monkees in the Ring
Monkees at the Circus
The Prince and the Paupers
Alias Micky Dolenz
Monkee Chow Mein
Monkees a la Mode
Monkee Mother
The Monkees on Tour
The Monkees Get Out More Dirt
The Monkees on the Line

Season One Broadcast Order
Royal Flush
Monkee See, Monkee Die
Monkee vs. Machine
Your Friendly Neighborhood Kidnappers
The Spy Who Came in From the Cool
Success Story
Monkees in a Ghost Town
Don't Look a Gift Horse in the Mouth
The Chaperone
Here Come the Monkees
Monkees a la Carte
I've Got a Little Song Here
One Man Shy
Dance, Monkee, Dance
Too Many Girls
Son of a Gypsy
The Case of the Missing Monkee
I Was a Teenage Monster
The Audition
Monkees in the Ring
The Prince and the Paupers
Monkees at the Circus
Captain Crocodile
Monkees a la Mode
Alias Micky Dolenz
Monkee Chow Mein
Monkee Mother
The Monkees on the Line
The Monkees Get Out more Dirt
Monkees in Manhattan
The Monkees at the Movies
The Monkees on Tour

342

(Bolded episodes are the three aired farthest out of order.)

Season Two Filming Order	Season Two Broadcast Order
The Picture Frame	It's a Nice Place to Visit
Art, for Monkees' Sake	The Picture Frame
The Monkees Blow Their Minds	Everywhere a Sheikh, Sheikh
Everywhere a Sheikh, Sheikh	Monkee Mayor
The Devil and Peter Tork	Art, for Monkees' Sake
I Was a 99 Lb. Weakling	I Was a 99 Lb. Weakling
Monkees Marooned	Hillbilly Honeymoon
Monkees Watch Their Feet	Monkees Marooned
It's a Nice Place to Visit	Card Carrying Red Shoes
Monkee Mayor	The Wild Monkees
<u>The Monkees in Paris</u>*	A Coffin Too Frequent
Hillbilly Honeymoon	Hitting the High Seas
A Coffin Too Frequent	Monkees in Texas
Card Carrying Red Shoes	Monkees On the Wheel
The Wild Monkees	The Christmas Show
Hitting the High Seas	Fairy Tale
Monkees in Texas	**Monkees Watch Their Feet**
Monkees on the Wheel	Monstrous Monkee Mash
Monstrous Monkee Mash	The Monkees' Paw
Fairy Tale	**The Devil and Peter Tork**
The Monkee's Paw	Monkees Race Again
The Christmas Show	The Monkees in Paris
Mijacogeo	The Monkees Mind Their Manor
The Monkees Mind Their Manor	Some Like it Lukewarm
Some Like it Lukewarm	**The Monkees Blow Their Minds**
Monkees Race Again	Mijacogeo

*The line under *The Monkees in Paris* represents the long break in filming for the summer 1967 concert tour. Episodes filmed after the tour are easily identified by Micky's wild, curly hair.

Appendix II: Actors in Multiple Roles.

It's a rare MONKEES episode that doesn't have at least one actor on the recycle list. In most cases, the roles were from different seasons or were at least spaced fairly far apart within a season—with the exception of Monte Landis, who filmed all seven of his appearances during a two-month stretch in the spring of 1967.

Monte Landis
 Everywhere a Shiekh, Sheikh (King)
 Monkee Mayor (Wilbur Zekenbush)
 Art, for Monkees' Sake (Duce)
 I Was a 99 Lb. Weakling (Shah-ku)
 Monkees Marooned (Major Pshaw)
 The Devil and Peter Tork (Mr. Zero)
 The Monkees Blow Their Minds (Oraculo)

Henry Corden
 Monkee See, Monkee Die (Mr Babbit)
 Don't Look a Gift Horse in the Mouth (Mr Babbit)
 The Chaperone (Mr Babbit)
 Monkee Mother (Mr Babbit)
 The Wild Monkees (Blauner)

James Frawley
 Son of a Gypsy (The Yugoslavian Guest)
 Monkees Marooned (Dr. Schwartzkopf)
 Fairy Tale (The Dragon of the Moat)
 The Monkees in Paris (Himself)
 The Monkees Blow Their Minds (Rudy Bayshore)

Rose Marie
 Monkees in a Ghost Town (Bessie "The Big Man" Kowalski)
 Monkee Mother (Millie Rudnick)

Vincent Beck
 Royal Flush (Sigmund)
 Son of a Gypsy (Marco)

Card Carrying Red Shoes (Ivan)

Lea Marmer
Monkee See, Monkee Die (Madame Rozelle)
The Monkees on the Line (Mrs. Smith)

Arlene Martel
The Spy who Came in from the Cool (Madame)
Monstrous Monkee Mash (Lorelei)

Ceil Cabot
Royal Flush (Chambermaid)
Success Story (Old Woman)

Victor Tayback
Your Friendly Neighborhood Kidnappers (George)
Son of a Gypsy (Rocco)
Art, for Monkees' Sake (Chuche)

George Furth
One Man Shy (Ronnie Farnsworth)
A Coffin Too Frequent (Henry Weatherspoon)

Joey Forman
Captain Crocodile (Captain Crocodile)
Monkee Chow Mein (Dragonman)

Rege Cordic
The Christmas Show (Doctor)
Fairy Tale (Town Crier)

Len Lesser
Monkees in a Ghost Town (George)
Monkees in Texas (Red)

Jim Boles
Don't Look a Gift Horse in the Mouth (Farmer)
Hillbilly Honeymoon (Preacher)

Dort Clark
Monkees a la Carte (Inspector)

The Picture Frame (Sergeant)
Monkees on the Wheel (Policeman)

Donald Foster
 Success Story (Rolls Owner)
 The Prince and the Paupers (Courtier)
 The Picture Frame (Vice President)

Joy Harmon
 The Picture Frame (Bank Teller)
 Monkees on the Wheel (Zelda)

Helene Winston
 Monkees a la Carte (Big Flora)
 The Monkees on the Line (Mrs Drehdal)

Rip Taylor
 Monkees on the Wheel (Croupier)
 Mijacogeo (Wizard Glick)

Bonnie Dewberry
 I Was a Teenage Monster (The Doctor's Beautiful Daughter)
 Monkees in Texas (Cousin Lucy)

William Benedict
 Monkee Mayor (Skywriter)
 The Monkees Mind Their Manor (The Butler's Elderly Father)

Burt Mustin
 Monkees Marooned (Kimba)
 The Christmas Show (Butler)

Peter Canon
 Monkees in the Ring (Bully)
 The Devil and Peter Tork (Billy the Kid)

Ted DeCorsia
 Hitting the High Seas (Frank Reynolds)
 The Devil and Peter Tork (Blackbeard the Pirate)

Lee Kolima
> *The Spy who Came in from the Cool* (Yakimoto)
> *The Devil and Peter Tork* (Attila the Hun)

Richard Klein
> *Fairy Tale* (Horseman)
> *Mijacogeo* (Henchman)

Henry Beckman
> *The Picture Frame* (Prosecutor)
> *The Monkee's Paw* (Club Manager)

Oliver McGowan
> *Monkee See, Monkee Die* (McQuinney)
> *Captain Crocodile* (Pontoon)

and one very special case...

Valerie Kairys
> *Monkees a la Mode* (Toby Willis)
> *Monkee vs. Machine* (uncredited, woman in burning building)
> *Your Friendly Neighborhood Kidnappers* (uncredited, Davy's date)
> *The Spy who Came in from the Cool* (uncredited, dancer)
> *The Chaperone* (uncredited, party guest)
> *I've Got a Little Song Here* (uncredited, woman outside studio)
> *Too Many Girls* (uncredited, fangirl)
> *The Case of the Missing Monkee* (uncredited, woman on rowing machine)
> *Monstrous Monkee Mash* (uncredited, woman in crypt)
> *Monkees Race Again* (uncredited, trophy presenter)
> *The Monkees Mind Their Manor* (uncredited, spectator)
> *Some Like it Lukewarm* (uncredited, one of the Westminster Abbeys)
> *Mijacogeo* (uncredited, pedestrian)

Appendix III: Index of Songs

While it would be nearly impossible—and highly impractical—to compile an index of every snippet of music that enlivens the 58 episodes of THE MONKEES, this list reflects the romps and performances that were central to the show's appeal.

A Little Bit Me, a Little Bit You	The Monkees at the Movies
All The King's Horses	The Spy Who Came in from the Cool
	Don't Look a Gift Horse in the Mouth
Cuddly Toy	Everywhere a Sheikh, Sheikh
	Monkees on the Wheel
Daily Nightly	Fairy Tale
	The Monkees Blow Their Minds
Daydream Believer	Art, for Monkees' Sake
	Monkees Marooned
	A Coffin Too Frequent
	Hitting the High Seas
Don't Call on Me	The Monkees in Paris
The Door into Summer	Monkees on the Wheel
	Some Like it Lukewarm
The Girl I Knew Somewhere	The Monkees Get Out More Dirt
	Monkees in Manhattan
	The Monkees on Tour
Goin' Down	The Wild Monkees
	A Coffin Too Frequent
	Monkees in Texas
	Monstrous Monkee Mash
	The Monkees in Paris
Gonna Buy Me a Dog	I've Got a Little Song Here
(I'm Not Your) Steppin' Stone	Your Friendly Neighborhood Kidnappers
	The Spy Who Came in from the Cool
	Monkees a la Carte
	The Case of the Missing Monkee
I Wanna Be Free	Success Story
	Here Come the Monkees
I'll Be Back Up on my Feet	Dance, Monkee, Dance
	Monkees in the Ring

I'm a Believer	One Many Shy
	Dance, Monkee, Dance
	Too Many Girls
	Son of a Gypsy
The Kind of Girl I Could Love	The Spy Who Came in from the Cool
	Alias Micky Dolenz
Last Train to Clarksville	Monkee See, Monkee Die
	Monkee vs. Machine
	Your Friendly Neighborhood Kidnappers
	The Monkees at the Movies
Laugh	Monkees in the Ring
	Monkees a la Mode
Let's Dance On	Here Come the Monkees
	Your Friendly Neighborhood Kidnappers
Look Out (Here Comes Tomorrow)	Monkee Mother
	The Monkees on the Line
	Monkees in Manhattan
Love is Only Sleeping	Everywhere a Sheikh, Sheikh
	I Was a 99 Lb. Weakling
	The Monkees in Paris
Mary, Mary	I've Got a Little Song Here
	The Prince and the Paupers
	Alias Micky Dolenz
No Time	Monkee Mayor
	The Devil and Peter Tork
Papa Gene's Blues	Monkees in a Ghost Town
	Don't Look a Gift Horse in the Mouth
	The Audition
	Hillbilly Honeymoon
Pleasant Valley Sunday	The Picture Frame
	Monkee Mayor
Randy Scouse Git	The Picture Frame
	Art, for Monkees' Sake
Riu Chiu	The Christmas Show
Salesman	The Devil and Peter Tork
Saturday's Child	Monkees vs. Machine
	The Spy Who Came in from the Cool
She	Monkees a la Carte
	Monkees at the Circus
She Hangs Out	Card Carrying Red Shoes
	Some Like it Lukewarm

Sometime in the Morning	Monkees at the Circus
	Monkee Mother
Star Collector	The Wild Monkees
	Hitting the High Seas
	Monkees Watch Their Feet
	The Monkees in Paris
	The Monkees Mind Their Manor
Sunny Girlfriend	I Was a 99 Lb. Weakling
Sweet Young Thing	Success Story
	The Audition
Take a Giant Step	Royal Flush
	The Chaperone
This Just Doesn't Seem to Be My Day	Royal Flush
	The Chaperone
Tomorrow's Gonna Be Another Day	Monkee See, Monkee Die
	Monkees in a Ghost Town
Valleri	Captain Crocodile
	The Monkees at the Movies
	The Monkees Blow Their Minds
What am I Doing Hangin' 'Round?	It's a Nice Place to Visit
	Monkees Marooned
	Monkees Race Again
Words	Monkees in Manhattan
	Monkees in Texas
	The Monkee's Paw
You Just May Be the One	The Chaperone
	One Man Shy
	Monkees a la Mode
Your Auntie Grizelda	I Was a Teenage Monster
	Captain Crocodile
	Monkee Chow Mein
Zor and Zam	Mijacogeo

Acknowledgements

There's a whole community that can rightfully claim to have participated in the birthing of this book. Two communities, in fact: a Monkees website forum called Monkeeland, and an informal network of Monkees-focused blogs following each other on the website Tumblr. Long before I ever dreamed of turning my episode reviews into a book, I was posting them in both communities and enjoying the conversations that resulted.

Prominent among the Tumblr bloggers are Meghan Brozanic (Psycho Jello) and Miss Mini and Moondreams (Naked Persimmon). These diligent and dedicated ladies of snark provide a vast storehouse of information—both reliable and subversive—for fans at all levels of experience. They have been both kind and helpful in this project.

Very early on, I invited readers of my blog to participate in the researching for my "female characters" essay. I received ideas from five readers, known to me as Rose-of-Pollux, Cellomouse, LittleMetalBottletops, Nora, and 1morejess. They not only helped me organize the essay, they also engaged me in the very conversations I was so desperately seeking..

Massive contributions by five special people made this book possible.

Andrew Hickey, the author of *Monkee Music*, first suggested that I turn my blog posts into a book. And he told me this again and again, until finally I began to believe him. He encouraged me throughout the process, and provided practical advice as well.

Librarian and blogger Sarah Clark took time from her doctoral studies to fact-check the manuscript. She joked that she never expected somebody to pay her to watch THE MONKEES, but her meticulous, eagle eye was worth every cent. I treasure her humor and her insight.

Sandy Jordan agreed to be my editor, and dragged me over the coals on more than one occasion. She made a heroic effort to break me of my excessive hyphen habit; evidence of

her success can be found in the previous phrase. She drove me hard, made me squirm, and improved the book. I couldn't have asked for a tougher, kinder editor.

Artist and puppet-maker Jaime Hitchcock charmed me with her colorful Monkees caricatures. We met at the Monkees convention in February 2013 and I was thrilled that she agreed to create the cover art for the book. I only regret that the project's budget did not allow me to fill the entire book with her delightful cartoons.

The very first person to comment on my blog has become a dear friend and confidante. Janet Paderewski Lattanzi is also the most reliable, supportive and insightful of advisors. Every moment spent in her company (Girls Gone Mild!) has been a treasure and well worth the trips to Texas from my home in Maryland. There is nobody I'd rather attend a concert with... and the next time, she has to come here!

I cannot end this without expressing my gratitude and admiration to the many people who gave so much of their hard work and inspired creativity to make this television show such a joy. The Monkees may be a quartet, but THE MONKEES was the work of a host of imaginative, industrious, dedicated and slightly wacky people, who took a chance and created something absolutely original. This list includes—but is absolutely not limited to:

- Micky Dolenz, Michael Nesmith, Peter Tork and Davy Jones
- Bert Schneider and Bob Rafelson: producers/creators
- Larry Tucker and Paul Mazursky: writers/pilot developers
- James Frawley: director/improv coach/actor
- Russell Mayberry, Alex Singer, and many others: directors
- Dee Caruso and Gerald Gardner: script and story editors/writers
- Treva Silverman, Peter Meyerson, Coslough Johnson and many others: writers
- Don Kirshner: music supervisor
- Bobby Hart and Tommy Boyce: songwriters/music producers
- Chip Douglas: music producer

Some of them are no longer with us.

I wish I had written this book sooner.

Printed in Great Britain
by Amazon